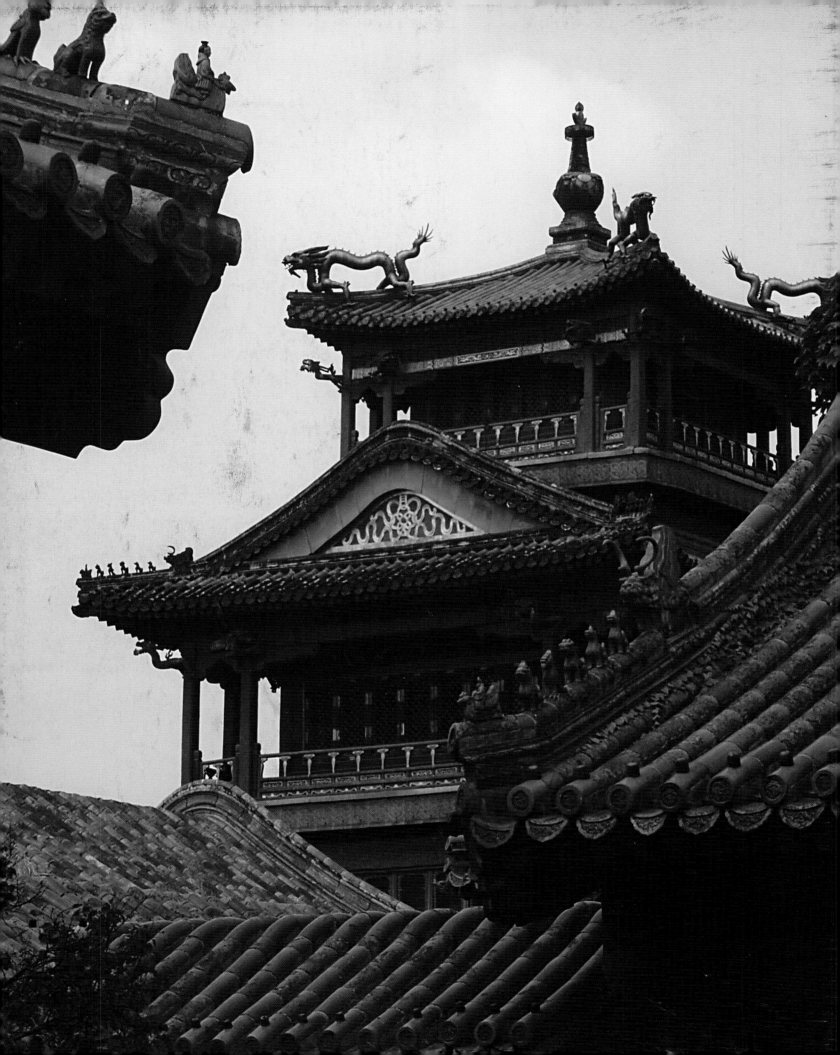

SPLENDORS OF CHINA'S
FORBIDDEN CITY

The Glorious Reign of Emperor Qianlong

Chuimei Ho and Bennet Bronson

MERRELL
LONDON · NEW YORK

The Field
Museum

Contents

CHAPTER I
The Last Chinese Empire

CHAPTER II
Symbols of Imperial Power

Sponsor's Statement

On behalf of my colleagues and the Board of Directors at Exelon Corporation, I want to express how pleased we are to sponsor the exhibition *Splendors of China's Forbidden City: The Glorious Reign of Emperor Qianlong*. I hope that you enjoy the opportunity to experience these remarkable works of art from Beijing's Palace Museum. One of Exelon's goals is to make Chicago a better place to live in and visit, and we think sponsoring this exhibition does just that.

John W. Rowe, Chairman and CEO, Exelon Corporation

Splendors of China's Forbidden City: The Glorious Reign of Emperor Qianlong was developed by The Field Museum in cooperation with the Palace Museum, Beijing.

Presented by

Proud Parent of ComEd

Additional support provided by the Elizabeth F. Cheney Foundation.

First published 2004 by Merrell Publishers Limited

Head office:
42 Southwark Street
London SE1 1UN

New York office:
49 West 24th Street
New York, NY 10010

www.merrellpublishers.com

in association with

The Field Museum
1400 S. Lake Shore Drive
Chicago, IL 60605-2496
www.fieldmuseum.org

Published on the occasion of the exhibition
Splendors of China's Forbidden City: The Glorious Reign of Emperor Qianlong
The Field Museum, Chicago
March 12 – September 12, 2004

Copyright © 2004 The Field Museum

All rights reserved. No part of this publication may
be reproduced, stored in a retrieval system or transmitted,
in any form or by any means, electronic or mechanical,
photocopying, recording, or otherwise, without the prior
permission in writing from the publishers.

ISBN 1 85894 203 9 (hardcover edition)
ISBN 1 85894 258 5 (softcover edition)

British Library Cataloging-in-Publication Data:
Ho, Chuimei
Splendors of China's Forbidden City : the glorious reign of
Emperor Qianlong
1.Qianlong, Emperor of China, 1711–1799 – Exhibitions – Art
collections 2.Forbidden City (Beijing, China) – Exhibitions
3.Art, Chinese – 18th century – Exhibitions 4.China – History
– Qianlong, 1736–1795 – Exhibitions
I.Title II.Bronson, Bennet III.Field Museum
709.5'1'09033

A catalog record for this book is available from the Library
of Congress

Produced by Merrell Publishers Limited
Designed by Matt Hervey
Copy-edited by Christine Davis with Kirsty Seymour-Ure
Indexed by Hilary Bird
Printed and bound in Hong Kong

Front jacket/cover: Portrait of the Qianlong emperor at the
age of twenty-five (detail of fig. 60)
Back jacket, top, left to right: Traveling bookcase in the shape
of a book and three scrolls (see fig. 102); *Taking a Stag with a
Mighty Arrow* (detail of fig. 226); Tiered basket (see fig. 109);
Statue of Yamantaka-Vajrabhairava (see fig. 156); Snuff bottle
in peacock-tail shape (see fig. 331)
Back jacket/cover, bottom: The Hall of Supreme Harmony,
or Taihe Dian (see fig. 1)
Page 1: Imperial seal impression (see fig. 56)
Page 2: Pavilion of Raining Flowers (see fig. 176)
Above: Portico of the Abstinence Hall (detail of fig. 198)

Foreword

John W. McCarter, Jr., President and CEO, The Field Museum

I am very pleased to present *Splendors of China's Forbidden City: The Glorious Reign of Emperor Qianlong.* This unique project explores multiple dimensions of the Qianlong emperor, revealing the important themes that lie beneath the glittering surfaces of the exhibition's spectacular objects. In contrast to surveys on imperial China, this project focuses on the social history of the ruling family during the late imperial period, providing comprehensive coverage of aspects of daily life in the palace. This tight focus enables readers and visitors to gain a better understanding of imperial China in general. We hope to provide a concrete picture of the intricate challenges inherent in ruling the vast nation of China – and how one ruler in particular met those challenges.

The Field Museum has long been interested in China and presently has an active research program spanning four disciplines: archaeology, botany, geology, and zoology. Our involvement there began with the fieldwork of former curator Berthold Laufer, one of the West's foremost sinologists, in 1907–10 and again in 1923. During those years, Laufer formed the nucleus of the Museum's outstanding collections of Chinese textiles, ceramics, metalwork, rubbings, and furnishings. And Laufer's work was only the beginning. Currently, a number of Field Museum scientists are conducting research in China. Active projects include: archaeologists Anne Underhill and Gary Feinman's excavation at Lianchengzhen in Shandong province; archaeologists Chuimei Ho and Bennet Bronson's explorations of early kiln sites in Fujian

province; geologist Peter Makovicky's research on dinosaurs discovered in Liaoning province and the Gobi Desert; archaeologist Deborah Bekken's excavation of a 200,000-year-old cave site in Guizhou province; botanist Jun Wen's documentation of the distribution of macrofungi in China; Olivier Rieppel's identification of four new genera and species of Triassic marine reptiles from Guizhou province; botanist Greg Mueller's documentation of macrofungi in China; botanist Rick Ree's investigation of plants and fungi in the Hengduan region; and a multi-disciplinary evaluation of conservation needs in Gaoligong Shan, Yunnan province. In addition, an average of six Chinese scientists conduct research in The Field Museum each year.

The Field Museum also has excellent Chinese collections and a long history of Chinese exhibitions. Not only does it have important holdings of fossils and plant specimens from northeastern China and of amphibians from western China, but it also has a major collection of Chinese artifacts. These include about thirty-two thousand archaeological, historical, and ethnographic objects, with world-class holdings of Chinese textiles, rubbings of stone and bronze inscriptions, utilitarian and decorative objects of the eighteenth to twentieth centuries, and materials from Tibetan-speaking areas in western Sichuan. Among the Museum's current China-oriented exhibitions are its Halls of Chinese Jades, Asian Mammals, and Tibetan culture. The Museum also has hosted a number of loan exhibitions from China, both large and

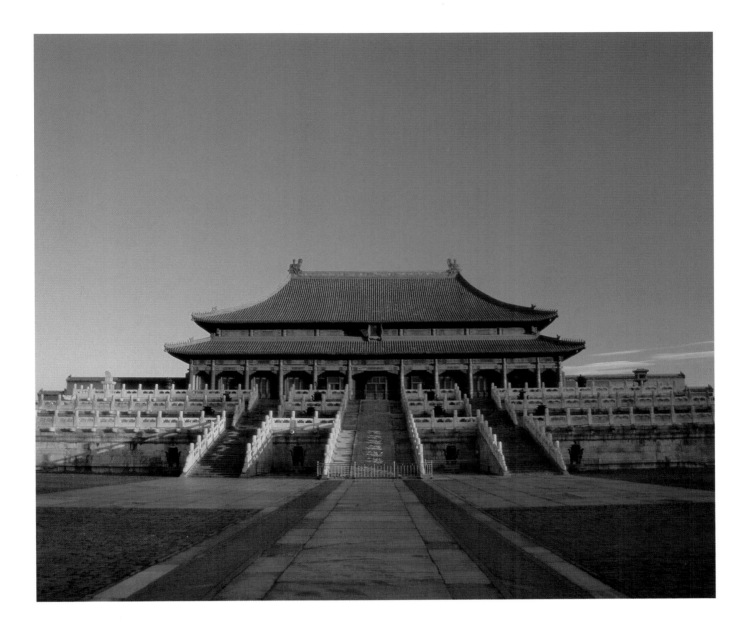

small. In the 1980s it was a venue for two trailblazing cultural exhibitions, *The Great Bronze Age of China* and the *Treasures of the Shanghai Museum*. Both of those exhibitions, as well as several smaller ones, served to strengthen ties between The Field Museum and Chinese institutions.

We have been collaborating with the Palace Museum in Beijing on this major exhibition and book project since 2000. Our collaborators, led by Professor Zhu Chengru, former Deputy Director of the Museum, and Ji Tianbin, current Deputy Director, have allowed an unprecedented five hundred objects to travel from the Forbidden City to the United States. All of the artifacts in the exhibition were used, dis-

played, or produced during the long and eventful reign of Qianlong. Few of the Palace Museum artifacts have ever been exhibited in North America, and more than one-third of the objects have never been shown outside the Palace Museum. Professor Zhu has opened wide to us the doors of the Forbidden City; his leadership has been invaluable. Deputy Director Ji has carried on Professor Zhu's vision for this exhibition and his support has been essential. We also extend special appreciation to Chen Lihua, Ma Haixuan, and Li Shaoyi for their administrative assistance. Many other scholars in China, the United States, and elsewhere have freely offered their help and expertise. They are listed in the introduction to this book.

1
The Hall of Supreme Harmony, or Taihe Dian
Photograph © 2003 Macduff Everton

The largest building in the Forbidden City, as seen from the south. This is the view that imperial officials and foreign ambassadors would have had on entering the palace compound and advancing to the throne room, which filled most of the Hall.

I am pleased to acknowledge the many members of The Field Museum staff who have worked on this project since its inception. Sophia Shaw Siskel, Director of Exhibitions and Education, Chuimei Ho, Adjunct Curator of Asian Archaeology, and Bennet Bronson, Curator of Asian Anthropology, conceived of this project and initiated the collaboration with our partners in Beijing. The expertise and intellectual rigor of Doctors Ho and Bronson are impressive; their dedication to making this subject-matter accessible to a broad audience is exceptional. Cathleen Costello, former Vice President of Museum Affairs; Robin Groesbeck, Manager of Exhibition Coordination; Ariel Orlov, Project Administrator; Francesca Pons, Project Administrator; Felisia Wesson, General Counsel; and Daniel Eck, Legal Counsel, stewarded all aspects of project coordination. Content Developer Matt Matcuk, Designer Robert Weiglein, Production Supervisor Nel Fetherling, Graphic Designers Tim Mikulski and Amanda Reeves, Conservator Betsy Allaire, Registrar Angie Morrow, and Mount Shop Supervisor Pam Gaible led the effort to bring the exhibition to life in Chicago.

I would also like to extend my thanks to Peter Keller and Anne Shih from the Bowers Museum of Cultural Art, in Santa Ana, California, for their guidance.

We are grateful to Exelon Corporation for its generous sponsorship of the Chicago presentation and we also wish to thank the Elizabeth F. Cheney Foundation for its support of the exhibition. Finally, we are sincerely grateful to the people of China, who have shared so many of their national treasures with the people of the United States.

Splendors of China's Forbidden City: The Glorious Reign of Emperor Qianlong is a major project for the twenty-first century. We hope that it will help American audiences better understand this important part of China's – and the world's – history, and contribute to increased friendship and understanding between the peoples of China and the United States.

Foreword

Zhu Chengru, Former Deputy Director, Palace Museum

The exhibition *Splendors of China's Forbidden City: The Glorious Reign of Emperor Qianlong* is going to open in the United States. On behalf of the Palace Museum, I would like to express my sincere congratulations.

The Qing dynasty was the last dynasty of Chinese feudal society. The Qianlong emperor was the fourth Qing emperor after the Manchurians entered the Shanhai pass and established a unified multi-nationality empire. He is not only the emperor who enjoyed the longest reign, sixty years as emperor and three years as over-sovereign, but also the emperor who enjoyed the longest life: he died at the age of eighty-nine. Owing to his political, cultural, and military achievements, he is regarded as one of the most outstanding Chinese emperors and left a splendid page in Chinese history.

In 1644 the Qing dynasty made Beijing its capital and began the last dynasty's rule in Chinese history. The rulers were a backward minority nationality from the forests in northeast China: the Manchurians. But they were good at learning and full of dashing spirit. After the Shunzhi, Kangxi, and Yongzheng reigns, especially that of Kangxi, the overall situation of multi-nationality unification had been established. The political life, economy, and culture of China had recovered and even developed; the war traumas at the end of the Ming dynasty had almost healed; the conflicts between different nationalities, especially between the Manchus and the Han Chinese, had been alleviated; the inner conflicts of the ruling class had been mitigated; and national power had been built on a secure foundation.

The last high point in Chinese history, the Kang-Qian Peak, took place in this period. The Kang-Qian Peak started in the Kangxi reign and ended in the Qianlong reign. That is to say, the Kangxi and Yongzheng reigns were the rising phase and the Qianlong reign was the climax and finale. The Kangxi and Yongzheng reigns prepared conditions for the Peak.

Qianlong was an ambitious and capable emperor. From the base formed by the Kangxi and Yongzheng reigns, the Qianlong emperor's efforts promoted rapid political, economic, and cultural development, and made important contributions to the progress and development of Chinese society. At the end of the Qianlong reign, however, the emperor's decrepitude and muddle-headedness caused civil corruption and a stagnant economy, thus pushing the Qing dynasty from a flourishing age to a declining abyss. The Qianlong emperor cannot escape historical responsibility for this.

After the Qianlong emperor ascended the throne, he, on the principle of "politics valuing leniency," carried out the policy of "reducing the heavy and harsh taxes and giving the people a break." He was keenly aware that "the people are the foundation of a country. The way of governing a country should be based upon loving the people. Loving the people should start from cutting taxes and exempting from rents," so that the people could feel the grace of "exempting and relieving." Therefore, the emperor adopted a series of measures, such as cutting corvée labor and taxation and reducing and exempting from land taxes, so as to

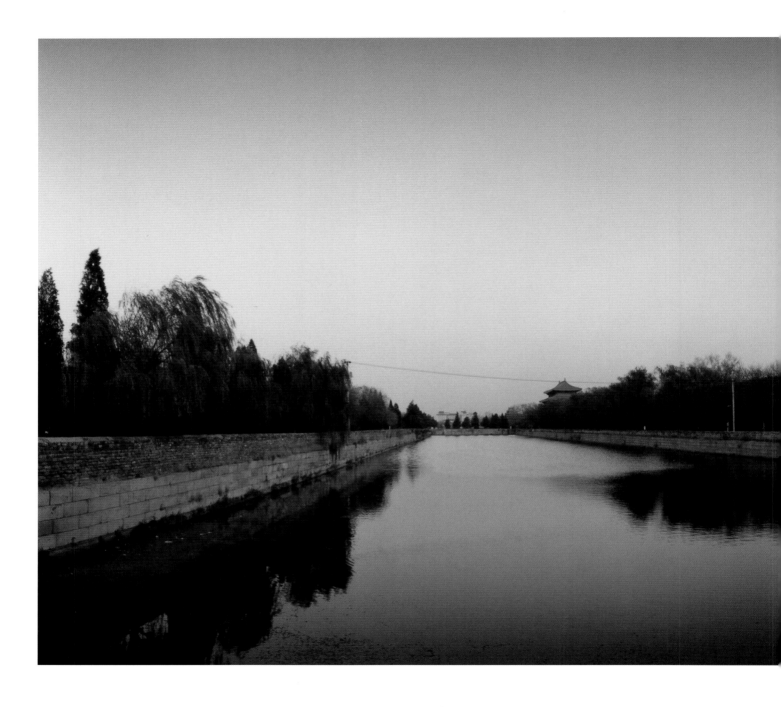

2
The Moat of the Forbidden City
Photograph © 2003 Macduff Everton

Finished in the Ming dynasty (1368–1644), the moat is almost 12,500 feet (3800 meters) in length. It looked much the same in Qianlong's day, except that there were no trees between the moat and the outer palace wall. This view is of the northeast corner of the palace.

relieve the people's difficulties. During the sixty-three years of his rule, the Chinese people were exempted five times from land taxes, and altogether 20,000 ounces of silver as taxation were dispensed with. The emperor also encouraged farming and sericulture, relieved the people in stricken areas, controlled river flooding, and freed able-bodied men in imperial villages as well as "slaves of the imperial household" in order to bring about an advance in social production. It was this advance that laid the foundation for the flourishing enterprise of the Qianlong period.

Even the emperor's imperial tours served to intensify his rule. He was the emperor who traveled most in Chinese history. According to incomplete statistics, during his reign he made more than one hundred and fifty imperial tours for such purposes as hunting in the North, paying homage at mausoleums in the East, and visiting Jiangsu and Zhejiang in the South. That is to say, on average he traveled two to three times every year. His six Southern Tours were most typical. South China was noted for its rich produce. It was an important financial center of the country as well as

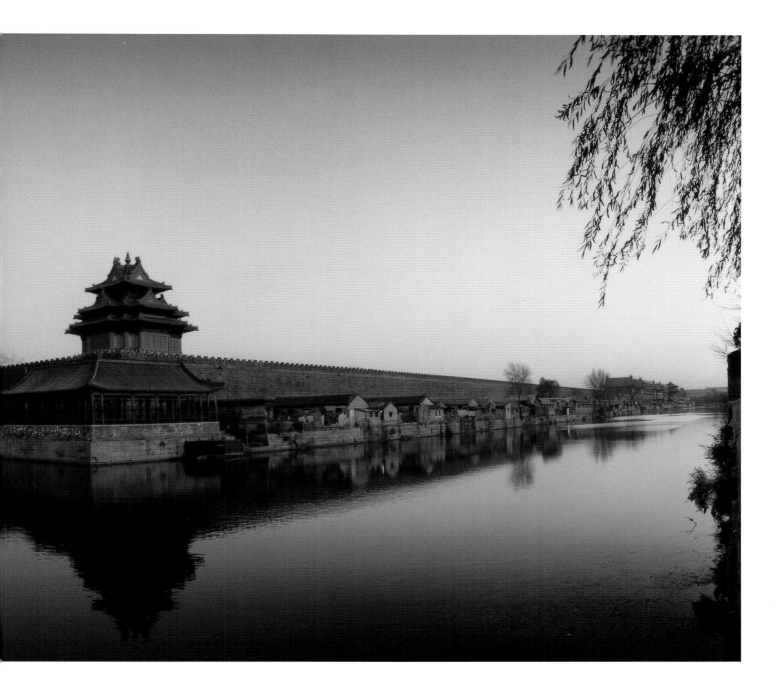

the "granary" of the Qing dynasty. Whether South China was blessed with bumper harvests or not was closely related to the whole country's prosperity. Therefore, the emperor visited South China six times from the 16th year to the 49th year of his reign. During his Southern Tours, he personally went to the Yellow River, the Huai River, and Zhejiang to inspect projects for river control and sea-wall construction, receiving local officials on the way, winning over intellectuals of the landlord class, and exempting the people from outstanding debts so as to display imperial grace, buy people's support, and consolidate the foundations of state power. The six Southern Tours forged closer relations between the central and local governments, partly removed dissatisfaction at Qing rule among the landlord class in South China, stabilized taxation and revenue, and strengthened the unification of the Qing dynasty. On the other hand, the six Southern Tours used a huge amount of human and material resources. The extravagance of the tours increased the people's burdens in various areas along the route. Therefore, it can be said that the tours

"exhausted the people and drained the treasury. Uselessness harmed usefulness."

Throughout his life, the emperor made important contributions to intensifying control over border areas and strengthening multi-nationality unification. He resolutely suppressed the rebellions led by a few ruling-class figures in the border areas. His contribution played a significant role in the flourishing of Qing rule and the final determination of the territory of China.

The Qianlong reign also attained certain cultural milestones. The economic prosperity laid a foundation for cultural development. During his reign, the emperor organized scholars to gather, sort out, and compile books, records, and documents on a large scale. According to incomplete statistics, the emperor endorsed the compilation of about one hundred and ten books in seven thousand fascicles. He also supported the collection of nearly one hundred thousand book fascicles for such works as the *Siku Quanshu* [Complete Library in Four Divisions] and the *Siku Quanshu Cuiyao* [Essence of the Complete Library in Four Divisions]. The highly influential *Siku Quanshu* project used the power of the whole country and yielded a comprehensive summary of all important books then in existence. It included 3461 titles and 79,309 book fascicles. This was an unparalleled feat in Chinese cultural history. Although the emperor's main purpose in compiling this monumental work was to shackle the thoughts of Han intellectuals and to show off his cultural achievements, the work objectively made an important contribution to preserving and transmitting ancient books, records, and documents, as well as causing cultural enterprises to prosper and promoting cultural development.

The Qianlong emperor was a versatile monarch. Proficient in Chinese traditional culture, he enjoyed composing poems and practicing calligraphy. As a prolific poet, he was the only Chinese emperor who left behind more than forty thousand poems. He loved calligraphy and without doubt wrote a good hand. In the eyes of modern people, he could even be counted as a calligrapher in Chinese history. After all, calligraphy was only an entertainment, for an emperor's free time. As a connoisseur, he not only appraised the famous paintings and calligraphic works in the imperial collection but also inscribed his opinions on them. His fascination with the well-known "Study of Three Rare Treasures" epitomized the emperor's cultivation in Chinese traditional culture and art.

In the Qianlong period, the emperor, on the one hand, promoted cultural development, and on the other hand, destroyed the cultural heritage obstructing his rule by carrying out literary inquisitions. The meticulous examinations and harsh charges were unprecedented. Even one character or one word could cast a person into prison. Nitpicking was common and laws were applied with the utmost severity. The general mood of society became mean. During the Qianlong period, about seventy to eighty cases can be found that were related to the literary inquisitions. While a few sufferers really opposed Qing rule, most of the sufferers just violated taboos. For example,

3
Gateway to the Hall of Mental Cultivation

Photographed shortly after the fall of the Qing dynasty, the gateway leads to the unpretentious buildings where several Qing emperors worked and lived while in the Forbidden City. (See also fig. 31.)

Outside China as well, the scholarly community has been very kind in sharing ideas and lending support. Patricia Berger of the University of California-Berkeley, Susan Naquin of Princeton University, and Pamela Crossley of Dartmouth University attended a conference panel at which exhibition themes were discussed. Terese Bartholomew of the Asian Art Museum of San Francisco, Mark Elliott of Harvard University, Elinor Pearlstein of The Art Institute of Chicago, Janet Baker of the Phoenix Art Museum, Pratapaditya Pal of the Los Angeles County Museum of Art, Rob Linrothe of Skidmore College, and John Listopad of Stanford University all offered advice and opinions. Several of them wrote sidebars for this volume, improving its quality as a reference for future scholars. Susan Naquin and William Watson, formerly of the Percival David Foundation in London, reviewed the volume before it went to print. We thank them profoundly for their patience and advice.

The actual production of the volume was assisted

greatly by Ariel Orlov, who coordinated communications with the staff at Merrell Publishers, by Mary Goljenboom, who handled image research and obtaining publication rights, and by Christine Davis and Kirsty Seymour-Ure, the very talented editors assigned to the project by Merrell. Their help was most vital. We also wish to thank the designer, Matt Hervey, and all the staff at Merrell, especially the managing editor, Anthea Snow, for their vigilance, literacy, and patience. They have performed miracles in getting this book ready in such a short span of time.

The volume would not have come into existence without the support of The Field Museum's Exhibition Department, led by Sophia Siskel. The Forbidden City exhibition project, administered first by Ariel Orlov and then by Francesca Pons, would have gone much less smoothly without the dedicated involvement of many Museum staff, including Orlov, Pons, and Robin Groesbeck. In addition, volunteers and assistants, such as Li Yuhang, Akiko Saito, Jean Vondriska, Malcolm

Another reason why historians have avoided Palace history has been the prevalence of colorful hearsay, false memoirs, and unsupported sensational exaggerations, popularized by a century of plays, novels, movies, and television programs. Two interest groups established recently have begun to hack away at this luxuriant undergrowth and to clear the ground for a responsible Palace-oriented historiography: the Qing Dynasty Palace History Research Society [Qingdai gongshi yanjiu hui], established in 1989 with biannual meetings, and the Chinese Forbidden City Research Society [Zhongguo Zijincheng yanjiu hui], formed in 1995. Many administrators and researchers from relevant museums and universities are members. Their excellent publications, conventions, and consortium efforts at museum exhibitions have begun to be felt, within and outside China.

A number of recent exhibitions have focused on the cultural achievements of the Kangxi, Yongzheng, and Qianlong periods. However, none was devoted to portraying Qianlong as an individual until last year, when the National Palace Museum's *Emperor Ch'ien-lung's Grand Enterprise* opened in Taipei. This was the first serious attempt by a museum to offer a comprehensive review of the emperor's impact and achievements in calligraphy, ceramics, bronze, jade, publications, and connoisseurship. In the words of historian Evelyn Rawski, the exhibition and accompanying symposium, *China and the World in the Eighteenth Century*, represented an unprecedented effort in "re-imaging" Qianlong.

Having long been convinced that the Qianlong emperor deserved attention in depth, the research and exhibition staffs of The Field Museum, having consulted the Palace Museum in Beijing, decided for exhibition purposes to concentrate on the following themes: Qianlong as a talented and hard-working ruler, a family man, a dedicated Buddhist who knew the importance of balancing Church and State, a competent art connoisseur and daring patron, and a lover of both publicity and privacy. The same themes are reflected in this book.

Almost all of the objects in the exhibition come from the Palace Museum in Beijing. The bulk of the objects illustrated in this book are from the same source, although not all are in the exhibition. Captions for illustrations only list owners when those are other museums or individuals. All illustrated objects without listed owners belong to the Palace Museum.

In the course of preparing the exhibition and book, many researchers and workers at the Palace Museum devoted much effort to providing us with information and images. Their names appear at the end of this introduction. We greatly appreciate their help. Several researchers in particular were instrumental in formulating ideas in the early stage of the exhibition preparation: Professor Zhu Chengru, Ma Haixuan, Chen Lihua, Zhang Yong, Wang Yaogong, Wang Jiapeng, Li Zhonglu, Yu Hui, Wang Liying, and Feng Xiaoqi, all of the Palace Museum; Professor Li Dejin of the Institute of Archaeology; and Professor Wang Qingzheng of the Shanghai Museum.

Introduction

Chuimei Ho and Bennet Bronson

This book is intended both as a free-standing publication and as a companion volume to an exhibition, *Splendors of the Forbidden City*, at The Field Museum. The theme of the exhibition was conceived by the first author as early as 1992, and research and planning have been under way ever since. Not wishing to funnel all of this effort into the usual kind of object-oriented exhibition catalog, the authors decided instead to produce a volume on Palace history, richly illustrated but with a text reaching well beyond art-historical topics. The focus of the book, we decided, would be the Qianlong emperor, who until very recently has been rather neglected by popular and academic historians. In spite of his great importance in the political and cultural history of the world in the eighteenth century, no general book on Qianlong is available in any Western language. We hope this book will help to fill that gap.

Although we have sought to keep references and other academic apparatus to a minimum, some have proved to be necessary. This is the more true because synthesizing secondary sources are, as yet, quite scarce, and because the Chinese-language primary sources are overwhelmingly abundant. The Qing dynasty (AD 1644–1911) is by far the best-documented period in the imperial history of China. However, thousands of the primary writings essential for a comprehensive understanding of the daily activities of key Palace personnel have not yet been read. Boxes and boxes of original Palace objects are still waiting to be fully inventoried in the Palace museums in Beijing,

Shenyang, and Taipei, as well as in the Nanjing Museum. Hundreds of published volumes have yet to be cross-referenced so as to check the accuracy of events, dates, and details. Partly because of the unmanageable abundance of resources and partly because of the anti-Manchu feelings of the first post-imperial generation of scholars, Chinese and foreign historians shied away from Qing Palace history until recently. They did recognize its importance but gave priority to earlier, less well-documented subjects.

In China the study of Qing Palace history has rarely been considered to be an independent field. Instead, it has been seen as a component of scholarship on the second of three phrases in Manchu history, covering the period between the Qing conquest of China in 1644 and the dark decades of the late nineteenth century. Most historians have recognized that the years between 1664 and 1798, the reigns of emperors Kangxi (1664–1722), Yongzheng (1723–35), and Qianlong (1736–98), were the golden era of the Qing period. The great majority of studies, however, have centered on Kangxi, an outstandingly attractive figure not only to his descendants and subordinates but also to modern historians. Qianlong, although regarded as a worthy successor, has been less appealing and, perhaps, more difficult to see as a real person. Thus, the Field Museum exhibition and this book are among the first attempts in any Western country to review the cultural, political, and personal achievements of the Qianlong emperor in a comprehensive way.

ordinary officials and people using some imperial characters and words would be regarded as overstepping their authority and opposing the emperor. Such large-scale literary inquisition was unusual. It reflects the strong dissatisfaction of the people and the intellectuals at Qing rule, as well as showing the Qing ruler's ruthless suppression of their resistance.

Besides the literary inquisitions muzzling public opinion, taking over and burning those books against the imperial rule was another high-handed cultural policy in the Qing dynasty. The Qianlong emperor used the chance of compiling *The Complete Library in Four Divisions* to examine thoroughly the books and records of the whole country. Under the guise of gathering rare editions, many valuable books were burned. In his examination, the emperor ordered the confiscation of all "contrary" and "presumptuous" books "against this dynasty." After this large-scale seizure, the books listed as "banned and destroyed" amounted to nearly three thousand books and between sixty thousand and seventy thousand volumes. The number was almost equal to that of the books in the *Complete Library*. This activity caused the loss of many historical documents and progressive books. Most of those left behind were official books acknowledged by the emperor. This was an enormous devastation of our ancient cultural heritage.

To sum up, the Qianlong period was one of the few golden ages in Chinese history and the Qianlong emperor was one of the most outstanding of Chinese emperors. His reign left behind rich works of art:

treasures from a flourishing age as well as gems from the cultural and artistic treasury of China. Our aim of showing in the United States these works of art representing Chinese culture is to enhance the American people's understanding of Oriental culture and to use cultural exchange as a bridge of friendship connecting the peoples of China and the United States. The increase in understanding between different peoples in the globalizing world will surely promote the development of human civilization.

Smith, and Margaret Larson, played an important role in making sure that all work was done on time. We the curators-editors-authors are in debt to all of them.

Palace Museum, Beijing

The following researchers and other staff members helped in providing information and accession details of the exhibits. Some contributed short essays to the volume.

Staff: Cai Yi 蔡毅, Cao Lianming曹連明, Chen Lihua 陳麗華, Chen Runmin 陳潤民, Ding Meng 丁孟, Fang Bin方斌, Fang Hongjun 房宏俊, Fu Chao 傳超, Guan Xueling 關雪玲, Guo Fuxiang 郭福祥, He Lin 何林, Hu Desheng 胡德生, Hua Ning 華寧, Jin Yunchang 金運昌, Li Weidong 李衛東, Li Yanxia 李艷霞, Li Yongxing 李永興, Li Zhonglu 李中路, Li Zhi'an李芝安, Liang Jinsheng 梁金生, Liu Baojian 劉宝建, Liu Jing 劉靜, Liu Liyong劉立勇, Liu Sheng 劉盛, Liu Yue 劉岳, Mao Xianmin 毛憲民, Ni Rurong 倪如榮, Nie Hui 聶卉, Qian Jiuru 錢九如, Ruan Weiping阮衛萍, Rui Qian 芮謙, Song Yongji宋永吉, Tie Qi 鐵琦, Tu Xuejun 屠學軍, Wang Qi汪亓, Wang Quanli王全利, Wang Hui王會, Wang Jiapeng 王家鵬,Wang Shuo 王碩, Wu Chunyan 吳春燕, Xia Gengqi夏更起, Yan Yong 嚴勇, Yang Jie 楊捷, Yin Anni 殷安妮, Yun Limei 惲麗梅, Zhang Guangwen 張廣文, Zhang Li 張麗, Zhao Congyue趙聰月, Zhao Guiling 趙桂玲, Zhao Lihong 趙麗紅, Zhao Yang 趙揚, Zheng Hong 鄭宏, and Zhou Jingnan周京南.

Photographers: Hu Chui 胡錘, Feng Hui 馮輝, Liu Zhigang 劉志崗, and Zhao Shan 趙山. Translator of Palace Museum contributions 故宮博物館稿件翻譯: Li Shaoyi 李紹毅.

Note on the Text

Chinese names are given in the normal Chinese order, with the surname first.

Ho Chuimei 何翠媚 and Bennet Bronson 班臣
October 2003

CHAPTER I
The Last Chinese Empire

CHAPTER I
The Last Chinese Empire

4 (page 20)
Calling Deer
(detail of fig. 9)

Qianlong on a hunting trip, at the age of thirty-one. He wears a jacket and skirt of tailored firs.

5
Map showing China under Qianlong

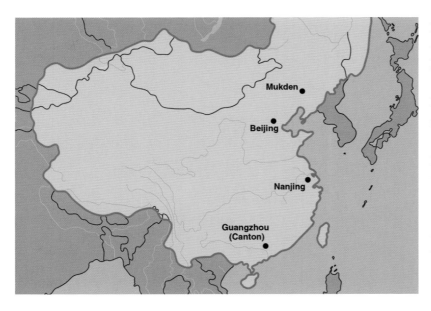

Introduction: Qianlong

Shortly after the death of the Yongzheng emperor, a small committee of high officials hastened to one of the throne rooms and retrieved a box sealed behind an inscribed plaque high above the floor. They opened it reverently, read the scroll inside, and made the announcement: Hongli or Prince Bao, the fourth son of the deceased emperor, would succeed to the throne. The year was 1735.

The twenty-five-year-old prince may not have been too surprised, for his father had given signals that he was a leading candidate without declaring him crown prince. Kneeling in mourning at the coffin, he must have reflected that he was to become the absolute ruler of two hundred and fifty million people. Not all would accept him, for he came from a minority group that had conquered China less than a century before. He would have been confident that he could prove himself, for he was highly intelligent and a natural leader. But for now he had to wait. Although he could take on his executive duties immediately, custom dictated that he must not assume the title of emperor until the lunar New Year, three months away. Hence it was not until 1736 that he could adopt a reign name of his own. He chose the name Qianlong.

As this book will show, Qianlong was a successful emperor. Under his rule, China was rich and at peace. Its territory, at more than five and a half million square miles (almost twelve million square kilometers), was greater than at any other time before or since (fig. 5). Its population doubled between 1700 and the end of his reign, to more than three hundred million. Its decorative arts and architecture reached new heights. Its long and splendid past was preserved and made secure. Only at the end of Qianlong's reign were there hints of the troubles that would come to China in the following century. He abdicated in 1795, and died in 1799, at the age of eighty-eight, with the reins of real power still firmly in his hands. No other emperor of China ruled so long.

Perhaps the most unusual thing about this outstanding Chinese ruler is that he was not Chinese, or at least not a native speaker of a Sinitic tongue, one of the cluster of Sino-Tibetan languages spoken by the Han Chinese ethnic group. Instead, Qianlong was a Manchu. His native tongue, also called Manchu, was

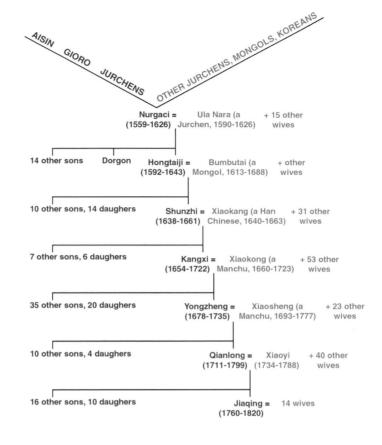

AISIN GIORO JURCHENS · OTHER JURCHENS, MONGOLS, KOREANS

Nurgaci = Ula Nara (a + 15 other
(1559-1626) Jurchen, 1590-1626) wives

14 other sons Dorgon **Hongtaiji =** Bumbutai (a + other
 (1592-1643) Mongol, 1613-1688) wives

10 other sons, 14 daughers **Shunzhi =** Xiaokang (a Han + 31 other
 (1638-1661) Chinese, 1640-1663) wives

7 other sons, 6 daughers **Kangxi =** Xiaokong (a + 53 other
 (1654-1722) Manchu, 1660-1723) wives

35 other sons, 20 daughers **Yongzheng =** Xiaosheng (a + 23 other
 (1678-1735) Manchu, 1693-1777) wives

10 other sons, 4 daughers **Qianlong =** Xiaoyi + 40 other
 (1711-1799) (1734-1788) wives

16 other sons, 10 daughers **Jiaqing =** 14 wives
 (1760-1820)

6
**Family tree of Qing rulers
before 1800**

a Tungusic language not even remotely related to Sino-Tibetan. He traced his ancestry to the Aisin Gioro clan of the Jurchen, a diverse group of tribal peoples – fishermen, hunter-gatherers, forest farmers, and herdsmen – from the far northeastern part of China.

To understand how these tribesmen came to rule all China, we must go back a century and a half before Qianlong. The key figure in the rise of the Jurchen was an exceptional leader, Nurgaci or Nürhachi (1559–1626). Beginning with a minor chiefdom near the Korean border, Nurgaci employed a combination of statesmanship and ruthlessness to subdue a whole series of ministates or chiefdoms, one at a time, adding each to the growing confederacy of which he was the paramount leader. In 1616 he felt secure enough to declare himself khan, or emperor.

Did his use of that title show that he was already thinking about conquering China? Perhaps not: he was not the visionary that his son Hongtaiji would be. Yet he probably was well aware that another khan, the Mongol Kubilai, had indeed conquered China four hundred years earlier. And he certainly knew that his Jurchen ancestors had done the same thing a century before that, seizing the northern two-thirds of China and calling their dynasty Jin, meaning Gold. Memories of those glorious days were still alive among the Jurchen when Nurgaci declared himself khan and named his nascent dynasty the Latter Jin with its capital at Mukden, modern Shenyang.

The vision that Nurgaci may have lacked was supplied by his ninth son, the remarkable Hongtaiji (often called Abahai by earlier historians). A fine leader, Hongtaiji gained his brothers' support and with his now-unified armies proceeded to cow first Korea and then eastern Mongolia before launching a series of ultimately decisive attacks on China itself. In 1635 he renamed his nascent dynasty Qing, meaning Bright or Pure, and his people the Manchus. In the process, he developed a new political system and a full-fledged ideology of Manchu identity that had a profound influence on his great-great-grandson, Qianlong.

In 1643 Hongtaiji died. His preliminary campaigns had left the road to Beijing wide open. The Ming dynasty fell a year later to Qing armies led by Hongtaiji's equally able brother Dorgon, who entered Beijing, expressed regret at the suicide of the last Ming emperor, and proceeded to install Hongtaiji's six-year-old son as the Shunzhi emperor, the ruler of all China (fig. 6).

Dorgon died in 1650 and Shunzhi was left to rule alone. Perhaps surprisingly in a lineage that had already produced three exceptional leaders, Shunzhi turned out to be a weak ruler in the Ming mold – well-intentioned but indecisive, unable to control the new conquest élite,

From the time he began to assume a role as political leader in 1587, Nurgaci, the founder of Manchu power, organized his troops into units called "arrows" [*niru*] in reference to a universal token of political affiliation used throughout Inner Asia. By 1616, when the state that would become the Qing empire was established, the military system was formalized as the "Eight Banners." These remained a hereditary imperial military force until the twentieth century. The banners were distinguished by the colors of their flags, with the basic four colors of yellow, white, blue, and red (which remained the general order of prestige) represented both as solid and as bordered standards. Just before the conquest of North China in 1644 the Eight Banners were further categorized as "Manchu," "Mongol," or "Chinese-martial" [*hanjun*], depending on the geographical origins of the lineages of the men enrolled in them. Some units of the traditional military remained outside these categories, including companies of "new" Manchus (hunting peoples of Northeast Asia), Muslims of northwest China, and "Russians" (mostly native peoples recruited or captured from the Russian-controlled territories of the Amur River). Thus though there were eight basic flag patterns there were always many more than "eight" banners – a minimum of eight each of Manchu, Mongol, and Chinese-martial, together with an irregular number of banners of other groups.

Originally the banners were owned by the highest princes who helped Nurgaci rule his state. But by the mid-1600s the Bordered Yellow, Plain Yellow, and Bordered White banners in each category had come to be considered the property of the imperial lineage, with a much higher rank than the other banners. In imperial processions and some ceremonies, the colors of the Eight Banners were joined by the Green Standard, representing the far less prestigious professional military recruited within China during and after the Qing conquest. Paintings from the Qing period suggest, however, that it was unusual to represent this hierarchy in the order of the parade. The banner ranks are usually not to be read from left to right, or from top to bottom. Banner officers sometimes grouped together while common bannermen came behind. On other occasions units grouped themselves by specialization (cavalry units or cannoneers together). In only a few instances do we see large numbers of bannermen arranged in the order of the prestige of their units. More often the banners were arranged as in the painting of the return of the emperor from the Southern Tour: flag bearers are concentrated by banner but not by the hierarchy of their units within the Eight Banners, and are frequently punctuated by groups of Green Standard soldiers (see fig. 112).

and in serious danger of allowing himself to become a puppet of the court eunuchs (castrated male servants) and bureaucracy inherited from the Ming.

Fortunately for the Manchus, Shunzhi's son and successor, the Kangxi emperor, proved to be a throwback to the generation of Hongtaiji and Dorgon (fig. 7). Enthroned as an eight-year-old child in 1662, he overthrew his reactionary regents in 1667 at the age of fourteen and proceeded to reign for another fifty-four successful, warlike, prosperous years. He died in 1722, leaving behind twenty sons, eight daughters, a fast-growing population outside as well as inside the Imperial Palace, a realm at peace, and money in the treasury. Few rulers in Chinese history have been his equal.

In the midst of an exceptionally active life, Kangxi found time to get to know his grandsons. One of his favorites was a tall, athletic boy named Hongli, the future Qianlong emperor. The old emperor, impressed by Hongli's bravery in the hunt and perhaps also by his sheer intelligence, for he seems to have been a child prodigy, invited him to come and live for a year at the new summer capital in Chengde. That year made a deep impression on the twelve-year-old boy. From then on he worshiped his grandfather. He was to spend the rest of his life trying – quite successfully, be it noted – to live up to Kangxi's remarkable example.

Kangxi's fourth son, Yinzhen, took over the throne in 1723 upon Kangxi's death. Adopting the reign name Yongzheng, Yinzhen proceeded to rule conscientiously for the next thirteen years until his own death in 1735. Fears of assassination kept him in the Palace for most of his reign, and fear of rival claimants led him to eliminate a number of brothers (including his first, second, third, eighth, and ninth) and to imprison several others (including his tenth, twelfth, and fourteenth). According to a tradition cultivated assiduously in later years, Kangxi had favored the future Yongzheng over his siblings because of Yongzheng's son Hongli, who Kangxi hoped would ultimately inherit the throne.

This story may or may not be true. Yongzheng cannot have had much faith in its credibility, for until the end of his life he remained anxious about his brothers' claims to the throne. By contrast, he did trust Hongli, now called Prince Bao, and seems to have been consciously training him to become emperor one day. He was a good trainer. In spite of his paranoia, Yongzheng was a capable and humane ruler. He

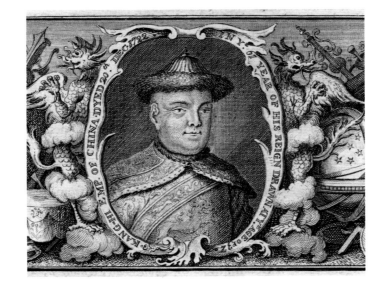

7

The Kangxi emperor as imagined by an English book illustrator

From Du Halde's *Description of the Empire of China*, 1738. Kangxi was in reality a slender man with hollow cheeks in old age. The text wrapped around the portrait reads "KANG-HI EMP. OF CHINA DYED 20ᵗʰ DEC 1722 IN YE 61 YEAR OF HIS REIGN DRAWN AT YE AGE OF 32."

was also innovative, intelligent, cultured, and as interested as was Kangxi in foreign styles and technology. He had two empresses, a modest number of other consorts, and a total of four sons and one daughter who lived to adulthood. He seems to have learned from his own problems with siblings and to have raised his children to live in peace with one another. He died somewhat prematurely at the age of fifty-seven, leaving Prince Bao as his clearly designated successor. The twenty-five-year-old prince already had substantial government experience and was eager to begin. He became emperor at the start of 1736.

The decree that Yongzheng hid behind the plaque in the throne room was written shortly after he became emperor, when his son was only twelve. It reads as follows:

> Prince Bao, Hongli, the fourth imperial son, is kind and compassionate. He is friendly and filial, and is the best loved grandchild of the [Kangxi] Emperor who raised Prince Bao in the court and thus bestowed most unusual grace on him. In the 8th month of the 1st year of Our reign, We assembled various princes, officials of both the Han and Manchu groups, to receive Our commands about the way in which We would designate a successor. We wrote this decree, sealed it, and hid it at the highest point of the throne room in Qianqing Gong [Mansion of Heavenly Purity]. It designates Hongli as the crown prince. Now the great event has taken place. It is Our wish to have him succeed to the throne to become Emperor.

The Manchus before the Conquest

One of our concerns in this book is the way in which material culture illuminates history, and the reverse: how documentary history can throw light on the design and function of artifacts. In the case of earlier Manchu material culture, the scarcity of written sources from the pre-Conquest period forces us to resort to inference based on ethnographic objects and other indirect sources. The Manchus did bring a good many types of artifact with them when they came to Beijing. A number of those artifact types survived until later centuries, either because they were useful or because the Qing emperors treated them as badges of Manchu identity.

8

Map showing major ethnolinguistic groups of Northeast Asia

Tungusic-speaking groups are shown in red.

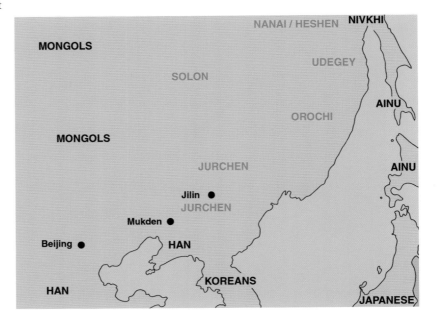

9

Calling Deer (detail)
Artist: attributed to Giuseppe
Castiglione (1688–1766)
Color on silk and paper;
105 × 125½ in.
(267 × 319 cm)
1741

A large mounted hunting
party makes its way though
the mountains near Mulan
north of Chengde. Qianlong
and his entourage are in the
foreground. The weapons,
including the spear, are of
special interest. About a
quarter of the full painting
is shown here.

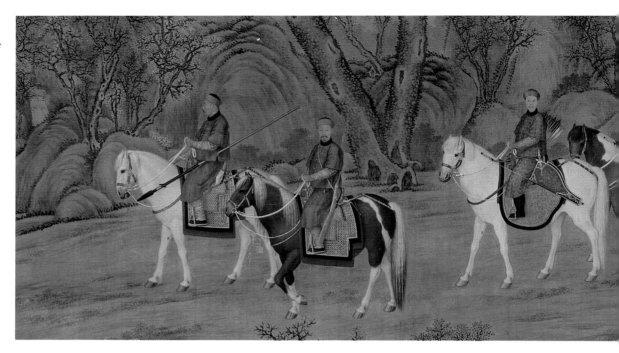

We may assume that the ancestors of the Manchus represented a variety of ethnic groups, centered on speakers of Tungusic languages but including a variety of Mongolian, Korean, Chinese, and perhaps speakers of Paleosiberian languages, such as Nivkhi, as well (fig. 8). Many of these groups, including most of the Tungusic speakers, were forest peoples, adapted to the frigid, snowy woodlands of eastern Liaoning, Jilin, and Heilongjiang provinces in China and Primorye province in Russia. The peoples of this area were familiar with agriculture but, except for Chinese and Korean immigrants, were limited in their depend-

ence on farms, preferring to exploit the rich local resources of freshwater and saltwater fish and of game. In the western part of their area the Tungusic speakers had taken to horsemanship and stock breeding, mostly learned (with an extensive horse-keeping vocabulary) from nearby Mongolian pastoralists.

Whether farmers, fishermen, or stock breeders, most Tungusic peoples were also skilled hunters.[1] Some of their weapons seem to have come down to the post-Conquest Manchus, including a type of heavy hunting spear with a pair of short horn or metal bars attached by chains or sinew just behind the spear head,

10

Hunting spear
Steel and birch wood, with
horn and leather; length
74¾ in. (246 cm)
1736–95, Qianlong mark and
period

The spear is meant for hunting
tigers and other dangerous
game. Two horn "ears" are
attached just below the head to
keep the spear from passing
through the body of a charging
animal. As shown by fig. 12,
the ears are a traditional device
among Tungusic peoples. In
his poems, Qianlong described
such weapons by such fanciful
names as "snow-edged pike"
[*xuefeng*].

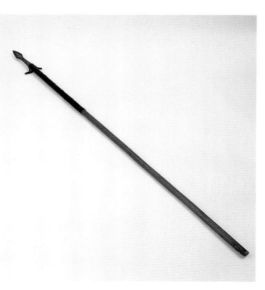

11
(detail of fig. 10)
"Da Qing Qianlong nianzhi"
[Made in the Qianlong reign
of the Great Qing] reign mark

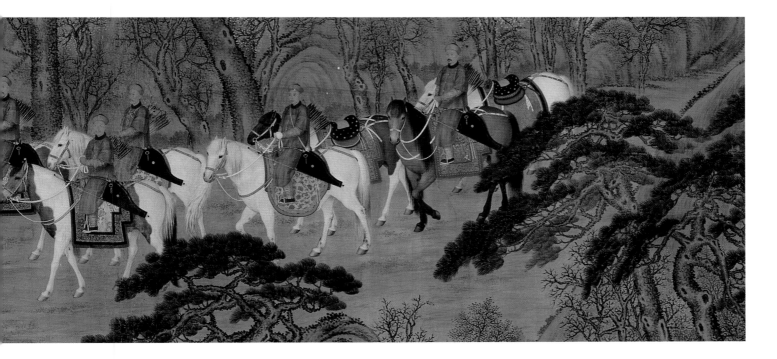

evidently intended to prevent the spear from sliding through a charging animal and letting the animal harm the hunter. The device seems to be especially suited to hunting bears, boars, and tigers. Such weapons appear in late nineteenth-century illustrations of tribal hunters (fig. 12) and in eighteenth-century paintings of imperial hunting parties (fig. 9). An actual example from the Palace collections is shown here as fig. 10; it has a Qianlong reign mark (fig. 11) and is likely to have been used by the emperor himself.

Many proto-Manchus did a great deal of fishing. As late as the seventeenth century, Jesuit map-makers in the Northeast encountered Tungusic tribesmen who, like the native peoples of coastal British Columbia, were almost entirely dependent on salmon.[2] The great abundance of that resource enabled some Tungusic tribes to live well without excessive labor. A strong interest in fishing was evidenced by various of their post-Conquest descendants. Although Qianlong seems to have disliked eating and catching fish, Kangxi was a real enthusiast. As Father Verbiest, Kangxi's Jesuit adviser, recalled:

A little below this place [Ula, on the Sungari], which is above 23 miles from Kirin [Jilin], the river is full of a sort of fish pretty like our plaice, and it was principally to take the diversion of the fishery that the Emperor came to Ula. But the rains coming on a sudden so swelled the river that all the nets were broken and carried away by the flood. ... In our passage back the bark in which I was with the Emperor's father-in-law was so damaged by the beating of the waves that we were forced to land and get into a cart drawn by an ox ... When we entertained the Emperor with this Adventure, he laugh'd and said, "The fish have made sport of us."[3]

The Northeast had a long tradition of metal-working, cloth-weaving, and pottery-making, but also regularly imported fine metal objects, textiles, and ceramics from both China and Korea. Like other minority peoples on the peripheries of great empires, the

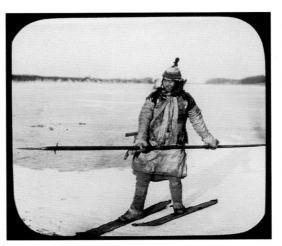

12
Tungusic tribal hunter on skis
Photographer: William Henry Jackson (1843–1942)
Lantern slide
1895
Library of Congress, Washington, D.C.
wtc1994000803/PP

This hunter of the Nanai ethnic group is wearing skis on the ice of a frozen river, either the Amur [Heilongjiang] or a tributary. His spear has "ears" similar to those on spears used by Qianlong.

13
Nanai robe
Fish skin, dyed and stitched;
length 53 in. (135 cm)
Lower Amur River area
c. 1890
The Field Museum 32016

This was formerly a common
costume for both men and
women among the southern
Tungusic-speaking tribes and
their neighbors, the Nivkhi.
The appliqué decoration is
also of fish skin. Such robes
button on the right side like
Manchu dragon robes.

proto-Manchus prized luxury goods from the metro-
politan central places of the Chinese empire. Usually
they traded those goods for local products – furs, dried
mushrooms, ginseng, falcons, and deer antlers and
tails from the forests, as well as freshwater pearls from
the rivers and lakes.

Several times in the past the tribesmen of the
Northeast had been powerful enough not to get their
fine silks and porcelains through trade but to demand
them as tribute.[4] In this they differed profoundly from
peripheral hunter-gatherers in most other parts of the
world. A thousand years before the Manchu conquest,
the hunting and pastoral peoples of the Northeast

were already showing a knack for military organiza-
tion and a taste for conquest. Tungusic peoples formed
much of the population and the troops of the Bohai
kingdom (698–926). Some must have fought beside
their neighbors, the Altaic-speaking Khitan (Qidan),
when they conquered Bohai and northern China to
establish their own dynasty, the Liao (916–1125). Most
of the Tungusic Jurchen opposed the Liao, cooperat-
ing with the Chinese Song dynasty against the Liao
during the tenth and eleventh centuries. In the early
twelfth century, the Jurchen broke relations with both
the Khitan and the Song to form their own dynasty,
the Jin (1121–1234). They destroyed the Liao, exacted

Until 1636, when the Qing empire was formally created, the main cultural group of northeastern China was called the "Jurchen." Members of this group, which included the family that would become the Qing imperial lineage, were distant cultural cousins of the Jurchen whose empire had ruled north China between 1121 and 1234, before being destroyed by the Mongols. Remnants of the Jin imperial population withdrew to Northeast Asia and rejoined the hunter-gathering and fishing peoples of the region. Others settled in China, farming and melding into the main population.

The later Jurchen who founded the Qing spoke a related language but originated well to the north of their earlier namesakes. More definitively, though they were not nomads they lived for centuries in close proximity to the Mongols. This exposure left vivid marks on Jurchen – and subsequently Manchu – social structure, political tradition, language, clothing, art, and religion. The result was a milieu that was neither traditional Jurchen nor assimilated Mongol, but distinctively and enduringly Qing. In 1636 the first emperor of the Qing, Hongtaiji, declared that his people should be known as "Manchu," which distinguished them forever from the traditional Jurchen and all related peoples of Northeast Asia.

Nevertheless, certain continuities with Northeast Asian culture existed. Like the Mongols to their west and the Koreans to their east, the Manchus incorporated both Buddhism and shamanism into their seventeenth-century culture. The emperors were enthusiastic patrons of several sects of Buddhism, and their court life in both Shenyang and Beijing was adorned with beautiful Buddhist figurines, paintings, texts, and prayer beads. But shamanist rituals figured very prominently in the court calendar, and all sites of imperial residence had facilities for shamanist worship in close proximity. The imperial shamanist temple, the Tangzi (now destroyed), stood in central Beijing. The Kunning Gong [Mansion of Earthly Tranquility] in Beijing is still equipped with cauldrons for preparing meat sacrifices and spirit poles for offering the sacrifices to Heaven, the universal shamanist deity of Central and Inner Asia. The imperial storehouses also yield up the distinctive spirit dolls, like those used by the Mongols, for invoking powers to work good or ill (see fig. 142). These were used in conjunction with drums, beads, mirrors, and musical instruments to communicate with spirits that the Manchus had in common with other peoples still living in Northeast Asia.

After 1636, Northeast Asian peoples were conquered by the Qing just as north China was. They were enrolled in distinctive units within the Eight Banners, and officially identified as subject peoples participating in the "tribute" system, though they sometimes played special parts in shamanist pantomimes and were given gifts by Qing emperors claiming to be nostalgic for the homelands. For the entire Qing period, the Qing court both acknowledged peoples such as the Evenks (Solons), Orochons, and Dagurs as cultural cousins and belittled them as aliens lacking in wealth and civilization. Today these peoples are largely recognized as distinct "minority" groups of the Northeast, very different now from their cousins, the Manchus.

massive tribute from the Song, and established their chief capital at Beijing. Their new Jin dynasty was a success and established itself as such in Jurchen tradition. Despite their eventual defeat by Genghis Khan's Mongols and the conquest of their northeastern homeland first by the Mongols and then by the Chinese Ming dynasty (1368–1644), the Jurchen of the fifteenth and sixteenth centuries had vivid memories of their moment in the sun.

Hence, it was clear to the Jurchen and their neighbors that China could be conquered, and that the conquerors could be Tungusic tribesmen like themselves. Taken from their boats and dogsleds, mounted on horseback, and properly led, the northeastern tribal peoples made formidable soldiers, and if the Chinese had forgotten this, as they may have done during the long sleep of the later Ming, the tribesmen themselves had not. A clan named the Aisin Gioro, from the northern slopes of the sacred mountain Changbai Shan (fig. 14), was the one that would eventually unify the tribes and shape them into a powerful army.

We have no direct evidence for the clothing of these proto-Manchus, but we may perhaps assume that they dressed much like the southern Tungusic hunting and fishing peoples who, as late as the nineteenth century, had still not been fully incorporated into the developed Manchu identity. These peoples include the Hezhen, Nanai, Ul'chi, Udegey, and Orochons of the lower Sungari, Ussuri, and Amur rivers and the Sihote Alin range. Among them, both sexes wore long robes with tight sleeves that buttoned on the right side, over trousers and leggings.[5] The similarity of these tribal costumes to Manchu robes was noted as early as the middle Kangxi period by Jesuit map-makers among the Nanai of the lower Ussuri: "They dress like Manchews, in the Chinese Habit; the only difference is, that the Bottom of their long Robes is commonly bound with a green or red Border on a white or grey

14

The Crater on Changbai Shan Mountain

Artist: F.E. Younghusband (1863–1942)
Hand-colored lithograph 1888

The Manchus believed that this lake, on top of their sacred mountain on the border between Jilin province and North Korea, was the source of all three major rivers in the area, the Yalu, the Tumen, and the Sungari. The artist was an English army officer who in later years led the force that conquered Lhasa for the British empire.

15
Forest on the northern slope of Changbai Shan Mountain

The homeland of the Aisin Gioro clan and the heart of Manchu tradition were the wet, cold, densely forested northern foothills of Changbai Shan and adjacent mountains.

Ground."[6] In later centuries, the fact that these robes were often made of fish skins caused the wearers to be known pejoratively to the Chinese as *yupi* [fish skin] wearers or in European languages as "Fishskin Tartars" (fig. 13). And yet in the late Ming period even the Jurchen of the northern foothills of Changbai Shan Mountain, direct descendants of the acknowledged ancestors of the Qing emperors, wore outer clothes of fish skin.[7]

Belts were sometimes worn over the long robes – by shamans among others – and usually worn over the short jackets with separate aprons favored by hunters. Like Manchus in Qing-period everyday and court costume (fig. 16), Tungusic-speaking tribal hunters hung various accessories from their belts: a knife, a flint and steel kit for fire-making, and other small cases and tools (fig. 17). Often these were suspended by a thong or cord that passed under the belt and was prevented from slipping through by a toggle tied to one end. Such toggles did not become part of

16 (opposite)
Taking a Stag with a Mighty Arrow
(detail of fig. 226)

The Qianlong emperor is shown here in his customary hunting costume. His Manchu robe has a lower right panel that can be unbuttoned for ease in mounting a horse. A number of small pouches hang from his belt, in the style of northeastern tribal hunters. He wears a thumb-ring on his right hand with which he has just released an arrow. His hard-soled boots are quite similar to the footgear worn with formal court robes.

Qing formal costume but, interestingly, did achieve popularity among the élite of Japan where, as *netsuke*, they acquired the cachet of a fine art form during the Tokugawa period. Knives were symbolically important to the Manchus. Qianlong even erected a tablet in front of the Jianting military training hall for princes (fig. 18), emphasizing that real Manchus should always carry knives to cut up their own pork at meals rather than having it cut up for them in the Chinese way. As he said on another occasion:

> Now I can see that Manchu traditions have been much relaxed. For instance, Prince Yi did not carry his knife. What is the reason for that? I read records of Taizong [Hongtaiji, son of Nurgaci and second ruler in the dynasty] who said "Imperial clan males who cannot cut their meat themselves and do not carry arrow quivers are not observing Manchu customs. What will become of their descendants?" These are the lessons taught by Taizong to his sons. He already worried about his children and grandchildren giving up on tradition.[8]

Another Manchu custom that may be derived from the Northeast is the use of well-made hard- and soft-soled boots (see fig. 63). In general, the traditional footgear of the northeastern tribes was much more complex in design than that of the northern Chinese. As in the case of other far northern Eurasian and American native peoples, skill in footgear manufacture among the Tungusic tribes was a life-or-death matter in the high-

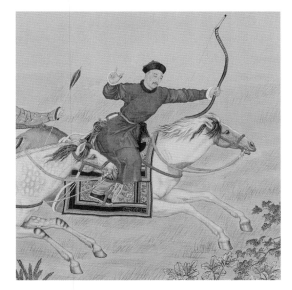

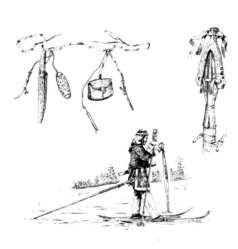

17 (left)
A Nanai hunter on skis in the 1930s
Redrawn from Levin and Potapov 1964

The Nanai seem not to have used their Manchu-style robes when hunting. They hung pouches, knives, and other possessions from their belts, as did Manchu emperors. The spear, with a wooden guard over its point, has "ears" made of bone.

18
Tablet with imperial decree
Stone; height 24 in. (60 cm)
1752
Located in the Jianting Archery Pavilion, Forbidden City, Beijing

This tablet bears an inscription by Qianlong emphasizing the importance of skill in archery and horsemanship for Manchus, as well as the importance of wearing Manchu-style clothing. The Pavilion was designed for training princes and others in archery and riding.

snowfall forest and river environments of the region. Traditions in this regard may help to explain the importance of boots in later Qing court costume.

In post-Conquest times, Manchu theorists maintained that a somewhat Mongolized style of dress had been part of their ethnic heritage, with front and rear vents in their robes, narrow belts, short-sleeved jackets worn over the robes, and hard-soled boots, although without the very long sleeves typical of Mongolian and other Central Asian outerwear. As pointed out by one influential historian, most of these costume features were adapted to riding and fitted in well with the Qing government's emphasis on horsemanship as a traditional Manchu skill.[9] And yet the pre-Manchu Jurchen of the Changbai Shan Mountain forests in southeastern Jilin province (fig. 15) cannot have had many horses. They seem to have been sedentary hunters and fishermen who also practiced small-scale agriculture.[10] In the eyes of later military experts, "their native hills [were] unsuited for cavalry exercises."[11] However, when certain of the Jurchen moved westward into the forest-prairie environment of eastern Liaoning, shortly before Nurgaci's day, they evidently began to keep horses and fight as cavalry.[12] This horse orientation must have been relatively new to the Aisin Gioro and their kin, in spite of what later generations claimed.

The Manchus Seize Power

We will not repeat here the story, glorious in Manchu eyes but once a hateful memory to Han Chinese, of the exceptionally rapid conquest of China by Qing armies. It is enough to say that the actual conquest began in 1644, that the last claimant to the Ming throne, Zhu Youlang, was killed in 1662, and that effective military resistance ceased in the same year with the (natural) death of the loyalist admiral Zheng Chenggong. With Zhu and Zheng both dead, armed opposition to the Manchu conquest ceased, although passive resistance by individual Chinese and rebellions by Chinese warlords continued for years afterward.

Chinese and Manchu traditions could combine in surprising ways, few more unusually than in the _Ode to Mukden_ [Shengjing fu].

Written in 1743 by Qianlong, this long bilingual poem (about three thousand words in Manchu) commemorates the emperor's visit in that year to the tombs of the Qing founders in the Manchu homeland, known as Mukden. Conceived in the classical Chinese form of the _fu_, or rhapsody, which traditionally lent itself to florid description, it begins with a very Chinese celebration of filiality by Qianlong, who notes that he undertook the trip to pay homage to his forefathers. Qianlong even cites Confucius on the importance of observing the ritual calendar of sacrifice.

Soon, however, the poem moves to a consideration of the wonders of the Manchu _terre natale_. Encircled on its southern periphery by a garrisoned palisade of willows and on its eastern rim by the snow-capped Changbai Shan [Everwhite Mountains], Mukden was the mythical locus of Manchu ethnogenesis and as such a place of hallowed memory. Qianlong's poem, one of more than forty-four thousand ascribed to him, exhaustively categorizes the flora and fauna of "this sacred land, blessed by heaven, [whence] khans arose." Under his brush, Mukden's sky and earth, its teeming wildlife, dense forests, and fertile fields all unite to create a uniquely auspicious environment deserving of awe:

Majestic Mukden was founded along the north bank of the Shen waters. Its mountains are high and its rivers broad. It is fixed as a universal model, a most wondrous place, great as a tiger or a dragon. ... Established on a grand scale, it promulgates the rule of great kings. ... It surpasses and humbles all other places and has united [lands] within and [lands] without.

According to Qianlong's imperial logic, it was only fitting that so majestic a dynasty as the Qing should have arisen in such a splendid setting.

Though in writing this paean Qianlong made use of a particularly Chinese genre (two famous _fu_ written about the capitals of the Eastern and Western Han were unquestionably familiar to him), the point of his rhapsody was, of course, to celebrate the glories of the _Manchu_ imperial enterprise. Qianlong was not being ironic; he was simply availing himself of the appropriate literary and linguistic tools at his disposal. As if the cultural bivalence of having written the poem in both Chinese and Manchu were not enough, five years after it was first published the emperor ordered the _Ode_ reprinted in a special edition. This required the carving of the entire text sixty-four separate times: thirty-two times in different Chinese antique seal scripts, and thirty-two times using the same seal scripts as adapted to the Manchu alphabet (thirty-two was an iconic Buddhist number). In so doing, Qianlong managed to pack the _Ode to Mukden_ with yet further political meaning, writing in a new preface of his desire to transmit to later generations the ancient forms of the Manchu script, so superior, as he noted, in its perfect combination of sound and form – quite a claim, as until around 1600 Manchu lacked its own writing system.

A translation into French of the _Ode to Mukden_ by a Jesuit missionary, Jean Joseph Marie Amiot, appeared in Paris in 1770. Done out of the Manchu, it was one of the first translations of Chinese poetry to be published in any Western language.

The rapidity with which the Conquest occurred had several consequences: low mortality among the conquered,[13] minimal disturbance to much of the national economy (although not in coastal Fujian province and such severely sacked cities as Yangzhou), and a degree of cultural self-confidence on the part of the conquerors that is unusual in the annals of barbarians who conquer empires. The Germanic peoples who conquered Rome were given to confessing that they had a lot to learn about ruling an empire. The Manchus, by contrast, felt that they already knew the secret and that this lay in the customs they brought with them.

Back in 1636, Hongtaiji had freely invoked his Jurchen ancestors and the Jin dynasty in support of his claim to the Chinese throne. In the same year he also set the pattern for many later edicts relating to clothing and personal adornment, all designed to assert the primacy of Manchu cultural norms: "All Han people – be they official or commoner, male or female – their clothes and adornments will have to conform to Manchu styles. Males are not allowed to fashion wide collars and sleeves; females are not allowed to comb up their hair nor bind their feet."[14]

Similar rules were promulgated numberless times by Manchu rulers, not only in the years immediately following the Conquest but especially during the reign of Qianlong, who felt strongly that retaining true Manchu customs was essential to the strength of the empire. Qianlong's edicts in favor of Manchu-ness were a recurring feature of his reign. In his 17th and 24th years, he commanded that Manchus must not dress like Han Chinese, nor abandon training in the ancestral arts of archery and horsemanship.[15] In his 20th year he criticized Manchus for learning Chinese rather than Manchu, stating that fluency in the latter language was as important as shooting and riding.[16]

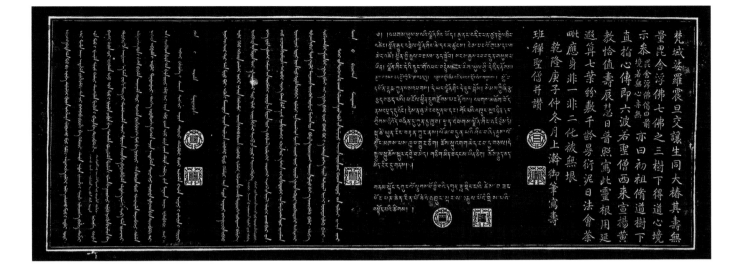

In his 23rd and 39th years, he criticized Manchu girls for wearing Han clothing and jewelry in his presence: for instance, putting a single earring in each ear instead of the traditional three: "If they do this before me, what is willfully worn at home?"[17]

The Chinese empire as envisioned by Qianlong and his predecessors was composed of several distinct, separate but equal, ethnic groups. As a leading Manchu specialist has argued, whereas the Ming saw China as a Confucian state the citizens of which lived by the same universally applicable principles, the Qing conceived it as a universal rulership based on the submission of a set of important confederated peoples whose separate cultural identities were respected.[18] Qianlong gave official recognition to four such peoples besides the Han Chinese. All were horse-riding semi-nomads dwelling in the northern and western border areas: the Manchus, the Mongols, the Tibetans, and the Turkish-speaking peoples of Xinjiang. Qianlong used their languages in official inscriptions and attempted to learn those languages himself. He eventually learned four besides Chinese and Manchu: Mongolian, starting in the 8th year of his reign; Uighur Turkish, starting in his 25th year, after Muslim Xinjiang was fully pacified; and the Tibetan languages spoken in Sichuan-Qinghai and in Lhasa, starting in his 41st and 45th years. He learned the last to show respect to the Sixth Panchen Lama when he visited Beijing and Chengde in 1780 (fig. 19).

Interestingly, however, ethnic groups outside this privileged set of northerners were treated not as culturally distinct confederates but as subjects for eventual full assimilation to Chinese ethnicity. Although his troops fought numerous campaigns against Miao-speaking and other tribal groups in southwestern China, Qianlong never sought to learn their languages and showed little respect for their cultures. Some of his other subjects and tribute-paying neighbors had complex civilizations and their own traditional writing systems: for instance, the Koreans and the Russians, not to mention the Western Europeans in Macao and at his own court. And yet (unlike Kangxi, who learned at least some Latin) he never sought to learn their languages either. The minority peoples that counted were those who fought on horseback and had a centuries-long record of armed incursions into the Chinese heartland. The idea that other neighboring ethnic groups – for instance, the Russians and the Japanese – were potentially more dangerous to China, and thus had to be conciliated if not included, must not have seemed believable to Qianlong and his policy advisers.

New Rulers in Old Palaces

The Qing did not wipe out the Ming legacy. They retained much of the former government structure, especially as it applied to the Han Chinese, and even left many Ming government personnel in place. They also retained many Ming governmental concepts. The fact that a familiar system of courts, agencies, and officials continued in use goes a long way toward explaining Han Chinese acquiescence in Manchu rule.

19
Rubbing: Four-language inscription by Qianlong (detail of fig. 152)

The text, in Chinese, Tibetan, Manchu, and Mongolian, was composed by Qianlong to accompany his painting of a tree presented to the Sixth Panchen Lama. Both the text and the painting were engraved on stone so that copies could be distributed in the form of rubbings.

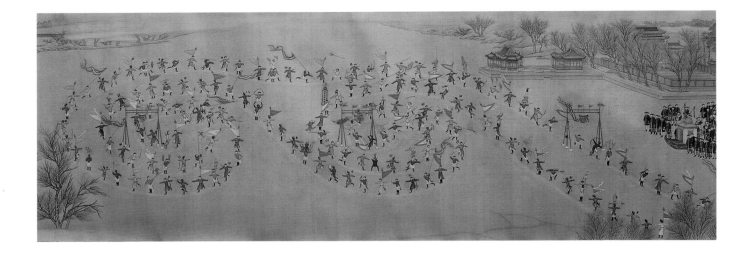

20

An Ice Game
(detail of fig. 137)

The game depicted here involved acrobatic skating and shooting arrows at targets while skating at speed. The skaters carry the triangular flags of seven of the Eight Banners: Yellow, White, Blue, Red, Bordered Red, Bordered Yellow, and Bordered White. The eighth banner, Bordered Blue, is not present.

21

The Ten Kings' Halls at the Shenyang Palace

The buildings on both sides of the central plaza were audience halls for the members of the Eight Banners between 1625 and 1644. At this time Shenyang was the only Manchu capital.

The conquerors did introduce a number of distinctive Manchu institutions, including the status of bondservant – a class of unfree individuals, most but not all Han Chinese, who were entirely dependent on the emperor and hence trusted by him with numerous important governmental tasks – and the division of the Manchu population into eight sections or Banners, designated as follows: Plain Yellow, Bordered Yellow, Plain White, Bordered White, Plain Red, Bordered Red, Plain Blue, and Bordered Blue (figs. 20, 21). Each Banner in turn was divided into three ethnic sections: Manchus, Mongols, and so-called Chinese-martial, whose ancestors had joined the Manchu armies before the Conquest. Like the bond-servants, the Banners too gave a new flavor to the government of China. Yet the Qing followed the Ming very closely in most other aspects of the practice and theory of government.

Partly in consequence, the chief imperial palace of the Ming – the so-called Gugong [Former Palace] or Zijincheng [Purple Forbidden City], the pivot of the four directions and symbolic center of the empire – underwent only limited changes under the Qing. The conquerors kept the Ming layout of the Palace complex nearly intact. The northern section continued to be the most sacrosanct part of the complex, reserved for the emperor, his women, and their attendants. As one historian points out, here the Ming custom prevailed of having religious worship carried out in halls rather than in named temples and staffed by trained Palace personnel rather than by professional priests.[19] Even as late as Qianlong's reign, most of the buildings in the Forbidden City were located in the same places and served the same functions as in Ming times, even though the great majority had been partially or wholly rebuilt.

The parks immediately north and west of the Forbidden City – Jingshan and Zhongshan – and the three lakes called Beihai, Donghai, and Nanhai were also already in existence during the Ming dynasty. However, other palaces such as those in the Qingyi Yuan (later the Yihe Yuan) and the Yuanming Yuan garden complexes, 12 miles (20 kilometers) northwest of the Gugong, were built by the Qing, as were a series of imperial retreats, travel palaces, and

The Yuanming Yuan Summer Palace

Cary Y. Liu

As early as 1650, the regent Dorgon planned to build a summer retreat away from Beijing to escape the heat, clamor, and disease, and to reside in quietude in a scenic area. He complained that "The capital city is old in years, the land is polluted and the water is salty, and while the three seasons of spring, winter, and autumn can just be endured, in the summer months the humidity and heat are unbearable."[1]

In 1709 Kangxi granted a garden residence in the western outskirts of Beijing to Yinzhen, the future Yongzheng emperor. Given the title "Yuanming," this princely garden occupied roughly one hundred acres (forty hectares). Yongzheng retained Yuanming Yuan as his principal residence on his accession to the throne in 1723. Elevated to imperial status, the garden expanded to include formal palaces and offices for conducting state affairs. Despite its proximity to the ceremonial Forbidden City in Beijing, duplicate palaces at the garden were needed because from this time forward the Qing rulers spent the majority of each year in residence at Yuanming Yuan.

This makes the garden notable in Chinese architectural history. Granted, many imperial gardens and hunting parks had existed in earlier periods, but they can primarily be viewed as attachments to palaces or temporary residences, and never the chief residence or center of government. Arguably, both the Yuanming Yuan and its predecessor, the Imperial Summer Villa in Chengde [Bishu shanzhuang] built by Kangxi at Rehe, mark the beginning of a new Manchu architectural typology, that of "imperial garden palaces" [*ligong xing huangjia yuanlin*].

In plan, the new garden palaces were designed as microcosms of the empire and cosmos, focusing on the emperor surrounded by scenic spots copied from around the nation and beyond its borders. Amid landscaped lakes, plains, and hills, the more public formal palace halls were arranged in front, followed by more private informal imperial residence compounds, with the grounds of the garden sanctuary at the back (see fig. 147).

Like all gardens, the Yuanming Yuan was a dynamic entity that grew and changed over time. Qianlong expanded it by annexing four adjoining gardens. Collectively this larger version became known as the "Yuanming Wu Yuan" [Five Gardens of Round Brightness] and occupied about eight hundred and sixty-five acres (three hundred and fifty hectares).

More than just a refuge from the summer heat and urban crowding, the Yuanming Yuan, with its idyllic hills and lakes, exemplified the Confucian concept of a wise ruler as embodied in the "Yong ye" section of the *Analects*: "The wise enjoy water, the virtuous enjoy mountains." The Qing emperors took a strong personal interest in the building of the garden palaces. The builders themselves included special Design Offices [*yang fang*] working with a system of construction drawings and models that enabled new and innovative designs to be built by traditional workshop craftsmen. This system was solidly in place during the Qianlong era, when the Yuanming Yuan saw many imitative and fanciful designs, including curious "Western buildings" designed by European Jesuits in a small sector within the garden.[2]

the great resort palace complex of Bishu shanzhuang at Chengde.

The Qingyi Yuan was Qianlong's own creation, sited on the location of a Jin dynasty imperial palace named Golden Hill. The Yuanming Yuan was founded by Kangxi and massively rebuilt and enlarged by Qianlong who, like his father Yongzheng, regarded it as his primary residence. Yongzheng and most of the emperors after him spent two-thirds of the year there, from shortly after the Chinese New Year until the Mid-Autumn Festival. Qianlong, too, would probably have spent that much time in the Yuanming Yuan if he had not been so fond of traveling, which led him to spend several months each year outside the Beijing area.

Qianlong may never have admitted that he disliked the Forbidden City. Yet undeniably it was not a comfortable place to live. Echoing many earlier judgments, "Princess" DerLing Yukeng, a lady-in-waiting in the court of Dowager Empress Cixi in the early 1900s, commented that:

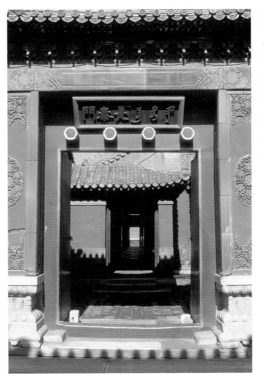

22

Doorways in the Inner Court

The visual confinement of life in the Forbidden City was one reason why emperors and their women preferred the summer palaces. This gateway leads to the Mansion of Eternal Spring, one of the twelve compounds for imperial wives (see fig. 210).

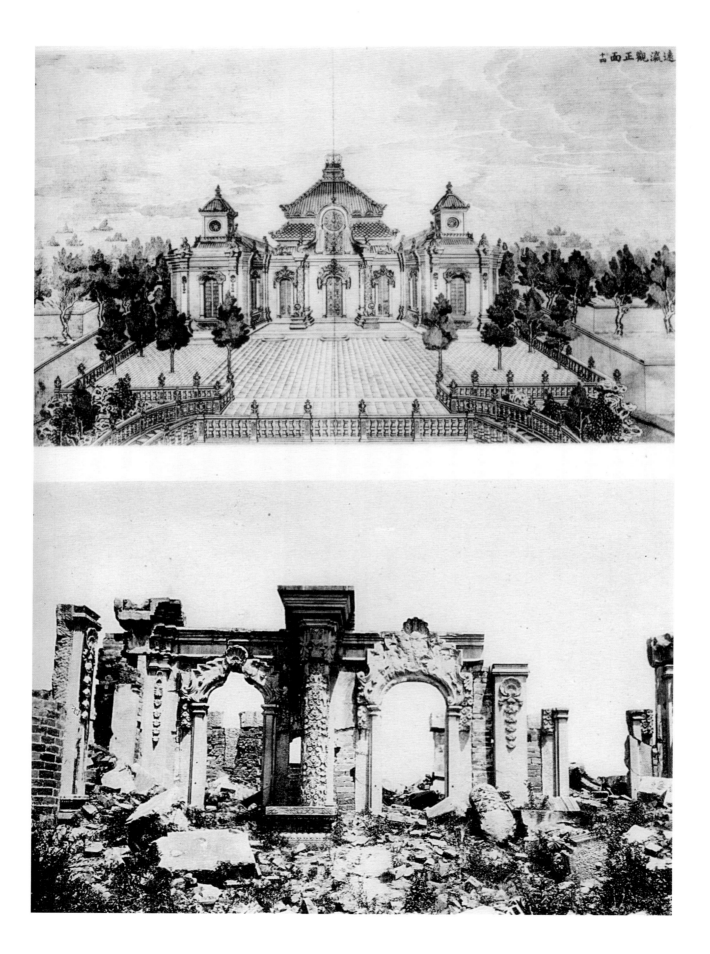

The Palace in the Forbidden City was so old, and built in such a queer way. The courtyards were small, and the verandas very broad. All the rooms were dark. We had to use candle light. One could not see the sky except by going into the courtyard and looking up. ... Her Majesty [Cixi] never liked to stay in the Forbidden City, and I was not a bit surprised, as I hated the place. We had to use candles to dress by, in the morning, as the rooms were in absolute darkness even in the middle of the afternoon. It rained so much that finally Her Majesty said she would return to the Summer Palace the next day, whether it was raining or not, and we were all very glad to go.[20] (fig. 22)

Qianlong himself, who was too fond of traveling to spend even half a year in any one place, was nonetheless the chief developer of the summer palaces, adding garden concepts from all over China as well as commissioning a number of buildings in European style (fig. 23). According to later legend, his life in the summer palaces was a continuous round of pleasure:

In four seasons there were so many festivals in
　　the Garden,
The Emperor himself loved the Moon Festival best,
And rode away on the back of a white peacock,
With singsong mingled with flowers white as snow.
Roads from east and west led to a day of late Autumn,
The horse carts rattled round and never thought
　　of stopping.
Candles with lights were seen all over the hills
　　and lakes,
We were told that His Majesty was just enjoying his
　　good nights in the Sea of Fortune.
It was like in a fairyland that this isle was
　　lanterned bright,
Amidst thousands of trees, they were playing
　　colored balls.[21]

Other Qing imperial enclaves, most of which witnessed very extensive construction in Qianlong's day, included the imperial retreats at Fragrant Hill [Xiangshan] (15 miles [25 kilometers] west of Beijing)

23 (opposite)
A European building in the Yuanming Yuan gardens
Engraving 1770s; photograph 1920

This is Yuanying Guan, one of the European structures designed and built for Qianlong by Jesuit architects in the 1760s. The engraving shows what it looked like originally, and the photograph shows what was left after its destruction by British and French soldiers in 1860. In spite of their fame among Westerners, the European buildings occupied only a very small part of the Yuanming Yuan.

24
Potala Monastery, Chengde
Completed 1771

The largest monastery in Chengde, this was built in imitation of the Dalai Lama's residence, the Potala, in Lhasa. Its original purpose was to accommodate élite visitors during the great celebration of Qianlong's sixtieth and his mother's eightieth birthdays in 1771. The monastery's rules highlighted religious and ethnic privilege. Only Mongolian princes, chiefs, and high-ranking lamas were allowed to climb to the highest terrace.

25
Map showing palaces and imperial residences in the Beijing region

and Panshan (62 miles [100 kilometers] east of Beijing), the resort palace at Chengde outside the Great Wall (124 miles [200 kilometers] northeast of Beijing), the imperial hunting park at Mulan north of Chengde, the ancient capital at Mukden (now Shenyang) in the Northeast, and the imperial Manchu tomb complexes: the Eastern Tombs at Malanyu in Zunhua (78 miles [125 kilometers] east of Beijing) and the Western Tombs at Yixian (80 miles [130 kilometers] west of Beijing). See fig. 25 for a map showing these locations.

Chengde, too, saw a great deal of building under Qianlong: a substantial palace complex extending over one million square feet (more than one hundred thousand square meters) and no fewer than ten vast Buddhist temple complexes built in a variety of ethnic styles. Notable are the Putuozongsheng Temple (fig. 24), a reproduction of the Potala in Lhasa, and a 230-foot (70-meter) glazed-tile pagoda built in the Yangtze delta style (fig. 27):

On one of his visits to Nanjing and Hangzhou, Qianlong was deeply impressed by two famed pagodas, the Baoenta and the Liuheta. He desired to have these reproduced in his summer palace at Rehe [Chengde] ... The plan was carried out, but one of the two pagodas was destroyed by a conflagration, and the other collapsed on its completion. The geomancers counseled and gave the verdict that southern monuments must not be built in the north. The emperor, however, scorned their decision and ordered new and more solid building material. After ten years' labor, the pagoda was completed – a landmark in the valley of Rehe.[22]

Thus, with masterful self-confidence and the expenditure of vast sums of money, the Qing emperors transformed most of their environment. They left one feature unchanged, however: the symbolic primacy of the Palace in Beijing.

Boxes within Boxes: The Geography of Imperial Life
It is not clear how literally contemporaries took the ancient Chinese metaphor of the Palace as the axis or pivot of the universe. The Qing government's planners certainly knew that the metaphor existed, having inherited the Ming layout of the capital as a series of irregular onion-like layers, reflecting graded levels of

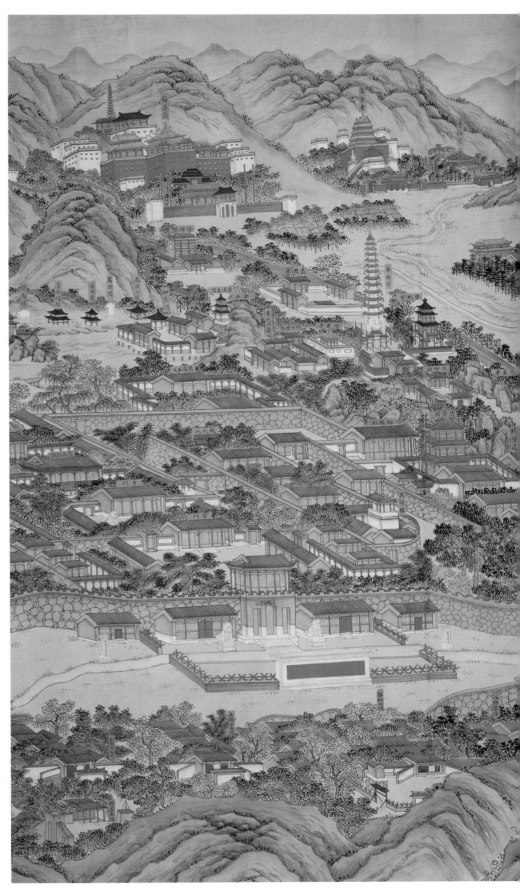

26

Complete Map of the Resort Palace at Rehe (detail)
Artist: Guan Nianci (d. 1909)
Ink and color on paper;
height *c.* 48 in. (119 cm)
1875–1890(?)
Library of Congress,
Washington, D.C.,
G7824.C517A3 1890.G8
Vault Shelf

This large horizontal scroll painting, about a quarter of which is shown here, is probably a copy of an original from the 1780s–90s. It presents an aerial view of the imperial palace and gardens at Chengde [Rehe], with two of the Eight Outer Temples in the background. Although the palace was founded by Kangxi, most of the buildings and gardens were built by Qianlong. (See also fig. 149.)

security and, it may be, sacredness. At its very heart were the audience halls of the Forbidden City, surrounded by the structural complexes of the Inner and Outer Courts with a massive wall and moat (fig. 28). Around this was a zone of government offices, parks, and élite residences known in later times as the Imperial City, with a somewhat less imposing wall and no moat. Next came the so-called Inner City, which under the Qing was inhabited exclusively by members of Banner families – Manchus, Mongols, and Chinese-martial – as well as by certain foreign legations. It, too, was walled and moated. The fourth layer was known as the Outer or Chinese City. A Qing creation, it did not in fact surround the Inner City but adjoined it to the south. It was inhabited largely by Han Chinese and other ethnic groups, including Muslims from western China, and was walled but not moated. Not only was the Outer City the business district of the capital but it was also the chief entertainment center and the locus of two crucially important ritual centers, the temples of Heaven and of Agriculture. And lastly, adjoining the Inner City on the north was the lightly populated area sometimes known as the Cap City, surrounded by substantial but neglected walls built by Mongol rulers back in the Yuan dynasty (1271–1368).

Around this series of walled complexes lay a densely settled suburban zone and beyond that, open countryside with steep hills to the west but otherwise flat farmland studded with satellite cities, government installations, and imperial enclaves like those discussed

27

Model of the Glazed Pagoda at Chengde

Wood; height 41 in. (104 cm)
c. 1910
The Field Museum 130384

The pagoda behind Xumifushou Temple (fig. 149) at Chengde, built in the 1780s, was made to imitate one of two pagodas in central China that the emperor had seen and liked. The original, constructed of brick, was 230 feet (70 meters) high. The model was made for exhibit at a world's fair in 1915.

in the previous section. To outside visitors in Ming and Qing times, Beijing's location cannot have seemed too impressive by comparison with the scenic surroundings of earlier capitals such as Nanjing or, especially, Hangzhou. However, insiders often saw it differently. One modern scholar, indicating that some observers feel the Beijing area is a bit insipid in appearance, quotes the early seventeenth-century encyclopedia *Sancai tuhui* as taking a much more positive view:

> On the left it is encircled by the Azure Sea, on the right protected by the Great Range; to the north it is pillowed by Juyong Pass; and in the south collared by the Yellow and Ji Rivers. The natural site is superior to all under heaven, truly what one can call "the country of Heaven's mansion."[23]

To come back to the subject of urban planning, the boxes-within-boxes layout of Beijing was well suited to carrying out the ceremonial duties of the emperor – not only was his palace at the axis of the world but it was also conveniently located with regard to the various state altars, major temples, and government offices. The only problem with the layout was that it

fitted poorly with the actual needs of the Qing emperors. The Forbidden City's buildings were cramped, its gardens were dowdy, there was next to no room for shooting bows and riding horses, and it was a long way from the nearest hunting park. Even more importantly, many members of the Qing imperial family, including Qianlong, seem not to have liked living there (see sidebar p. 35).

Thus we see the development of a curious dualism of attitude among the early Qing emperors. They appreciated the meaning of what they had seized, and moved to reinforce the symbolism of the Forbidden City and its environs. And yet they refused to stay there more than was absolutely necessary. Dorgon, Kangxi, Yongzheng, and Qianlong all built suburban garden palaces as residences and part-time administrative centers. From Kangxi onward, the Qing emperors spent more time in their other palaces in the Yuanming Yuan and Yihe Yuan gardens than in the Forbidden City. Kangxi and Qianlong went even further afield, establishing several lesser imperial vacation spots in the exurbs around Beijing and constructing a vast new summer capital and Buddhist ritual center at Chengde, 125 miles (200 kilometers) to the northeast. The later Ming emperors seem to have submitted meekly to the spatial imperatives of their symbolic position within Beijing and the universe. The Qing emperors did nothing of the sort. They acknowledged the symbolism, performed the essential ritual duties, and then went elsewhere to work, to hunt, to relax, and to live.

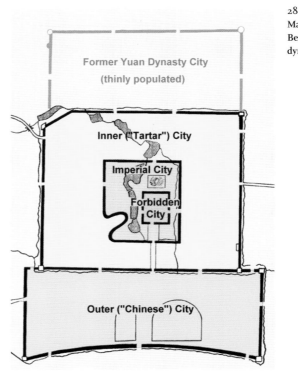

28
Map showing layout of
Beijing during the Qing
dynasty

Former Yuan Dynasty City
(thinly populated)

Inner ("Tartar") City

Imperial City

Forbidden City

Outer ("Chinese") City

Notes

1. Lattimore 1933, p. 51.

2. Du Halde 1738, II, p. 247.

3. Father Verbiest, in Du Halde 1738, II, p. 270.

4. For examples of the porcelains, see Eugenia Gelman, "Russian-Bohai Ceramics: Local and imported?" *ACRO Update*, 2002, nos. 1–2, pp. 5–7.

5. Laufer 1902; Levin and Potapov 1964, pp. 620–787.

6. Du Halde 1738, II, p. 247.

7. Wakeman 1985, I, p. 34.

8. Tie 1991, p. 312.

9. Cammann 1952, p. 21.

10. Lattimore 1933, p. 51.

11. James 1888, p. 53.

12. Sin Chung-il, quoted by Crossley 1997, pp. 40, 56.

13. Most demographic historians agree that a rapid increase in population occurred in the eighteenth century, from 120–160 million during the Kangxi period to 300–350 million by the end of the Qianlong period. See Ping-ti Ho, *Studies on the Population of China, 1368–1953*, Cambridge MA 1959; and James Z. Lee and Wang Feng, *One Quarter of Humanity*, Cambridge MA 1999.

14. Ko 1998, p. 41.

15. For example, DQGZCHDSX, *juan* 262, 10th year, 3rd month (1745), p. 7; Wu 1987a, p. 13.

16. In responding to Manchu officials' memos, Qianlong on several occasions condemned them for their inadequacy in the Manchu language (Tong 2001, I, p. 211, II, p. 616). Qianlong was so upset with the Fujian viceroy's delayed reporting that he condemned all Manchu scholar-officials, implying they had been converted to acting like their Han Chinese peers (Tong 2001, I, p. 197). See also Yang Naiji, "Qiren mingming [Names of Banner People]," *Forbidden City*, 1988, no. 6, p. 11.

17. Rawski 1998, p. 41.

18. Crossley 1997, pp. 109–37.

19. Naquin 2000, p. 303.

20. DerLing Yukeng 1997.

21. Wang Xiang-yi or Mao Cheng, *c.* 1900, quoted in http://www.cs.ubc.ca/spider/wang/whole-map.html.

22. Museum label by Berthold Laufer, *c.* 1925, archives, The Field Museum, Chicago.

23. Naquin 2000, p. 15.

Sidebar notes

1. *Qing shilu (Shizu shilu)* [The veritable records of the Qing dynasty (Shizu)], Beijing 1985, III, *juan* 49, p. 7ba.

2. Cary Y. Liu, "Architects and Builders of the Qing Dynasty Yuanming Yuan Imperial Garden-Palace," *Hong Kong University Museum Journal*, 2002, no. 1, pp. 38–59, 151–61.

3. Editors' note: The author is a leading authority on early Manchu history and derives his data from numerous sources. One source, compiled in 1780–82, is the *Da Qing shilu* [Veritable records of the Great Qing], published several times in recent years.

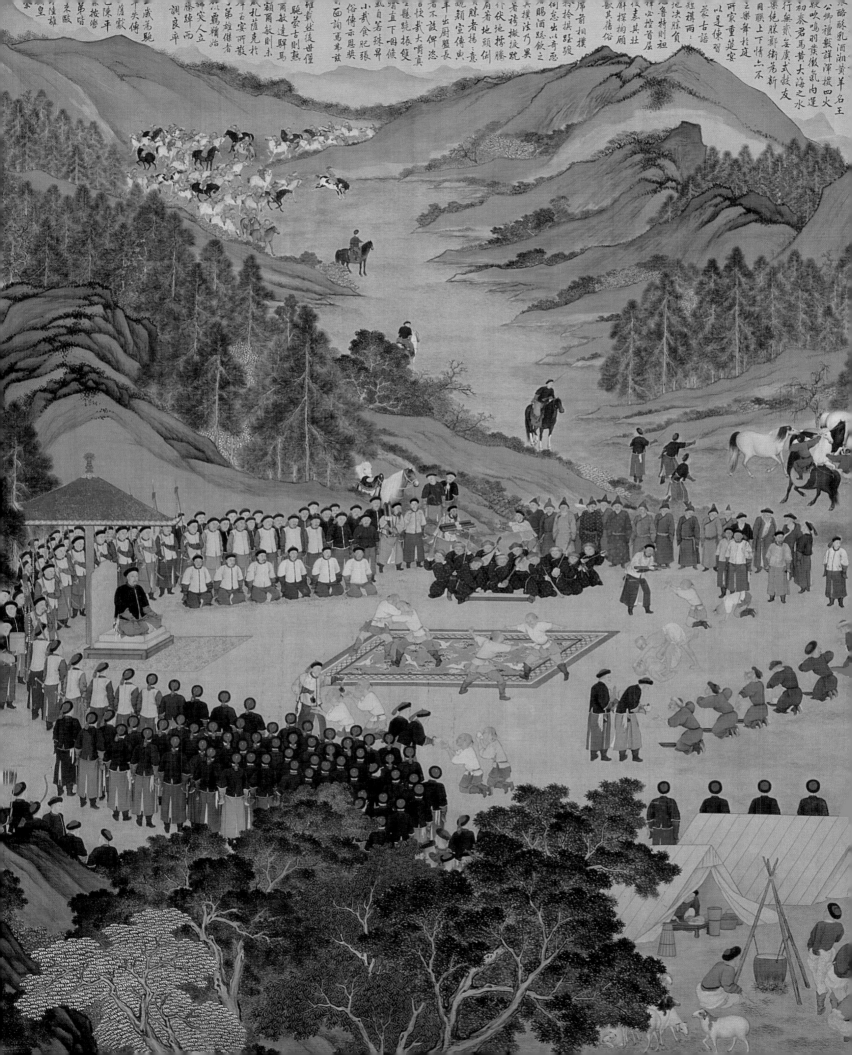

CHAPTER II
Symbols of Imperial Power

CHAPTER II
Symbols of Imperial Power

29 (page 42)
Four Dinner Scenes Beyond the Great Wall **(detail)**
Artist: Giuseppe Castiglione (1688–1766) and others
Color on silk;
88½ × 167¹³⁄₁₆ in.
(221 × 419.6 cm)
1736–66
(see also fig. 67)

This is the central part of a large horizontally oriented scroll painting. The emperor, with his guards, officials, and Mongol guests, watches a Mongolian-style wrestling match while a horse race takes place in the distance. The women's area, shown in fig. 67, is on the far right of the painting.

Introduction: The Son of Heaven

A seal that Qianlong often used reads "Respect Heaven and follow the ancestors." He evidently liked this motto. By "follow the ancestors" he meant accepting traditions as laid down by previous Manchu rulers. To "respect Heaven" was a promise to his people that he would govern under Heaven's watchful eye.

In Chinese dynastic history, the emperor's absolute authority to rule was based on universal acceptance of his office as expressed through the idea of the Mandate of Heaven. In a system without elections, the collective vote was believed to be expressed through signs in the natural world that supposedly reflected the quality of the ruler. When the government worked poorly, natural disasters, such as drought, famine, floods, earthquakes, and fires, would occur to indicate that the ruler's legitimacy was being questioned by Heaven. Thus, in a way, the Mandate was a pact between the ruler and the ruled, with Heaven as the judge and people's advocate, and with the ruler as executive director. When the ruler was the emperor, the Son of Heaven, he had the job of placating a stern and watchful father.

The Qing joined preceding dynasties in asserting the quasi-sacred status of the emperor while engaged in rituals, even though he was by no means a divine king on the Indian or African model. Those rituals centered on Beijing, the symbolic center of the world, where communication with Heaven was easiest and where the principal national shrines were located. As discussed in Chapter IV, the emperor devoted a great deal of effort to worshiping at those shrines. Except for sacrifices to the imperial ancestors, all of the great state rituals were related to nature and the elements – the worship of Heaven and Earth, the gods of agriculture and sericulture, or silkworm raising, the god of rain, the dragon kings that controlled floods, and so forth. Most such rituals with their powerful symbolism had continued unchanged since Ming times.

Yet by no means all Qing imperial rituals and symbols were derived from Ming prototypes. The Qing rulers, especially Qianlong, felt free to choose among traditions and to invent new ones as the needs of the empire required. While many Qing rituals with their attendant symbolism were Han Chinese in origin, others supposedly came with the Manchus or were borrowed from Tibet and other regions. Chapters III and IV explore imperial government and religion in more detail. In this chapter we will discuss the signs that expressed the emperor's authority in terms of three areas: where the emperor lived, what he wore, and how he acted to prove his right to rule China, the Celestial Kingdom.

Imperial Environments

In accordance with ancient Han Chinese tradition, the emperor was symbolically the central figure in his capital and nation, which in turn were at the very center of the universe:

In the imperial capitals the symbolism of the center was more strongly developed, for it was at this quintessentially sacred spot that was raised the royal palace,

30
The Forbidden City as seen
from Jingshan Hill, looking
south

which corresponded to the Pole Star, the residence (at the axis of the universe) whence Taiyi watched over the southerly world of men ... "the place where earth and sky meet, where the four seasons merge, where wind and rain are gathered in, and where Yang and Yin are in harmony."[1]

The Qing were happy enough to pick up and exploit this symbolism. In early June 1644, the Manchu conquerors passed through the Great Wall, entered Beijing, moved into the Ming emperors' just-vacated palace, and made it the center of their newly established government. The layout and basic functions of the palace buildings were left unchanged.

The new rulers might have preferred another capital. As discussed in Chapter I, most Qing emperors, with few exceptions and with good reason, disliked the Forbidden City. Qianlong in particular was absent from it as much as possible, spending three-quarters of each year in the Yuanming Yuan Summer Palace and the Chengde Resort Palace. Yet neither could replace the Forbidden City in symbolic significance. Even the old palace in Mukden [Shenyang], the homeland of the imperial clan and a place of immense spiritual significance for all Manchus, could not compete. At no time after their occupation of Beijing in 1644 did the Qing ever contemplate moving back to Mukden. The symbolic significance of the Forbidden City as the rightful place for the mandated ruler outweighed all other concerns. This was especially true because the Manchus were outsiders and thus

needed badly to be seen as legitimate claimants to the throne.

The grandiose scale of the Forbidden City, the consistency of each building in terms of architectural detail, and the calculated effect of the layout in humbling visitors all served to highlight the authority of the emperors. Architectural rules with widely accepted meanings were applied to everything a visitor could see. Doors had nine rows of nine brass bosses, panels and other features could bear only nine dragons or phoenixes, and the widest buildings had no more than nine bays. The numbers nine and five were reserved for the highest of ranks; hence a sobriquet for the emperor was "the nine and five honored one."

In accepting the existing palace, the first Qing rulers sought to ensure legitimacy and emphasize continuity. However, they also had to make adjustments to problems of ethnicity. The area just outside the walls of the Palace was the most affected. During the first few weeks of the Conquest, it was occupied by élite units of the Eight Banners composed of Manchus, Mongols, and assimilated northeastern Chinese. When the inevitable conflicts arose with regular Han Chinese residents, the latter were summarily removed to the southern district known as the Outer City, a painful and brutal process. The newly segregated Inner and Imperial Cities remained exclusively Manchu until the end of the dynasty. Within the walls of the Forbidden City, the changes that did occur tended to reflect Manchu needs. The Ming empress's residence, the Kunning Gong [Mansion of Earthly Tranquility], was converted by the

The Mansion of Heavenly Purity

Chuimei Ho

The administrative center and imperial residence during the Ming and the first two reigns of the Qing, the Qianqing Gong [Mansion of Heavenly Purity] (fig. 32) kept its symbolic importance long after the third and fourth Qing rulers, Yongzheng and Qianlong, had moved out.

Completed in 1420, the hall is nine bays wide and five bays deep. It was a first-rank building of the Inner Court. Last renovated in 1798, the interior preserves much of its eighteenth-century layout today. In the central bay is a three-step platform on which sits the emperor's throne and its accessories. Although there were many thrones for the emperor inside the Inner Court, this one continued to be significant because of its symbolic location.

Qianlong held annual New Year banquets at the hall to entertain princes, imperial males, key officials, and on separate occasions his mother and other imperial ladies, in addition to giving audiences to state visitors there. One of the largest formal meals in palace history, the "Thousand Elderly Banquet," was held at the Qianqing Gong in 1785. On that occasion almost four thousand males aged sixty and above were the emperor's guests. The hall also served as the farewell place for the deceased emperor; part of the funeral service and the official wake were held there.

The wooden lintel board above the throne bears four characters reading, from left to right, "*Zhengda guangming*" [Be transparent and fair]. The calligraphy is that of the Shunzhi emperor. Copies of the same phrase were used to decorate all imperial buildings with similar ceremonial functions. The lintel played a central role in the system for designating the next emperor, as introduced by Yongzheng and continued by Qianlong. In order to avoid fratricidal quarrels among his sons after his death, Yongzheng named his choice in a decree that was placed in a box and stored behind the lintel board, high above the throne-room floor. Another copy of the decree was kept secretly with the emperor alone. When the time for the announcement came, which usually meant at the emperor's deathbed, the two copies had to match in content as witnessed by key officials.

Against the eastern and western walls are tall cabinets that stored daily records [*shilu*] of the previous emperors, jade books that bestowed imperial titles, and some seals. On several occasions Qianlong ordered his staff to sun the records and dust the jade books.[1]

31

Gateway to the Hall of Mental Cultivation

Photographer: Osvald Sirén (1879–1966)

c. 1920

Very different from the monumental entrances of the great axial throne halls of the Forbidden City, this modest gateway led to the real center of power in the empire, the office-residence of Qianlong.

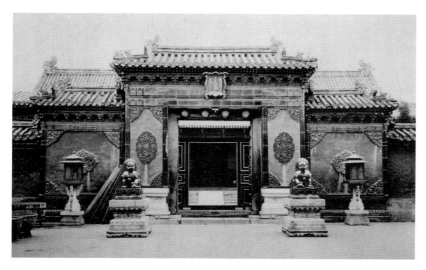

Qing into a place for Manchu shamanistic rituals. Several former Daoist and Han Chinese religious structures were converted to Tibetan Buddhist functions, in line with the personal interests of the Manchu rulers. Even the retirement palace that Qianlong built in the northeastern corner of the Forbidden City, one of the most sweeping architectural changes made since the Ming dynasty, had a Manchu connection. He modeled it after the Qingning Gong [Mansion of Pure Tranquility] in the old palace at Shenyang.

Symbolism sometimes had to give way to convenience. The Qianqing Gong [Mansion of Heavenly Purity] on the central axis of the Forbidden City had been the formal office-residence of all Ming and early Qing emperors (fig. 32). Yet first Yongzheng and then Qianlong refused to live in it. Instead, they favored the cozier Yangxin Dian [Hall of Mental Cultivation] in a non-symbolic location farther west (figs. 31, 283).[2] The Mansion of Heavenly Purity continued in use as a formal throne hall for ceremonial events (see sidebar above).

There were only four formal throne halls in the Forbidden City, although there were many halls with thrones (see sidebar p. 51). The formal throne halls – the Taihe Dian [Hall of Supreme Harmony], Zhonghe Dian [Hall of Central Harmony], Baohe Dian [Hall of Preserving Harmony], and Qianqing Gong – served mainly as places where the emperor could receive homage from, and dispense largesse to, selected subjects and foreign envoys. In Qing China, unlike contemporary India and even Europe, throne rooms were not places for business in the sense of receiving petitions and adjudicating disagreements. Their significance was ritual rather than practical.

In the Forbidden City today one finds that thrones are usually surrounded by a standard set of moveable

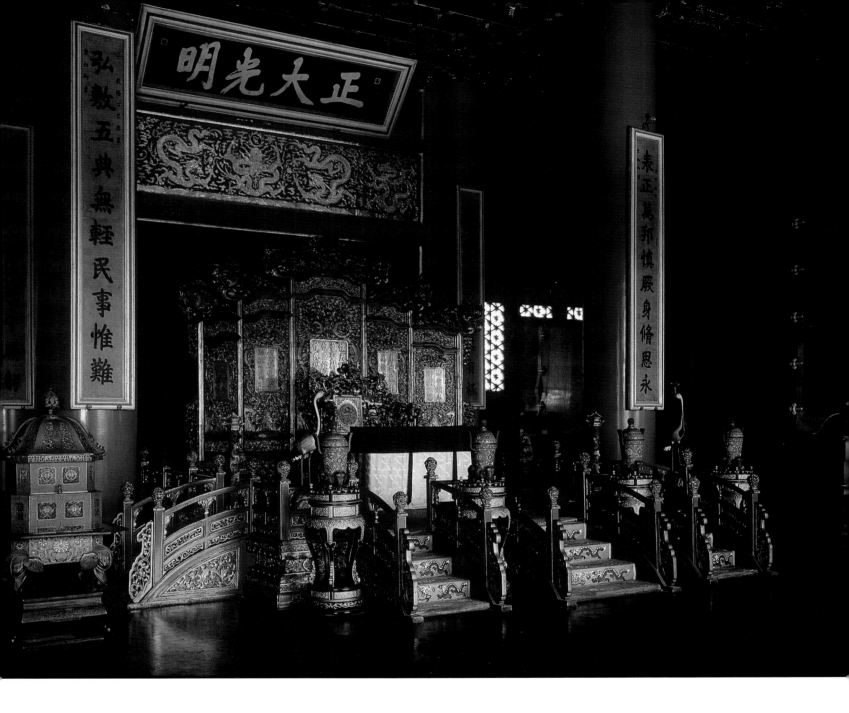

accessories (fig. 32). Most of these accessories are made of cloisonné enamel and sometimes jade: vertical censers, animal-shaped censers, which could either be the mythical *jinni* or *luduan*, elephant trunk-footed censers, braziers, and figures of cranes (see figs. 33, 34, 36–38). Censers added fragrance to the room, while braziers were needed for warmth. The cranes sometimes served to hold incense or candles, or may have been purely for decoration. It is interesting that none of these objects is shown with thrones in early Qing court paintings, even in those that meticulously illustrate details of court architecture (fig. 35).[3] Perhaps the accessories only gradually came to be standardized after 1760. In that year Qianlong ordered that his most formal throne room at the Yuanming Yuan Summer Palace be furnished as follows: "On the two sides of the treasure throne make a matching pair of tall wooden stools and another pair for the *luduan*. The dragon-hanging incense censers too will need matching bases. They all need covers. Show [me] the decorative designs first"[4]

Thrones, generally without throne screens, are shown quite often in early Qing paintings. The emperor and empress both are represented sitting on

32
The throne hall in the Mansion of Heavenly Purity

The throne, with a desk in front, was the only seat in the hall. The four-character lintel board above the throne was more than a decoration. It hid the name of the next emperor, only to be revealed at the old emperor's death.

33
Tripod censer with feet in the shape of elephant trunks
Cloisonné enamel on copper alloy; height 20½ in. (52 cm)
1736–95, Qianlong mark and period

Elephants symbolized peace. (Compare figs. 82, 334.)

34
Pair of cylindrical censers with pagoda tops
Cloisonné enamel on copper alloy; height 39⅜ in. (100 cm)
1736–95
Qianlong period

Placed near the throne, these tall censers would have burned sandalwood incense.

36

Pair of crane figures
Cloisonné enamel on copper
alloy, with wooden stands;
height 38⅜ in. (97.5 cm)
1736–95, Qianlong mark
and period

Crane figures such as these
often held candles in their
beaks. Some of those in the
Palace had moveable wings.
The crane is a symbol
of longevity.

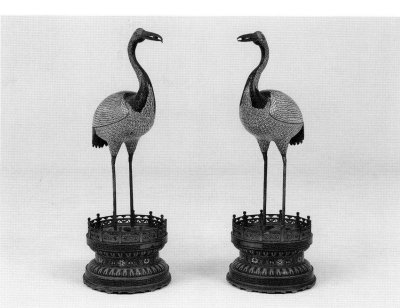

37

**Censers in the form of
mythical *luduan* animals**
Cloisonné enamel on copper
alloy; height 20 in. (51 cm)
1736–95, Qianlong period

The incense smoke comes
out of the animal's mouth.
Luduan are supposed to love
smoke and to remind the
emperor that he must always
be receptive to honest advice.

35 (opposite)
*Ten Thousand Envoys Come
to Pay Tribute*
(detail of fig. 80)

The painting shows that
on this winter day in the
eighteenth century the
interior of the Hall of
Supreme Harmony
[Taihe Dian] was fully
carpeted. Part of the throne
platform is in sight but no
throne accessories, such
as cloisonné censers and
braziers, are shown. On
the eastern side of the hall
are a set of bells and a
drum; on the western
side is a set of chimes.

38

Pair of tripod braziers
Cloisonné enamel on copper
alloy; height 48½ in.
(123 cm)
1736–95, Qianlong period

The openwork covers allowed
the heat to disperse evenly.
Braziers for burning
charcoal were primary
heating devices in the Palace.
Fig. 267 shows that similar
braziers were sometimes
used without covers.

39
**Throne with openwork
design of dragons**
Gold lacquer on wood;
height 69 in. (175.5 cm)
Eighteenth century

As symbols of imperial
authority, thrones for formal
occasions were made of
lacquered wood with many
dragons. This throne and
footstool set resembles
the one in Qianlong's
inauguration portrait
(fig. 60).

40
**Throne screen carved with
dragons, clouds, and lotus
petals**
Gold lacquer on wood; height
90 in. (229 cm)
Eighteenth century
The Field Museum 127954

Even though this is a three-
panel screen, it is designed
to look as though there are
seven panels. A similar
screen is in the Palace
Museum, Shenyang.

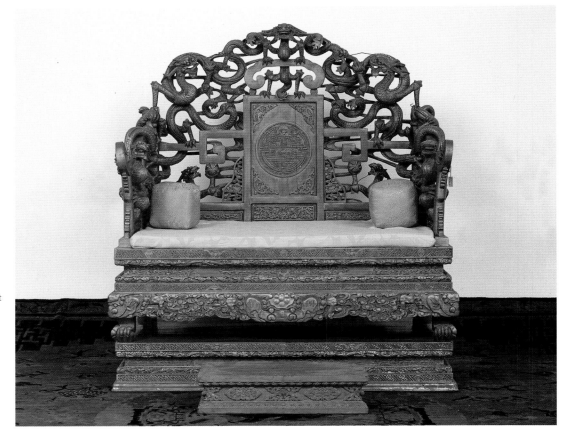

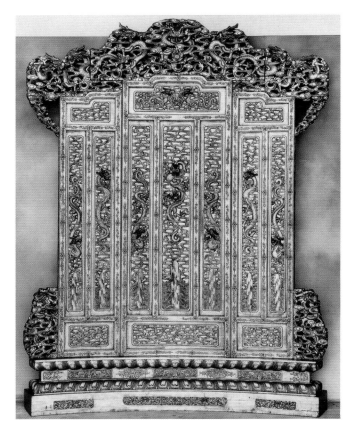

them, although never – as was apparently sometimes the case in Europe – side by side. Thrones suitable for formal throne rooms were large, made of wood coated with an orange-gold lacquer, furnished with matching footstools, and backed by a vertical throne screen with five leaves; both the throne and screen were ornamented with carved dragons in high relief (fig. 39). Lower-ranked throne screens had only three leaves (fig. 40) and were used in settings that were generally less formal. Informal thrones and screens could be made of many materials, including plain wood, carved cinnabar, or painted lacquer, and wood with painted or cloisonné panels (see, for example, figs. 320, 321). Whether formal or informal, thrones were emblems of imperial authority.

Of other court furnishings, musical instruments were among the most ubiquitous. Court protocol required that certain instruments be present at four major types of formal occasions: state rituals, court assemblies, formal banquets, and processions of the Imperial Guard. The instruments prescribed for these solemn events included a set of sixteen gilt-bronze

Emperor Qianlong's Thrones
Hu Desheng

On July 11, 1747 Jibao, the Supervisor of the Jiangning Imperial Textile Factory and Longjiang tax officer, presented a colored-lacquer throne with auspicious designs to the emperor. On the same day, another official, Yilaqi, who was Inspector of the Changlu Salt Administration, presented another throne with floral designs in colored lacquer and gold tracery. On November 4, 1761 Yang Xifu, the Governor of Water Communications, gave the emperor a red *zitan* wood throne. Five days later, Gao Jin, the Governor of the South China River Channels, presented yet another red *zitan* wood throne.[2]

Visitors to the Palace Museum in Beijing find that the main halls of the emperor's residences and offices often include a singular set of furnishings. The set usually consists of a throne in the center; a screen at the back; and on either side of the throne, an elephant statue with a vase on its back (symbolizing peace), a standing fan, a *luduan* unicorn statue, and a vertical censer. This assemblage is commonly referred to as the "throne-room group." Although the furnishings have their fixed places in throne rooms, each throne and screen has its own unique shape and design. Far more than a simple set of furniture, these special furnishings epitomize the strict imperial hierarchy in Chinese feudal society.

The throne, symbolizing imperial authority, must be

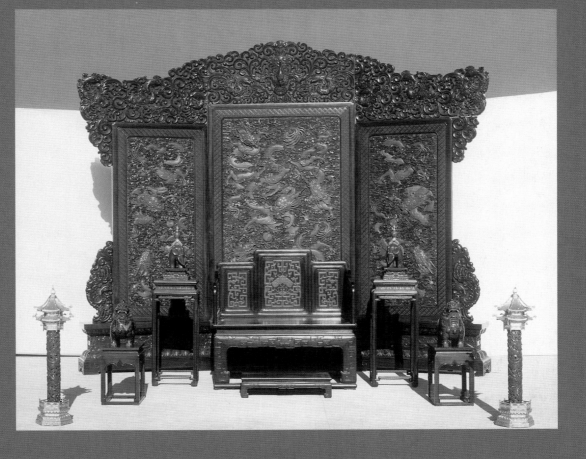

placed in the middle of the room. With the exceptions of the emperor and empress dowager, nobody could sit on the throne at will. The throne set placed in the main hall of an imperial consort's residence could be used by the consort only on her birthday or on important festivals to receive congratulations from her servants. If the emperor chose to visit her residence, she should have sandalwood burned in *luduan* and censers. The lingering incense smoke and fragrance helped to create a solemn atmosphere of imperial order.

The red *zitan* wood throne set in fig. 41 is a typical example. The throne has a straight back, two arms, and curved legs joined by crossbars. Its back is made

up of three panels. Both the back and the arms are inlaid with raised dragon designs in boxwood. The throne, with its superb workmanship, is in perfect harmony with the screen behind it.

The three-leaf red *zitan* wood screen has three connected tops decorated with dragon and phoenix designs in high relief. The screen's middle leaf is wider than the leaves on the sides. The border of the screen is decorated with swastika-like patterns. The overall effect of yellow dragons partially visible among black clouds forms a strong and vivid color contrast.

When the Qianlong emperor ascended the throne, he encouraged thrift in accordance with the instructions of his father.

But later, in the wake of China's economic prosperity and cultural and artistic development, he began to seek a greater degree of comfort. Subordinates catered to his taste and presented the Imperial Palace with many kinds of thrones like those mentioned above. Qianlong followed in his father's footsteps in employing auspicious signs. A distinctive feature of Qianlong throne sets is their richness in symbols of good fortune and authority.

41
Throne and screen
Zitan wood; height of screen *c.* 96 in. (244 cm)
1736–95, Qianlong period

Officials assigned to wealthy districts quite often presented gifts, including informal thrones and throne screens, to the emperor. This finely carved throne and screen may be one of two sets presented to Qianlong in November 1761.

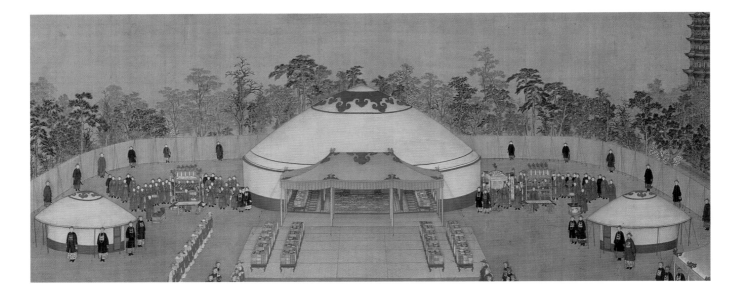

42
Imperial Banquet in Wanshu Garden
(detail of fig. 101)

The court music troupe stands on both sides of the white yurt that is serving as a temporary throne hall, with bells and drums on the right side and chimes on the left. Many state ceremonies were held at this location on the grounds of the Chengde Resort Palace.

bells (fig. 43), a set of sixteen green chime stones, a large drum, and zithers, as depicted in the paintings in figs. 35 and 42. Some of these instruments evoked a sense of antiquity and continuity; similar bell sets went back two thousand years.[5] For his eightieth birthday, Qianlong's officials gave him a set made of solid gold.[6] As such a set would thud rather than ring, the value of the gift must have been more symbolic than acoustic.

Each month a large single *bo*-bell was used to set the pitch of other instruments. The gilt-bronze Huangzhong [Yellow Bell] shown in fig. 44 was for

the eleventh month. It was the biggest of the monthly bells and had the lowest pitch.

With their glittering surfaces and elaborately carved stands, these ceremonial instruments were used for visual as well as musical effect. Although Kangxi and Qianlong both attempted to standardize court music, along with many other court rituals, their efforts in the area of musicology are not admired by most musicians. Nonetheless, in 1741 Qianlong set up a Music Division for court music and chose melodies for specific court functions.[7] His musical legacy was maintained at court until the beginning of the twentieth century.

43
Set of sixteen bells on frame
Gilt bronze and gold
lacquered wood; frame
length 138 in. (350 cm)
1779, Qianlong mark

Cast and then machined to the right thickness for the desired pitch, sets of tuned bells were essential for court ceremonies. This set is decorated with the Daoist trigrams. Qianlong made several sets of ceremonial bells; most have dragon designs instead of trigrams. Like many much humbler Chinese bells, these have suspension eyes in the image of Pulao, one of nine dragon sons noted for his bellowing.

44 (opposite)
The month bell named Huangzhong
Gilt bronze; height 35½ in. (90 cm)
1761, Qianlong mark

Huangzhong is the largest of the twelve special bells that were played, one each month, by the court musicians at ceremonies. The king of the set, Huangzhong was used during the eleventh month.

Ascending Mount Tai
Susan Naquin

Mount Tai, the Eastern Peak, dominates the north China plain, and from early times it has been known as the home of powerful gods and spirits. For centuries, petitioners high and low have come here with their prayers. Qin Shihuangdi, the mighty unifier of early China, was the first emperor to worship at the mountain, but the Qianlong emperor of the Qing dynasty, two millennia later, was the one who came here most often.

Qianlong visited Mount Tai nine times, making his first "Eastern Tour" in winter of 1748 and his last one in 1790. He also incorporated the mountain into his longer "Southern Tours" to central China, arranging the schedule so that he could visit Mount Tai in May.

An Eastern Tour to Shandong province took about six weeks. The emperor's first destination was Qufu, where he paid his respects at the venerable shrine to Confucius, the First Teacher. The imperial entourage then moved on to nearby Mount Tai. From his tented encampment outside the town at the foot of the mountain, the emperor went to the Dai Miao, the large temple complex dedicated to Dongyue, the Great Emperor of the Eastern Peak, where he burned incense and offered a prayer. On six of his trips, Qianlong also ascended the rocky path to the summit, probably mostly in a sedan chair but sometimes on horseback. There, he burned incense at the peak temple to Bixia Yuanjun, the Sovereign of the Clouds of Dawn (also translated as the Lady of the Azure Clouds), the daughter of the god of the mountain.

Combining business with pleasure was something that Qianlong did very well, and these Eastern Tours allowed him to please his mother, meet local notables, bestow gifts, perform solemn rituals, and make offerings to powerful spirits.

Some of Qianlong's pleasures were personal. The empress dowager was a devotee of Bixia Yuanjun, and she accompanied her son on seven tours. For her, these would have been pilgrimages. The trip in 1771 was taken expressly as part of the celebrations of her eightieth birthday, and it was perhaps out of filiality that on other occasions, the emperor donated new bronze images to the summit temple and paid for expensive repairs. For himself, Qianlong enjoyed the dramatic mountain scenery, and he wrote short verses to commemorate moments of pleasure on these ascents. One poem was grandiosely inscribed on the rock face of the mountain, 35 feet (9 meters) wide and 65 feet (20 meters) high.

These Eastern Tours were more commonly framed in terms of the grand purposes of past emperors, and advertised as serious occasions when the emperor reported great dynastic victories, and offered sincere thanks and prayers, first to Confucius and then to the God of Mount Tai. These imperial rites were elaborately scripted and very formal, and the temple grounds were generously maintained with imperial funds. Qianlong was very conscious of the antiquity of these sacred places, and he made sure that his own place in their history could not easily be forgotten.

Qianlong was the last emperor to climb Mount Tai. Today, two centuries after his death, the mountain has become an ever more popular pilgrimage and tourist destination, but among this wealth of sights, the traces of this confident, energetic emperor are still very visible.

At the time when the Palace buildings were the tallest and largest in the capital, their heavy roofs with bright yellow tiles must have been conspicuous to all visitors to Beijing. No private structures in the city could have similar roof tiles, as yellow was the color of supreme power. Even princes' compounds outside and within the Forbidden City had green rather than yellow tiles. While previous dynasties had reserved the same orange-tinged yellow as an imperial symbol, the Qing emperors were even more color-conscious than their predecessors, using colors as rank indicators in many official situations.

Imperial Adornment: Accessories

The last emperor of the Qing dynasty, Puyi (reign 1909–11), in his memoirs recalled that his sharpest image of the Forbidden City was its being engulfed in yellow. Like all of his predecessors, the boy emperor was clad in yellow garments. Most of the objects he used, from shoes to bowls and sedan chairs, were colored imperial yellow. His dragon-emblazoned court robes were made of yellow silk, as were the robes of emperors long before the Ming. But there were significant differences between Ming and Qing imperial costumes and between the wearable symbols of Han Chinese and Manchu identity.

Dragon robes are the most famous of all traditional Chinese garments and may be the most misunderstood. They are not at all rare – literally thousands of them survive in museums all over the world. They were not exclusive to emperors or to men either. Basically they were uniforms worn on formal occasions by the emperor, his immediate family, more distant imperial relatives, and the entire bureaucracy down through quite low-ranking officials, including eunuchs with official titles. The principal wives of officials, including the

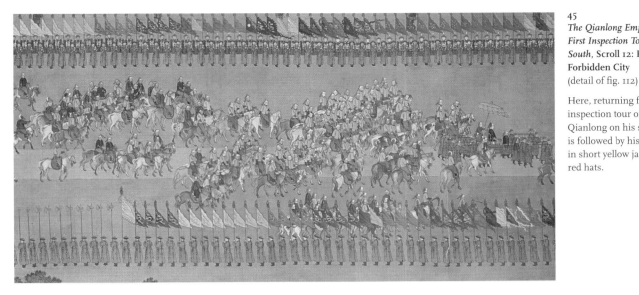

Here, returning from his first inspection tour of the South, Qianlong on his sedan chair is followed by his élite guards in short yellow jackets and red hats.

wives of the emperor, were entitled to wear the same sort of robes as their husbands. The separate and superior rank of the emperor was highlighted in his garments primarily by details of color, cutting, and decoration. These details changed over time.

Only certain individuals could dress in the imperial shade of yellow. Wearing a yellow robe or jacket meant the owner was the emperor, an empress or consort, a member of his extended family, an imperial guard, or the recipient of a special imperial honor (figs. 45, 46). The yellow fabric of one's belt signified membership in the imperial clan. Thus, forbidding a clan member to wear his woven yellow belt was one way of showing that he was in disgrace.[8] Penalties were severe for those caught wearing such belts or other yellow costume items without permission. When Qianlong's corrupt favorite Heshen (see sidebar p. 86) was indicted by Qianlong's successor, the Jiaqing emperor, one of his offenses was that he possessed

a court necklace made of proper pearls. I [Jiaqing] looked at it and was astonished. Proper pearl necklaces are part of the imperial costume and not something mere officials should keep. If this necklace was prepared as a gift [to the emperor] then why was it already backed by a woven fabric in the [imperial] yellowish incense color? It was clearly not meant as a gift [but for Heshen's own use].[9]

The imperial privilege included the use of freshwater pearls harvested from the Heilongjiang and other rivers in the Northeast, the homeland of the Manchus. The use of "eastern" pearls above a certain size was monopolized by the emperor.[10] Even the empress could not wear the finest pearls. Palace regulations stated that the empress's crown should have

a three-tiered finial with each tier topped by a third-grade pearl and gold phoenix, each of which should be decorated with three second-grade pearls, one fourth-grade pearl, and 16 small pearls. Each phoenix's beak should hold a third-grade pearl. On top of the red floss should be seven gold phoenixes, each decorated with

Qianlong, invisible in his covered sled, is watching ice skaters on Zhongnanhai Lake just west of the Forbidden City. Seven yellow-jacketed élite "Leopard Tail" guards stand behind the sled, shielding him from the crowd of spectators. As their nickname implies, the guards carry the tails of leopards on their spears.

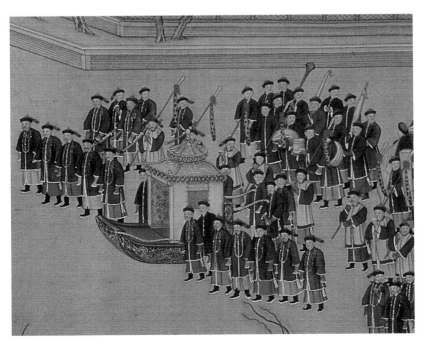

47 (below)
Emperor's court necklace
White nephrite, jadeite, coral,
gilt silver, kingfisher feathers,
yellow fabric ribbon; length
39⅜ in. (100 cm)
1736–95, Qianlong period

A standard court necklace
of the Qing period had 108
beads, three side strands,
and a back strand, punctuated
with semiprecious stones.
The right to wear a white jade
necklace of this kind was
reserved for the emperor.

48 (bottom)
**Court necklace for imperial
family member**
Coral, jadeite, rock crystal,
ruby, green glass, gilt silver,
kingfisher feathers; length
51 in. (130 cm)
1736–95, Qianlong period

Only members of the
immediate imperial family
could wear official necklaces
made of coral. The empress
in full regalia wore no fewer
than three such necklaces,
one of pearls and two of coral
(see fig. 70).

nine second-grade pearls, 21 small pearls, and one
cat's eye. ... Hanging at the back should be five rows of
pearls with 302 fourth-grade pearls. ... The central
pendant should have ... six second- and third-grade
pearls plus rubies and coral, woven in bright yellow
fabrics.[11]

The hat in fig. 51 matches the description of the
empress's crown with the exception that only three,
not five, rows of hangings are present. If indeed this
was a crown of Qianlong's empress, it must have been
used before 1759, when court dress codes were final-
ized. Or it could be the crown of the second-ranked
imperial consort [*huang guifei*] after 1766, when
Qianlong no longer had an empress. Second- and
third-ranked consorts wore crowns of similar design
with fewer pearls.

Other court costume accessories introduced by the
Qing were rosary-like necklaces for both sexes
(figs. 47, 48), belts with attached objects, and feath-
ers for the hat. All of these were new Manchu addi-
tions to an otherwise very conservative imperial look.
While there were detailed rules for when, where, and
how these items should be worn, the rules could be
altered at the emperor's pleasure.

The right to wear peacock feathers on the hat was
awarded by the emperor for outstanding achievement
(fig. 50). The feathers were graded according to the
number of "eyes" on each one, with three eyes hav-
ing the highest status and one the lowest. Although
meant as awards for achievement, princes naturally

wished to wear them too. However, Qianlong forbade it, ordering that only princes who had achieved an appropriate official rank could wear such a feather. He made an exception for very young princes, granting them the right to wear feathers "for beauty's sake."[12]

Perhaps the most Manchu of all the imperial accessories, in the sense that the remote ancestors of the Qianlong had probably used it, was the belt with pouches and a knife. Such belts are often shown in pictures of native peoples of eastern Siberia and far northeastern China, where they formed a standard part of the equipment of hunters. Unlike their counterparts in Europe, who favored accessories attached directly to the belt, Northeast Asian hunters chose to attach their field equipment – knives, small bags for money and other valuables, flint and steel sets for lighting fires, and, later, tobacco pouches – by hanging them from the belt by cords 4–8 inches

(10–20 centimeters) long (fig. 17). Although this arrangement might seem better adapted to hunting on foot or skis than on horseback, the post-Conquest Manchus adhered loyally to the old traditions.

In his inauguration portrait, Qianlong is depicted as wearing two pouches and a cased knife, suspended by ribbons from a gold-colored belt (fig. 53). A similar belt of his with more pouches is shown in fig. 52. Along with a cased knife and chopstick set, a toothpick case, two drawstring pouches, and two gourd-shaped pouches of the kind sometimes used for a pipe and tobacco, the belt accessories also include a flint and steel case with a curved steel strip along the bottom and the flint and tinder inside. Such steel-bottomed fire-making cases are frequently seen in museum collections of Central and Northern Asian artifacts. Even though it is unlikely that Qianlong ever lit his own pipe or campfire by this method (it is uncertain whether he

49
Fire-lighting pouch
Deerhide, silk;
width *c.* 5 in. (13 cm)
1737–48, Qianlong period
National Palace Museum,
Taipei

The pouch, with two pieces of flint and a steel striker in the form of an oval ring, was stored in a Japanese lacquer box that reposed on a brocade cushion in a larger wooden box, with a poem by Qianlong on top. The poem tells the story of the pouch. One day he mentioned to Empress Xiaoxian that Manchus were once too poor to make their pouches from cloth and had to settle for simple deerhide instead. She immediately made him this one. He was touched by the gift.

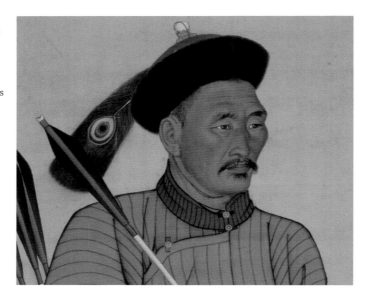

smoked a pipe at all), fire-lighting pouches were important to him as costume accessories. On the 6th day of the 12th month of 1759, Qianlong noticed that no pouch was attached to the belt he would wear that day, and asked, "Where is the fire-lighting pouch made of couched gold and silver thread and Eastern pearls? Why is it not included in Our personal belongings today?" He wanted it immediately. Two pouches with the requested features were shown to him, both prob-

ably made by his second empress, Ula Nara. Apparently he was pleased with what he saw, and commanded "take one of these to the Empress and ask her to make one more."[13] A somewhat less ostentatious flint and steel pouch, from his first empress Xiaoxian's own hands, is shown here (fig. 49).

For the first hundred years after the Conquest, official robes and ornaments were relatively unregulated in terms of design and use. Detailed regulations were not published until 1759, with the appearance of the *Illustrated Compendium of Qing Rituals*. Qianlong himself wrote the preface to the book. In it he made the claim that the prescribed official costumes were distinctively Manchu and that changing to Han Chinese costumes would endanger the dynasty itself:

> We accordingly have followed the old traditions of our dynasty, and have not dared to change them, fearing that later men would hold us responsible and criticize us regarding the robes and hats; and thus we would offend our ancestors. ... [Earlier non-Han dynasties] all changed to Chinese robes and hats; they all died out within one generation. ... Do not change our Manchu traditions or reject them. Beware! Take warning![14]

The emperor may have been exaggerating the width of the gap between Ming and Qing costumes, however. As noted below, Qing dragon robes were largely copied from Ming dragon robes.

Seals were an important part of the imperial regalia. In fact, control of the twenty-five great seals was

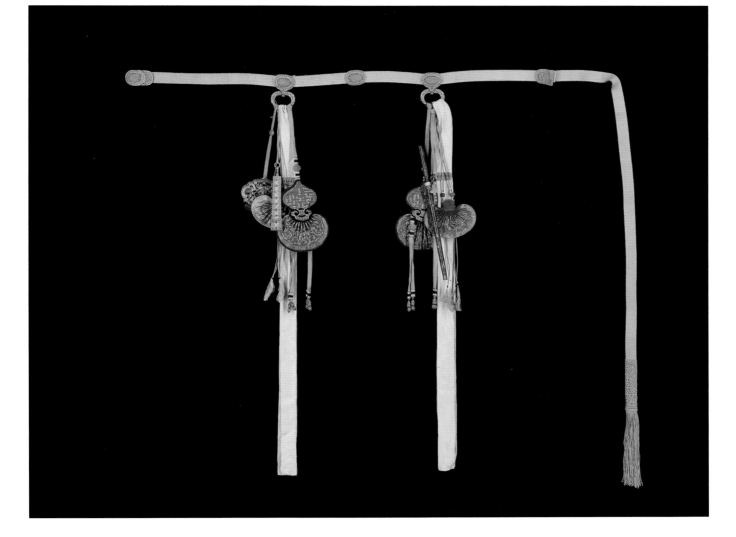

symbolically (and perhaps actually) equivalent to control of the empire. They were kept safe in Jiaotai Dian [Hall of Union], a building on the axis of the Palace complex, and cleaned in an annual ritual. Several of the twenty-five are shown here in fig. 54. The gold seal (figs. 55, 56) was originally one of the great seals but, because the emperor saw that it duplicated the text of another great seal, it was taken to the Imperial Palace in Mukden [Shenyang] and deposited there. Unlike most other great seals, its text is entirely in Manchu. The jade seal (figs. 57, 58) was of lesser importance. It was cut posthumously and dedicated to the spirit of Empress Xiaoxian.

Imperial Adornment: Men's Clothing

Most Ming dragon robes became obsolete after the Qing takeover in 1644. Even before then, the Qing

53 (left)
Portrait of the Qianlong emperor at the age of twenty-five
(detail of fig. 60)

Pouches and a cased knife suspended from the belt formed part of the emperor's ceremonial costume as well as his hunting outfits (see figs. 16, 248).

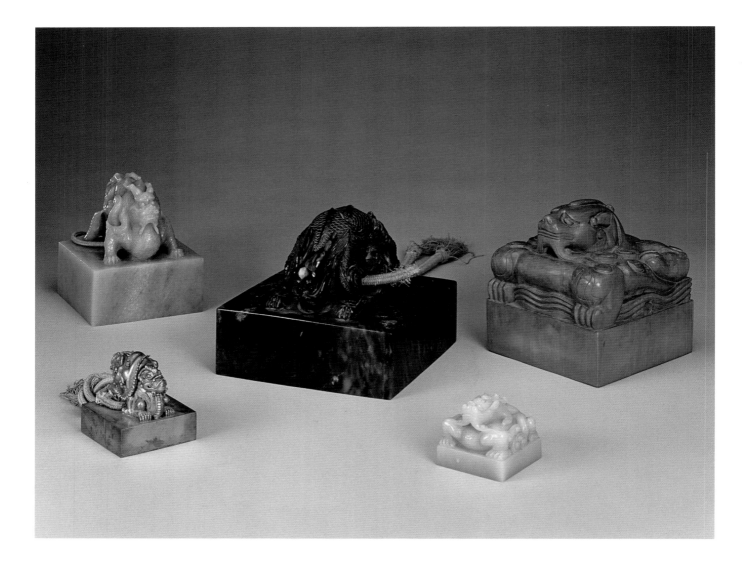

had begun to legislate against the full-cut, loose-sleeved Ming style in favor of official costumes that were tighter, with slit skirts for ease of riding and with tight sleeves and horse-hoof cuffs. Now that wearers of dragon robes were required to conform to Qing rules, many heirloom robes had to be re-tailored or discarded. On the other hand, the dragons on Qing robes were very similar to those on Ming robes. So were the colors and the overall graphic design. The Manchus simply took an old idea and, after a few slight modifications, adopted it.

The emperor's dragon-ornamented robes were of two kinds: the ceremonial robe, or *chaofu* (fig. 61), and the regular formal robe, commonly known as the *longpao* or "dragon robe" (like the one in fig. 69). Both kinds of robes were heavily adorned with dragons. A ceremonial robe could be distinguished from a regu-

lar formal robe by the fact that it was made in two pieces, with a pleated skirt sewn on to a smooth top, whereas the regular formal robe was unpleated, having been cut from a single piece of cloth. Both were usually imperial yellow in color but could be in other colors if the ceremony required it. For instance, the *chaofu* for sacrifices to the Sun was red, while for sacrifices to the god of grain it was blue. The *chaofu* also included a short cape-like collar. At least when outdoors, the *longpao* was usually covered by a blue or black knee-length surcoat. Imperial wives wore surcoats that were slightly longer but otherwise identical (fig. 62).

Ceremonial robes were worn only a few times each year, for major sacrifices, birthday rituals, and the like. The portrait in fig. 60 shows Qianlong in what may have been his inauguration outfit. The regular *longpao*,

55, 56
Imperial seal, with impression
Gold; 5 in. (12.8 cm) square
Late seventeenth–early
eighteenth century

One of the great seals of the
early Qing period, this is
made of solid gold and is
entirely in Manchu. The seal
text reads "Treasure of the
Son of Heaven." The attached
ivory medallion repeats the
text in Chinese. In 1746
Qianlong inspected the
collection of imperial seals
and sent fourteen of the thirty-
nine major seals, including
this one, to be housed in the
palace in Shenyang.

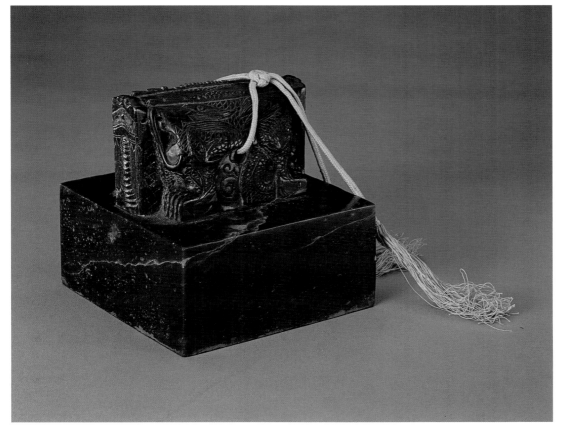

57, 58
**Empress's seal, with
impression**
Nephrite jade; 5 in. (12.8 cm)
square
1850

Honoring retrospectively the
first empress of Qianlong,
Emperor Daoguang con-
ferred a new title on her and
ordered a new seal to be cut.

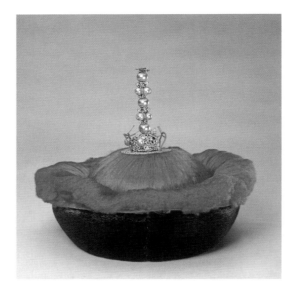

the kind often seen in museums today, was worn much more frequently. The emperor often gave away such regular formal dragon robes as a sign of imperial favor. The gifts were not meant to be worn but rather displayed. When hung on the wall above an élite family shrine, they would have had the same effect as today's office photographs showing influential businessmen shaking hands with heads of state.

The full ceremonial and formal outfits of an emperor included a hat with a pearl-decorated finial (fig. 59), a long necklace, a belt with various pouches and a knife hanging from it, and strongly constructed boots (fig. 63), generally blue or black, of the kind the Manchus used for riding.

On the 15th day of the 1st month of 1756, Qianlong attended a formal court banquet at the Yuanming Yuan Summer Palace in celebration of the New Year Lantern Festival. The official daily dress record states that he wore

a sable fur hat with silk lining and dragon-and-pearl finial, ... a yellow-ground *wan*-patterned *kesi* tapestry-woven dragon robe bordered with black fox fur, a sable fur surcoat, a wide belt with turquoise stones, necklaces with the proper pearls, white cotton socks with thick cotton trousers, and blue silk boots with sheepskin linings.[15]

It was an unusual day when Qianlong did not change clothes several times. Legend has it that he never wore the same clothes twice. If true, each year he must have generated enormous quantities of second-hand dragon robes.

In line with his interest in the details of everything from taxation schemes to porcelain design, the emperor was concerned about the details of his costume. It is reported how one day in 1756 he asked, "How long is this robe of mine?" and the Chief Eunuch promptly replied, "4.15 feet for the front, 4.25 for the back." The emperor responded with, "It is too short. Lengthen it in front and in back by one inch"[16]

The regular formal dragon robe, together with its accessories, was also the standard costume for all imperial males and ranked officials. In paintings of imperial events with many princes and officials, it is usually not possible to tell from clothing and accessories alone who is the Qianlong emperor. Court artists tried to highlight the emperor by making him slightly larger than the crowd, as well as positioning him in a more eye-catching position (see fig. 101). Viewers can also narrow down their search by spotting figures clad in blue surcoats with large round rank-badges. Only a member of the imperial clan wore round badges that were embroidered directly on the coat; all others wore square badges or "mandarin squares" that were made separately and then applied to the coat (fig. 64).

Under the surcoat, princes and their wives could also wear dragon robes with five-clawed dragons. The only difference between their robes and that of the emperor was the presence on the latter's robe of the Twelve Symbols – sun, moon, constellation of

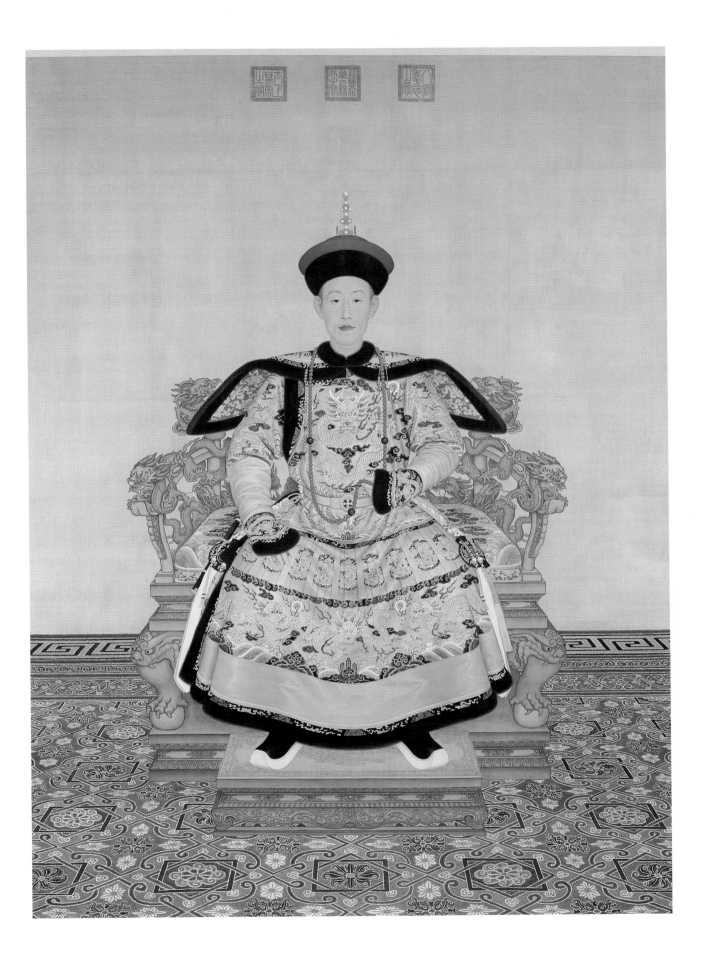

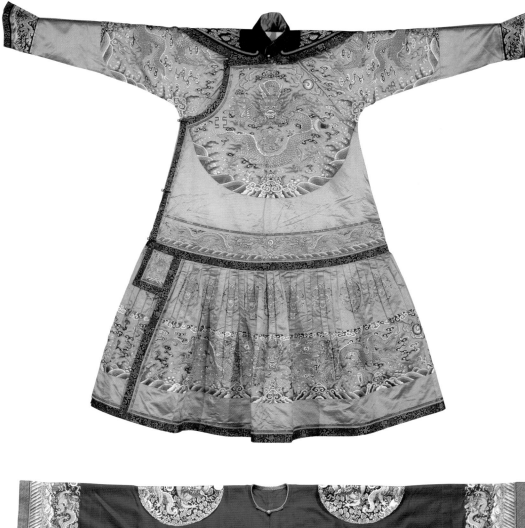

61

Emperor's ceremonial robe
[*chaofu*]
Silk, embroidery with gold
and colored thread, gilt
bronze buttons; height
56½ in. (144 cm)
1736–95, Qianlong period
Made in Suzhou Imperial
Textile Factory

This ceremonial robe
consists of a top and a
pleated skirt joined together.
The embroidered designs
include dragons and colored
clouds together with the
twelve emblems of imperial
authority: the Sun, the Moon,
a constellation, mountains,
a dragon, a pheasant, a pair
of cups, waterweed, grain,
fire, an axe, and bats.

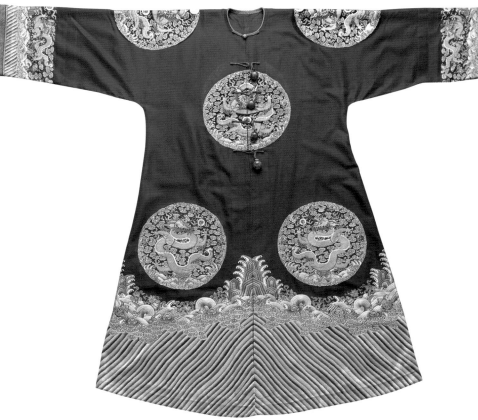

62

Imperial formal surcoat
Silk, gauze-woven with gold
and colored thread,
aventurine glass buttons;
height 51 in. (130 cm)
Nineteenth century
The Field Museum 125901

Dragon robes for officials at
all levels were usually worn
underneath a dark blue
surcoat, thus exposing only
the banded waves of the
bottom of robe. This surcoat
has eight roundels with
imperial dragons, indicating
that it belonged to an empress
dowager or an empress.

63

Emperor's ceremonial boots
Silk, velvet, cotton, gold
thread; height 21¼ in.
(54 cm)
1736–95, Qianlong period

The emperor's ceremonial
boots varied in color,
depending on the color of
the overall outfit. Of all the
accessories of the ceremonial
robe, the boots were probably
least regulated in terms of
imperial symbols. Note that
the dragon design at the
border shows only four
claws; this part would not
normally be seen.

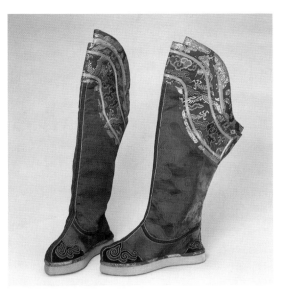

three stars, mountains, dragon, pheasant, *fu* [bat] pat-
tern, axe, a pair of sacrificial vessels decorated with
animals, water plants, fire, and millet grains. These
could only be worn by the emperor and empress.
Puzzlingly, they are small and scattered over the whole
decorated surface of the robe, making them hard for
an inexperienced eye to spot.

A non-princely official wore identical robes except
that he could not use five-clawed dragons without the
emperor's permission. Qianlong was not as generous
with such permission as his successors. In addition to
square rank-badges on surcoats, each grade of offi-
cials had its own prescribed ornaments, types of semi-
precious stone for necklaces and hats, and colors for
robe fabrics and belts.[17] These restrictions sometimes
caused problems. Since officials were responsible for
outfitting themselves, proper appearance could be
costly and also confusing. Wives were sometimes
included in formal events and were required to dress
in formal robes in accordance with their husband's

rank. Apparently not everyone was always in compli-
ance. The Qianlong court kept several dozen female
dragon robes to ensure the proper staging of events.
Some officials went overboard. A second-rank army
official who was also an acting second-rank civilian
official put both rank insignia on the same badge.
Qianlong was displeased: "Rank-insignia regulations
are the solemn tradition of the nation. They are not to
be treated like children's toys."[18]

Not all of the emperor's robes were dragon robes,
and he did not always wish to distinguish himself
from the people around him. When hunting, he took
care not to dress more ostentatiously than his fellow
hunters with their plain robes, short jackets, and
equipment-laden belts. Qianlong's preferred hunting
robe was of brown, undecorated, heavy cloth that came
to his ankles and had a lower right panel that could be
unbuttoned for ease in mounting a horse (see fig. 16).
His companions dressed similarly except that other
shades of brown along with blue and gray seem also

64
*Imperial Banquet in Wanshu
Garden*
(detail of fig. 101)

Uniformed officials would
kneel when the emperor
came on the scene. Their
blue or brown surcoats
showed their ranks. Those
on the right are high-ranking
imperial princes, as indicated
by the round badges on their
shoulders in addition to
those on their chests and
backs. The fourth official
from the left is a low-ranking
prince, with a round badge
on his chest but none on his
shoulder. Officials without a
blood relationship to the
emperor wore square badges.
Compare fig. 62.

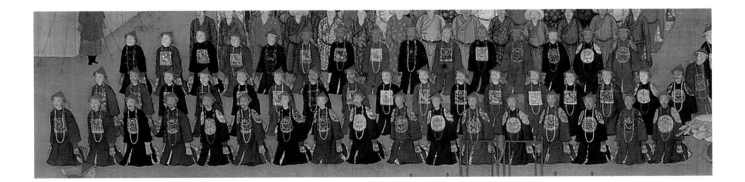

At first glance, the stereotypical features of a Manchu woman's dress seem as timeless as the genre of formal portraiture that presents royal women in frontal view against an empty background. Qianlong's empress Xiaoxian, for example, appears as a mannequin in fig. 70.[3] Her triple earrings and narrow sleeves that terminate in a flaring "horse-hoof" trim distinguished her from a woman dressed in the Chinese Ming style, characterized by single pendant earrings, wide sleeves, and pointy slippers for bound feet.[4] The Qing dress code specified that imperial ladies were to wear three earrings in each ear, each made of a string of two pearls dangling from a gold dragon or cloud (see fig. 77). The origin and quality of the pearls also served to mark status differences among imperial consorts.[5]

A photograph taken about 1900 of Dowager Empress Cixi in her banqueting or semi-formal outfit (fig. 65) shows that there was not one Manchu style but many. In her T-shaped "giant spread wings" [*da lachi*], framed coiffure [*jiazi tou*], and bejeweled platform shoes, Cixi epitomizes Manchu chic. Her sleeves are wide, evidence of a Manchu–Han hybridity in vogue toward the dynasty's end. The Qianlong emperor, who in 1759 complained about Banner daughters fashioning wide sleeves, would have turned in his grave.[6]

Particularly dramatic in this picture is Cixi's hairdo, which is neither purely Manchu nor traditional. Some have argued that the "giant spread wings" headdress was inspired by the Chinese "peony coiffure" or "lotus coiffure," a Suzhou-originated style in vogue during the Kangxi and Qianlong reigns. These chignons were fashioned from natural hair piled above the forehead with an overhang, reinforced by false hair mixed in with glue. The Manchu T-shaped chignon was at first made from glued natural hair only, which resulted in a low "twin-stubs coiffure" [*liangba tou*]. As time went on, a wire frame was inserted to augment the height, and false hair was applied to add volume. By the Xianfeng reign (1851–61), the hairdo had turned into a headdress, with black felt or silk strips stretched over a wire frame – the "giant spread wing." It was so representative of the Manchus that the Chinese called it "Banner head" [*qitou*]. The style remained in vogue until the first decade of the republic.[7]

Far from being timeless, the "old Manchu ways" were

to have been acceptable. In cold weather, such robes were made of padded cloth or, in the case of high-ranking individuals, of close-cropped furs.

In the early days of the Conquest, the Qing leadership made a fateful decision: they would force Han Chinese men to adopt Manchu styles, while Han women were allowed to wear their own traditional clothes, hairdos, and accessories. The long Manchu gown that buttoned on the right side was only required of officials and, as a warm and comfortable garment, may not have been felt as a hardship by the Han Chinese population. The same may have been true of the excellent Manchu-type boots. The Manchu hairstyle was another matter, however. Even though the emperor himself had the front half of his head shaved and wore his remaining hair in a pigtail just like his male subjects, the style was bitterly resented by the Han population as a mark of subjugation. It remained a standing grievance through the end of the dynasty (see fig. 66).

Imperial Adornment: Women's Clothing

The Qing government was more relaxed in regulating the appearance of Han Chinese women. Instead, it was the costumes and hairdos of Manchu women that were subjected to close supervision. The fact that the rules of the Manchus obliged their women to dress differently from Han women seems to have been resented more by the former than the latter. In fact, judging from surviving court paintings, even imperial Manchu women sometimes wished to adopt a Han Chinese look (see, for example, figs. 223, 232). The greatest difference between women of the two ethnic groups was the custom of footbinding, socially imperative for all middle- and upper-class Han

66

A Street Barber in Central China
Artist: Thomas Allom
(1804–1872)
Lithograph
1843–47

The Qing government's heavy-handed policy of enforcing the pigtail haircut did succeed in forging a common identity for all Chinese males but also caused lasting resentment among the Han and other non-Manchu ethnic groups. Like most foreigners who visited China during the imperial period, this English artist was interested in pigtails.

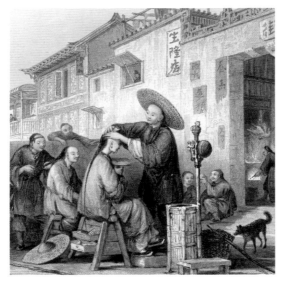

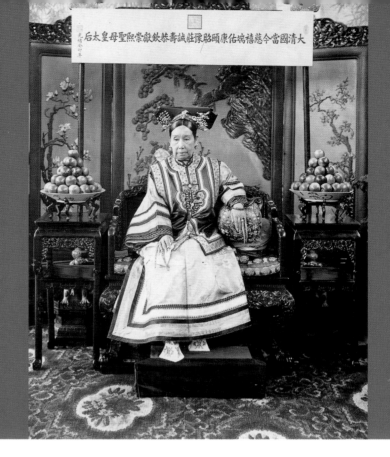

大清國當今慈禧端佑康頤昭豫莊誠壽恭欽獻崇熙聖母皇太后

as fickle as women's fashion. Many aspects of Qing institutions were modeled after the Jurchen, the ancestors of the Qing who had established the Jin dynasty. But there were no historical precedents for the triple earrings, horse-hoof sleeves, T-shaped chignons, and platform shoes: the four elements that we identify as the quintessential Manchu style.[8] All were invented traditions. For political purposes the difference between Han and Manchu had to be made absolute, but exactly who was a Han or a Manchu and what she looked like were not inherently apparent. To the extent that women of Han origin from Chinese-martial [*hanjun*] Banner families also adopted Manchu attire, it was style that made the ethnic identity of a woman. She was what she wore.

65
Dowager Empress Cixi
Photograph
c. 1900
Freer Gallery of Art and Arthur M. Sackler Gallery, Smithsonian Institution, Washington, D.C.

women but flatly forbidden for Manchus (see sidebar pp. 70–71). Another was the one-piece unisex Manchu *qipao* as distinguished from the two-part jacket and trouser/skirt outfit worn by Han Chinese women. A third was a series of extreme hairdos, not so much prescribed by the emperor but freely adopted by Manchu women in an effort to assert a separate non-Han identity (see sidebar above).

Although the emperor's two types of dragon robes – the *chaofu* and the *longpao* – were very different in design, the ceremonial (fig. 68) and ordinary formal robes of the empress were quite similar. They differed, however, in that the empress's full ceremonial outfit included a wide detachable collar and a vest that covered the entire robe except the sleeves (fig. 70). On ordinary formal occasions, the empress and the other consorts would dress in *longpao* dragon robes (fig. 69), which they wore without the belts used by men and sometimes without surcoats (fig. 67). Distinguishing the dragon robes of the two sexes is not easy, for the design and details are very similar. Modern museums with costume collections from the Qing period make the distinction somewhat arbitrarily by measuring the width of the neck band, on the theory that women had more slender necks.

No paintings show imperial ladies' feet, so we cannot be sure about their footgear, but one assumes that they wore Manchu-type platform shoes on informal occasions and might wear boots like those of men on formal occasions. The long black vest that hides the empress's robe in fig. 70 was probably worn by court ladies only on ceremonial occasions (fig. 73). Other accessories of imperial women's ceremonial and formal outfits included a diadem around the forehead (confined to consorts of the fifth rank and above), a torque around the neck (fig. 78), and triple-paired earrings ornamented with freshwater pearls from the Northeast (fig. 77), plus a ribbon with multiple pendants and a necktie-shaped kerchief, both suspended from buttons in front (fig. 74). Ladies wore hats with

67
Four Dinner Scenes Beyond the Great Wall (detail)
Artist: Giuseppe Castiglione (1688–1766) and others
Color on silk; 124½ × 217 in. (316 × 551 cm)
1736–66
(see also fig. 29)

While the emperor watches wrestling and riding demonstrations, his consorts stay within a screened-off area protected by eunuchs. Four ladies wear dragon robes with court hats and two wear casual Manchu dress but still with court hats. The one in red has a different outfit that is neither Manchu nor Han Chinese. Could the outfit be Uighur, and its wearer the Muslim consort Rong Fei?

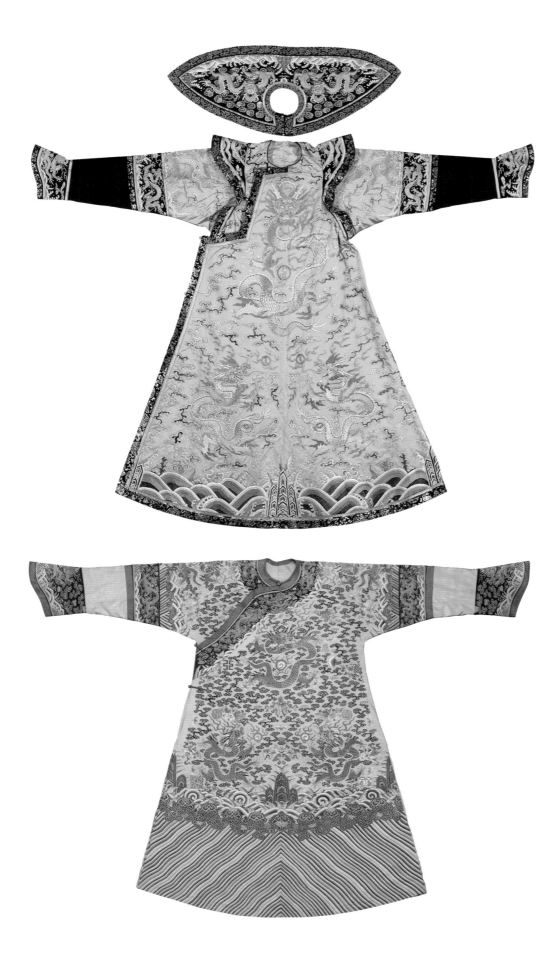

68
Empress's ceremonial robe and cape for spring and autumn
Silk in *kesi* tapestry weave, gilt-bronze buttons; height 54¾ in. (139 cm)
1737–66

This yellow silk robe features five five-clawed dragons on the front and three on the back, without the twelve imperial emblems mandated by the revised regulations of 1766.

69
Empress's summer dragon robe
Silk in *kesi* tapestry weave, gilt-bronze buttons; length 46 in. (117 cm)
Nineteenth century
The Field Museum 125898

As the robe bears the twelve imperial emblems but has a small neck opening, it must have been made for a woman of the rank of empress or empress dowager. This example has a thin lining and is relatively light in weight.

70
Portrait of Empress Xiaoxian in winter ceremonial robe
Artist: attributed to Giuseppe Castiglione (1688–1766)
Color on silk; 76 × 46 in. (194 × 116 cm)
c. 1737

Qianlong's first empress is shown in a full ceremonial outfit. She and her mother-in-law were the only imperial women of Qianlong's time to be depicted with one hand raised rather than both hands folded demurely in their laps and seated on dragon, not phoenix, thrones.

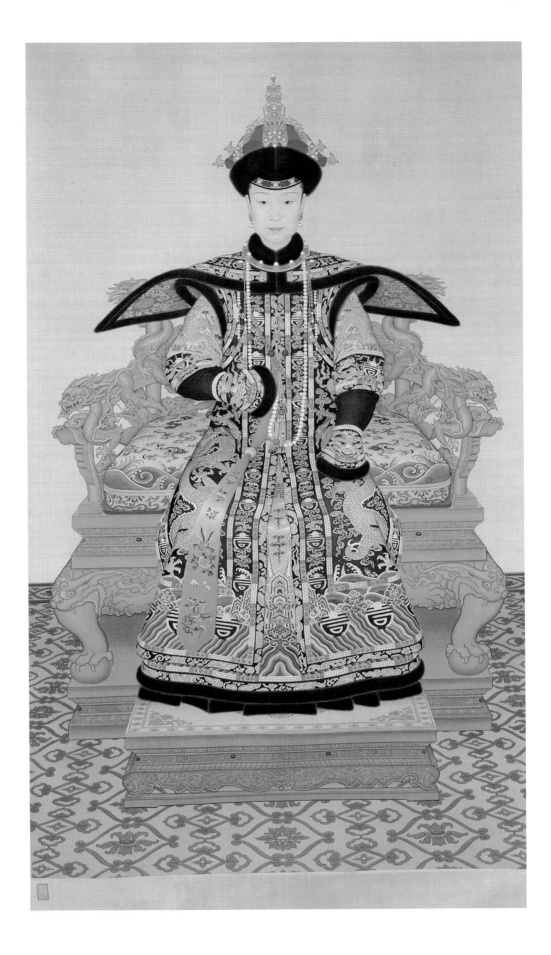

The banning by the Qing court of footbinding for Manchu women made it into an ethnic trademark for the subjugated Han Chinese people, which ironically led to its spread across geographic and class lines during the Qing.[9] Similarly, the platform shoes favored by Manchu women – who enjoyed more legal privileges than did their Han Chinese counterparts – were often seen not only as an ethnic marker but as a sign of freedom and mobility.[10]

The difference between Chinese slippers and Manchu platforms was not as absolute as the contrast in size would suggest. The two-part construction as well as the lining, seam-binding, and stitching of the uppers of the platform shoes were modeled after a style of Ming unisex shoes.[11] The embroidered floral or butterfly motifs and stitches on the vamp resembled those on Chinese women's footwear. The horse-hoof soles [*matidi*], named for the hoof-shaped marks left on the floor, in three common shapes, were made of fabric stretched over a wooden base, a construction similar to high-heeled slippers for bound feet.[12] The ship's-keel platform [*chuandi*], 1–2 inches (2.5–5 cm) tall, made sensible wear for older women and for everyday use. The "flower-pot soles" [*huapandi*], part of formal and semi-formal attire, could soar as high as 4–5 inches (10–12.5 cm). Some platforms were so narrow that they were virtually stilt-like (fig. 71).

The latter two styles were so debilitating that they were often compared to shoes for bound feet. Manchu ladies admired the "lotus gait" of bound-foot women but could not or would not submit to the gruesome footbinding routine, it has often been suggested, hence the imitation. But the flat platforms, attached against the arch of the foot, produced a gait different from high-heeled slippers for bound feet, which elevated the heel and shifted the wearer's weight to the tip of the foot. Although

73

Empress's long ceremonial vest

Silk, gold, and silver thread, gilt bronze; length 52⅜ in. (133 cm)

1723–35, Yongzheng period

Ceremonial vests are not good rank indicators as the fifth- and higher-grade imperial consorts all wore vests that were essentially identical. This vest is said to have belonged to Yongzheng's empress.

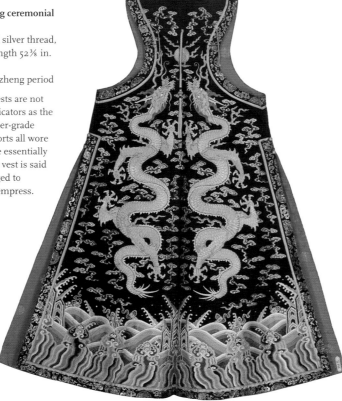

phoenixes on top at formal events and with a single pearl or red bead finial on less formal occasions.

In spite of the need to stress Manchu identity through clothing, it is interesting that Qianlong and his consorts were often depicted in Han Chinese costume. In a sample of court paintings in the collections of the Palace Museum in Beijing, there are at least seventy-five that depict Qianlong himself and at least sixteen that depict imperial consorts.[19] The kinds of costumes involved are listed in the table below.

Costumes as shown in imperial paintings of the Qianlong period

EMPEROR

Number	Costume type	Context
21	formal	official ceremonies and portraits
20	informal Manchu	hunting
3	religious Tibetan	represented as monk/bodhisattva
31	informal Han	at leisure

CONSORTS

Number	Costume type	Context
11	formal	official ceremonies and portraits
5	informal Han	at leisure

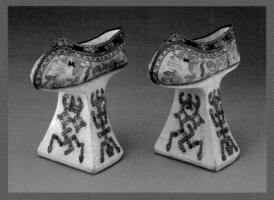

71
**Manchu women's platform
shoes**
Silk, cotton, glass, wood;
height 7¼ in. (20 cm)
Nineteenth century

72
Venetian women's chopines
Seventeenth century, Venice
Bata Shoe Museum, Toronto

In view of the likelihood that Qianlong decided on every detail of each painting, the high proportion of Han costumes is surely significant. How can this be reconciled with Qianlong's frequent denunciations of Han Chinese dress as being unsuitable and corrupting for a Manchu? It was evidently important for the emperor to portray himself as an elegant Han scholar (see fig. 278), and important too for his women to be shown in Han ladies' array. With regard to Qianlong's father's similar fondness for depictions of women dressed in Han style (see fig. 223), one commentator has suggested that this was meant to symbolize masculine Manchu dominance of Han femininity.[20] This could be true of Qianlong as well (see, for instance, figs. 229, 232), although the women thus depicted were not Han but Manchu instead.

Another possible reason for having his ladies painted in Han costume could have been the emperor's desire to show that the mothers of his sons, like himself, sustained the values of all ethnic groups in the empire. And a third possibility is that the paintings reflected reality. Qianlong and his ladies may indeed have worn Han clothing, at least sometimes and perhaps quite frequently. In any case, both the emperor and the court artists were sensitive about such ethnic details as triple earrings. When imperial ladies were shown in Manchu official or casual outfits, they wore triple earrings, even when they were out hunting (see fig. 192). However, when court ladies were shown in Han Chinese costumes they wore only one pair, as shown in the depictions cited in the previous paragraph. Consistency in the ethnic coding of costume items was evidently important to the artists' sole client, the emperor.

Imperial Actions

The emperor's actions as well as his possessions were laden with symbolic meaning. Like his predecessors he was aware that as a descendant of alien conquerors, he continually needed to reinforce his legitimacy as a ruler in Han Chinese as well as in Manchu terms. And the ideology through which legitimacy could be obtained and kept was mind-bogglingly complex. An emperor had to perform and be known to perform an astonishing variety of rituals, without which Heaven's favor and popular support would certainly be lost. He also had to provide the usual services – police and military protection, flood control, famine relief, justice, regulation of commerce, and so forth – that in all nations help to justify the payment of taxes.

Further, because the Qing emperors needed the Han intellectual élite to help run the government, it

74
**Portrait of Empress Xiaoxian
in winter ceremonial robe**
(detail of fig. 70)

This empress's vest is
fastened with buttons and
bordered by bands of coral
and pearl beads. She wears
three ceremonial necklaces,
and has a silk scarf and gem-
weighted ribbons hanging
from the buttons.

The Empress's Silkworms
Evelyn S. Rawski

That the Qing empress would officiate at rituals to the god of sericulture, the raising of silkworms for making silk, seems at first glance to be completely in keeping with the symmetry of many Chinese religious practices. The emperor, as the pre-eminent male, made sacrifices to the god of agriculture, Xiannong, each spring, and ritual specialists viewed the rites to Xiancan (literally, First Silkworm) as its female, or *yin*, counterpart. Both rites had ancient precedents; both were assigned to the second rank in a three-tiered hierarchy of state rituals, which were frequently performed by deputies.[14] The imperial ritual was also merely the capstone on a rite that continued to flourish in sericultural districts: there is, for example, a depiction of domestic sacrifice to the Silkworm Deity in the imperially commissioned *Illustrations of Tilling and Weaving [Gengzhi tu]*.[15]

The apparent similarities between the Xiannong and Xiancan sacrifices actually masked a major difference, however: the sericultural rites were the only state rituals in which a woman had the leading ritual role. An attempt in the 1530s to revive the sericultural ritual showed that Chinese ritual officials found it difficult to balance the theoretical justifications for carrying out the sacrifices against the social customs that barred women from appearing in public and participating in public affairs.[16] Canonical texts dictated that the Xiancan Tan [Altar to the Silkworm Deity; also known as the Sericulture Altar] should be located in the northern suburbs, since north was the *yin* compass direction; but that would require the empress and other Palace women to remain outside the inner quarters overnight, which was not acceptable. On the other hand, if the altar were relocated simply for convenience, would the sacrifices be efficacious?

Decorum prevailed: the Ming and Qing both compromised on the proper location of the Sericulture Altar for the convenience of the Palace women; but in fact the empress rarely performed the ritual. It was performed only seven times, from 1530 to 1536, in the Ming; in the Qing dynasty, the ritual seems to have been revived in 1736. The Qianlong emperor observed, however, that the records showed that the ritual had normally been performed by a male official from the Court of Sacrificial Worship, thus destroying the symbolic gender balance that the ritual had aimed to create. He arranged for imperial consorts to substitute for the empress. Later, princes' wives were also selected for this duty.

The Xiaoxian empress may have performed the ritual once before her death in 1748.[17] In later reigns, it was occasionally performed by empresses of the Jiaqing, Daoguang, Xianfeng, and Guangxu periods, but otherwise it was carried out by imperial consorts or male ministers. Perhaps to offset the court's perfunctory obeisances to the Silkworm Deity, the Qianlong emperor ordered in 1794 that local sacrifices to Xiancan at the Yellow Emperor's shrine in Zhejiang province (a center of sericulture) be incorporated into the state ritual calendar.

75
Shrine at the Xianchan Tan
Photographer: Osvald Siren (1879–1966)
c. 1920

Offerings were made here on behalf of the millions of women who, with their men, produced China's silk. The throne is for the empress. Thread produced in the course of the ceremony was supposed to be used to make ritual garments for the emperor.

77
Triple earrings in boxes of jade and *zitan* wood
Freshwater pearls, gold; length 2 in. (5 cm)
1736–95, Qianlong period

The empress and the next three ranks of consorts wore triple golden earrings, each with two pearls. The higher the rank, the larger the pearls. All Manchu women were supposed to wear three earrings in each ear, whereas Han Chinese women wore only one.

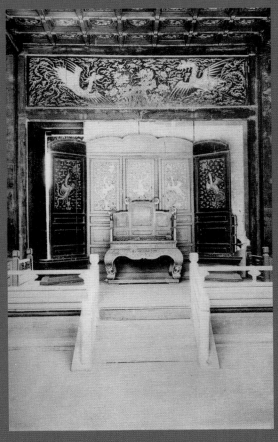

76
Inside the compound of the Xiancan Tan, the Altar of the Silkworm Deity or Sericulture Altar
Photographer: Osvald Siren (1879–1966)
c. 1920

Waited upon by forty-six female assistants, the empress presided over the initial phase of the sacrifice, the collecting of mulberry leaves, and preparing the silk. The compound was built in 1742 and enlarged in 1757. It contained chambers for attendants, an altar, a shrine, a small mulberry tree farm, sheds for raising the silkworms, and a simple workshop for preparing silk thread.

78
Imperial consort's ceremonial torque
Gold with coral, pearls, silk ribbons; diameter 7⅞ in. (20 cm)
Nineteenth century

The torque is similar to the one worn by Empress Xiaoxian in fig. 70. However, her torque would have had eleven pearls while this has only seven, indicating that it belonged to a consort of *huang guifei* or lower rank.

79
Woman and man in Manchu costume
Artist: anonymous
Color on glass;
19¼ × 15⅜ in. (49 × 39 cm)
c. 1760–80
Nordiska Museet, Stockholm

In this export painting, both the woman and the man wear romanticized Manchu court costumes.

was essential to gain their respect. The best way to do this was to demonstrate a mastery of Chinese cultural tradition. This is one reason why Kangxi, Yongzheng, and Qianlong all boasted of their fondness for practicing brush calligraphy. It is also partly why Qianlong collected ancient art and wrote many poems filled with allusions to classical Chinese literature.

One would think that maintaining legitimacy in Manchu terms was easier. After all, by the time of Qianlong's reign, the Manchus, outnumbered and softened by almost a century of luxurious urban life, needed Qianlong as much as he needed them. He took no risks with Manchu loyalty, however. He showered benefits on ethnic Manchus, and conciliated Manchu cultural conservatives, of whom he indeed was one. He placed new emphasis on the speaking and writing of the Manchu language, made a total of four tours to the ancestral capital and tombs at Shenyang in the Northeast, sacrificed daily to the ancient shamanic deities of the pre-Manchu Tungus, insisted that Manchu men and women should both wear Manchu rather than Han costumes, and engaged frequently in hunting expeditions designed to bring him in contact with ordinary Manchus and Mongols. He took as much care to excel in activities valued by

Manchus and Mongols as to master such sedentary Han Chinese pursuits as calligraphy. He was tall, strong, a skilled rider, and – by his own account, which no one doubts – an excellent shot with a bow and arrow on foot and on horseback. He may have been a cultured scholar among scholars but he was also a warrior among nomad warriors, and he devoted as much time to promoting the one persona as the other.

Later chapters will discuss Qianlong's martial and literary achievements at greater length. Here we wish to underline certain key activities that were at least partially aimed at proving the emperor's right to rule.

One was touring beyond the capital (see pp. 95–105). This had its ritual as well as its practical aspects. As one scholar has written of an earlier period in Chinese history:

Thus, on behalf of Heaven, the king goes along the roads to guard and shepherd his people. His personal performance of the task of inspection is the highest expression of his care and esteem for the masses. ... The tour of inspection ... seems to have been a means whereby a new king tested the acceptance of his sovereignty throughout the land, and his acknowledgment as ruler by Heaven, the spirits and the people.[21]

80

Ten Thousand Envoys Come to Pay Tribute

Artist: anonymous court painter(s)

Color on silk;
126¾ × 48⅜ in.
(322 × 122.7 cm)
1761, Qianlong seals
and poem

One of the iconic art objects of the Qianlong period, this very large painting by court artists depicts foreign tribute missions gathering in the courtyard just inside the southern gate of the Forbidden City, waiting to present their gifts to the emperor during the New Year celebrations. The presentation will take place in the Hall of Supreme Harmony [Taihe Dian], in front of which eunuchs and officials are waiting. Most of the Palace is veiled in mist, but in the space to the right of the Taihe Dian a group of eunuchs is preparing sets of return gifts for the envoys.

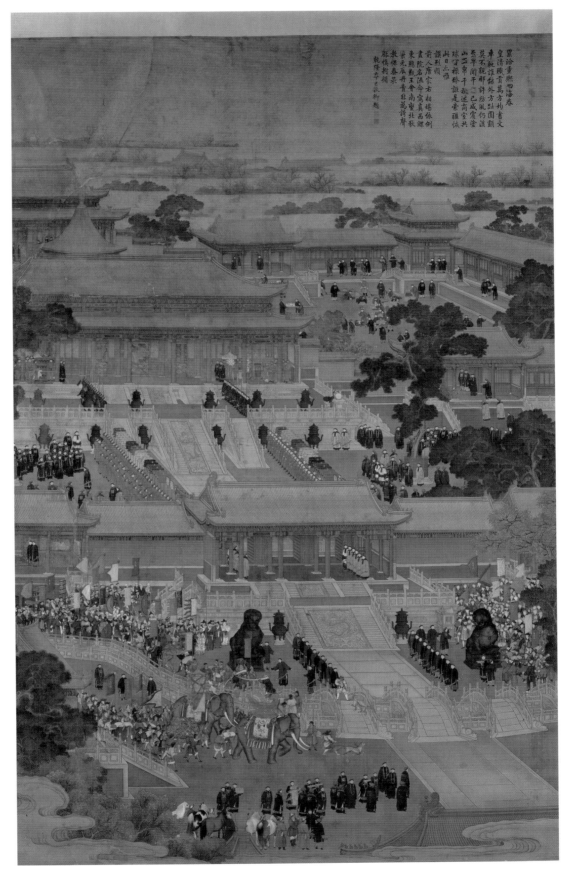

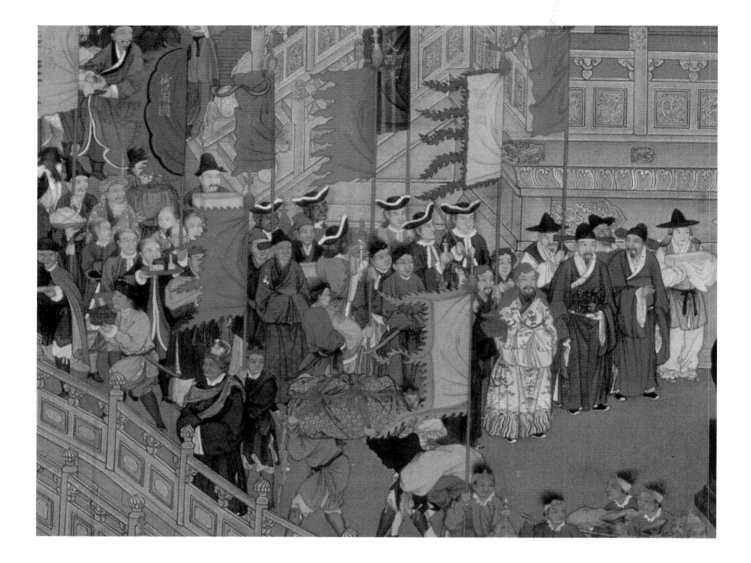

81
Ten Thousand Envoys Come to Pay Tribute
(detail of fig. 80)

Waiting on the north side of the Gold Water Stream, the Korean envoy leads the group, followed by delegations with banners bearing the names of their countries, including "Pacific Ocean," Brunei, and Holland.

Another proof that the emperor ruled legitimately was the performance of a series of major annual ceremonies affecting the welfare of the empire as a whole, conducted at state altars in and around Beijing (see "The State Religion," pp. 154–56).

A third was support and patronage of temples of many religions. In Qianlong's case, his primary personal allegiance was to the Tibetan–Mongolian form of Buddhism but he also made major donations to build or rebuild Chinese Buddhist, Daoist, Muslim, and even Christian religious structures (see "Introduction: Public and Private Faiths," pp. 122–23).

A fourth was providing frequent evidence of submission by foreign states and hence, of the emperor's status as a universal ruler. The constant parade of tribute missions from other parts of Asia was a sign of this status, as was the less frequent

reception of envoys – also interpreted as bringers of tribute – from more distant European powers (figs. 80, 81, 82). The emperor's efforts to learn other languages – he was fluent in northern Chinese (the language that later became Mandarin) and in Manchu, good in Mongolian, and fair to poor in Tibetan and Uighur Turkish – were a further sign of his universalist pretensions, as was his strong interest in European and Indian arts and science, his hiring of European artists, and his collecting of artifacts from many countries.

A fifth was the military success of his armies, discussed in "Martial Arts and Hunting," pp. 105–19. Neither Qianlong nor his subjects forgot that the boundaries of China reached their greatest extent during his reign and that the reality of Chinese power reached from Taiwan and Sakhalin to Uzbekistan on

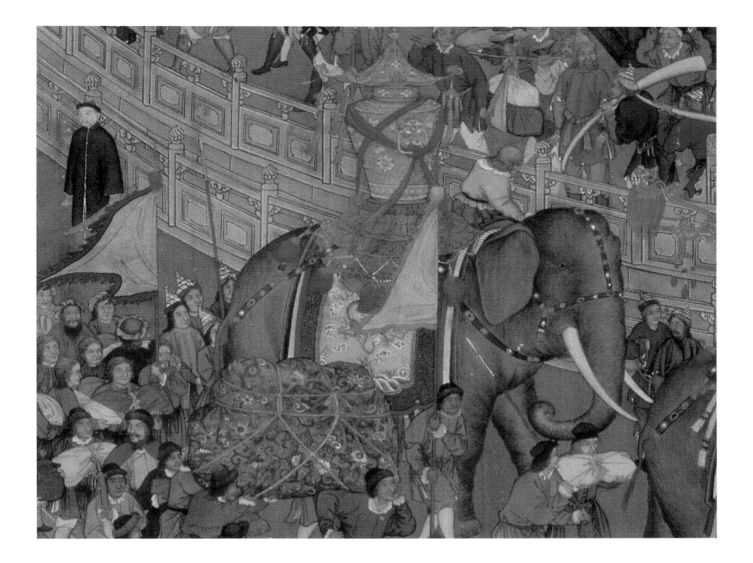

the far side of the Pamirs, and from Lake Baikal to Nepal and the Mekong delta.

A sixth was the flowering of arts that bore Qianlong's own imprint of taste. As Chapter VI shows, a multiplicity of craft and art styles flourished in Qianlong's time. Not everyone is enamored of the complex color schemes and intricate rococo designs favored by the emperor. Yet it is arguable that in terms of sheer technique a number of these arts reached a peak that will never be reached again.

A last proof of Qianlong's right to rule was his extraordinary effort to perpetuate Chinese literary and artistic culture. His vast collection of ancient paintings and other arts represents one side of this program of collection and preservation. Another side was his leadership of enormous projects of literary conservation (see "Introduction: Image and Reality,"

pp. 212–18). He and later generations felt he gained legitimacy from this, and it was indeed a magnificent undertaking. His collections of art and books still survive. Many modern observers would agree with Qianlong that those collections constitute the very heart of the greatness of Chinese civilization.

82
Ten Thousand Envoys Come to Pay Tribute
(detail of fig. 80)

South of the Gold Water Stream, the Siamese envoys are busy passing ivory tusks and mobilizing their two elephants.

Notes

1. Wheatley 1971, p. 428.

2. The official reason was not to show disrespect to earlier emperors who had died in the Qianqing Gong.

3. Another painting similar to fig. 35, *Scenes of Great Joy*, shows the use of tall censers between sets of steps (Zheng and Qu 1988, p. 81). However, those particular censers were in a regular pavilion shape that bears no similarity to the cloisonné sets found in the Taihe Dian and Qianqing Gong throne halls today.

4. Zhongguo diyi lishi danganguan 1991, II, p. 1394.

5. For example, bell sets such as the one unearthed from the mid-fifth-century BC tomb of Marquis Yi in Hebei province were a prototype for later Qing ritual bell sets. The latter differed from ancient sets in that bells tuned to different notes varied in thickness rather than, as in Marquis Yi's bells, size. See Fritz Kuttner, *The Archaeology of Music in Ancient China*, New York 1990, pp. 31–58; Robert Bagley, "Percussion," in *Music in the Age of Confucius*, ed. Jenny So, Seattle and London 2000, pp. 35–64.

6. Yu 1999, pp. 211–22.

7. Wan Yi and Huang Haitao, *Qingdai gongting yinyue* [Palace music of the Qing dynasty], Beijing 1985, p. 13.

8. DQSL(RZ) 1964, *juan* 43, pp. 483–84.

9. *Ibid.*, *juan* 39, p. 425.

10. The Imperial Household Department controlled the harvest of "eastern" pearls. They were graded into five classes by size, roundness, and luster. First-grade pearls were naturally for the emperor. Lower-grade pearls were allowed for wives other than the empress, princes, and daughters. Fifth-grade pearls could be sold commercially (*e.g.* QDDQHDSL 1976, *juan* 1215, p. 19,185).

11. Qinggui *et al.* 1965, *juan* 5, p. 265.

12. Lu Tong, "Qingdai kongjue hualing [Peacock feathers of the Qing dynasty]," *Forbidden City*, 1984, no. 3, p. 15.

13. Wu 1953, p. 91.

14. Cammann 1952, p. 50.

15. Zhongguo diyi lishi danganguan 1991, II, p. 830.

16. Wu 1953, p. 89. The measurement is in Chinese feet.

17. Chen 1986; Verity Wilson, *Chinese Dress*, London 1986, pp. 17–18.

18. Lu 1987, pp. 15, 39.

19. The authors counted images in three Palace Museum publications; images of the same painting appearing in more than one book were counted as a single image: Nei 1999; Beiping gugong bowuyuan, *Qingdai dihou xiang* [Images of emperors and empresses], Beijing 1998; and Palace Museum, *Court Paintings of the Qing Dynasty*, Beijing 1992.

20. Wu Hung, "Beyond Stereotypes: The Twelve Beauties in Qing Court Art and the 'Dream of the Red Chamber,'" in *Writing Women in Late Imperial China*, ed. Ellen Widmer and Kang-i Sun Chang, Stanford CA 1997, p. 330.

21. Wechsler 1985, p. 161.

Sidebar notes

1. Wu 1985, *juan* 17, p. 186.

2. Palace accession records, Palace Museum, author's research.

3. Wu Hung has argued that the women, devoid of facial expressions, served as puppets displaying Manchu-style hats and jackets as symbols of their ethnic identity: "Beyond Stereotypes: The Twelve Beauties in Qing Court Art and the 'Dream of the Red Chamber,'" in *Writing Women in Late Imperial China*, ed. Ellen Widmer and Kang-i Sun Chang, Stanford CA 1997, p. 352. See also the excellent analysis of stylistic elements of formal female court attire shown in formal portraits in Zhou 1989, pp. 528–29.

4. For an overview of Qing sartorial regulations, see Zhou 1989, pp. 472–77. Dress codes were drawn up as early as 1623 and 1632, before the conquest of Ming (p. 474).

5. There were five grades of pearls: four grades of eastern pearls (*dongzhu*, pearls fished from the rivers of the Manchu homeland), and regular pearls (Huang and Chen 1995, pp. 365–66).

6. Edict dated 1759, translated by Evelyn Rawski and cited in

Rawski 1998, p. 41. From this edict itself it is unclear if some girls wore shoes for bound feet.

7. On the evolution of Manchu hairstyles, see Zhou Xun and Gao Chunming, *Zhongguo zhuantong fushi xingzhishi* [The institution of traditional clothing in China], Taipei 1998, pp. 175–76. See also Dai Zheng, *Zhongguo gudai fushi jianshi* [A brief history of dress and ornaments in traditional China], Taipei 1992, pp. 235–37.

8. The Jin sartorial tradition had changed from a deerskin- and fur-based one to one influenced by northern Song sedentary civilization. For a summary of Jin costumes from documentary sources and excavated figurines, see Huang and Chen 1995, pp. 237–41, 333–34. For the excavation report of a rare textile-rich Jin tomb in Heilongjiang, that of the Qiguo Wang Wanyan Yan (d. 1162) and his consort, see Zhao Pingchun and Chi Benyi, *Jindai fushi: Jin Qi guowangmu chutu fushi yanjiu* [Jin-dynasty costumes: An analysis of costumes excavated from the tomb of the King of Qi], Beijing 1998.

9. I have made this argument in an earlier article on the early Qing hair-shaving and anti-footbinding edicts: "The Body as Attire: The Shifting Meanings of Footbinding in Seventeenth-Century China," *Journal of Women's History*, VIII, no. 4, Winter 1977, pp. 8–27.

10. For the privileges of Manchu women and their distinct shoes and hairstyles, see Elliott 2001, pp. 246–55.

11. Called "*yuntou lü*" [cloud-tip shoes] or "*chao xie*" [court shoes], this Ming-style footwear was worn by monks and scholar-officials (Zhou Xun and Gao Chunming, *Zhongguo yiguan fushi dacidian* [A dictionary of dress, cap, and gown in China], Shanghai 1996, p. 292; Yuan 1994, p. 303).

12. Yanxian, a native of Beijing, described a basic twenty-step process of shoe-making that was similar for Han and Manchu footwear, male or female. See Yao Lingxi (ed.), *Caifei lu* [Picking radishes], Tianjin 1934, pp. 206–08.

13. For chopines, see Elizabeth Bernhardt, "Renaissance Venetian Chopines: Material Culture Keys to Understanding Similarities and Differences between China and Venice, Noble Women and Courtesans," unpublished seminar paper, University of Toronto, 1998. Yuan Jieying first suggested this possible connection between platforms and chopines (Yuan 1994, p. 303).

14. The Qing records of the sericulture rite are found in QDDQHDSL 1899 edn, *juan* 314, p. 439.

15. See fig. 19, p. 252 in Francesca Bray, *Technology and Gender: Fabrics of Power in Late Imperial China*, Berkeley CA 1997.

16. Joseph S.C. Lam, "Ritual and Musical Politics in the Court of Ming Shizong," in *Harmony and Counterpoint: Ritual Music in Chinese Context*, ed. Bell Yung, Evelyn S. Rawski, and Rubie S. Watson, Stanford CA 1996, pp. 35–53.

17. See Naquin 2000, p. 308, note 25; but the QDDQHDSL, *juan* 439, pp. 10,900–02, which covers 1744 and 1749, does not record the empress's performance.

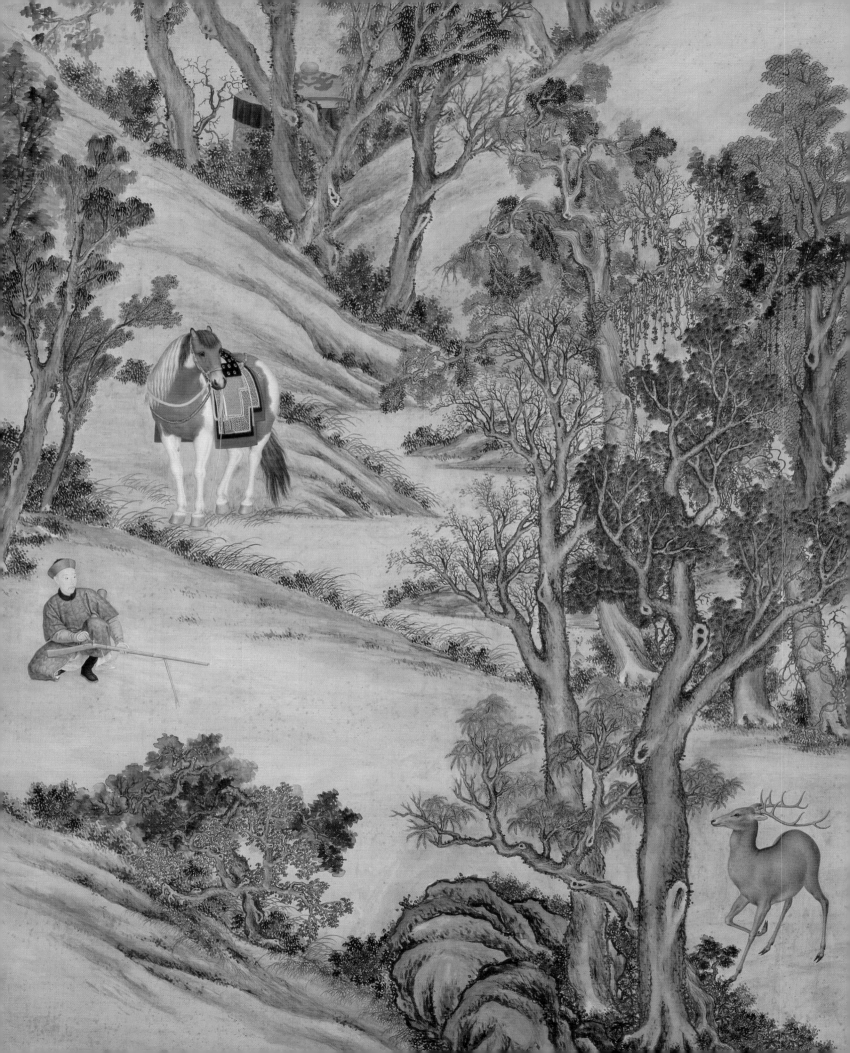

CHAPTER III
The Emperor in Action

CHAPTER III

The Emperor in Action

83 (page 80)
Qianlong Shooting a Stag with a Musket
Artist: anonymous court painter
Ink and color on silk; approx. 103 × 69 in. (258 × 172 cm) 1736–95, Qianlong seals and period
(see also fig. 121)

The painting is one of several in a similar style that show the emperor hunting alone. If his apparent age matches that of the paintings, they date to the 1730s. About two-thirds of the full painting is shown here.

Introduction: How to Be an Emperor

By the time of his abdication, in 1795, Qianlong was theoretically, and to a large extent actually, the absolute ruler of more than three hundred million people. This was many more human beings than any king or emperor in history had ruled before. It also may be more than any recent president or dictator has ruled with absolute authority. Hitler and Stalin wielded power that was equally absolute but had fewer subjects. The later rulers of India, China, and the British empire had and have more subjects but less absolute power. It is quite possible that no other individual has ever ruled so large a population so directly with such focus, vision, and personal attention to detail. Our purpose in this chapter is to explore how this feat was accomplished.

Qianlong, a highly intelligent man with exceptional skill and experience as an administrator, offered the following, not very helpful, five-ingredient recipe for being a good emperor: "To continue the fortune bestowed from Heaven, one must respect Heaven, love one's people, work hard, work well with those who are capable and good, and not forget tradition."[1]

Similar idealistic clichés pervade Qianlong's public pronouncements on governing. Privately within high official circles, however, he must sometimes have listed other ingredients in the recipe that related more to effectiveness than to goodness as such. These would have included taxing the rich as well as the poor, tracking expenditure with extreme care, keeping corruption down to a tolerable level, choosing competent personnel, conciliating as many interest groups as possible, cracking down ruthlessly on political disloyalty, and giving extensive publicity to the strength, splendor, and benevolence of the imperial government. In his own mind, Qianlong might have added still more ingredients: knowing whom to trust, not trusting anyone too much, and being all things to all men – in the words of one historian, being "a paragon of multi-literacy, the esthete of all cultures, and the universal emperor."[2]

Perhaps the most essential function of an ideal emperor was that of teacher. Kangxi, Yongzheng, and Qianlong all worked at producing illustrated instructions for rice farming and producing silk and cotton cloth, for distribution to the common people (fig. 84). Kangxi explained why:

> The most important thing for the people is food and clothing ... hunger stems from the decline of farming while cold results from the neglect of weaving. ... We should use the pictures to tell our descendants and subjects as well as the common people that each single grain or piece of cloth comes from suffering and hardship. ... only through teaching the people of the whole world to cherish their respective occupation and be diligent and frugal, can ample food and clothing be ensured.[3]

經緯相資南北方耤
知物性亦如強刷紗
束絲俾成緒骨力傅
自在布將來

縷縷看陳㦿濕宜糊盆度後撥車施爬梳莫
使忘塵污想到衣成蕢幹時

布漿有二法先用糊而後作絍者為漿紗先成絍而後用糊
或米汁刷過稀乾則將已合之絍束如索絢嘗以沸湯入糊盆
兩端以帛刷之崇衍陸離有修而不整若漿絍乃上軸䤲引
彎潊加爬梳俾繾綣直無或不仲自拘節流功莫察於此

84
Warping a Loom with Cotton Yarn
Artist: anonymous; text: Fang Guancheng (1698–1768)
Rubbing: ink on paper; height 10¼ in. (26 cm)
1765 or later, Qianlong seal and poem
The Field Museum 118293-3

Like earlier emperors, Qianlong showed an interest in agriculture. This image is from a set, *Pictures of Cotton with Imperial Inscription*, conceived by Fang and supported by the emperor. The set consists of sixteen pictures showing the different stages of cotton production, from sowing the seed to weaving the cloth. Facing each of the pictures is a description by Fang and a poem by Qianlong. The work was engraved in stone so that rubbings could be made and distributed.

Ruling

As noted in Chapter I, the Qing did not wipe out the Ming legacy of governmental concepts and institutions. Under the regent Dorgon they adopted a pragmatic, even conservative attitude toward that legacy, especially as it applied to ruling the Han majority. The civil service examination system, whereby even poor boys had a chance to reach the highest levels of officialdom, was retained. So was the basic organization of regional and local government, divided into provinces, prefectures, counties, and so forth; the boundaries of those units also remained largely unchanged. And there was massive continuity in the structure of the central government, which consisted of an Imperial Chancery or Grand Secretariat, an executive–judicial arm divided into six Boards (of Civil Office, Revenue, Ritual, War, Punishment, and Works), an independent body of Censors serving as inspectors-general, the Hanlin Academy from which many of the highest civil officials were recruited, and so on. The main changes instituted by the Qing were, first, to re-create the powerful Imperial Household Department, or Neiwufu, transferring control over the Palace's vast income from the hands of eunuchs to those of imperial bondservants; and second, to shift the formerly central role of the Imperial Chancery to a group of the emperor's personal assistants who functioned as an imperial cabinet or council of state.[4]

Qianlong's great administrative contribution was to finalize the development of this council, which came to be the chief instrument of imperial control. Its real reason for being was to ensure that the emperor rather than the national bureaucracy could make and implement all strategic decisions. Under the late Ming, a series of bureaucratic shells enclosed the emperor, cutting him off from direct contact with the outside world. Often the gatekeepers were the eunuchs of the Inner Palace, who gained immense power as a consequence. While it may be going too far to claim that the later Ming emperors were prisoners in their own palaces, the early Qing emperors clearly believed that to have been true and set out to revamp the relevant parts of the Ming system.

Kangxi and Yongzheng began the process but Qianlong completed it. He had evidently devised plans for a decisive administrative reorganization long before his accession to the throne. He made his move within a few weeks of his father's death, appointing a nucleus of talented personnel to the council known in Chinese as the Military Planning

85

The back courtyard of the Yangxin Dian

In spite of its modest appearance, the Yangxin Dian [Hall of Mental Cultivation] was the center of power in later Qing China, serving as the emperor's main office and residence in the Forbidden City. (See also figs. 31, 283.)

86

Qianlong's response to a memo from an official of Shanxi province

Ink on paper, marked in red by Qianlong
1736–95, Qianlong period
First Chinese Historical Archives, Beijing

Senior officials often used red ink, made from cinnabar, to indicate their responses to memoranda from their subordinates. In the Palace, red ink was reserved for the emperor and for clerks writing on his behalf. Here Qianlong responds in red to a suggestion that a grassroots religious movement be suppressed. His comment: "Do not rush into action."

Office [Junjichu] and to foreigners as the Grand Council. The new council was located in the Inner Court, next to the emperor's residence and working office, the Hall of Mental Cultivation [Yangxin Dian] (figs. 31, 85). Its councillors and clerks were the only officials the emperor met with on a daily basis, and he gave it full control of the system for receiving memos ("memorials") from the provincial level and issuing imperial commands ("rescripts") in reply (fig. 86). He also used the Grand Council to gather intelligence that was independent of the administrative bureaucracy. For one of the first times in Chinese history, an emperor was in a position to be fairly certain that his orders had been both transmitted and obeyed.

The new system worked but was dangerous. Thinly staffed and lacking the structural checks and balances built into old established bureaucracies, the Grand Council depended heavily on the qualities of the man in the center. So long as that man had Qianlong's phenomenal memory and attention span, not to mention sheer dedication to the job, the system functioned well. But it fell apart when he shifted his attention to other things. Arguably, this is what happened in the last two decades of Qianlong's reign. Increasingly interested in culture and religion,

87
Pair of hanging panels with couplet
Poem by Qianlong,
calligraphy by Heshen
Ivory inlaid on black
lacquered wood, *zitan* wood
frame; height 47⅝ in.
(121 cm)
c. 1785

In 1785 Qianlong became a
great-great-grandfather at the
age of seventy-five. He was
proud that five generations
could be together and
composed this couplet.
It was written out by his
notorious favorite, the
talented but corrupt Heshen.
Top to bottom, right to left,
the poem reads:

Five generations, fourth
and fifth, come together
to wait at my knee
Ten thousand subjects
gather to pay homage
to [the legendary ideal
emperor] Shun.

Like many of Qianlong's
poems, this one contains a
historical allusion. He is
comparing himself, none too
modestly, to a legendary ideal
ruler of antiquity.

88

Scroll weight with winged dragon design

Nephrite; length 9½ in. (24 cm)
Eighteenth century

Though scroll weights usually came in pairs, Qianlong sometimes used them singly, as shown in figs. 95 and 278.

he shifted more of the administrative burden to the Grand Council and eventually appointed a talented but profoundly corrupt court favorite, Heshen, to run it (see fig. 87). The appointment was a disaster. By the end of Qianlong's reign, the problems of the empire no longer were being dealt with and Heshen, his powers virtually unchecked, had not only made himself one of the richest men in history but, in the opinion of later commentators, had brought the empire to near-ruin (see sidebar above; also p. 272).

The Imperial Workplaces

Qianlong routinely woke at 5 o'clock in the morning. The time between breakfast (at 6 am) and lunch (between 12 and 2 pm) was invariably devoted to office work. He followed this schedule even when traveling. Partly due to his numerous clocks, his staff were as time-conscious as he. He never took real non-working vacations. Days of major sacrifices, when entire mornings had to be spent performing rituals, were the only times he did not meet with members of his Grand Council to attend to official paperwork. When in the Forbidden City, that work was usually done in the Hall of Mental Cultivation.

While no detailed description exists of the emperor's office work routine, meticulous daily logs make it clear that he not only read the memoranda sent to his attention but that he replied personally, jotting his comments on the document in the vermilion red ink that within the Palace could be used only by the emperor (see fig. 86). The red cakes of dried ink that he used still survive (fig. 94), along with examples of other desk equipment made for him and other high-ranking Palace office workers:

89 (top)
Brush for red ink
Nephrite, animal hair;
length 7¼ in. (18.2 cm)
1736–95, Qianlong period

Jade, though suited to an
emperor's status, would have
been too heavy for extensive
writing. Like the great
majority of traditional
Chinese writers, Qianlong
must have mainly used
bamboo-handled brushes.

90 (center)
**Brush with a tortoiseshell
handle**
Sea turtle shell, bamboo,
animal hair, gilt bronze;
length 10 in. (25.3 cm)

Sixteenth–seventeenth
century, Ming dynasty

The shape of the brush tip
is generally seen as a Ming
feature.

91 (bottom)
**Large brush with longevity
design**
Painted lacquer, animal hair;
length 11¾ in. (30 cm)
1736–95, Qianlong period

Brushes for the élite were
made from the hair of a
variety of animals, among
them sheep, goat, sable,
badger, cat, horse, deer, wolf,
and rabbit. This brush was
never used.

inkstones for grinding the ink cake into water-soluble powder (fig. 92), wrist rests for use while employing a brush (fig. 97), weights for holding paper flat while writing (fig. 88), small water pots (fig. 93), cylindrical jars for holding brushes when not in use (fig. 99), brush rests on which wet brushes could be set during writing (fig. 98), and the brushes themselves (figs. 89–91). The desk and nearby bookshelves would support a good many books, some in fancy holders like the one shown here (fig. 102). While writing, the emperor probably sometimes used a table screen like the one shown in fig. 100.

Although of very high quality, none of this equipment was of a kind unfamiliar to every literate person in China. Qianlong had many desks in his offices and studies (see, for example, fig. 95). As in the office area of the Hall of Mental Cultivation, some of his desks would have been set up for practical work, with room in front for clerks to kneel and councillors of high rank to stand or perhaps sometimes, if very frail, to sit. When meeting with larger numbers of officials, which he did every month or so, the emperor would shift operations to more formal throne halls such as the one in the Qianqing Gong, or Mansion of Heavenly Purity. Such meetings were meant for giving orders, not discussing issues or soliciting comments. Yet nonetheless, the emperor had a desk in front of him while on those thrones (see fig. 103).

92
Inkstone in a stone box with fossil fish
Green Songhua stone, in yellow stone box with inlaid fossil fish and glass cover; length 7 in. (18 cm)
1664–1720, Kangxi seals and comment

Green stone from the Songhua River in Jilin province was a new resource for making inkstones for the seventeenth- and eighteenth-century Chinese court. The Kangxi emperor preferred Songhua stone for its close association with the Manchu homeland. The fossil fish belongs to the genus *Lycoptera* and dates to between 145 and 150 million years ago. Its use as an ornament may reflect Kangxi's serious interest in fish and fishing. The inkstone still bears traces of red ink.

93
Water pot in a lotus bud shape
Porcelain with blue "robin's egg" glaze; height 2¾ in. (7 cm)
1736–95, Qianlong period

Used to store water for preparing ink (see fig. 278).

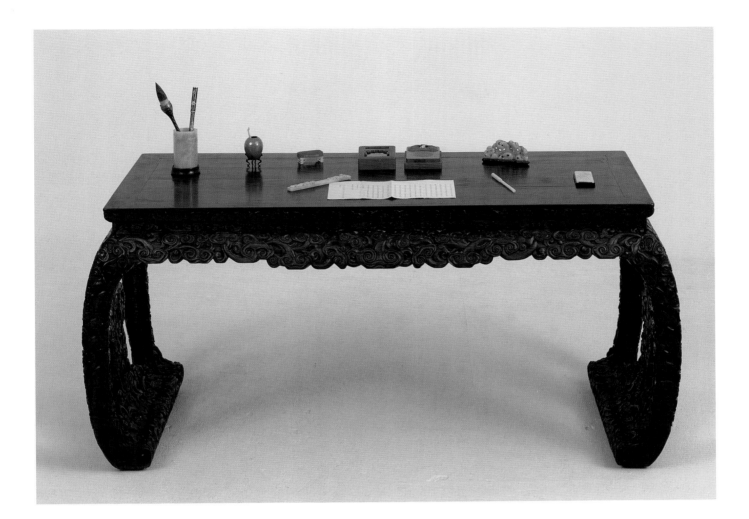

94
Cake of dried red "Phoenix Pond" ink
Cinnabar and glue;
width ¾ in (1.9 cm)
1737, Qianlong mark and period

As with black ink, a red ink cake was ground on an inkstone together with a little water so as to produce a thick, densely colored liquid suitable for brush writing. The red color comes from natural cinnabar, a mercury sulfide. Being well aware that mercury was poisonous, emperors may have usually had their ink prepared by assistants. Qianlong's son, Prince Cheng, boasted that he had written so many poems (in black ink) that his assistant suffered from what is now called carpal tunnel syndrome from grinding ink cakes on inkstones.

95
Office desk
Carved wood;
height 33 in. (84 cm)
1736–95, Qianlong period

The densely carved surface and the strongly curved, massive legs represent a departure from earlier furniture design.

96
Ink cake stand
Nephrite; height ¾ in.
(1.9 cm)
Eighteenth century

Carved in the shape of a
low table, the stand is made
for a flat, slab-like imperial
ink cake.

97
Calligrapher's wrist rest
Nephrite; height 5 in.
(12.8 cm)
Eighteenth century

The wrist rest is carved with
a phoenix and peach on the
upper side, and a two-line
poem underneath.

98
**Brush rest shaped like a
garden rock**
Nephrite; height 2½ in.
(6.5 cm)
1736–95, Qianlong mark
and period

Larger versions of such
stones, often of limestone
formed by nature into
evocative shapes, were
eagerly collected in the Qing
period as garden ornaments.
This one is of jade and
artificially formed.

99
Brush pot with Three Friends design
Nephrite; height 5¾ in.
(14.6 cm)
1736–95, Qianlong mark and period

Pine, plum, and bamboo, known collectively as the Three Friends of Winter, were admired for their endurance in cold weather. The motif was used frequently in Palace paintings (see figs. 232, 233). This pot is likely to have been used by Qianlong himself.

100
Table screen
Nephrite, incised and gold-filled, with *zitan* wood frame; height 9¾ in.
(24.8 cm)
1736–95, Qianlong period

The incised landscape is of a riverside scene, with a short poem by Qianlong.

Qianlong was the most mobile emperor in Chinese history. His usual schedule was to stay in Beijing between mid-September and early July, treating the Forbidden City as his primary residence for the first three months and then moving for the next six months to the Yuanming Yuan Summer Palace. He spent about two and a half months between July and September of each year in Chengde at the Bishu Shanzhuang Resort Palace and in the Mulan hunting park. In most years he fitted in several week-long trips to the imperial cemeteries and favorite secondary palaces, such as those at Panshan and Fragrant Hill [Xiangshan] (see pp. 33–38). The longer tours described in the next section took place every two years or so. These were at the expense of time normally spent in the Forbidden City or the Yuanming Yuan. His ten weeks at Chengde and Mulan were sacrosanct, however. Nothing was allowed to interfere.

All of this traveling meant that Qianlong throughout his sixty-year reign spent an average of three and a half months each year away from the center of government in and around the Forbidden City and Yuanming Yuan. These extended absences posed a problem for the Beijing-based imperial bureaucracy, which was much too large to pack up and follow the emperor wherever he went, in the manner of

101

Imperial Banquet in Wanshu Garden

Artist: Giuseppe Castiglione (1688–1766) and others
Color on silk; width 160 in. (419.6 cm)
c. 1755

The Wanshu [Ten Thousand Tree] Garden was part of the vast garden complex attached to the imperial resort palace at Chengde. In May 1754 the leaders of the Torgut (Durbet) Mongols, a group that had entered China seeking imperial protection, were given a fabulous reception by the emperor, who showered his guests with silver, silk, furs, herds, and princely titles. The event was recorded by a team of court painters among whom were several European artists skilled in portraiture: Jean Denis Attiret (at court 1738–1768), Ignatius Sichelbart (at court 1745–1780), and Castiglione. The finished painting, showing many identifiable faces, hung in a palace building in Chengde.

In the lower right the emperor, accompanied by high officials, is being carried in on a sedan chair. The group kneeling to face the emperor in the left center includes Manchu princes, other officials, and Torgut leaders. In the foreground are wooden frames for the acrobats who will be performing during the banquet. On the center right is a tent with gifts for the guests. In the rear is the great imperial yurt, where the emperor and his highest-ranking guests will eat. In front of the yurt are tables laden with food and more guests, including a row of Buddhist lamas. The persons wearing red robes with white rosettes are lower-ranking eunuchs, mostly musicians and sedan-chair bearers.

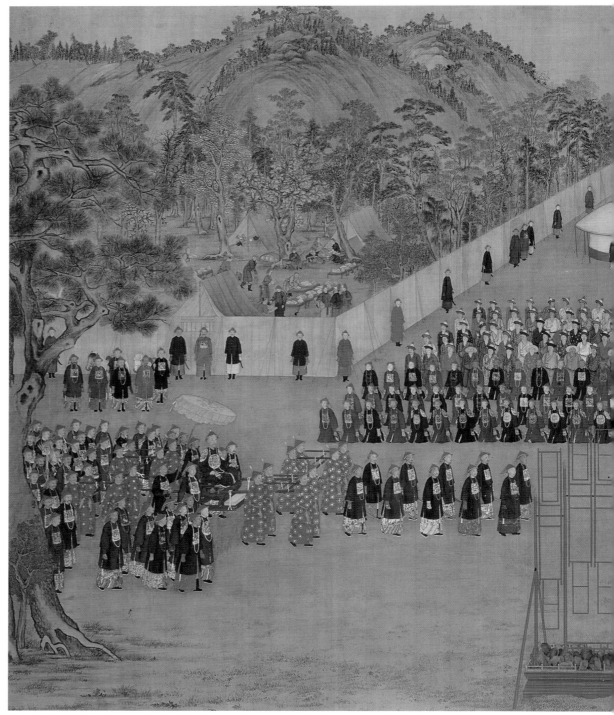

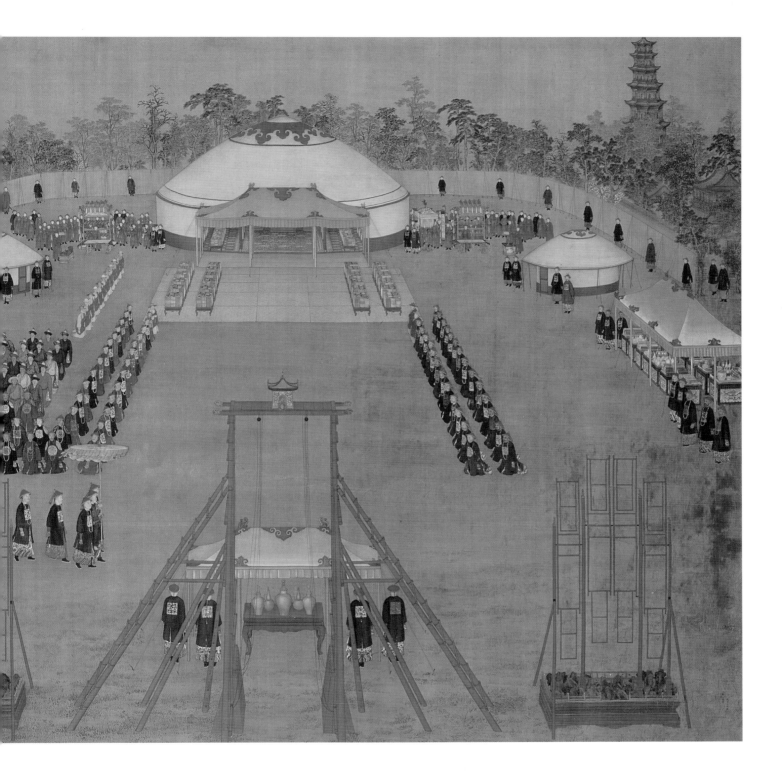

Traveling bookcase in the shape of a book and three scrolls
Cinnabar lacquer; height 6⅜ in. (17 cm)
1736–95, Qianlong period

The lower book-shaped section contains an actual book, Qianlong's *100 poems on Chengde Bishu shanzhuang*, the resort palace at Chengde. Each scroll-shaped section contains a painting. Given the quantity of books and scrolls owned by Qianlong, this type of box cannot have met the regular needs of the emperor and thus may have been used for traveling purposes. The Palace Museum, Beijing, has several boxes of similar size and shape.

Mughal Indian or early Russian governments. The solution seems to have been for the emperor always to keep at his side a significant part of the Grand Council – at least several council members and a select group of clerks, to maintain duplicate office facilities at the Yuanming Yuan and the Chengde Resort Palace, to appoint trusted officials as deputies to handle day-to-day business in the capital, and to make constant use of the efficient imperial courier system. With the ability of its messengers to cover more than two hundred miles (three hundred and twenty kilometers) per day, the existence of the courier system meant that documents about an urgent problem in Beijing could reach the emperor in his hunting camp at Mulan in less than twelve hours, and that an imperial answer could be back in Beijing by the end of the next day.

The emperor also needed an experienced local staff at his various destinations to help with advance arrangements and to advise him about any on-the-spot problems that arose during his visit. This must have happened often while he was staying in Chengde which, as noted previously, served as the

unofficial capital to which Mongols, Uighurs, Tibetans, and other northerners brought tribute and complaints, received imperial commands and gifts, and were granted face-to-face meetings with the emperor. The painting included here (fig. 101) depicts one such reception in Chengde. In it are too many officials – persons wearing official rank-badges on their breasts – for them to be locally based. Most had undoubtedly been brought from Beijing to enjoy the hunt, to help with administrative problems relayed from the capital, and to serve as specialists in dealing with northern and western tribesmen.

When the emperor was at the Yuanming Yuan Summer Palace, communication with offices of the major boards and ministries in the Forbidden and Imperial Cities was simplified by the fact that the emperor himself, as an excellent horseman, was quite mobile. During the three months he resided in the Forbidden City, he would go out to visit his mother in her palace in the Changchun Yuan [Happy Spring Garden] every ten days, and while in residence at the Yuanming Yuan, he quite often came into the city to take part in ceremonies and,

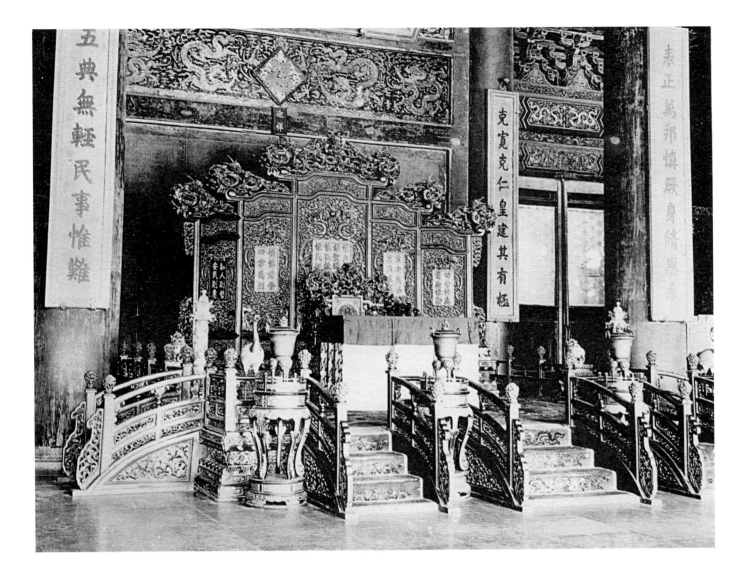

presumably, to keep an eye on his bureaucrats as well. Many senior officials were given offices and staffs at the Yuanming Yuan. Those who lacked such offices could always be summoned to come out to the Yuanming Yuan for a day or two.

Touring

Like his grandfather Kangxi, Qianlong did a good deal of touring to other parts of his realm, accompanied by large retinues and in a highly visible style.[5] The grand tours were public relations events, opportunities to showcase the power and concern of the emperor. According to folklore, Qianlong often left his palace incognito with a handful of companions, to see for himself what was happening in his empire. In reality, he must sometimes have had to

travel fast and light, with a few clerks and a minimum number of guards, especially when moving back and forth between the Forbidden City and his resort palaces in the Yuanming Yuan, Fragrant Hill, Panshan, and Chengde. But these modest modes of travel were not suitable for a grand tour in the Qing style, with a slow-moving train numbering in the thousands. As one historian has noted in connection with the similar travel habits of much earlier emperors, the main point was for "the greatest numbers of persons to view directly, or at least hear about, the glorious transit of the Son of Heaven, in magnificent train, making solicitous inquiries about the disadvantaged or freely dispensing largesse"[6]

The ostensible reasons for such journeys are expressed in a poem at the end of one of the long

103
The throne hall in the Qianqing Gong
Photographer: Osvald Siren (1879–1966)
Early 1920s

The Qianqing Gong [Mansion of Heavenly Purity] had been the imperial residence in the Forbidden City since Ming times. Yongzheng and Qianlong, however, moved out, preferring the smaller Hall of Mental Cultivation (see fig. 85). Both emperors continued to use the central building of the Qianqing Gong as a formal throne hall.

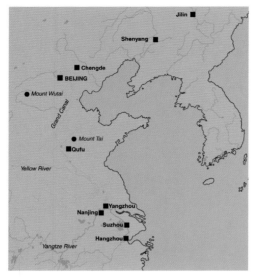

104

Map showing eastern China under Qianlong

Qianlong visited Mukden, now Shenyang, four times and the cities of the Yangtze delta six times. Although an energetic traveler, he never went to southern or western China.

handscrolls depicting Qianlong's first "Southern Tour" to the Yangtze delta in central China (fig. 112, bottom right). Composed by the emperor himself, the poem reads:

Spring is about to shift to Summer

The return journey takes 6000 *li*

Eagerly I follow the ancestors' way and entertain my
 parent's wish

Visiting local areas and enquiring about their
 customs that enrich feelings and experiences

My prayers go to counties to have adequate food and
 clothing

My worries tie to the southern regions where
 indulgence occurs

Peace of a hundred years keeps evils at bay

Harmony and auspicious blessings come from
 regular efforts

Imperial composition after respectful travel with the
empress dowager on a southern tour. Penned
respectfully by the official Yu Minzhong.[7]

The longest trips, lasting several months each, were to the old palace at Shenyang (four times, in 1743, 1754, 1778, and 1783) and to the Yangtze delta region (six times, in 1751, 1757, 1762, 1765, 1780, and 1784) (fig. 104). He might have made more trips to both Shenyang and the Yangtze delta if his mother, whom he insisted on taking with him on all of his earlier journeys, had not been getting too old for long trips. As it was, he stopped making very long

trips in the late 1760s and did not resume them until after her death in 1777. Having to spend more than a decade in the immediate neighborhood of Beijing must have been a real sacrifice for someone as fond of travel as Qianlong. It is convincing proof that his devotion to his mother went much deeper than simple filial piety.

The emperor also went a number of times to Mount Tai and to Confucius's birthplace in Qufu, Shandong (about 280 miles [450 kilometers] from Beijing), sometimes as a stopover on his way to or from the Yangtze delta and sometimes as a special journey, and paid several visits to the sacred Buddhist site, Mount Wutai in Shanxi (about 180 miles [300 kilometers] from Beijing). Those trips did not have to take more than a few weeks. It must have taken even less time to get to Chengde, 124 miles (200 kilometers) from Beijing, and onward to the Mulan hunting camp, about 60 miles (100 kilometers) farther north, as both lay on imperial roads that the emperor traversed nearly every year. He hunted at Mulan forty times during his reign and went even more often to Chengde, which if necessary he could reach in a day of hard riding. He also made twenty-eight short trips to his resort palace and gardens at Panshan,[8] 60 miles (100 kilometers) east of Beijing, often en route to the Eastern Tombs, and numerous even shorter trips to his palaces on Fragrant Hill and the Western Hills just west of Beijing.

The longer tours were organized entirely by the Grand Council, which was given full responsibility

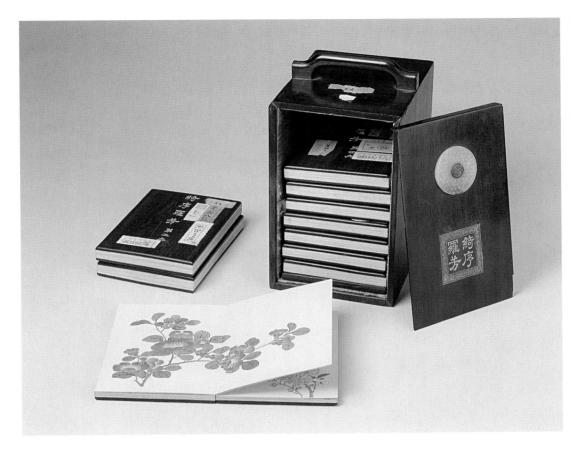

for all arrangements. One reason for this may have been the necessity for a number of councillors and clerks from the Council, as well as personnel from the Six Boards, to accompany the emperor for the duration of the journey. Some of the portable refreshment and stationery items shown in this book (figs. 105, 107–09) were made for Qianlong's use during his tours. His staff must have had similar, if less ornate, items of writing equipment with them at all times, partly to take notes on events and the emperor's on-the-spot decisions but partly also to transcribe or record the several poems, some quite long, that Qianlong was accustomed to produce each day. Artists were also included on his staff and must have needed their own portable sketching and painting equipment. Some idea of the number of artists and artists' assistants involved may be gained by examining the painting of the Chengde reception shown in fig. 101, where at least a hundred high-ranking figures are depicted so realistically as to be undoubtedly recognizable as individuals.

As many as three thousand persons – guards, eunuchs, officials, Palace ladies, maids, princes, cooks, horse tenders, soldiers – could accompany the emperor on some of his longer tours. On his first Shenyang trip to visit the old palace and ancestors' tombs, Qianlong took along 215 eunuchs to handle cooking and serving food (fig. 106), 511 junior eunuchs to do other jobs, and 100 senior eunuchs and imperial guards. A two-thousand-man advance

106
Imperial Banquet in Wanshu Garden
(detail of fig. 101)

The men with red hats are eunuchs from the emperor's regular kitchen staff. The others are probably locally recruited helpers.

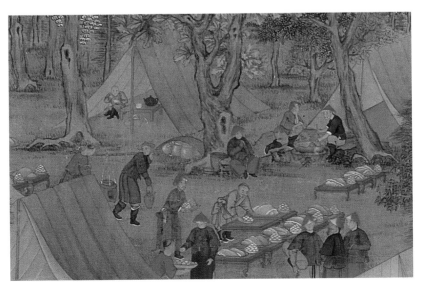

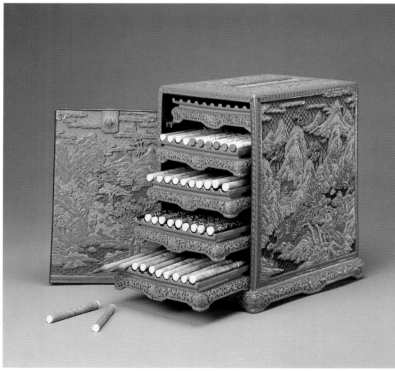

107
Portable brush case with five drawers
Cinnabar lacquer, bamboo, rabbit hair; height 14¼ in. (36.2 cm)
1736–95, Qianlong period

Beautifully carved, the case holds fifty rabbit-hair writing brushes and is inscribed with Qianlong's comments on flowers. The brush-tip protectors of two brushes have been removed and lie in front of the case.

108 (above)
Folding desk
Zitan wood; width 29⅛ in. (74 cm)
1736–95, Qianlong period

This travel desk folds into a box that contains a candlestick with shade, stationery equipment, and an assortment of small, lightweight curios. It may be unique in the history of Chinese furniture.

109
Tiered basket
Huali wood; height 20⅞ in. (53 cm)
1736–95, Qianlong period

Compactly designed and fitted with eating and drinking utensils, this basket accompanied Qianlong on some of his picnics and tours.

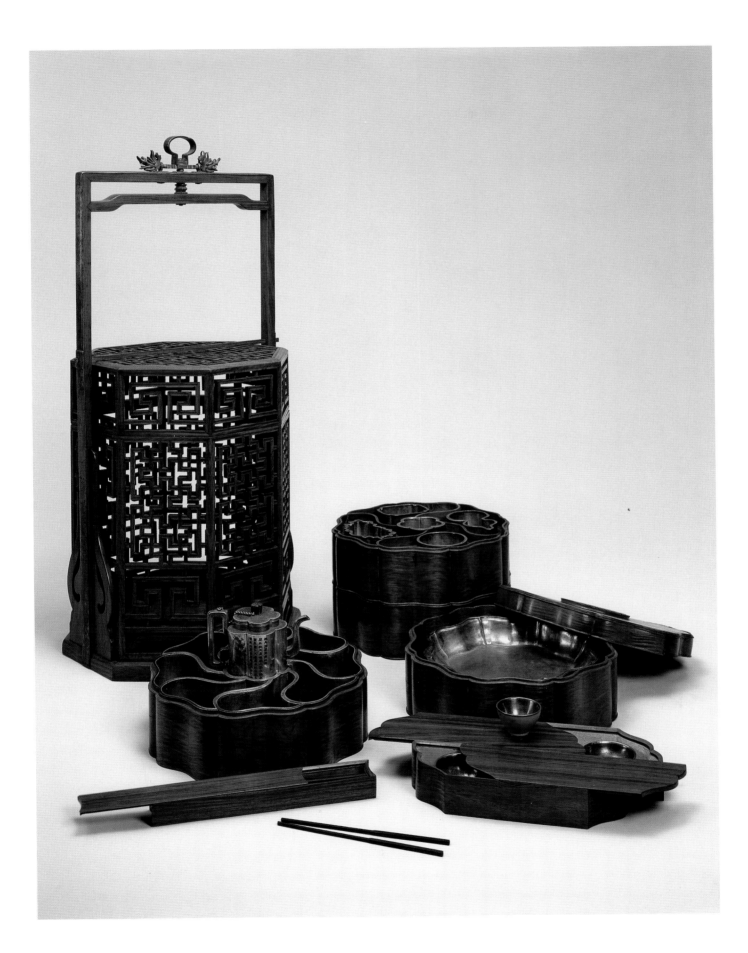

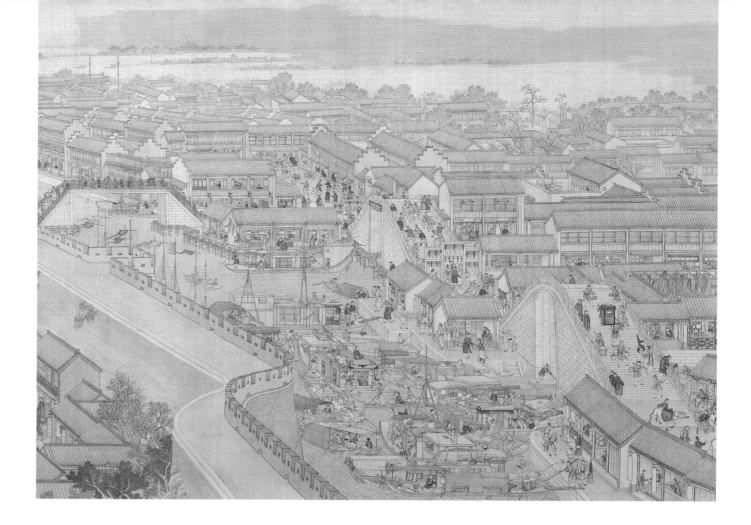

110
The Qianlong Emperor on his First Inspection Tour to the South, Scroll 6: Entering Suzhou
Artist: Xu Yang (active in court 1751–1777)
Color on silk;
height 27¼ in. (69 cm)
1770
The Metropolitan Museum of Art, New York

The emperor commissioned the painting in 1764, two years after his third Southern Tour to the Yangtze delta and one year before his fourth. For reasons that are unclear, he wanted it to depict neither of those tours but his first, in 1751. The result was a monumental work, more than 330 feet (100 meters) long but only 27¼ in. (69 cm) high, divided into twelve horizontal scrolls. This is from the fourth scroll. It depicts the inhabitants of Suzhou awaiting the arrival of the imperial party.

party was charged with making sure that all arrangements were in place before the emperor's arrival. Key members of the imperial group changed horses three times along the way. Movement was necessarily slow: 20–40 *li* (6–12 miles [10–20 kilometers]) per day, and stops for hunting – common en route to Shenyang but rare when heading south – could slow progress still more.

On his tours to Shenyang, the emperor and high-ranking members of his party ate mostly game and drank mares' milk and grape wine from jade bowls. Princes and officials along the way paid for tables and food for informal refreshments as well as banquets: fresh fish (which Qianlong disliked), pigs, geese, ducks (of which the emperor was very fond), chickens, lamb, and eggs. At certain stations, local officials were directed to keep a hundred cows ready to supply milk for the imperial tea, which seems to have been drunk Manchu-style with milk rather than Tibetan-style with butter, and some were required to have ice ready as well. The milk supplied in this way must not have been too good, for on later trips the

emperor took along his own herd of milk cows. As one would expect, eunuchs and servants ate less well, surviving on a road diet of vegetables, pickles, tofu, rice, and noodles. Presumably they too drank tea.

The Southern Tours were directed toward the great cultural centers of the region known as Jiangnan, or the Yangtze delta: the cities of Yangzhou, Nanjing, Suzhou, and Hangzhou. Qianlong was particularly fond of Suzhou (fig. 110), noted for its food, jade carving, and gardens. Folklore adds that he was also interested in another of Suzhou's famous attractions, its outstandingly beautiful women. Like his grandfather on earlier Southern Tours, Qianlong spent much of his time inspecting dikes, canals, and other public works while being entertained in splendid fashion by wealthy local officials and merchants. The fact that the region was by far the richest and most populous in China made this possible: certain private individuals, especially the merchants who bought and sold salt under the government monopoly, could actually afford to act as hosts to the imperial party.

An Active Emperor Slows Down

Bennet Bronson

Qianlong could not make all his tours on horseback. After he reached his sixties, his health was often too poor for him to stay in a saddle for long. Father Jean Joseph Amiot, who was writing in French and thus could afford to be more frank than his Chinese contemporaries, included several relevant anecdotes in his letters.

In 1784, just before the seventy-three-year-old emperor's Southern Tour of that year, his health seemed so poor that his highest officials knelt before him and petitioned him to cancel the tour. He insisted on going anyway, conceding only that a trusted general named Agui and one of the imperial princes could act as viceroys while he was away. Their fears for his health were somewhat eased by his plans to travel by boat along the Grand Canal. He did stay on the boat for several days. Then the viceroys received this letter:

My health, as I had foreseen, strengthens day by day. Today I wished to test my strength. I got off the boat and rode on horseback for eight li [about three-quarters of a league]. I felt wonderful after this small exercise and plan on doing it again often. Share with my nobles what I am writing to you, so as to calm their worries on my account.[2]

Qianlong seems to have recovered fully. But he could not go on riding forever. In 1789 he was ill again. Again he overrode the objections of his courtiers to risking his health on a journey, this time to Chengde. But he could no longer stay on a horse and thus agreed to go the whole distance in a covered sedan chair. It was already raining when he left Bejing. As he went on, the rain got worse and the water in low places began to rise. One by one, says Amiot, the emperor's mounted assistants, eunuchs, and officials dropped out. Eventually there was no one left except the emperor, a few officials, a handful of guards, and the emperor's valiant sedan-chair bearers. They often had to lift the poles of the chair above their heads to keep it out of the water, and at least once the water rose to the emperor's knees. They pushed on anyway and at last came to one of the imperial travel palaces. They stopped there until the floods subsided.[3]

The custom was that whenever the emperor passed through a province, he waived or reduced taxes for that year. Further, like earlier emperors back as far as the Tang dynasty (618–907), Qianlong routinely directed officials in the destination provinces to hold down expenses. But a great deal of money from private and provincial government sources was spent anyway.

The great poet, intellectual, and gourmet Yang Mei explained why this was so in a critical letter addressed to the governor-general of Jiangnan, written in 1751 after Qianlong's first Southern Tour:

When the Emperor made his tour in the South and labor was needed for building bridges and so on, the ordinary taxes were remitted. It therefore came as a surprise when a special levy on each household was instituted to pay for the preparations, particularly in view of the fact that, in the Mandate announcing the tour, the Emperor repeatedly expressed the desire that it should not be made burdensome to the people. You ignored this desire, believing that His Majesty did not mean what he said. [9]

When going to the North and Northeast, to Chengde and Shenyang, it was necessary to go by

land, on horseback, or in horse- or camel-drawn carriages. When going south, however, the imperial party had the option of traveling via the Grand Canal, which led from Beijing directly to Yangzhou and then, after crossing the Yangtze, onward to Suzhou and Hangzhou. Kangxi had always used the canal for at least part of each of his six Southern Tours. It was smoother, not much slower, and incomparably more luxurious. And yet Qianlong, until he became quite old, preferred to go on horseback (see sidebar above; fig. 111). He also seems to have made the rest of his party, including his womenfolk, go by land as well. Two possible explanations exist. One is that he was

111

Saddle with cushion, saddle blanket, and stirrups
Cloth, gilt bronze, wood, coral, iron; length 23⅝ in. (60 cm)
1736–95, Qianlong period

This set belonged to Qianlong, with the saddle blanket decorated in imperial symbols – dragons in waves and colored clouds. Like the Han Chinese, the Manchus used fiber (often silk) webbing rather than leather for saddle straps, reins, and other harness items. The velvet used on the saddle cushion and the trim had only recently begun to be made in China, by weavers in the southeastern province of Fujian.

112

The Qianlong Emperor on his First Inspection Tour to the South, Scroll 12: **Return to the Forbidden City**
Artist: Xu Yang (active in court 1751–1777), calligraphy by Yu Minzhong
Color on silk; height 27¼ in. (69 cm)
1770, Qianlong seals and poem

Here the emperor and his party return to the Forbidden City. Led by rows of riders, one bearing a yellow umbrella, the emperor's red sedan chair is about to enter the Wumen [Meridian] Gate. The empress dowager's yellow sedan chair at the end has already passed the Tiananmen Gate. The artist chose not to show the full equipment and baggage of the returned travelers. Instead he has focused on the imperial processional insignia, or *lubu*. The courtyard outside the Meridian Gate is lined with elephants, carriages, and ceremonial guards who carry fans, weapons, banners, flags, and musical instruments. A row of officials in court uniform kneels behind the ceremonial guards.

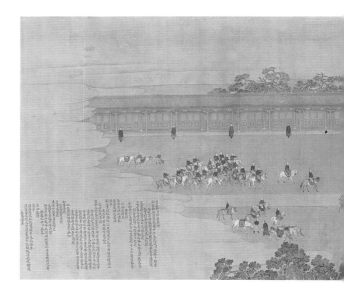

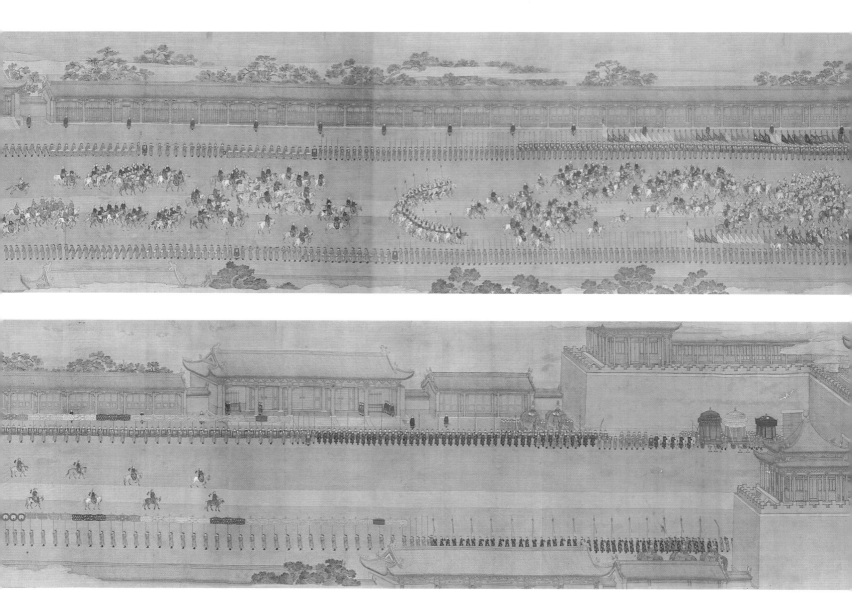

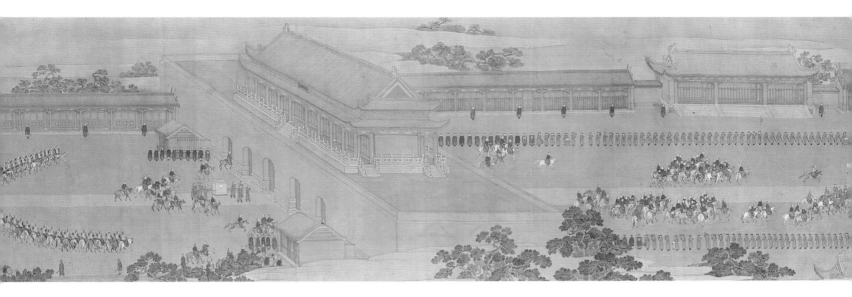

In 1792 Great Britain sent a large ambassadorial party to China. As always in relation to Asia the motive was largely commercial, spurred by the mercantile success of Dutch, Russian, and Portuguese missions during the previous century. Chosen as leader — in this capacity already called ambassador on the mission, and possible eventual ambassador in a full sense — was Sir George Macartney, aged fifty-six and experienced diplomatically in Russia, the West Indies, and India.

Macartney was instructed to negotiate for: permission to trade at Shandong ports; a warehouse at Beijing (the Russians had had one); an "unfortified island" for storing and residence near to the Yangtze mouth (the Portuguese had long possessed a factory at Macao); various measures aimed at easing business and improving merchants' comfort at Macao and Canton (the existing transit dues for shipping between these ports were a senseless anomaly); better control of exactions made on British merchants at the ports of delivery and despatch; and permission for a British ambassador to be in residence at the emperor's court.

Lamentably, the mission's very great efforts resulted in utter failure. Chinese attempts to make the visitors conform to regulations for tribute-bearers meant that repeatedly the British request for a formal business meeting was sidetracked into feasting and entertainment. The British party was simply a nuisance to the Beijing court. A list of particularized requests drawn up by Macartney was ignored, for the good reason that even before the arrival of the British party Qianlong had decreed that whatever their demands proved to be they were to be rebutted. All this was not calculated to assuage fraying British tempers, while the hosts felt equally annoyed. But Macartney admirably kept his calm.

That the mission also had non-commercial aspirations may be judged from its personnel. Sir George Staunton, an established scientist-botanist, was second-in-command; Jacobus Li, from the Chinese college at Naples, was to be the interpreter. Others included specialists in metallurgy, botany, fine art, and the making of scientific instruments and watches, Qianlong's interest in European timepieces being well known. There was also a physician, a "comptroller," a military escort, and George Staunton's remarkable twelve-year-old son, fluent in French, German, Latin, and Greek, and during the journey fast imbibing Chinese from his accompanying tutor Mr. Huttner and from Jacobus Li. How far young

yielding to the apprehensions of Palace officials who considered boat travel dangerous. The other explanation is offered by a recent historian who suggests that Qianlong was simply acting out his Manchu identity:

> The Qianlong court seized upon horseback riding as an ethnically particular (*i.e.*, Manchu) practice that simultaneously indicated and inculcated traits of martial prowess and vigor ... While on tour, the Qianlong emperor also projected horseback riding as an ethnically specific manifestation of a more universalistic (read more familiarly "Chinese") principle of administrative activism in carrying out benevolent civil governance ... A ruler on horseback stood as the central trope of a High Qing political spectacle that preserved the dynasty's "ethnic sovereignty" without undermining its broader claims to rule over a multiethnic empire.[10]

Kangxi's Southern Tours between 1684 and 1707 had been smaller in terms of the size of the tour party (perhaps one thousand men on the first tour and three hundred on the second, although the rest were large) but went to the same places and were generally similar in terms of imperial activities. As noted by one historian, Kangxi tended to do the same things on each trip: "He met with the local officials, inspected the dikes, discoursed on local conditions, talked to retired scholars, remitted taxes, pardoned criminals, tested archery, held extra examinations, rewarded his retinue and the local troops, and usually agreed to stay on another day when the people begged him to, which they nearly always did."[11] Qianlong's activities during his Southern Tours were very similar. They even included a triumphal welcome home when he arrived back in Beijing (see fig. 112).

Lest Kangxi and Qianlong should seem impossibly self-indulgent in their touring, it should be noted that neither of them ever traveled with an entourage as large as that enjoyed by contemporary Mughal and British rulers in India. In the 1840s, the Governor-General of India reportedly needed 12,000 people and 240 elephants to travel across India from Calcutta to the Punjab.[12] Two hundred years earlier, the trains of Mughal emperors such as Akbar and Shah Jehan, with greater security

Staunton coped with the Cantonese–Mandarin division is not on record, though he is frequently mentioned as interpreter. He traveled often with his father or the ambassador himself.

The main part of the British mission was accommodated, fed, and entertained mostly in halls of the Yuanming Yuan to the north of Beijing city, the party from time to time being divided in a manner that caused anguish to some members (the shifting of baggage alone was a major concern) who were thus separated from the ambassador himself and manifestly lost hope of participating at an imperial reception. The journey the main British party were prevailed upon to undertake from Beijing into Chengde – 20 miles (193 kilometers) – was seen by the Chinese as a climax of their hospitality, by the British as the most trying of their experiences (fig. 113). Meanwhile an exchange of documents had made abundantly clear that none of Macartney's points was conceded. The Chinese retorts were worded with immovable firmness but did not descend to insult.

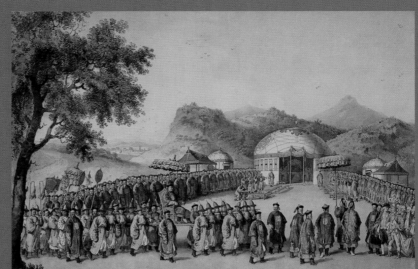

113
Qianlong meets Lord Macartney at Chengde
Artist: William Alexander (1767–1816)
Pencil, ink, and watercolor on paper

1792–94
British Library, London: 1872-2-10-4
British Atlas PIV

The artist, who was left in Beijing while Lord

Macartney and others in the British mission went on to Chengde, seems to have used a Chinese painting like fig. 101 as his model. Macartney's group is on the right.

problems and a long tradition of itinerant government, are said to have been even larger.

Martial Arts and Hunting

Like his grandfather Kangxi, Qianlong was an enthusiastic and frequent hunter. One of his motives was military training. As a Jesuit adviser to Kangxi noted, the emperor often organized great hunts involving thousands of men

> to maintain his rough militia, in peace as in war, in a perpetual movement and exercise ... By the pursuit and killing of deer, wild boar, bears, and tigers, he wanted under the banner of the hunt to provide his soldiers with a new kind of combat which would teach them how to overcome rebels and would be like a prelude to future battle, preventing the troops from softening in the leisure of peace, the pleasures of China, and luxury.[13]

Interestingly, no less an authority than Edward Gibbon picks up on the same theme in the second volume of his *History of the Decline and Fall of the Roman Empire*, published in 1781. After discussing at length the idea of military training through hunting as practiced by the Scythians, he goes on to mention Kangxi and Qianlong:

> The Jesuits Gerbillon and Verbiest followed the emperor Khamhi [Kangxi] when he hunted in Tartary ... His grandson, Kienlong [Qianlong], who unites the Tartar discipline with the laws and learning of China, describes (*Eloge de Moukden*) [*Ode to Mukden*, see sidebar p. 32] as a poet the pleasures which he had often enjoyed as a sportsman.

Another motive was Qianlong's own skill with horses and weapons and his desire to show off that skill: "When in former years I would practice mounted archery or shoot a gun at Mulan hunting ground, none of the Mongols who accompanied me for several decades was unaware of the excellence of my martial skills."[14]

The audience was large and of a kind to be impressed by an emperor who could ride and shoot. As many as thirty thousand persons sometimes

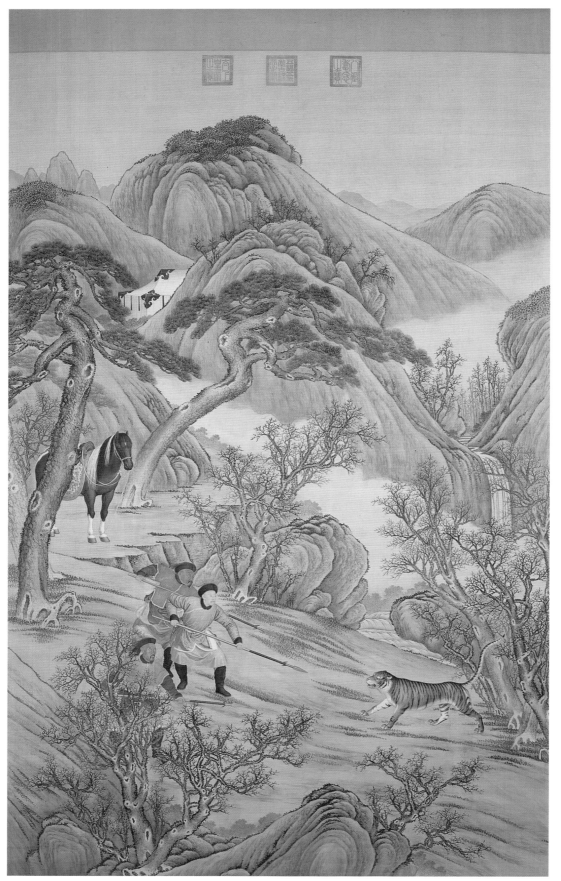

114
Emperor Qianlong Hunts a Tiger
Artist: anonymous court painter
Color on silk;
101⅝ × 67⅝ in.
(258.3 × 172 cm)
1736–95, Qianlong seals

The Manchus valued this kind of high-risk hunting and institutionalized it as a sport. Here Qianlong is assisted by a yellow-jacketed imperial guard and his assistant. There can be no doubt that the painting reflects a real incident. However, cynics may suspect that certain essential features are missing, including the platoon of sharp-shooting archers who must have been with the emperor at all times. The spears are of the traditional Manchu type shown in figs. 9–11, with short bars attached just behind the spear heads to keep them from passing through dangerous game, such as tigers.

115
Bow and arrows with emperor's bow case and quiver
Bow: wood, sinew, horn, shagreen (stingray skin); arrows: wood, iron, feathers; cases: wool(?); length 65 in. (165 cm)
1736–95, Qianlong period

The bow case and quiver, made of tough Indian or Persian cloth, are said to have been used by Qianlong personally. The bow and arrows may be later replacements. As shown in fig. 9, the emperor's actual bows and arrows were elaborately decorated.

116
Archer's thumb-rings and case
Nephrite, wooden case; height ⅞ in. (2.3 cm)
1736–95, Qianlong seals, poem, and mark

A gift of three archers' rings meant a wish for good luck in passing the three levels of the civil service examinations. Qianlong did not need such luck but, like other Central and East Asian archers, he did use a thumb-ring to draw and release the bowstring, as shown in fig. 117.

joined the annual hunts at Mulan: princes; government and Banner officials; and Mongol, Kazakh, and Uighur nobles and commoners.[15]

Qianlong may have had a third, more personal, motive as well. The season he spent as a boy with Kangxi at Mulan clearly made a deep impression on him. Partly this must have been because he did well and was praised for it (sidebar p. 111). Partly, too, it may have been because Kangxi himself was an impressive man. What eleven-year-old boy would not worship a grandfather and legendary warrior who coolly reloads his gun, steps in, kills the charging bear, and then turns with confidence to see the boy has bravely stood his ground?

When that boy grew up, he too was not immune from the need to prove his masculinity by taking seemingly foolish risks. The tiger hunt painting shown in fig. 114 is an example, where the emperor with only two companions is depicted facing a tiger armed only with a long spear. Similar exploits are part of the warrior cultures of many peoples, especially in East Africa, where groups of young men on coming of age were formerly obliged to face charging lions with no weapons except shields and spears. One should not be surprised to find that the absolute ruler of three hundred million people felt the need to prove himself in the same way. The spear in fig. 10, still in the Palace Museum's collection, was made for the emperor's use and is similar to the one in the painting.

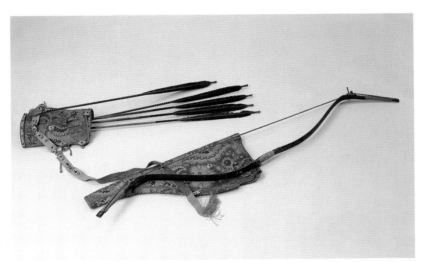

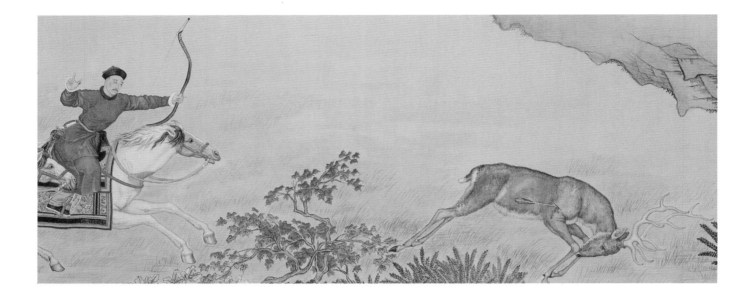

117

Taking a Stag with a Mighty Arrow
(detail of fig. 226)

Clearly intended for viewers who were experienced hunters, the painting shows that the emperor has achieved a heart shot, placing his arrow just behind the front leg to kill the stag instantly.

118

Military strength-testing bows
Wood, sinew, horn, leather; length 62½ in. (159 cm)
Beijing, nineteenth century
The Field Museum 127570

These three bows belong to a set of at least seven with graduated draw weights indicated by inscriptions, used to test candidates for military promotion.

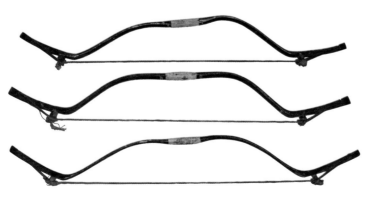

Qianlong, proud of his skill in archery, placed constant emphasis on the need for real Manchus to be able to handle a bow, both on foot and horseback. He often had himself painted shooting at game and targets (fig. 117). He had three new bows made for himself annually which with their arrows were carried in cases and quivers made, curiously, from imported Indian cloth (fig. 115). Like other serious archers, he had a collection of thumb-rings for use in drawing the bowstring (fig. 116). He personally supervised the examinations for the highest military degree, held each year in the Ziguang Ge [Pavilion of Purple Brightness] (fig. 135), in which three of the five tests involved bows and arrows: mounted archery, archery on foot, bending bows with graduated draw weights (fig. 118), lifting stones of fixed weights, and swordsmanship.[16]

All this emphasis on bows raises a problem. By the early eighteenth century, in Western eyes at least, the bow was hopelessly outdated as military armament, having long since been superseded by the gun. Guns had also come to dominate Middle Eastern and Indian warfare. Is it possible that Qianlong, a weapons expert since boyhood and the owner of many guns himself (see figs. 119, 120), did not know this?

He certainly appreciated cannon of the Western type, which had been used by Chinese armies for more than a hundred years. But what about smaller guns – muskets and pistols – that could be carried by individual soldiers? Good firearms of this sort had been available in East Asia since the mid-sixteenth century. Chinese soldiers had been on the receiving end of massed fire from Japan-made matchlock muskets when fighting Hideyoshi's troops in Korea in the 1590s. By the 1650s, flintlock muskets too must have begun to arrive in East Asia from Europe. Chinese technology of the period was well up to the task of mass-producing these, and the well-filled Chinese treasury could easily have afforded them. By the early 1700s, the Qing emperors could have been equipping entire armies with modern flintlock guns as good as those used in Britain and France. And yet we find that Qianlong's armies still outfitted their finest soldiers with bows and arrows. Why?

One possibility is that Qing notions of how to use guns, whether in hunting or in warfare, were very underdeveloped. Consider, for example, the painting shown here (fig. 121), where Qianlong kneels while

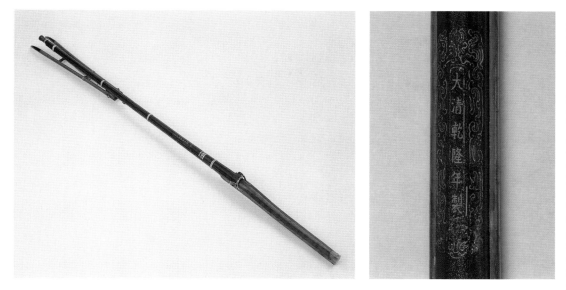

119 (far left)
Matchlock musket
Wood and steel, with gold
inlay; length 73¼ in.
(186 cm)
1736–95, Qianlong mark

Made for the emperor's
personal use, this is a fine
but – by eighteenth-century
standards – outdated
weapon. When the trigger
was pulled, a "match," a
length of fuse, came down on
a gunpowder-filled hole
which ignited the charge
behind the bullet, firing the
gun. Much less reliable than
contemporary eighteenth-
century flintlock muskets
and less accurate than
contemporary rifles, such
smooth-bore matchlock
muskets continued in
use in Tibet, Xinjiang,
and Mongolia until the
twentieth century.

120 (above left)
(detail of fig. 119)

The reign mark on the
musket reads: "Da Qing
Qianlong nianzhi" [Great
Qing Qianlong year made].

shooting at a deer with the gun butt resting on his thigh, the muzzle supported by a bipod, and his eyes a good twenty inches (fifty centimeters) above the barrel. If the emperor often fired from this position, it is a wonder he ever hit anything. Another possibility is that Qing infantry, which indeed was often equipped with matchlocks, was not valued enough to be drilled intensively in the continuous firing techniques that had proved decisive in seventeenth- and eighteenth-century European warfare.[17]

A third possibility, however, is that the preceding presumptions are wrong and that Qing mounted archers actually were superior to musket-equipped infantry when the latter were not defended by fortifications. It is conceivable that the greater rate of fire of bows as used by mounted archers (fig. 122) more than compensated for the greater range of guns in the hands of infantry. European cavalrymen of the same period were usually beaten by resolute infantry due to their lack of a stand-off weapon, which required them to charge the infantry formations head-on with frequently disastrous results. Manchu cavalrymen, by contrast, could keep moving at a distance while they poured in clouds of arrows, waiting for the infantry to break before charging home.

Hence, we should not conclude *a priori* that Qianlong and his commanders were ignorantly conservative in their enthusiasm for the bow, as shown by imperially commissioned portraits of noted soldiers, who are almost always depicted as archers

(fig. 123). The commanders may have been quite right. The powerful Inner Asian recurved bow may still have been a practical weapon in the age of firearms, so long as enough cavalrymen could be trained in the difficult art of shooting arrows accurately from horseback. However, this can only have been the case until the mid-nineteenth century.

121
Qianlong Shooting a Stag with a Musket
(detail of fig. 83)

The emperor as a young man shoots at a deer with his gun resting on his knee and on a bipod under the barrel.

Manchus and Tigers and Bears

Mark C. Elliott

Beginning in 1742, and for nearly every year of his reign thereafter, the Qianlong emperor left Beijing to spend a month at the summer retreat at Chengde, during which time he visited the hunting preserve at Mulan, a day's ride further north. He was accompanied by his family, including women and children, as well as by a skeleton crew of courtiers and officials. Specially selected soldiers from the Manchu and Mongol Eight Banners joined, too, for the grand *battue* hunts in late summer. Mulan then was a wilderness, with but one or two simple structures near the southern entrance. Visitors here lived *al fresco*, spending the days in the pursuit of game and dismounting in the evenings to enjoy campfire cooking and a good night's rest in their tents. This was a style of life that Manchus living in the forests of China's northeastern frontier had known for generations before the rise of the Qing state, and it was one that Qianlong's grandfather, the Kangxi emperor, had adored.

Qianlong made sure that his dedication to maintaining the Manchu "family tradition" of hunting was well documented, as in hunt paintings such as fig. 114, of himself and two companions about to spear a tiger. The sheer abundance of hunting images from the Qianlong reign, almost all of them set in Mulan, suggests, however, that the emperor was interested as much in politics as in hunting. The hunt, after all, was a kind of military exercise and the elaborate drill of the *battue* helped prove that the conquering Manchus retained their edge even after long years of residence in China. Hunts also provided an opportunity for camaraderie with the Qing court's Inner Asian subjects and allies, who were regularly invited to join in the festivities. Not least, the rustic but dramatic settings of the hunt showcased the emperor's personal bravery, allowing him to demonstrate his practice of the "manly virtues" deemed vital to upholding Manchu traditions. Thanks to the skills of Qianlong's court artists, those of us who could not be present at the occasion can still glimpse this aspect of the vitality of Qing rule.

Qianlong's passion for the hunt was personal as well as political. It was Kangxi who, in 1722, had taken him on his first hunt. Qianlong, then about eleven years old and still known by his personal name, Hongli, had spent the summer that year at Chengde at his grandfather's side, dividing his time between calligraphy practice and target practice. Under the circumstances, it was only natural that Kangxi included him on a hunting trip up to Mulan. One fateful morning the party came upon a bear. The emperor felled the animal with a single musket shot and then instructed his grandson to finish off the wounded creature, planning in that way to allow the boy to take credit for the kill. Qianlong began to approach more closely when the bear reared up and – according to legend – charged him directly. Disaster was averted when Kangxi hastily fired again and dispatched the bear for good. Turning to check on his grandson, he found him still sitting on his horse, unfazed and unharmed. In camp that night Kangxi reportedly observed, "Good fortune is certainly with that boy." After Qianlong became emperor, many would cite this anecdote as evidence that he was destined to rule.

Mounted archers did not stand a chance after that, when rapid-fire pistols and breech-loading rifles began to appear in the hands of ordinary foot-soldiers. It was at that point that Manchu military conservatism began to seem tragically pig-headed. As late as the 1890s, foreign observers were mystified to see that Qing commanders issued modern firearms to Han Chinese units while élite Manchu units still were using bows.[18]

Swords continued to be employed in Chinese warfare until well into the twentieth century. In Qianlong's day, they seem to have been the prescribed weapon for imperial guards, who judging from paintings of imperial ceremonies, were never allowed to carry bows (see, for example, fig. 101). It is not clear whether Qianlong himself received training in fencing methods as taught by the various martial arts schools, but he definitely had a strong interest in swords. A good many of those made for Qianlong himself were traditional Chinese longswords with double-edged straight blades; examples are shown in figs. 124 and 132. One has an inscription on the blade

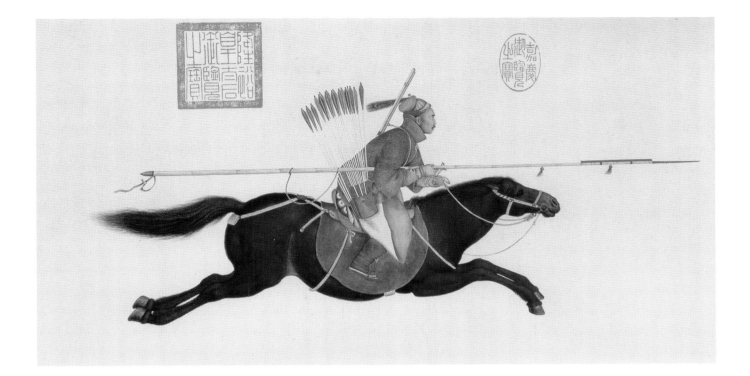

giving its name, "Bright Moon" (fig. 126), as well as its original eighteenth-century Palace inventory tag (fig. 125). Single-edged straight swords of the kind used widely in China and Tibet in the nineteenth and twentieth centuries seem not to have been employed by the emperor, and the same is true of rapier-type swords like those used by Europeans. He also used few or no Japanese swords, even though those had long been admired in China.

On the other hand, the emperor appears to have been quite fond of non-traditional curved sabers of the Indian and Middle Eastern type, often furnished with jade hilts carved in the Indian Mughal style. Some were imitations made in the imperial armory in Beijing. Examples include the dagger shown in fig. 129 and the sabers shown in figs. 127 and 130. The last have blades with Qianlong period dates as well as names in *kuftgari* inlay; one is named "Frost Clear" (fig. 128) and the other "Virtuous Dominance" (fig. 131). It seems very probable that the blades of both were made in China, although the hilt that bears elaborate gold inlay looks like imported Mughal work. The sheaths of all are Chinese work as well. Qianlong did possess Mughal-type swords that were actually from India: Lord Macartney included one (with an Indian hilt and an English blade) among the gifts presented to Qianlong in connection with the British diplomatic mission of 1792.[19]

Unlike Kangxi, Qianlong never went on campaigns himself, although he took a deep interest in military affairs. The superb helmet and suit of armor shown here (figs. 133, 134) were used for reviews of his armies, not for combat. An interesting example of a military review combined with entertainment is the demonstration by troops on ice skates that took place regularly on Zhongnan hai Lake, next to the Pavilion of Purple Brightness. In the painting reproduced here, the emperor, invisible in a covered sled, is surrounded by guards and military officers while watching archers skate by and shoot at targets (fig. 137).

The Pavilion of Purple Brightness, or Ziguang Ge, sometimes called the Hall of Military Valor, was in a

122
Detail of *Ayusi Assailing the Rebels with a Lance*
Artist: Giuseppe Castiglione (1688–1766)
Ink and color on paper;
10⅝ × 41 in.
(27.1 × 104.4 cm)
c. 1755
National Palace Museum, Taipei, 01.11.01099

A hero of the Xinjiang campaigns of the 1750s, Ayusi, a Kalmuk Mongol, is shown with his horse at a flying gallop, armed with a lance, bow, and gun. The Jiaqing emperor (reign 1796–1820) and Empress Dowager Longyu (son's reign 1909–11) left their seals on this painting; Qianlong did not.

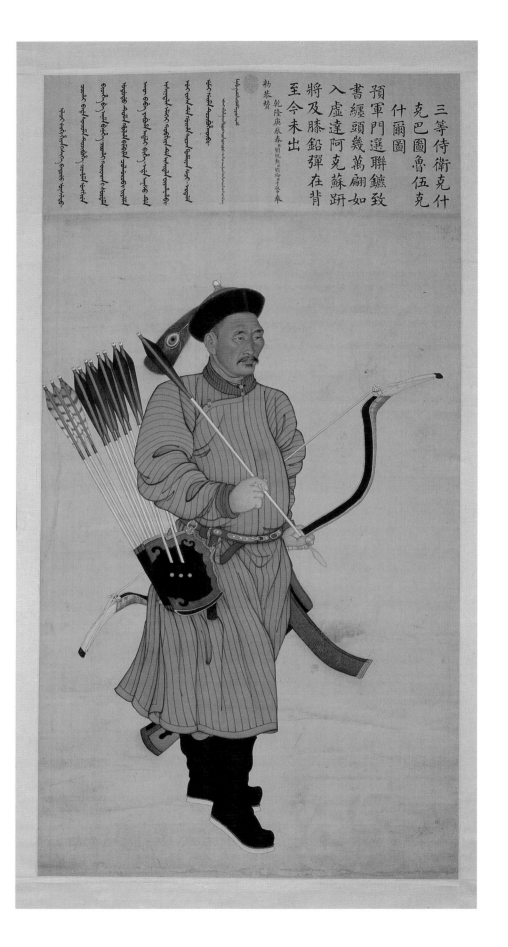

三等侍衛克什
克巴圖魯伍克
什爾圖
預軍門選聯鑣致
書纏頭幾萬翩如
入虛達阿克蘇跰
將及膝鉛彈在背
至今未出

勅恭贊

乾隆庚辰春劉統勳劉綸于敏中奉

123
Portrait of the Imperial Guard Uksiltu
Artist: anonymous court painter with text by Liu Tongxun (1700–1773), Liu Lun (1711–1773), and Yu Minzhong (1714–1780)
Color on silk; width 38 in. (96.5 cm)
1760, Qianlong seal
Collection of Dora Wong, New York

An imperially commissioned painting of a noted soldier, number twenty-nine in a set of one hundred portraits of military officials credited with the pacification of the far western province of Xinjiang. The portraits were formerly displayed in Qianlong's military hall of fame, Ziguang Ge [Pavilion of Purple Brightness], near the Forbidden City. Uksiltu is presented as primarily an archer. His bow case and quiver, along with his sword, hang from his belt. The Manchu and Chinese text praises Uksiltu's bravery in battle, noting that he still had a bullet lodged in his back.

124
Straight sword called "Bright Moon"
Steel, iron fittings with gold inlay, red stingray skin-covered wooden scabbard; length 39 in. (99 cm)
1757, Qianlong mark

Another sword used by Qianlong. In 1748 Qianlong ordered thirty "standard" straight swords, which were delivered in 1757, after many changes in designs and details. Bright Moon [Yingyue] was one of these. The scabbard is of red-stained stingray skin or shagreen, a material that in both China and Europe was usually stained green. The novel color pleased Qianlong, who called it "red child skin."

125 (left)
(detail of fig. 124)

A Palace inventory label in Chinese and Manchu, as used by the Imperial Household Department in the eighteenth century. The Chinese part of the label reads "Ren No. 3, Yingyue sword, weight 27 *liang* [ounces], made in the Qianlong era."

126 (right)
(detail of fig. 124)

The inscriptions in three-colored (red gold, yellow gold, and silver) inlay read "Ren No. 3" [third of the third series] and "Yingyue," with a frontal dragon below. On the other side is an inlay of a swordsman drawing a circle with his sword, facing the full moon.

127
Saber called "Frost Clear"
Steel blade with jade hilt, patterned peach tree bark scabbard with gold-inlaid iron fittings, and woven lanyard and slings; length 37¾ in. (96 cm)
1757, Qianlong mark

Qianlong ordered a total of sixty ceremonial curved swords on five occasions, in 1748, 1757, 1779, 1793, and 1795. Each sword was named and numbered, and all were identical in length, weight, and basic design. The scabbards were made either of red or green stingray skin or of patterned bark. The swords differed in terms of their inlaid details and the style of the hilts. Hilts made after completion of the 1757 batch were mostly in Mughal style, often with gold and inlaid gems. Although Frost Clear [Shuangming] was one of the first sabers to be completed in 1757, the Mughal style of its hilt suggests that it was refitted later.

128
(detail of fig. 127)

Both sides of the blade near the hilt are inlaid with yellow gold, red gold, and silver wire decoration according to Qianlong's orders. These include three inscriptions: Qianlong's reign mark, a series number ("Tian No. 18" – the 18th of the first series), and the sword's name. (See also figs. 126, 131.)

129
Knife in Mughal style
Steel blade, jade hilt, leather sheath, gilded iron fittings; length 17⅞ in. (44 cm)
1736–95, Qianlong period

The knife is presumably for skinning and cutting up game but is of an unusual size and shape by Chinese standards. The hilt and blade may well be from India, fitted with a Chinese sheath.

130

Saber called "Virtuous Dominance"

Steel blade with jade hilt inlaid with gold and gems, and a patterned peach tree bark scabbard with gold-inlaid iron fittings, and woven lanyard and slings; length 38¼ in. (97 cm) 1795, Qianlong mark

One of the ten swords ordered by Qianlong in 1795. The jade handle is shaped and decorated in the Indian Mughal style.

131

(detail of fig. 130)

The yellow gold, red gold, and silver inlaid designs on the upper part of the blade include three inscriptions: Qianlong's reign mark, a series number ("Di No. 27" – the 27th of the second series), and the name of the sword.

132

Straight sword

Steel, nephrite, precious stones, leathered-covered wooden sheath with gilded iron fittings; length 28¾ in. (73 cm)

One of Qianlong's personal swords. The blade is in a traditional Chinese shape while the hilt is Indian in design and perhaps in origin (see also fig. 311).

133
Imperial parade helmet in box
Black lacquered leather, cloth, gold, and pearls; height 12⅝ in. (32 cm)
1736–95, Qianlong period

The box disassembles in an ingenious way to allow the helmet to be put in and taken out without damage. The helmet is for military ceremonies, not for battle: although the leather top might be hard enough to deflect a sword, the cheek and neck pieces are of cloth without the embedded metal plates of Chinese fighting armor. Beginning with Kangxi, emperors' helmets had three or four horizontal rows of Buddhist texts written in Tibetan script. The texts may have had a protective function.

sense the symbolic military center of the Qing empire (fig. 135). It was there that major military service examinations and inter-unit shooting and martial art competitions were held, as well as regular banquets for Mongolian princes and minority dignitaries. One such banquet had 180 guests, who were served 45 sheep and 40 jars of wine.

Qianlong furnished a number of rooms in the Pavilion of Purple Brightness with paintings of soldiers and battles, maps, inscriptions by him marking important military events, and trophy weapons with the names of the enemies who had used them. Although located within a restricted imperial enclave, the exhibits at the Pavilion were open for viewing by selected army officers, including Mongol leaders, during the banquets held there for the Lantern Festival of each year. This made the Pavilion the first military museum in China and yet another of the media through which imperial ideas and images, including pictures of the emperor himself, were disseminated to a wider public.[20]

As one might expect, the military successes of the imperial armies were given wide publicity elsewhere

in China. Professional soldiers may have been the only ones to have access to the Pavilion's images and inscriptions, but the public in most parts of the country could view commemorative military art objects sponsored by the central government and by local officials seeking to please the emperor. An example is shown here, a rubbing of a stone set up in a temple in Xian, western China, commemorating an imperial victory over Red Miao tribesmen (fig. 136).

It is unclear whether Qianlong promoted his image as a strategist and soldier to the wider civilian population. Most citizens must have viewed him, if at all, either through brief glimpses during tours and hunts or through his many writings that were distributed beyond the Palace walls. All citizens must have known of him. All except those in recently conquered outer territories must have valued the peace and prosperity he brought for so long to the Chinese heartland, even as it chafed under the imperial Manchu yoke.

134
Imperial parade armor and helmet
Steel with lining of silk and silk floss; jacket length 28¾ in. (73 cm)
c. 1761, Qianlong mark

An extraordinary technical feat, this suit of armor is made of 600,000 tiny steel plates with rounded outer surfaces. The armorers of the emperor, based in the Hangzhou Imperial Textile Factory, had trouble giving the steel the colors desired by the emperor (gold, silver, copper, and black) and beginning in 1758 had to undertake an extensive testing program before they arrived at a coloring method that remained stable when exposed to the weather. The final suit, finished in the early 1760s, consisted of twelve pieces and weighed 33 pounds (15 kilograms). The helmet is quite similar to the one shown in fig. 133. It still has its finial, however, decorated with very large pearls, gold, and hanging strips of red silk-backed sable fur.

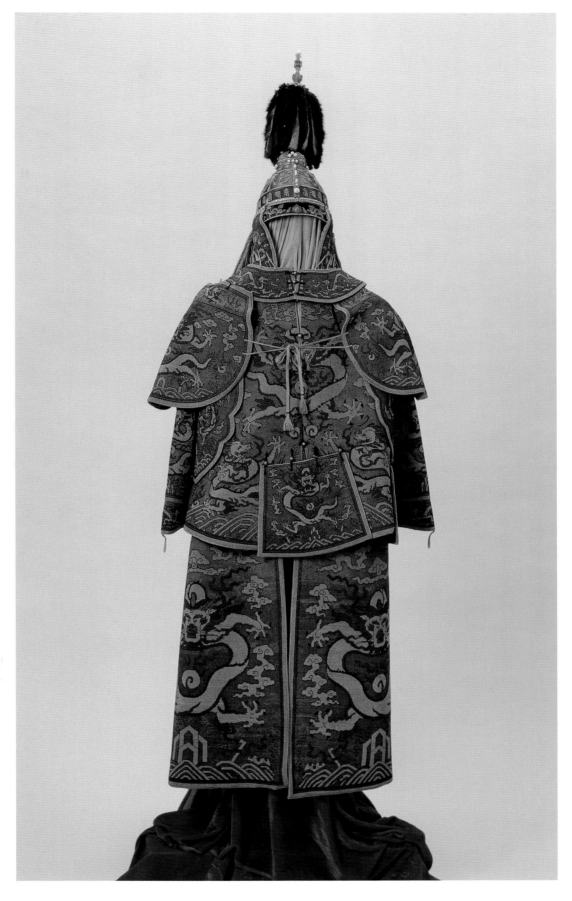

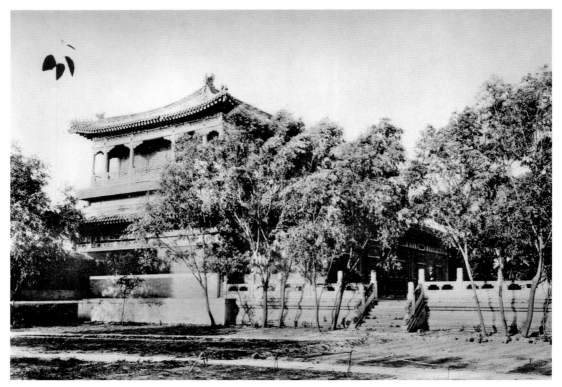

135
The Pavilion of Purple Brightness [Ziguang Ge]
Photographer: Osvald Siren (1879–1966)
c. 1920

Also called the Hall of Military Valor. Regular feasts to honor victories and successful soldiers were held here as well as ice-skating contests and exhibits of military paintings, including the portraits of Ayusi and Uksiltu (see figs. 122, 123).

136
Rubbing: Submission of the Red Miao
Ink on paper;
height 34¼ in. (87 cm)
1740
The Field Museum 245119

Cut in stone at a temple in Xian, this was intended to publicize the success of the national army in subduing groups of rebellious tribesmen in a mountainous part of the southwestern provinces. The defeated tribesmen may be seen at the top, on their knees in front of their igloo-like dwellings.

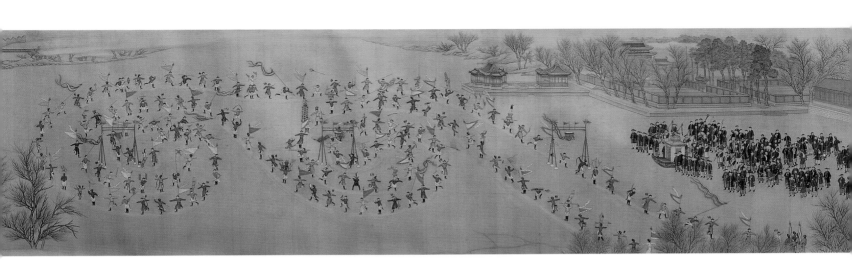

Notes

1. Qinggui *et al.* 1965, *juan* 59, p. 1933.

2. Crossley 1997, p. 128.

3. Wang Chaosheng (ed.), *Farming and Weaving Pictures in Ancient China*, Beijing 1995.

4. Bartlett 1991, pp. 137–99.

5. Much of the data in this section comes from Tie 1991, and Tang and Luo 1994.

6. Wechsler 1985, p. 169.

7. See also Nei 1999, p. 255.

8. Naquin 2000, p. 314.

9. Waley 1970, p. 57.

10. Michael Chang, "A Ruler on Horseback: The Southern Tours and the Historical Transformation of High Qing Ethno-Dynastic Authority," paper presented at the Sixth Asian Studies Conference, Sophia University, Tokyo, June 22–23, 2002.

11. Jonathan Spence, *Ts'ao Yin and the K'ang-hsi Emperor*, New Haven CT 1996, p. 133.

12. Emily Eden, *Up the Country*, Oxford 1930, p. 131. Emily Eden was the governor-general's sister.

13. Ferdinand Verbiest, quoted in Wakeman 1985, p. 1041.

14. Rawski 1998, p. 46.

15. *Ibid.*, p. 21.

16. Wu 1987, p. 13; Qinggui *et al.* 1965.

17. The military formations diagramed in Amiot (1782, no. 7, p. 319 ff.) show that Qing tacticians were aware of the importance of firepower and mutual support by combined arms.

18. John Ross, *The Manchus*, London 1891, p. 624.

19. Illustrated in National Museum of Chinese History, *Exhibition of Chinese History*, Beijing 1998, p. 180.

20. Much of the data in the preceding two paragraphs comes from Wu 1987a, Wu 1987b, and Naquin 2000, p. 311.

Sidebar notes

1. Feng Zuozhe, *Heshen mishi, tanwu zhiwang* [King of corruption – Heshen's secrets], Changchun 1989; DQSL(RZ) 1904, *juan* 3, pp. 378–85; Torbert 1977, pp. 115–17; Bartlett 1991, p. 234.

2. Amiot 1788, XI, p. 585.

3. Amiot 1791, XV, pp. 387–92.

137
An Ice Game
Artist: Yao Wenhan
(active in court after 1743)
and Zhang Weibang
(active in court after 1723)
Color on silk;
height 13¾ in. (35 cm)
1740s–60s, Qianlong seals
and poem

Here, about half of the full scroll is shown. Ice skating on the lake just west of the Forbidden City was a regular winter entertainment. Qianlong, invisible in his covered sled, watches as skaters representing the different Banners compete in acrobatics and archery. An almost identical painting exists by Jin Kun, another court painter of the Qianlong period. (See also figs. 20, 46.)

CHAPTER IV

*Religions of the Qianlong
Court*

CHAPTER IV
Religions of the Qianlong Court

Introduction: Public and Private Faiths

As befitted a universal monarch at the center of the world, Qianlong lent his support to a variety of religions. He paid the expenses of a few Christian priests and of the places where they lived and worshiped. He also contributed to the building of a few Islamic mosques. With somewhat more enthusiasm, he supported Daoist and Chinese Buddhist temples. He made magnificent donations to Confucian shrines and to tombs and shrines of the imperial ancestors. He maintained the buildings and altars that housed the so-called State Religion, the worship of impersonal Heaven. He supported Manchu shamanic shrines and the rituals that took place in them. And in the case of the Tibetan–Mongolian brand of Tantric Buddhism, which he believed in personally and which was also of great political importance to the Qing, he kept his purse wide open, founding numerous well-endowed temples and monasteries.

Total expenditure on religious activities cannot be quantified but was very large. In Beijing alone, sixty-three Inner City temples received imperial patronage before 1800, along with eighteen in the Outer City and many more in the suburbs, mainly in the imperial gardens.[1] One historian estimates that the regular annual religious expenses of the Neiwufu, the Imperial Household Department, came to at least fifteen thousand ounces of silver.[2] This does not count capital expenses for construction, which for Tibetan Buddhist temples alone must have exceeded fifteen thousand ounces of silver in most years. In addition, there were

a total of fifty state ritual temples in the Beijing area (fig. 139), all supported by the Ministry of Rites rather than directly by the emperor through the Neiwufu.

Between them, Kangxi, Yongzheng, and Qianlong founded fifty-seven temples in Beijing. Twenty-five of these were Tibetan Buddhist, twenty were shrines to special individuals, and the others were dedicated mostly to the State Religion.[3] Donations for maintaining religious structures were spread more widely. In Beijing and its outskirts, Qianlong supported temples for Guanyin [the Goddess of Mercy], Guandi [the God of War], Bixia Yuanjun [the Lady of the Azure Clouds], Zhenwu [the North God], Dongyue [the Great Emperor of the Eastern Peak], fire gods, dragon-kings, and assorted Buddhas, as well as at least one mosque. The level of his support for these various religions depended to some extent on the degree of his participation in them. He had no personal involvement in Christianity or Islam. In the case of shamanism, Han Buddhism, Confucianism, and Daoism, he attended rituals and made sacrifices on appropriate occasions. In the case of Tibetan Buddhism and the State Religion (see pp. 154–56), he was not only a dominant financial supporter but also an officiant.

The point of all this conspicuous religiosity was, as one might expect, to reinforce the emperor's image as a devout and worthy ruler in the eyes of his various publics: the old Han élite, for whom Confucianism and details of the State Religion still had great importance; the new Manchu élite, who Qianlong hoped would re-adopt shamanism as a strengthener of ethnic

identity; Han and Manchu commoners, who liked to hear that their emperor shared their devotion to popular Daoist and Buddhist deities as well as their firm belief in such disaster-controlling spirits as dragon-kings; and his turbulent Mongolian and Tibetan subjects, who might be more easily controlled by the word of an incarnate Tibetan Buddhist lama than by regiments of heavily armed cavalrymen. Qianlong also had a private agenda. He believed deeply in the Tibetan form of Buddhism. Although wisely he did not try to force his faith on his subjects, it mattered to him greatly – perhaps even more than the other central focuses of his life: family, hunting, art, and power.

Shamanism

On the morning of New Year's Day in 1741, the thirty-one-year-old emperor got up early to perform three important rituals. First, he went to the Hall for Worship of Ancestors [Fengxian Dian] in the Palace, to pay homage to preceding emperors. Second, accompanied by princes of the imperial family, he left the Palace proper and went to the eastern quarter of the city, where the shamanic shrine, the Tangse, was located. There he led the princes and Manchu officials in sacrificing to Heaven and, again, his imperial ancestors. Third, Qianlong returned to the Palace to pay homage to his mother.[4] With these rituals accomplished, he had given recognition to the three kinds of beings superior to himself. Now he was free to step inside the imposing Hall of Supreme Harmony, or

Square dots: State Religion sites
Round dots: Buddhist and Daoist sites

Taihe Dian, the largest single building in the Forbidden City and used only for grand ceremonies, to receive greetings from his officials.

Those officials too, whether Manchu, Mongol, or Han, had probably made offerings to their ancestors that morning. However, only the Manchu officials would have also have performed ceremonies at

139
Map showing major religious sites in eighteenth-century Beijing

140
Nanai shaman and assistant
Photographer: William
Henry Jackson (1843–1942)
Lantern slide
1895
Library of Congress,
Washington, D.C.

Of special interest are the
large tambourine-like
drums being played by
both individuals. A similar
drum was among the
instruments played at
shamanic ceremonies in
the Forbidden City (see fig. 145).

shamanic shrines in their homes or, if high-ranking enough, at the Tangse. To Han Chinese and other ethnic groups, these shrines were forbidden and the subject of unnerving legends. To Qing rulers, the shrines embodied Manchu identity.

Shamanism was indigenous to Northeast Asia. It was the chief religion of the Tungusic-speaking peoples of the region, including the Jurchen. In fact, the English word "shaman" is usually accepted as originally a Tungusic term. The essential features of developed shamanism – communication with spirits through trances, ritual dancing, exorcism and healing ceremonies, spells, and practitioners credentialed through revelation or apprenticeship rather than by a formally constituted church – must have been familiar to all

Manchus before the Conquest. Although after the Conquest they were secretive about the full range of their shamanic practices, there can be little doubt that ordinary Manchus in need of supernatural advice sometimes had recourse to female and male shamans of the old school, with wild hair, flat drums, mirror- and bell-covered costumes, and skill in entering a trance state. This is the version of Northeast Asian shamanism that is sometimes called "primitive" or, following Chinese usage, "wild" shamanism (fig. 140).

The Manchu government-approved version of the religion had for long worn a more decorous, domestic aspect. The Qing emperors were evidently uneasy with the wilder forms of the religion even while, especially under Qianlong, they embraced it as an exclusive badge of Manchu-ness.[5] Moreover, rituals varied among different clans and even households. The solution was to standardize the rites. Qianlong assembled a research team to conduct surveys and to collect written and oral material. After a decade of exhaustive ethnographic work, the team produced a standard reference manual for shamanic ritual.[6] With a preface by Qianlong himself, the Manchu version of the manual appeared in 1747 and the Chinese version in 1780.

In accordance with imperial instructions, Banner families built shamanic shrines in their homes, where they offered sacrificial food at altars on which portraits of their ancestors were displayed. Since the offerings had to be made twice daily,[7] we may assume that Manchu commoners and middle-class officials, unlike the emperor, could not afford to slaughter a

black pig nearly that often. Ordinary rituals must therefore have relied more on grains and pastries, and used less expensive animals, such as chicken or sheep, for sacrifice on the equinox or solstice days.[8] The similarity to Han ceremonies was increased by the Manchu habit of including several Daoist deities among those to whom sacrifices were offered. Guandi, the God of War and exemplar of all soldierly virtues, was one such Daoist deity. Another was Niang-niang, who may be identical with the Lady of the Azure Clouds, the Daoist patron of safe child-birth[9] (see sidebar p. 54 and p. 127). Other rituals at household shrines were dedicated to Buddhist deities, Heaven and Earth, various Manchu and Mongolian gods, and horse and smallpox spirits.

In Qianlong's Palace, shamanic rituals that had formerly been the duty of imperial wives were conducted by women specially chosen from among the wives of high-ranking members of the upper three banners. The only imperial shrine that still had male shamans was the one in the old palace in Shenyang.[10] As far as is known, the Inner Court shamans of the Qianlong period did not have training in the ecstatic side of shamanism. Their role was to preside over the daily offerings in the imperial family's private shamanic shrine in the Forbidden City, the Kunning Gong [Mansion of Earthly Tranquility] (fig. 141).[11] The morning offerings were made first to images of three Han Chinese deities on the west altar platform and then to three *weceku*, traditional Manchu deities, on the north altar platform.[12] Whether the *weceku* were represented by images is not clear. Interestingly, two of the Han Chinese deities, Shakyamuni and Guanyin, were Buddhist, while the third, Guandi, was Daoist.

The evening offerings in the Kunning Gong featured other deities. Two are shown here: spirits of

141

Interior of the Mansion of Earthly Tranquility

Remodeled after a structure in the Shenyang palace, this former Ming empress's residence in the Forbidden City, the Kunning Gong mansion, was outfitted by the Qing for daily shamanic rituals. In line with Manchu tradition, the shrine was simply furnished. The tall cabinet at the western end housed images for morning offerings. The emperor's seat was set against the window, facing north where the images of the evening deities were installed.

142
Pair of shamanic deities
Cloth with stuffing; height
47¼ in. (120 cm)
Eighteenth century or earlier

These male and female
images of deities, perhaps
called Kedun Nuoyan ,
received sacrifices from
shamans every evening at
the Kunning Gong mansion.
These particular deities are
said to have been introduced
early in Qing history by a
consort of Mongolian origin.
Although not made to awe,
the images were thought to
have great spiritual power.

uncertain origin who in the form of large floppy cloth-covered figures had become part of the regular imperial Manchu shamanic ritual (fig. 142).[13] One theory is that they were Mongolian deities, brought to the Manchu imperial family by Mongolian brides.[14] They were originally placed on a black lacquered seat on the northern platform inside the Kunning Gong, and referred to in Manchu as "Kedun Nuoyan," the meaning of which is unclear.[15]

An even more complex example of cultural syncretism was the worship of a group of seven female deities in a painting that formed the main focus of the evening ceremonies. The Palace Museum in Beijing has three such paintings, each with some variations. Two are shown here (figs. 143, 144). Discussed in a separate sidebar (p. 159), these deities are of interest because they were, first, centrally important to the ritual and, second, female rather than male.

Women shamans were in charge at both the morning and evening sacrifices in the Kunning Gong. Females led the rituals even when the emperor was present.[16] Up to thirty assistants (all eunuchs) did the slaughtering, cooking, and displaying of the prescribed black pigs while twenty others prepared the grains and wines.[17] On some occasions the emperor may have carved and served the sacrificial meat himself, as described by Prince Zhaolian.[18] The emperor was also supposed personally to raise the spirit pole on which the sacrificed pig's intestines had been placed as food for magpies or crows.[19] One doubts that many rulers were enthusiastic about this messy phase of the

ceremony, but Qianlong, ever conscious of the need to set an example, probably sometimes did it himself. During and after the offerings and the ritual meal of pork, the shaman beat a flat drum and danced, wearing metal bells, to music played on specially decorated stringed instruments (fig. 145). The drum and the bells were ancient types of shamanic equipment, used by shamans of most Tungusic tribes.

The boiled and unseasoned pork served during the ceremony may not have been bad eating, being freshly cooked and from a freshly killed animal. But this was not always so. In 1732, during the reign of Yongzheng, it came to light that the eunuchs in charge of procurement either had been switching the fresh-killed pork with older meat or had been using only undesirable cuts for the offerings:

The Emperor has issued the following decree, that sacrificial meat in the Kunning Gong has been rather untasty. He previously commented that sacrificial meat offered to the Spirits was important and should be treated with respect and dedication ... [Yet] the Zhangjing group has been too unconcerned, not being mindful and paying no attention to the taste of the meat. They have ganged up with Ah Musun, the eunuch in charge, to steal the meat for sale and caused the problem as it is. Now I have given orders to the Head Eunuch, Ah Tai, to investigate the situation. From now on, if the sacrificial meat is still as tasteless as before, or is being stolen for sale, Ah Tai will be given 40 strokes of the cane and penalized

143, 144

Paintings of shamanic goddesses

Ink and color on silk;
31½ × 32½ in. (80 × 82 cm)
Eighteenth century or earlier

The central deity in both paintings resembles the Daoist goddess Bixia Yuanjun [the Lady of the Azure Clouds] but the settings have many shamanic features. In the painting in fig. 143 (top), the seven ladies may represent the ancient Manchu Seven Stars. Two sacred magpies are flying toward them from either side of the draperies. The two male musicians in the foreground, dressed in Manchu court outfits, play a shamanic drum and cymbals. In the painting in fig. 144 (bottom), the dominant central female deity is flanked by four servants, two of them women dressed as men. A pair of lesser deities stands next to the sacrificial altar in front. (See also p. 159.)

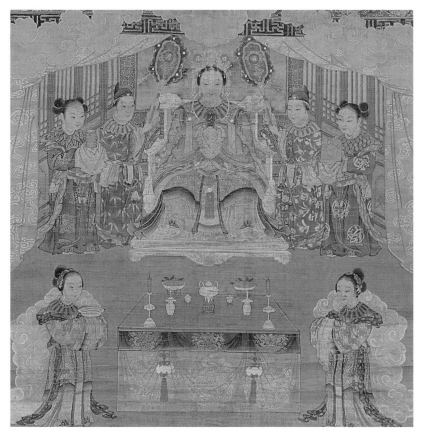

Shamanic musical instruments

Wood, leather, metal; length of longer stringed instrument 49 in. (117 cm) Eighteenth century or later

Shown here are a flat drum on a stand, a *pipa* stringed instrument with lacquer paintings of the Eight Buddhist Emblems, a three-stringed *sanxian* instrument with similar paintings, and a belt hung with bells. The shaman wore the bells and played a hand drum during the evening sacrifice dance. Eunuchs or male members of the imperial clan played the drum-on-stand during the dance, and the stringed instruments while the shaman was making wine offerings.

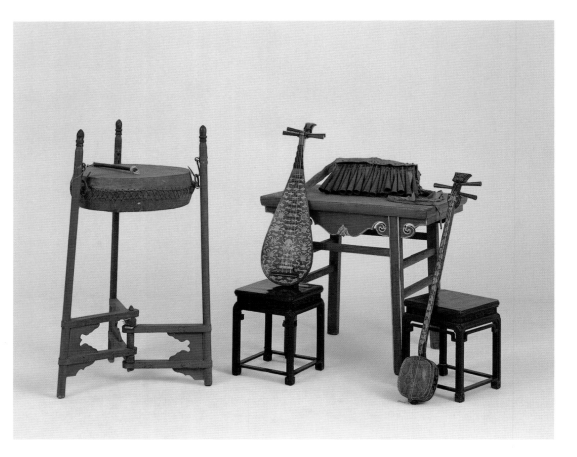

seriously. Ah Musun and his group will be treated severely too.[20]

The abuse proved to be deep-rooted. In 1787 Qianlong in turn became aware of the problem. He issued this decree:

> According to the traditions of the Manchus, the sacrificial meat after the evening ceremony is to be distributed by the imperial kitchen. The meat from the morning offering may not be taken out of the palace. ... Participating officials and guards are wrong in thinking that it is their privilege [to take a share of the meat]. Worse still are eunuchs who secretly hide the good meat and distribute ordinary meat instead. They really should be severely chastised.[21]

Buddhism

As we noted in the introduction to this chapter, Qianlong mainly confined his Buddhist religious gifts to institutions and projects associated with the Tibetan ("Lamaist," or Vajrayana) version of that religion. Through the Neiwufu, or Imperial Household Department, he made annual contributions to a few Chinese (conventional Mahayana) Buddhist monasteries in the Beijing area. He also showed an interest in several famous Chinese Buddhist temples in the Yangtze delta area during his Southern Tours. However, in terms of religious effort, his personal and political focus was on Tibetan Buddhism.

Out of piety and for reasons of state, Qianlong turned Beijing, Chengde, and Mount Wutai in Shanxi, all within China proper, into major Tibetan Buddhist centers by initiating and financing the construction of numerous monasteries of the dominant Gelugpa sect. He personally wrote lintel inscriptions and foundation tablets for these edifices. He also offered support to Tibetan Buddhist religious entities in other parts of China, especially in Mongolia, eastern Xinjiang and Qinghai provinces, and Tibet itself. One of the paintings shown in this book is evidence of that support: a thangka depicting Qianlong as the Buddhist deity Manjushri, donated by him to the Panchen Lama's home monastery in southern Tibet (fig. 146).

For motives that must have been mainly personal, Qianlong also built numerous Tibetan Buddhist

The Qianlong Emperor as Bodhisattva
Terese Tse Bartholomew

A special type of painting produced during the Qianlong period was the depiction of the Qianlong emperor as an incarnation of the Bodhisattva Manjushri.[1] These unusual works have no precedent in the history of Chinese art. They are in fact based upon the religious paintings (*thangkas*) of Tibet, specifically the lineage paintings of the Gelugpa, one of the four orders of Tibetan Buddhism and the one favored by the Qing dynasty emperors (fig. 146).

These paintings – seven of which have been found so far[2] – all show the Qianlong emperor dressed as a monk, with his right hand raised in the gesture of religious discussion (*vitarka mudra*) and his left hand holding a wheel. The lotus blossoms issuing from his hands support a sword and a book at shoulder height. The sword that cleaves the clouds of ignorance and the Book of Wisdom are symbols of Manjushri, the Bodhisattva of Wisdom; their presence indicates that the Qianlong emperor was being represented as an incarnation of Manjushri. The wheel in his left hand symbolizes him as the Universal Monarch.[3]

In these paintings the emperor is seated on an elaborate throne in a blue-green landscape and surrounded by cloud-borne deities. Above him are Buddhas and bodhisattvas, famous teachers, and gods

of Tantric Buddhism. In the center are the major figures of Buddhist history past and present, with the emperor placed strategically in the center. Below him are goddesses, and on the very bottom are the Eight Protectors of the Law, the Guardians of the Four Quarters, and wealth-giving gods.

Why would an emperor have had himself depicted in such a fashion? The Qianlong emperor was a genuine practitioner of Tibetan Buddhism, but he was first and foremost an astute politician. When the Manchus conquered China, the Mongols posed a threat to them. Knowing the Mongols' reverence for their Tibetan religious leaders, the Manchus decided to win over these leaders as a means of controlling the Mongols. Therefore, the Manchus supported the Dalai and Panchen Lamas of Tibet, who were the leaders of the Gelugpa order of Tibetan Buddhism.

Beginning with the Fifth Dalai Lama, the Tibetan lamas regarded the Manchu rulers as incarnations of Manjushri.[4] The Qianlong emperor took this to heart and had himself painted as such. These were definitely political paintings, but they also showed his devotion to Tibetan Buddhism. Such paintings were given to the Tibetan religious leaders and were also shown in temples frequented by both Tibetans and Mongols, such as the Yonghe Gong of Beijing and the temples of Chengde. The Manchu emperors used five official languages: Chinese,

Manchu, Mongolian, Uighur, and Tibetan. When an inscription appeared on one of these paintings, it was in Tibetan only, as if the painting was meant only for Tibetans and for the Mongolian lamas who were familiar with this language rather than for the Chinese people.

To design such a painting, the artist must have had a deep knowledge of Tibetan iconography. The person who designed this particular painting could have been no other than the great iconographer Rolpay Dorje (1717–1786), the Third Jangjya Hutuktu [Chinese: Zhangjia Hutuketu], who was the emperor's guru, diplomat, artistic consultant in all Buddhist matters, and chief temple architect. In these paintings, his image appears above that of the Qianlong emperor.[5]

Though these paintings are the products of the Imperial Workshop and are in the style of Tibetan *thangkas*, the face of the emperor resembles Western portraiture. The Jesuit artist-missionary Giuseppe Castiglione (1688–1766; see sidebar pp. 168–69) and his colleagues at the Chinese imperial court had painted similar portraits; either a European artist or a Chinese court artist who had trained in the European tradition could have painted the face of the Qianlong emperor in this group of paintings. The body and background would have been the work of the monk artists (*hualama*) of Zhongzheng Dian, the Hall of Central Uprightness, inside the Palace.[6]

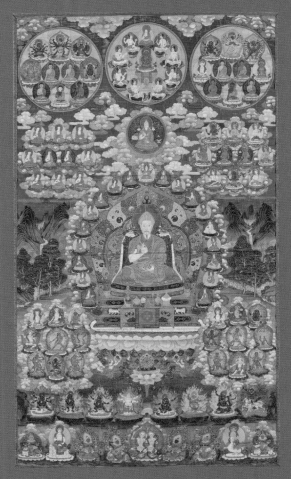

146
Painting of Qianlong as Manjushri
Artists: anonymous European or European-trained painter(s) and anonymous monk-artist(s)
Color on cloth; width 25½ in. (64.7 cm)
1745–80, Qianlong period
(see also fig. 138)

The image of Rolpay Dorje, Qianlong's spiritual tutor, appears in the circle above Qianlong's image. Protective deities, other Buddhas, and saints of the Gelugpa sect are depicted above. Images of Yamantaka are included in the circles on both sides.

147
Map showing religious structures in the Yuanming Yuan Summer Palace

Minor Shrine

Major Shrine

0 100 200 m

148
Map showing religious structures in the Forbidden City

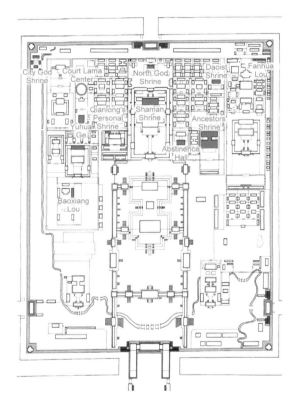

City God Shrine
Court Lama Center
North God Shrine
Daoist Shrine
Fanhua Lou
Qianlong's Personal Shrine
Shaman Shrine
Ancestors Shrine
Yuhua Ge
Abstinence Hall
Baoxiang Lou

Beijing. Although he was ostensibly criticizing a Ming emperor, the contemporary relevance of his comments were obvious:

Rich were the nine continents, filial was the Son of
 Heaven
Construction was frequent and often, for making
 merit to Buddha. ...
The treasury was depleted to build stupas
Look at the many valuable pagodas in the halls. ...
[But] how can immortals keep enemies [in this world]
 at bay?
Let us stop revisiting the past
Just refurbish the icons and start the golden wheel. ...[23]

Historians have often maintained that Qianlong's interest in sponsoring Tibetan Buddhism as practiced by the Gelugpa sect stemmed mainly from a desire to gain the support of Tibetans and Mongols, which had been a major goal of Manchu rulers since Nurgaci's day. In summarizing his achievements in this respect, and in confirming that the State was above the Church, Qianlong wrote shortly before he retired:

... to encourage the Yellow [Gelugpa] sect means pacifying the Mongols. ... When [this policy] was first introduced, there were criticisms for over-sponsoring and causing arrogance among [the Tibetan and Mongol lamas]. But look how the new and old Mongols are now wrapped within the [government's] power and benevolence. Could the several decades of

shrines within his palaces. By the time of his death, most of the religious space within the Forbidden City was Tibetan Buddhist: thirty-five freestanding structures and ten as part of other buildings (fig. 148).[22] The Yuanming Yuan had several large Tibetan Buddhist shrines with resident lamas (fig. 147).

The money and effort poured into Buddhism did not go unnoticed. An official of the Qianlong period wrote this poem when visiting a Buddhist temple in

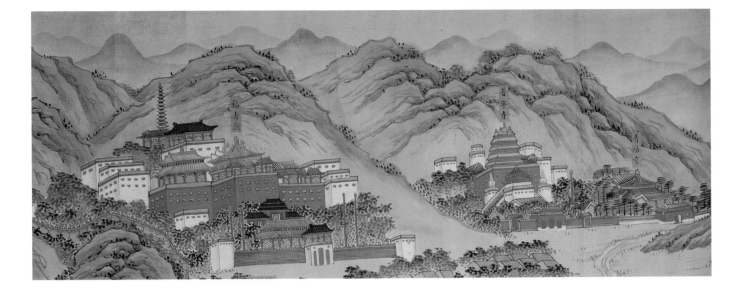

peace have come otherwise? The lamas who caused the rebellion in Ulterior Tibet were properly brought under the law. Could the Yuan government [which was submissive to the Buddhist church] ever have done this? [24]

It is hard to separate these political objectives from Qianlong's personal support of Tibetan Buddhism. He succeeded in subdividing the formidable religious (and secular) authority of the Gelugpas by putting it into the hands of four chief lamas, each with a territorial base – the Dalai Lama in Eastern (Anterior) Tibet, the Panchen Lama in Western (Ulterior) Tibet, the Jebtsundanba Hutuktu in Outer Mongolia, and the Jangjya Hutuktu in Inner Mongolia. Moreover, benefiting from conflicts between Tibetans and Mongolians, Qianlong in 1792 managed to establish the authority of the Qing government over identifying newly reincarnated high-ranking lamas. This authority has been maintained by Chinese governments ever since.

Qianlong built numerous monasteries as part of his drive for Tibetan Buddhist support and influence. The greatest and most glamorous cluster of such monasteries was not in Beijing but adjacent to the imperial resort palace in Chengde (fig. 149). The area north and east of the imperial compound there held a total of twelve Tibetan Buddhist temples, of which ten were built by Qianlong. Most of these were designed in a mixture of Chinese and non-Chinese (mostly Tibetan) styles, with glittering bronze roofs, yellow ceramic tile siding, and brightly colored façades. [25] The largest and most famous was the so-called Potala Temple [Putuozongcheng], built in imitation of the Potala in Lhasa, Tibet (see fig. 24). Curiously, the imitation, though convincing from below, is only a façade. The Tibetan front and side walls turn out to be quite thin and shelter a temple in purely Chinese style. Of even greater religious importance was the Sumeru Temple [Xumifushou], dedicated in honor of and for the use of the Panchen Lama, who lived there during his visit to Qianlong in 1780. [26] Eight of the twelve temples, including Sumeru, had lamas in residence. Most of the lamas were Mongolians rather than Tibetans. [27]

Chengde was more than the jumping-off point for Qianlong to go hunting in Mulan every fall. It was also the de facto administrative capital for the nomadic peoples of the North and West, where the emperor could deal with issues affecting his Mongolian and Tibetan subjects in a setting more congenial than Beijing. This political role made it natural to develop Chengde as a religious center as well. An added benefit was that the monasteries provided logistic support, probably including a place to stay, for visiting Mongolian and Tibetan notables.

The foreign and domestic policy needs of the empire provided a motive for Qianlong's support of Tibetan Buddhism. Whether the military threat posed by Mongolia and Tibet constituted a sufficient reason for that support is hard to judge in retrospect – after all, those regions together cannot have had more than a million people at the time, a small fraction of China's

149
Complete Map of the Resort Palace at Rehe
(detail of fig. 26)

Two of the Outer Temples at Chengde [Rehe] – Xumifushou Temple on the left and Puning Temple on the right – are shown here in more detail. All of the Eight Outer Temples were Tibetan Buddhist, and built in a variety of Sino-Tibetan, Sino-Mongolian, and other styles. As may be seen, they were a conspicuous, even dominating, feature of the landscape.

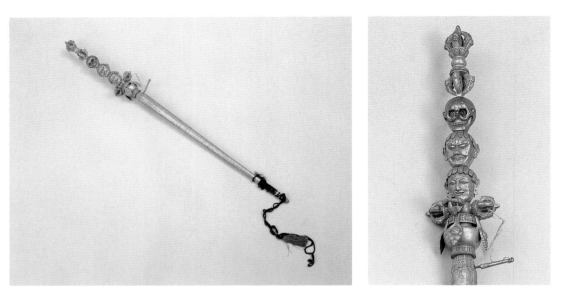

150
Khatvanga staff with a *vajra* and three skulls on top
Gilded bronze, silver, enamel; length 35½ in. (90 cm)
1781

A gift to the emperor from Rolpay Dorje, his spiritual adviser. Such staffs were used in certain esoteric rites. The Palace had a number of *khatvanga* staffs, which Qianlong sometimes inspected. In 1775 he ordered two from the Building of Treasured Images [Baoxiang Lou] to be regilded.

three hundred million. However, Qianlong had other reasons. One was personal. Another was his interest in finding a new religion for the Manchus.

Personally, he was a sincere and even devout believer, judging from what he put himself through. He received a good deal of religious instruction from Rolpay Dorje, his early friend and official tutor, who was also the Third Jangjya Hutuktu. As one of the four highest incarnations in Tibetan Buddhism, Rolpay Dorje was exceptionally qualified to act as a spiritual adviser. Qianlong and he became friends as teenagers and subsequently formed a close religious–political partnership, often exchanging gifts (fig. 150). Qianlong may well have felt that he had attained a degree of spiritual enlightenment through his adviser's teachings. When the Sixth Panchen Lama made his long trip from western Tibet to Beijing in 1780, he is supposed to have ordained the emperor.[28]

It is not certain if Qianlong seriously thought of himself as being not just a devotee but also a bodhisattva, a being who had declined buddhahood in order to ease the suffering of all beings. After all, since Kangxi's reign it had been the custom for Mongols and Tibetans to refer to the emperor as the Bodhisattva Manjushri, partly because the words Manju and Manchu sounded alike.[29] Yet Qianlong seems to have taken the idea seriously enough to have his Jesuit court artists work with lamas to paint no fewer than seven portraits of himself in the guise of Manjushri (see sidebar p. 129). Further, rather than keeping the portraits in his private chapels and residences, he displayed them in public places, including several temples at Chengde and in Tibet.

The emperor made an extraordinary effort to show honor to the Sixth Panchen Lama. Among his numerous gifts was a statue of the lama in cloisonné enamel (fig. 151), and his own painting of a sacred sal tree (*Shorea robusta*), which he later had cut in stone in remembrance of the Panchen Lama's visit (fig. 152). An important outfit meant for a high-ranking lama, perhaps the Panchen Lama or one of his entourage,

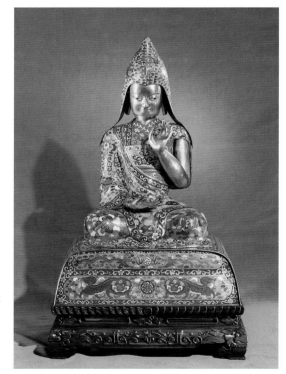

151
Statue said to be of the Sixth Panchen Lama
Cloisonné enamel on wooden base; height 13⅜ in. (34 cm)
1780s
The Field Museum 125698

The Sixth Panchen Lama's visit to Chengde and Beijing in 1780 was a major spiritual and diplomatic event for Qianlong, who commissioned a number of statues and paintings of the holy monk. The unusual feature of this statue is its colorful monk's robe.

152

Rubbing: *Shorea* tree painted by Qianlong
Ink on paper; height 91 5/16 in. (232 cm)
1780
The Field Museum 244007

The original painting was meant to be a get-well message from the emperor to his guest, the Sixth Panchen Lama, when the latter came from Tibet to Beijing in 1780. Sadly, the lama caught smallpox and, after an illness of two months, died while still in Beijing. It must have been during this period of illness that the painting was carved in stone so that many rubbings could be made from it. The tree is a sal tree, *Shorea robusta*. It was under such a tree that the historical Buddha was born and died. The four-language inscription is discussed in the caption to fig. 19.

was a monk's robe made from silk satin in imperial yellow, worn with a dancer's headdress and under a net of shell beads (figs. 153–55).

The depth and sincerity of the emperor's devotion is best illustrated by his provisions for private prayer, in the "personal" shrine attached to his office-study, the Yangxin Dian [Hall of Mental Cultivation].[30] Begun as early as 1746, this small, simple shrine was so private that Qianlong allowed no mention of it in the *Guochao gongshi* [History of the Qing Palaces] of 1769. The shrine was furnished with images of the historical Buddha and of the deity Yamantaka (fig. 156). He later built the Fanzong Lou [Pavilion of Buddhist Origin] to house the largest bronze statues (of Yamantaka and the deity Manjushri) in the Palace.[31] He also took a strong interest in Tibetan Buddhist shrines outside the Palace. For instance, he gave the Miaoying Temple a copy of the much-venerated Vajracchedika-Prajnaparamita Sutra (Diamond Sutra) in his own calligraphy, thus imitating his grandfather, who had hand-copied the same religious text (fig. 157).

The tallest Buddhist building in the Forbidden City was the unusually designed multi-story Yuhua Ge [Pavilion of Raining Flowers] (see fig. 176). For his own use, Qianlong also built a number of shrines with a distinctive horizontal architecture. Each shrine is divided into six cells laid out in a row with a central hall that separates three cells on each side. Each cell is two stories high and with a floor area of only 30 square feet (9 square meters). All cells contained

153, 154 (left)
Ritual diadem and black headdress
Gilt bronze, glass, fiber, ivory; height of headdress 31⅞ in. (81 cm)
1779

The diadem, or "lama's crown," bears painted images of the five transcendental Buddhas, each with a skull as guardian. Such diadems were worn by monks during ceremonies. In this case, the diadem was wrapped around the base of an unusual headdress of black cotton fiber. Both go with the lama costume in fig. 155. According to the 1876 and 1915 inventories, the Palace shrines possessed ten sets of ceremonial costumes with beaded aprons, but only two diadems and two headdresses.

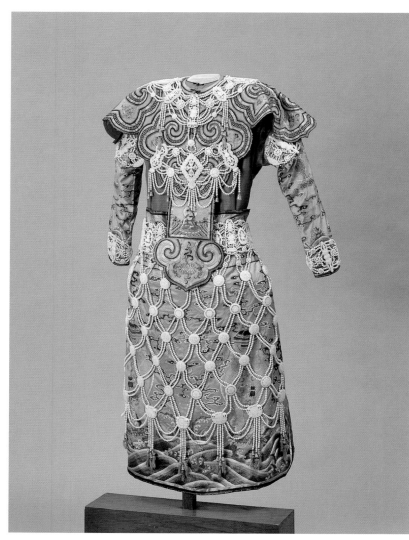

155 (left)
Ceremonial costume for imperial lama: collar, sleeves, skirt, beaded apron, and appliqué shell ornament
Embroidery on yellow silk, shell; skirt length 39 in. (99 cm)
1779, inventory slip of Imperial Household Department

An unusual costume, perhaps unique for court lamas, that may have been used for sacred dances. Like a dragon robe, the multi-part outfit is in imperial yellow and has an ocean at the bottom plus the eight Buddhist symbols and a Buddha portrait – yet it has no dragon. The shell-bead ornaments on the upper body may be an invention of the Qing court. The lower part resembles the human bone aprons sometimes worn for dancing by Tibetan monks of the "black hat" sects. A simplified version of such an apron may be seen on the image of Yamantaka in fig. 156.

156 (opposite)
Statue of Yamantaka-Vajrabhairava
Bronze with fire gilding; height 36⅝ in. (93 cm)
Eighteenth century

This magnificent figure portrays Yamantaka, a fierce manifestation of Manjushri and the destroyer of the God of Death. In this version he has nine heads with a highly expressive bull face in the middle and the peaceful Manjushri on top. Revered as the Protector of the Gelugpa sect and of Lhasa, Yamantaka enjoyed a special position in a palace where the emperor identified himself with Manjushri.

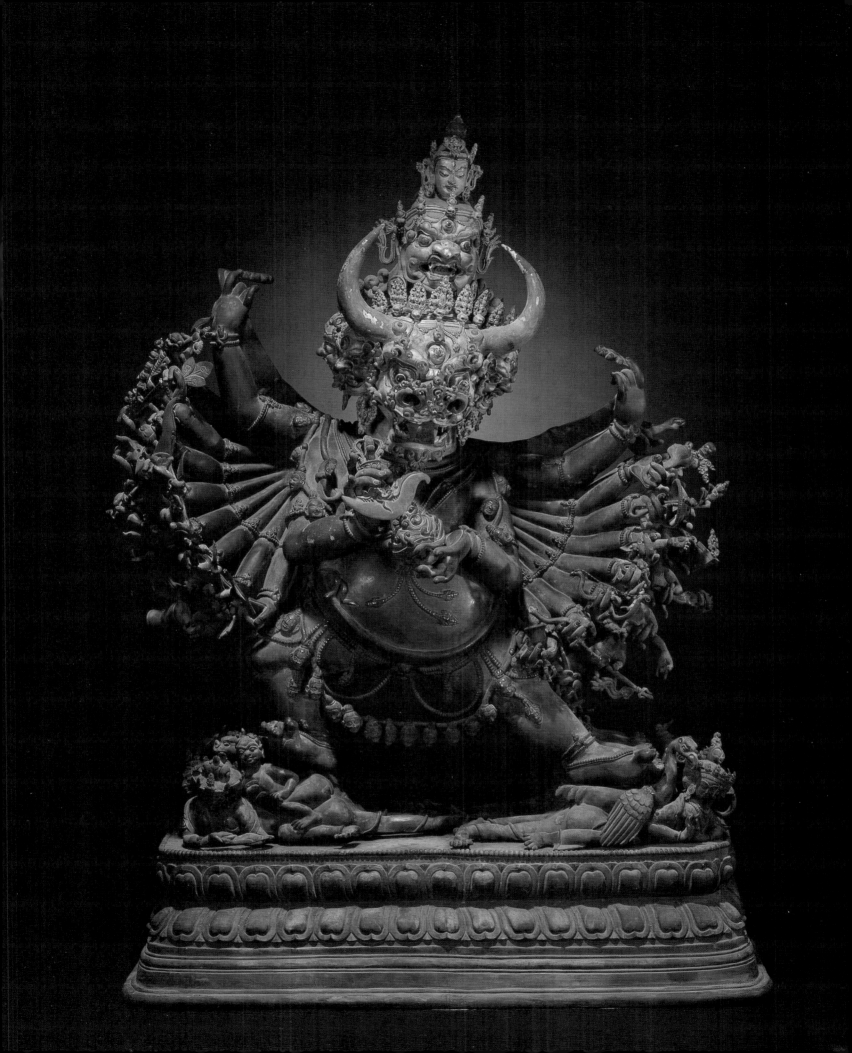

157
The Diamond Sutra, hand-copied by the Kangxi emperor
Dark-blue paper with golden ink and yellow fabric-covered box; length 10½ in. (26.8 cm)
1693

Making copies of Buddhist sutras was seen as a meritorious activity; in this case, Kangxi did it for his grandmother's health. In 1753 Qianlong made a similar copy and "buried" it along with other offerings at the Miaoying Temple in Beijing.

158 (opposite)
Interior of the first cell of the Building of Buddhist Brilliance

Constructed in 1774, the building – the Fanhua Lou shrine – has a total of six cells, each honoring a Dharmapala, a defender of the Buddhist Law. Each cell has a cloisonné stupa in the middle and large *thangka* paintings on three sides. The paintings in this cell show the four cardinal guardians (*lopakala*).

a tall stupa. Each of the cells also contained several large religious paintings, or thangkas, and a number of smaller bronze images relating to specific religious practices. The overall design may have served as an aid to those practices, which must have been adopted by the emperor himself. Between 1758 and 1783, a total of six such buildings were constructed at imperial residences: three in the Forbidden City, one in the Yuanming Yuan Summer Palace, and two at the Chengde Resort Palace.[32] Qianlong's mother seems to have shared her son's faith. One of the Forbidden City shrines, Baoxiang Lou [Building of Treasured Image], was constructed in her own compound shortly after 1765 (figs. 164–75, 177). As a sign of filial piety and dedication to Tibetan Buddhism, Qianlong also built a golden stupa to store his mother's hair after her death (sidebar pp. 152–53).

The shrine cell shown here (fig. 158) is in the Fanhua Lou [Building of Buddhist Brilliance] (side-bar p. 139), completed in 1774, in the northeastern corner of the Forbidden City. The building was modeled after a similar shrine, the Fanxiang Lou [Building of Buddhist Fragrance], in the Yuanming Yuan Summer Palace (fig. 159). Both shrines were intended for Qianlong's use in his last years and were located within his retirement compounds. The various objects that furnished the cells of such a building are shown on pages 137–45. The deities involved all are in tutelary form, meant to assist ordained monks or advanced laymen while meditating. The group of three horizontal thangkas depicting deities in wrathful form (fig. 178) served to protect the Buddhist Law and perhaps the user of the shrine.

The splendor of the imperial version of Tibetan Buddhism is illustrated by the gold statue shown in fig. 181.

Further evidence of Qianlong's personal devotion to Tibetan Buddhism comes from his vision of the

159
Elevation of the Building of Buddhist Fragrance

The layout of this building, the Fanxiang Lou, is similar to that of the Fanhua Lou and seen only in shrines built by Qianlong. Its six cells reflect progressive steps of religious practice. Each cell is a two-story duplex, with the central stupas placed on pedestals so that their tops reach the second floor through the central opening.

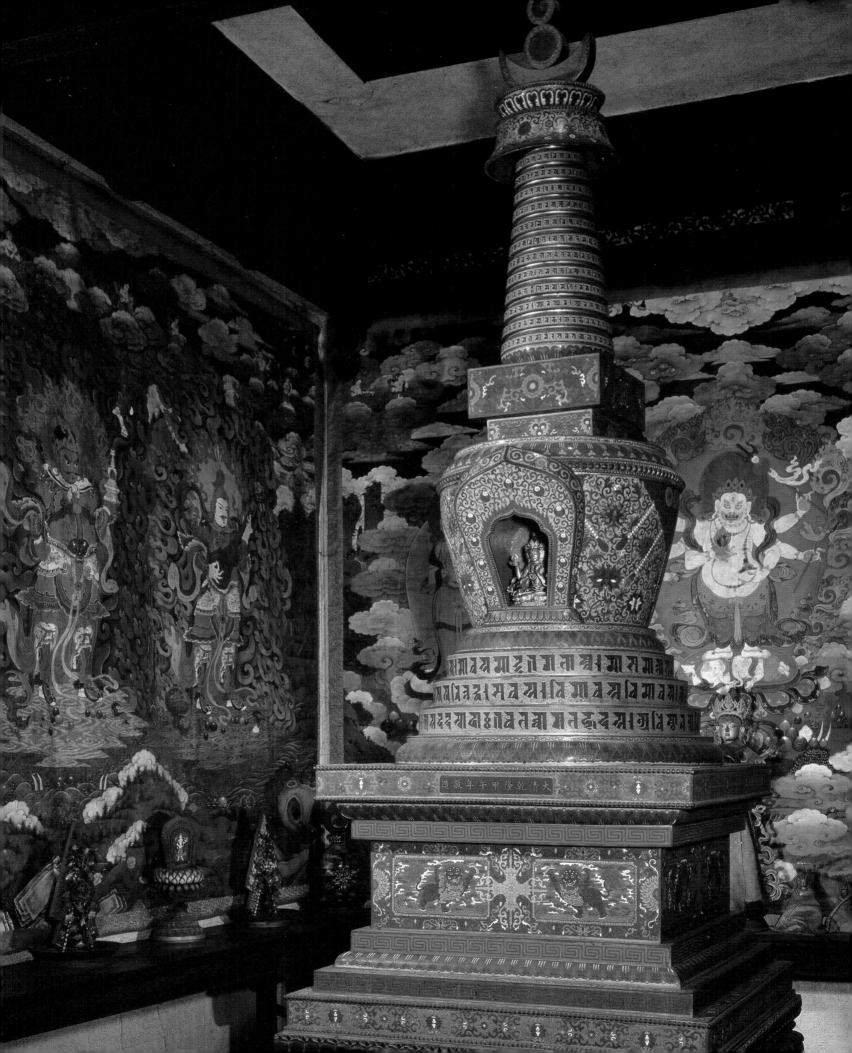

160
Thangka painting: Palden Lhamo accompanied by Zhi-bavi-lha-mo and Rgyas-pavi-lha-mo
Color on heavy cloth; height 128 in. (325 cm)
1765

This set of three large *thangkas* was taken from the fourth cell of the Building of Treasured Images [Baoxiang Lou]. Another set featuring the same deities is still in place in the fourth cell of the Building of Buddhist Brilliance [Fanhua Lou]. Lhamo is the only female among the Eight Terrible Defenders of the Law, and is the protectress of both Lhasa and the Dalai Lama. She wears a garland of human heads, sits on a saddle of human skin, holds a skull-cup of blood in her right hand, and rides through a pool of human parts floating in blood. For a full set of the Eight Terrible Defenders, see the second row from the bottom on fig. 146.

161
Thangka painting: (left to right) Sarad-devi, Vasanta-devi, Dbang-gi-lha-mo
Color on heavy cloth; height 63¾ in. (162 cm)
1765

Sarad-devi is the Goddess of Autumn and Vasanta-devi the Goddess of Spring.

162
Thangka painting: (left to right) Drag-povi-lha-mo, Varsa-devi, Hemanta-devi
Color on heavy cloth; height 87¾ in. (223 cm)
1765

Varsa-devi, the Goddess of Summer, rides a red bull while Hemanta-devi, the Goddess of Winter, rides a camel.

The Storied Building of Buddhist Brilliance

Wang Jiapeng

The Fanhua Lou [Building of Buddhist Brilliance] is an important Tibetan Buddhist structure that still retains the style of the Qianlong period and is noted for its intact architecture and neat furnishings. Its construction began in 1772. Located at the north end of Qianlong's retirement palace, the Ningshou Gong [Mansion of Tranquil Longevity], the Fanhua Lou faces south and has two stories with a ridgeless, gabled roof. It consists of a row of six double-storied cells, flanking a central hall, and is referred to as the "six-part Buddhist building" in Qing Palace documents (fig. 163). Its layout is typical of Qing imperial Buddhist

architecture. No fewer than three other Buddhist buildings with the same layout exist in the Forbidden City: the Huiyao Lou [Building of Shining Wisdom], the Baoxiang Lou [Building of Treasured Images], and the Danyuan Lou [Building of Mild Distance]. The six parts correspond to six modes of Tibetan Buddhist practice: prajna, two parts of anuttarayoga-tantra, yoga-tantra, carya-tantra, and kriya-tantra. Each part is furnished with statues, *thangka* paintings, and ritual implements placed according to the tenets of both the exoteric and esoteric schools of the Gelugpa sect.

At the center of each of the six cells on the first floor of the Fanhua Lou is enshrined a cloisonné stupa. Made in the 39th year of the Qianlong

reign (1774), these splendid stupas each have a different shape. Covering three walls around each stupa is a *trompe-l'œil thangka* portraying nine dharma guardians and featuring bright colors, flying lines, and grotesque images (figs. 160–62). The combination and location of these fifty-four guardians strictly follow Tibetan Buddhist doctrine relating to their function and status in the celestial universe. The *thangkas* were painted by lama artists in the Zhongzheng Dian [Hall of Central Uprightness], the office in charge of Tibetan Buddhist affairs within the Palace.

Upstairs, the six cells together enshrine fifty-four bronze statues of the main Buddhas of the esoteric and exoteric schools. There are

nine statues in each room, placed on long tables near the north wall. The east and west walls in each cell are covered with gilded *zitan* wood niches containing 122 small copper alloy Buddha statues. Thus there are 786 statues altogether, encompassing the main Tibetan Buddhas. From west to east, the first cell houses the historical Buddha Shakyamuni and the eight chief bodhisattvas; the next four cells house protective forms of such deities as Guhyasamaja, Yamantaka, Samvara, Hevajra, Kalachakra, and Vairocana; and the sixth cell houses Amitayus, the Buddha of Boundless Life. Characterized by complete systematization and superb craftsmanship, these bronze statues are the culmination of Tibetan Buddhist statues made in the

Qing Imperial Palace. The Fanhua Luo Buddhist statues are probably the only complete existing set in China representing the esoteric school of Tibetan Buddhism.

The Sixth Panchen Lama came to Beijing in the 9th month of the 45th year of the Qianlong reign (1780). He visited the Forbidden City, the North Lake, the Summer Palace, and the Fragrant Hill, paying homage to the imperial Buddhist shrines there. On the 13th day of the 9th month, he prayed at the Fanhua Lou. On the 5th day of the 10th month, the Qianlong emperor also went to the Fanhua Lou to burn incense sticks and pray.

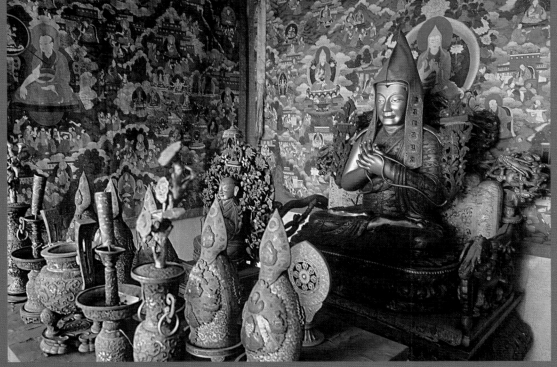

163
Inside the Building of Buddhist Brilliance
Lacquered wooden statue; height 49¼ in. (125 cm)
1774

The building's central hall houses this large statue of Tsongkhapa, the founder of the Yellow (Gelugpa) sect of Buddhism. A five-piece altar set and some petal-shaped *baling* offerings can be seen in the foreground, and *thangka* paintings in the background.

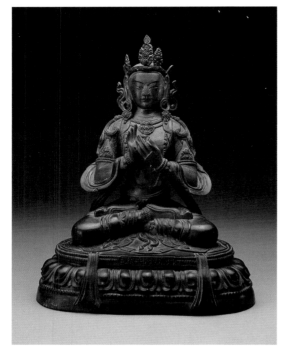

164 (left)
Nava-sikhin Buddha
Bronze; height 15 in. (38 cm)
c. 1765, Qianlong mark

The seated Buddha's hand
gesture shows that he is
turning the Wheel of the Law.
This and figs. 165–77 are
from the Building of
Treasured Images.

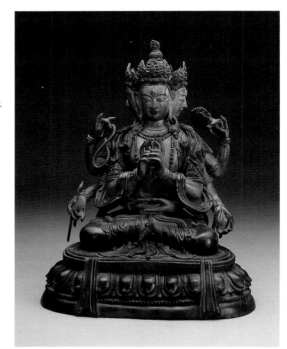

165 (right)
Vajradhatu Buddha
Bronze; height 15 in. (38 cm)
c. 1765, Qianlong mark

This Buddha has four heads,
three eyes on each face, and
eight arms. Each hand holds
an emblem: rosaries, arrows,
a wheel, a bow (which is
missing here), and a *vajra*,
or thunderbolt.

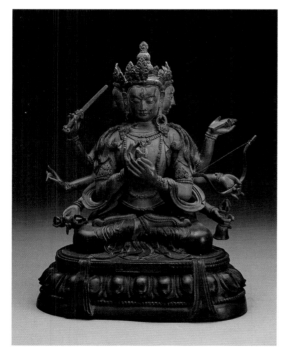

166 (left)
**Dharmadhaturagisvara
Buddha**
Gilt bronze; height 15 in.
(38 cm)
c. 1765, Qianlong mark

Also with four heads, three
eyes on each head, and eight
arms, this Buddha's principal
hands show the gesture
of turning the wheel. His
other hands hold a sword,
an arrow, a thunderbolt, a
volume of sacred text, and
a bell.

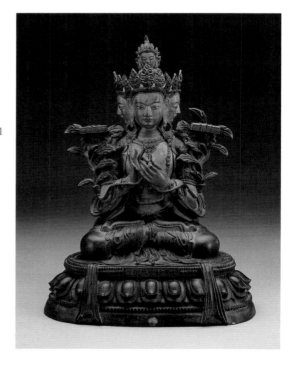

167 (right)
Guhya-Manjushri Buddha
Gilt bronze; height 15 in.
(38 cm)
c. 1765, Qianlong mark

This four-headed
manifestation of Manjushri
is flanked by flowers bearing
Buddhist texts.

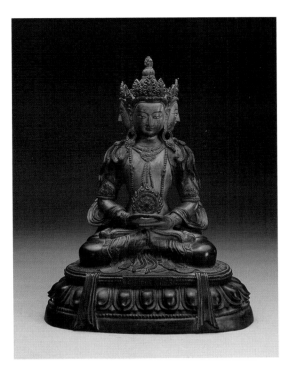

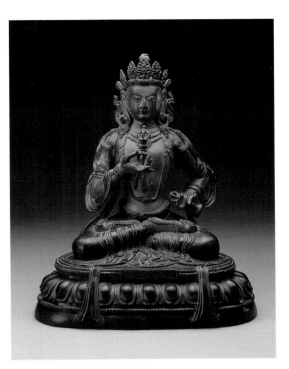

168 (left)
Sarvavid-Vairocana Buddha
Gilt bronze; height 15 in.
(38 cm)
c. 1765, Qianlong mark

As the main deity of the set of nine, this form of Vairocana is peaceful. He has four heads but only two arms, which are in a meditation gesture holding a Wheel of the Law.

169 (right)
Uttamasri Buddha
Gilt bronze; height 15 in.
(38 cm)
c. 1765, Qianlong mark

Holding in his right hand a thunderbolt and in his left hand a bell, the Buddha conveys movement even though seated.

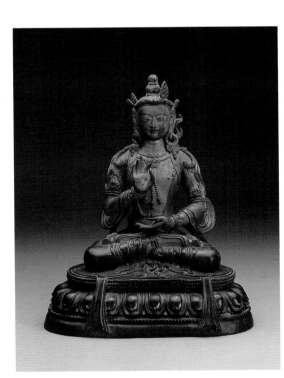

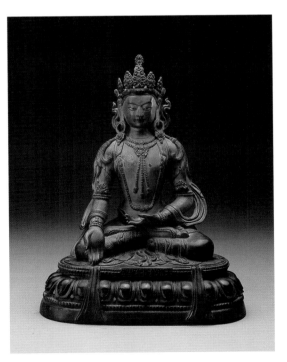

170 (left)
Amoghasiddhi Buddha
Gilt bronze; height 15 in.
(38 cm)
c. 1765, Qianlong mark

The Buddha's right hand is in a gesture of reassurance. His crown should have five leaves in front but has lost some of them.

171 (right)
Dusheng Buddha
Gilt bronze; height 15 in.
(38 cm)
c. 1765, Qianlong mark

Modern scholars have Rolpay Dorje, Qianlong's spiritual adviser, to thank for helping to label the Palace statues and paintings, often with names in three languages: Chinese, Tibetan, and Sanskrit. Without his work, the study of historical Sino-Tibetan iconography and identifying images such as this one would be much more difficult.

172
Trailokyavijayavajra Buddha
Bronze; height 15 in. (38 cm)
c. 1765, Qianlong mark

One of the set of nine bronze
statues made for the upper
floor of the fourth cell in the
Building of Treasured
Images; the others are shown
in figs. 164–71. This one is
the three-eyed deity who is
the angry manifestation of
Vajrasattva Buddha, hence
his military posture and the
two thunderbolts in his
hands.

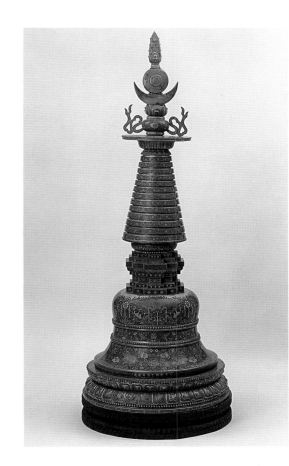

173 (left)
Large Tibetan stupa or chorten
Cloisonné enamel; height
98⅜ in. (251 cm)
1765, Qianlong mark

As in the other six-cell shrines, each cell in the Building of Treasured Images had a stupa in the center. All stupas from that building were taken to Chengde in 1780 for the visit of the Sixth Panchen Lama.

174 (right)
Incense burner on a wooden stand
Bronze, wood; height 7⅞ in. (20 cm)
c. 1765, Qianlong mark

This censer was used in the Building of Treasured Images in the residential compound of Qianlong's mother.

175
Seven *baling* petal plaques with carved designs
Wood with appliqué; height
18⅛ in. (46 cm)
c. 1765

Symbolic altar food offerings, *baling* were often made of flour, wood, or cloisonné. Qianlong sometimes asked to examine the working sketches of *baling* prior to manufacture. Court records show that in making *baling*, lama craftsmen also used "purple grass," coarse cloth, decorated handkerchiefs, silver, and mineral pigment.

176
Pavilion of Raining Flowers

Built and supervised by Rolpay Dorje in 1750, the pavilion Yuhua Ge was modeled after Toling Monastery in Tibet and was the most conspicuous Tibetan Buddhist structure in the Palace. It was used exclusively by the emperor.

177
Thangka **painting**
Color on heavy cloth; height 65⅜ in. (166 cm)
1765

The main *thangka* for the upper floor of the fourth cell of the Building of Treasured Images, it portrays the same deities as the nine bronze statues shown in figs. 164–72. The central Buddha, Sarvavid-Vairocana, is easily distinguished by his size. It is interesting that peonies, not lotuses, appear prominently in these Palace-made *thangkas*.

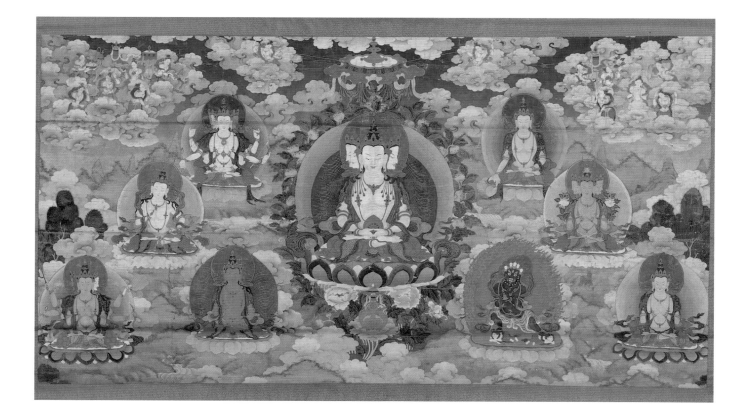

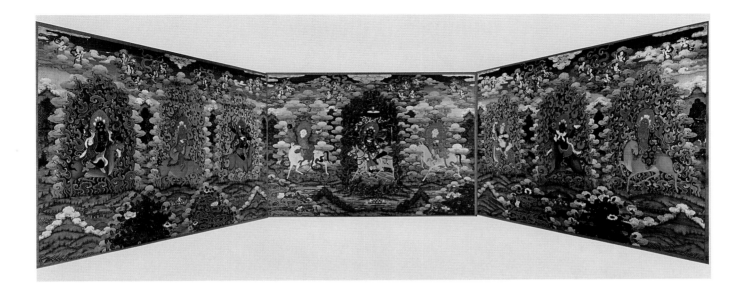

178

Three *thangka* paintings
Artist: anonymous
Color on cloth; height
89⅜ in. (227 cm)
1765

The three *thangkas* were
mounted on the three walls
of the fourth cell in the
Building of Treasured Images
[Baoxiang Lou], yet another
of Qianlong's six-cell shrines,
built in 1765. This particular
cell focused on female
Defenders of the Law, with
the terrifying Palden Lhamo
as the central deity (see also
figs. 160–62).

afterlife. As tradition required, emperors began building their own tombs early. Qianlong was only thirty-three years old when the project began, and it lasted throughout his reign (see fig. 179). Today visitors to the tomb, which is open to the public as part of the imperial Eastern Tomb complex, can see that Qianlong meant to enter the afterlife from an underground lama temple outfitted for the dead. The walls and his coffin were carved with sutras in the Sanskrit and Tibetan languages, along with many relevant icons. No other Chinese emperor's tomb is as strongly Buddhist in decoration (see fig. 180).

A probable separate motive behind Qianlong's support for Tibetan Buddhism was his hope that it could become a special religion for Manchus. He founded a total of twelve monasteries staffed not by Tibetans or Mongols but by specially trained Manchu monks. Such monasteries served primarily Manchu patrons, used the Manchu language in rituals, and housed Buddhist scriptures translated into Manchu. Qianlong's first all-Manchu monastery was built in 1746 at his Fragrant Hill resort west of Beijing. Perhaps the most famous was the Zhengjue Si or Lama Si Monastery in the Yuanming Yuan, completed in 1773. All twelve were located at places where the imperial families resided and visited.[33]

Scholars have suggested that Qianlong founded these monasteries in an effort to broaden the religious outlook of the Manchus. Shamanism as practiced by the Manchus was far from a popular religion, and the court was not eager to share it with other ethnic citizens, including Mongols and Tibetans. The all-Manchu monasteries, therefore, can be seen as a bridge to those groups. The efforts of the emperor must have met some resistance among conservative shaman-oriented Manchus, for as late as the twentieth century there were folktales about contests in which shamans were victorious over lamas.[34]

In 1773 Qianlong commissioned the translation into Manchu and first publication of the Kangyur, the canon of Tibetan scripture. In the preface Qianlong stated:

> This scripture was translated into Tibetan, then Chinese, then Mongolian. It has been over 100 years since the Qing ruled over the Central Plain. People of those three languages are Our subordinates. Yet there has not been any Kangyur scripture in Manchu language. Is that acceptable?[35]

In his later years, Qianlong ordered all-Manchu monasteries to be built at the imperial Eastern and Western Tomb complexes. He noted that visitors, Mongolians and Manchu alike, sought blessings from lamas when they came to the tombs. Perhaps he thought that it was better for living visitors and deceased emperors to hear chants in Manchu than in a tongue they could not understand.

Qianlong was not so committed to Tibetan Buddhism that he opposed traditional Han Chinese Buddhism. None of the many temples in Beijing dedicated to the Buddhist Goddess of Mercy, Guanyin, received regular support from the Board of Rites.

Entrance to Qianlong's tomb, Eastern Tombs

The tomb, Yuling, was also the resting place for two empresses and three second-rank consorts. In July 1928, the warlord Sun Dianying sent two brigades of his troops to dynamite the entrance of the tomb and seize its contents. The looted treasures disappeared without a trace, but fortunately the architecture was left intact. While the above-ground buildings at Yuling are in Chinese style, the interior bears extensive Tibetan Buddhist symbolism.

180

Stone relief on a wall of Qianlong's underground tomb

Nothing much is left in the tomb except the stone carvings on the walls, which bear witness to Qianlong's twin passions for art and Tibetan religion. The walls are richly covered with Buddhist texts in Tibetan script and images of Heavenly Guardians, Buddhas, bodhisattvas, and ritual objects. The guardian shown here wears Chinese armor and an elaborate helmet.

Eight, however, were supported by the Imperial Household Department and the emperor provided informal funding for a total of twenty-six.[36] In addition, the imperial residential compounds contained a multiplicity of shrines to Guanyin and other Han Chinese Buddhist deities (fig. 181), partly to meet the needs of imperial wives and mothers.

Daoism

Any Qing emperor had to be respectful toward Daoism, which was not only the oldest native religion in China but also important personally to most Manchus and Han Chinese. No matter what other religions they believed in, almost all citizens of the empire sometimes made offerings to Daoist gods and temples. Unlike most Tibetan Buddhist temples in the capital region, the great majority of Daoist temples did not receive state funding. In Beijing alone there were 254 temples dedicated to the God of War [Guandi] and 102 dedicated to the Lady of the Azure Clouds [Bixia Yuanjun]. Most were privately supported. When measured by the number of local associations of believers, the Lady rather than the God of War attracted the bulk of private support and perhaps the most fervent devotion.[37] Qianlong did offer help to prominent Daoist temples in Beijing and elsewhere. He provided state sponsorship for certain major Daoist deities throughout China, including the City God, the God of War, the Lady of the Azure Clouds, and the Empress of Heaven [Tianhou].

There were important Daoist shrines in the Forbidden City. Although for the most part not personally followers of Daoism, the early Qing emperors maintained state-level sacrifices at several major Daoist edifices within their palaces. In the Forbidden City, for instance, the Qin'an Dian [Hall of Imperial

181

Statue of seated four-armed Guanyin

Gold, silver, mineral gems, pearls; height 35½ in. (90 cm)
1748, Qianlong mark

On the back of this finely sculpted Guanyin, a Buddhist deity popular among Han Chinese as well as Tibetans, are inscriptions in Chinese, Manchu, Mongolian, and Tibetan. In one incident involving a Guanyin image, probably not this one, Qianlong gave incorrect instructions about the appearance of the deity. When his Buddhist teacher Rolpay Dorje corrected him, the emperor accepted the correction and had flowers added at the deity's shoulder.

182

Shakyamuni Buddha image

Silk embroidery; length 140 in. (335.5 cm)
1736–95, Qianlong seals and poem

The satin-stitch embroidery on this textile creates striking optical effects. Qianlong seems to have prized it more as art than as a religious work. The twelve seals on the piece show that he examined and appreciated it at different times in his life, especially in old age. Interestingly, the image also bears the seal of the last emperor, Xuantong, also known as Henry Puyi.

御製繡線釋迦
牟尼佛贊
堂已趺坐寶蓮
羊心金鍼竪窣橫遍
度與好八十種三
十二大千絲一縷已
過去來令默然
不動一令默然
三十大千絲一縷然
無語教乘演有
日空不空謂全
何有大圓鏡前
禮無量壽

Interior of the Hall of Imperial Peace Daoist temple

A legacy of the Ming dynasty, this shrine to the North God continued to enjoy Palace attention throughout the Qing dynasty. The great bell, 10 feet (3 meters) high, was cast in the fifteenth century. It may have been put in place before the building was constructed.

184

Rubbing: Guandi image
Ink on paper; height 56 in. (142 cm)
1704
The Field Museum 244853

Guandi, also known as the God of War, has for centuries been the patron saint of the Chinese army, police, fraternal organizations, and even gangster secret societies. A personification of courage and loyalty, Guandi became popular among Manchus who even incorporated him in shamanic rituals. The stone from which this rubbing was made was cut in Xian in the Kangxi period.

Peace], dedicated to the North God from Ming times onward, occupies a commanding symbolic position at the north end of the central axis, just inside and in line with the northern Palace gate (see fig. 148). One would think that the Qing emperors might have been tempted to convert it to another use, as they often did with Ming palace structures. They seem to have resisted the temptation, however. The Qin'an Dian kept its ritual importance, with Qianlong and other emperors sacrificing there on New Year's Day (fig. 183; sidebar p. 149).

When it served the interests of the state, Qianlong was willing to go to some lengths to endorse others' beliefs in Daoism. At least twice he did this in a military context. When in February 1787 the navy failed repeatedly to land on Taiwan due to unfavorable winds, Qianlong wrote his admiral that he was praying to Tianhou, the Empress of Heaven and protector of seafarers (fig. 185). After the landing had been accomplished successfully, the emperor fulfilled his part of the bargain by dispatching the admiral to offer a sacrifice to the deity.[38] Most of the navy's sailors were Han Chinese from the southeastern coastal region, where

Tianhou was especially popular. One can imagine that they were pleased to learn that their emperor recognized the power of their favorite goddess.

Similarly, Qianlong approved when his commanders-in-chief wished to give Guandi, the God of War (fig. 184), credit for the success of the campaign against Nepal in 1792–93. In this case, two Manchu generals, both in-laws of Qianlong, renovated a small Guandi temple at Tashilhunpo Monastery in western Tibet before beginning the campaign. They sacrificed at the same temple afterward. True, Guandi was so well integrated with Manchu belief that his worshipers were not necessarily Daoists. But it is significant nonetheless to find that a Guandi temple not only existed in a major center of Tibetan Buddhism but that it was also evidently accepted without protest from Tibetan religious authorities. Tashilhunpo was the home base of Qianlong's close political ally, the Panchen Lama.

At a personal level, Qianlong might have had good reason to be ambivalent about Daoism. Legend had it that the unexpected death of his father Yongzheng was caused by immortality pills prepared by Daoist

The North God at the North Gate

Wang Yaogong

Located to the south of the North Gate and near the north end of the Forbidden City's central axis, the Qin'an Dian [Hall of Imperial Peace] is the main building of the Imperial Garden. It was built in the Ming dynasty, in the early fifteenth century. According to Ming records, "The Yongle emperor had the Qin'an Dian built to worship the North God."[7] With its furnace, pavilion, and flagpole base, the Qin'an Dian is the largest Daoist complex within the Forbidden City. The complex might be more correctly referred to as

the "Xuanwu Daoist Shrine" because it had always been dedicated to the worship of that deity. Currently the shrine houses three large and two small niches, each with bronze statues of the deity. None of these has any datable inscriptions. The large statue in the center has the quality of Yongle bronze work. The other statues were probably added at later dates. Records state that there were nine North God statues made in gold, copper, jade, or porcelain during the Qianlong and Daoguang periods.[8]

The Daoist guardian spirit of the North is known as Xuanwu, the Black Heaven God, the Real Warrior

Monarch, or simply the North God. His icon is a warrior with a snake and a turtle as his vehicle. Supposedly the Yongle emperor was assisted by the North God in battles. In addition, according to Daoist belief the north is represented by the black color and governs water as its element. Because water puts out fires, eliminating fire danger was another reason for having a shrine to Xuanwu within the Palace.

As the Qing imperial family first followed shamanism and later mainly believed in Tibetan Buddhism, Daoist beliefs declined in the Palace after the Ming. Only the worship

of the North God in the Qin'an Dian remained popular. This phenomenon owed much to the emphasis placed on the firefighting function of the North God, on the one hand, and on the other, to the theory expressed by the fourteenth-century intellectual Zhao Mengfu (see p. 221) that "the vital energy in the north betokens the appearance of monarchs there. So the North God made his power felt first. These are the signs indicated by Heaven."[9] Because the Manchus arose in the North, they regarded the North God as their guardian spirit.

The Qianlong emperor was a worshiper of the North God. He routinely made

sacrifice to the deity on New Year's Day. Today the furnishings in the Qin'an Dian remain just as they were in the eighteenth century. A few ritual objects – the scripture wrapper, the streamer, and most of the sacrificial vessels in the shrine – were added during Qianlong's reign.[10] The lintel inscription "Tongwo yuanshu" [Controlling the center] was completed and suspended at the shrine in December 1746, on Qianlong's orders.

alchemists who had been invited to live in both the Yuanming Yuan Summer Palace and the Forbidden City. Qianlong cannot have believed this legend, for the Daoists seem to have stayed alive. Yet he clearly disapproved anyway. He drove all of them away as soon as he came to the throne.[39] Early in his reign he also showed a somewhat anti-Daoist attitude in other instances. In 1739 he stated that the annual sacrifices organized by Daoist temple guilds were interruptive to agriculture and a cause of decadence.[40] Like all rulers of China, he was deeply suspicious of grassroots religious movements that might be a cloak for subversion.

The emperor's uneasiness with Daoist beliefs did not keep his court ladies from embracing them. In the Forbidden City, the Tianqiong Baodian [Treasure Hall of Heaven] contained another major Daoist shrine dedicated to the Daoist concept of Heaven. The hall housed Lingguan, the chief general of Heaven, and a number of thunder gods able to work magic with the elements and distinguish good from evil. Several of these are illustrated here (figs. 186–88). Judging from the quality of the statues, they are likely to have been cast in the imperial foundries. Likewise, the court also

185
Tianhou, the Empress of Heaven
Wood; height 11½ in.
(29.2 cm)
Late nineteenth century
The Field Museum 166451

A popular goddess along the southern coast, this statue was probably made in Taiwan or Fujian. She wears a Ming dynasty imperial robe.

186 (left)
Immortal Marshal Wang Lingguan
Gilt bronze; height 25¼ in. (64 cm)
Eighteenth century or earlier

Wang Shan, entitled Lingguan, and his eight accompanying elemental deities were honored immortals at the Treasure Hall of Heaven [Tianqiong Baodian], another Daoist shrine in the Forbidden City that received state sacrifices. Wang has a third eye and is always shown in military posture holding his knotted staff. The deity was very popular in Beijing. Because it was widely believed that he was capable of expelling evil spirits, Lingguan was featured as the leading overture character at every theatrical performance in the Forbidden City.

188 (below)
Thunder deity Gou
Gilt bronze; height 22 in. (56 cm)
Eighteenth century or earlier

The immortal Gou could be mistaken for a ferocious general if it were not for his third eye. The weapons of both thunder deities shown here are missing.

187 (right)
Thunder deity Zhang Jie
Gilt bronze; height 23¼ in. (59 cm)
Eighteenth century or earlier

It was in the sixteenth century that the eight thunder deities were placed under Marshal Wang's command, as shown by a surviving Palace painting dated to 1542. Zhang Jie is shown here with typical thunder deity features: three eyes, a monkey face, wings, and vulture feet. Although in the artistic tradition of the Ming dynasty, these images continued to be worshiped throughout the Qing period.

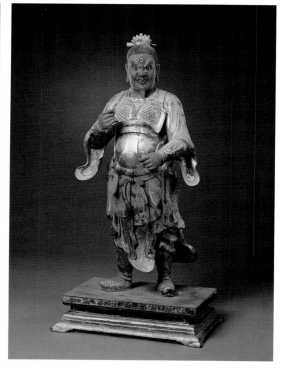

189
Mirror with Daoist signs
Bronze; diameter 5¼ in.
(13.5 cm)
1736–95, Qianlong mark

Traditional mirrors of high-tin bronze, with one side polished for reflection and the other side with molded designs, were no longer widely used in middle Qing times. In spite of this, the Qianlong court seems to have sponsored the making of bronze mirrors for Daoist rituals.

sponsored the making of Daoist ritual objects, such as the mirror shown in fig. 189.

The need for Daoist spiritual comfort was given freer rein in the Yuanming Yuan Summer Palace than in the more rigidly managed Forbidden City. Private shrines put up within the ladies' quarters were not recorded but one still finds historical mentions of numerous Daoist deities being honored at various locations within the Yuanming Yuan. One of the most important Daoist structures was the Ritian Linyu [Sunny Sky Beautiful Edifice], housing the Jade Emperor, the year gods, and the God of War. Qianlong maintained those deities' shrines but showed his disapproval by having Tibetan Buddhist lamas chant at the Ritian Linyu on a regular basis. Other deities, such as the Flower Goddess (perhaps a smallpox deity), the Big Dipper, and the Lady of the Azure Clouds, were honored in less imposing buildings. The Lady of the Azure Clouds was almost exclusively a women's deity. Qianlong's mother's wishes were perhaps the reason why he burned incense to the Lady and made donations to her temple when in 1771 he visited her sacred dwelling, Mount Tai, in celebration of his mother's eightieth birthday (sidebar p. 54).

Islam and Christianity

Qianlong also supported Islam and Christianity in a limited way. He must have been conscious of the dangers posed by both religions, with their seemingly warlike traditions and highly motivated adherents in distant places, which, contrary to his expressed wishes, could not feasibly be brought under Qing imperial control. On the other hand, a strongly held ideology of inclusiveness made it necessary for the imperial government to make an effort to accommodate both Islam and Christianity as well as the traditional religions of the Manchus and Chinese.

Qianlong explained his reasons for doing so in an inscription (in Chinese, Manchu, Mongolian, and Turkish, the last in Arabic script) written for a mosque he built in 1764 just outside the walls of the Imperial City (fig. 191):

> It is sublime to be master of the world, so that even in the remotest regions people submit to our control, and wherever our laws and methods have access, our customs and practice are adopted. However, our ancient policy in regard to the control of remote territories has always been to get acquainted with people's ideas and wishes, and while educating them up to our standard and according to our systems, to still carefully conserve their own religious practices. It is only by accommodating the different ideas of different people that a real uniformity can be attained, in order that our civilization may be so comprehensive as to leave nothing outside.[41]

In spite of this, however, Qianlong was not noticeably enthusiastic about either Christianity or Islam. While his decree prohibiting the teaching of Christian doctrine under penalty of death was never actually implemented, the glory days of Catholic missionaries, when some of their number had been on close

A Gold Stupa for the Empress Dowager's Hair

Terese Tse Bartholomew

On the 26th day of the 1st month, in the 42nd year of the reign of the Qianlong emperor (1777), Niugulu, empress dowager and mother of the emperor, passed away at the age of eighty-six. A month later, the emperor decreed that a golden stupa be constructed to hold his mother's hair, collected from a lifetime of combing, together with an image of Amitayus, the Buddha of Boundless Life.[11]

In doing this, Qianlong was following an ancient Indian tradition: the stupa was originally a burial mound and was subsequently developed and embellished by Indian Buddhists to hold relics or mark sacred sites. When the Buddha Shakyamuni was cremated, his ashes were divided and stored in stupas. In Buddhist practice, to construct a stupa is a meritorious act, and in the Chinese tradition, to remember one's mother is an act of filial piety. Hence, Qianlong had dual motives in ordering a stupa to be built to hold his departed mother's hair. He was known to be a filial son who took his mother along on his grand tours of China and celebrated her sixtieth, seventieth, and eightieth birthdays in a grandiose manner.[12]

Documents from the Zaoban chu [Imperial Workshop] give us the history of the stupa.[13] The design went through numerous stages, and the final one was based on one of a pair of existing stupas, slightly over 4 feet (1.2 meters) high, in the Zhonghua Gong mansion inside the Forbidden City. Although gold was plentiful in the Palace, it was not inexhaustible. The first thing the Palace officials did on receiving the emperor's order was to look for available gold in the Shoukang Gong [Mansion of Longevity and Good Health], the late empress's palace. They melted down all the remaining gold, alongside objects such as a set of gold documents, a golden seal, and golden vessels from the household supply. Tiny gold objects, such as a snuff bottle, a pair of chopsticks, and a teaspoon, which together added up to less than one ounce, were also melted down. To make up the required amount, extra gold was requested from the Neiwufu [Imperial Household Department], but the total only added up to slightly over 2300 ounces. Finally, the emperor gave permission to make up the difference by adding 700 ounces of silver.[14]

The process, from beginning to end, took more than three months, with the Qianlong emperor and his top officials supervising every step of the way. Designs for the various sections of the stupa – the golden case for the hair and its white sandalwood base, the *zitan* wood pedestal for the stupa, even the altar table in front with its offerings – each had to be approved by the emperor before work began.

The end result was an elegant gilded stupa in the Tibetan style, encrusted with coral and turquoise (fig. 190). Supposedly made of

191

Rubbing: Four-language inscription by Qianlong for a Beijing mosque (detail)
Ink on paper; height 78 in. (193 cm)
1764
The Field Museum 244336

The inscription was cut in Manchu, Mongolian, Chinese, and Turkish (in Arabic script); the latter two languages are shown here. The emperor's text enjoins religious tolerance while celebrating the completion of a mosque built near the Palace by imperial order.

personal terms with Shunzhi and Kangxi and even had hoped to convert those emperors, were now long past. To Qianlong, the carefully chosen and technically accomplished Jesuits still being sent to his court were valued employees rather than spiritual advisers. In their own eyes, these priests' main function was to keep the emperor tolerant of their co-religionists elsewhere in China rather than to preach or proselytize. In the words of Jean Denis Attiret, a Jesuit painter sent to Beijing from France in the 1730s:

> The Emperor received me as well as a stranger can be received by a Prince who thinks himself the only sovereign in the world, who has been brought up to be unfeeling to everything, who believes that any man, particularly a stranger, must be only too happy to take service under him ...[42]

Qianlong consulted with his Jesuits on such technical matters as architecture and the production of

3000 ounces of gold, it actually contained only 77% of that metal; the rest was silver. A beaded curtain of turquoise hangs below the sun and moon symbols, while a jeweled shrine encloses a statue of the Buddha Amitayus. Supporting the square base are lions confronting double thunderbolts, and similar designs are repeated on the *zitan* wood base.

In having this stupa made, the Qianlong emperor did more than just follow his religious inclination; the filial act also served to protect him from criticism from his courtiers.

190
Gold stupa made to enshrine the empress dowager's hair
Gold-silver alloy, coral, lapis lazuli, gilt bronze, malachite, turquoise; height 20¾ in. (53 cm)
1777

The stupa was originally placed in a shrine within Qianlong's mother's residence, after her death. Weighing 237 pounds (107.5 kilograms), it is the largest and heaviest gold stupa in the Palace.

enamel and glass. He was quite close to some of his Jesuit artists, such as Attiret and Giuseppe Castiglione. However, unlike his predecessors, he did not discuss theology and philosophy with them and showed no interest in their opinions on those matters. For spiritual advice, he turned almost exclusively to Tibetan Buddhist monks.

The history of Qianlong's relations with Islam must be seen in the context of the campaigns of 1759, whereby what is now called Xinjiang province, with its large Turkish-speaking Muslim population, became administratively a part of China. The above-mentioned mosque under the southwestern wall of the Imperial City, paid for entirely by Qianlong and favored with a long and supportive inscription, bears witness to this. Qianlong did donate twenty thousand ounces of silver in 1775 to rebuild the Christian Nantang [South Church] after it had burned to the ground, but he never wrote an inscription for a Christian church. He also never had a Christian consort or, as far as is known, a Christian female companion of any kind, whereas he was deeply involved with a Muslim consort, the remarkable Rong Fei (fig. 192).

The story of the historical Rong Fei and the way she has been confused with the legendary Xiang Fei [Fragrant Concubine] is told in an accompanying essay (sidebar p. 184). Rong Fei's life seems to contradict the basic rules about imperial consorts: she was not from a Banner family, she entered the Inner Court as a twenty-seven-year-old woman rather than a barely post-pubescent teenager, she remained high in the emperor's favor in spite of being childless, and she received unprecedented privileges, including the rights to retain her religion and to eat Muslim food. The apparent contradiction is striking but irrelevant. The example of Rong Fei simply reaffirms an even more basic rule of court life: that an emperor, especially a capable, autocratically inclined emperor at the height of his powers, could never be wrong.

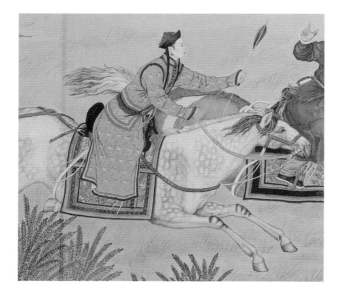

192
Taking a Stag with a Mighty Arrow
(detail of fig. 226)

The costume of the female rider is seen as "Muslim" by some scholars. The pattern of the cloth she wears could be from an Islamic region but her hat and horse-hoof sleeves are clearly Manchu. This neither proves nor disproves that the painting depicts the famed Muslim consort Rong Fei.

The State Religion

The State Religion, as it is called by non-Chinese scholars, was little more than an assortment of ancient rituals focused on gaining the approval of Heaven but without other metaphysics or ethical teachings. And yet those rituals – sacrifices to Heaven, Earth, and various deified nature spirits – were of supreme importance, ranking as the most important of all the emperor's duties. It was convenient for the Qing rulers that Manchus, too, regarded Heaven as controlling people's fate. An emperor who failed to perform the rituals each year, at exactly the right time and in precisely the right way, might well have been considered to have lost the Mandate of Heaven. They were not only his duty, however, but also his privilege as Son of Heaven. For anyone else to attempt to perform the major sacrifices would have been seen as a sure sign of an attempted coup or usurpation of the throne.

The Qing emperors, coming as they did from outside the historical Chinese system and liable to be regarded as alien usurpers, were acutely aware of the importance of the State Religion. Qianlong was punctilious in this regard. He saw to it that all major state rituals were observed. He even went to the trouble of reviving state ceremonies that, like the sericulture sacrifices (sidebar pp. 72–73), had fallen into disuse.

No fewer than 256 ceremonies were listed in Qing regulations as being important enough to be controlled and financed by the Board of Rites, one of the six principal ministries of the imperial government.[43] Most of these ceremonies were deep-rooted in a traditional agricultural society that worshiped the harvest-related elements – the Sun, the Moon, wind, thunder, water, fire, and soil, the twenty-four calendrical dates that mark the change of seasons, and Heaven and Earth as supreme powers. All of these, as well as the professions of weaving and farming, received regular offerings seen as benefits to the common people and as renewals of the contract between the universe and the state, represented by the emperor.

Qianlong sent stand-ins to represent him at many such rites. Indeed, he could hardly have done otherwise in view of the tremendous time commitment that personal participation required. A closer examination of one such rite will help demonstrate the demands made by a typical first-rank sacrifice, as well as Qianlong's fondness for planning in all fields.

Let us consider the annual Sacrifice to Earth, held on the summer equinox at the Altar of Earth [Di Tan] outside the northern city wall of Beijing.[44] Though less famous than the Sacrifice to Heaven, held in the Altar of Heaven [Tian Tan] complex in the southern part of the city (fig. 193), the Earth Sacrifice was equally important for the prosperity of the empire. It was also personally important to Qianlong. He performed the sacrifice himself in all but two of the first fifty years of his reign, dispensing with stand-ins even though it usually meant making a special trip from his summer palace back to Beijing. This unusual degree of personal attention was connected with the fact that Qianlong had decided that his father's spirit tablet would receive sacrifice on the same day as the

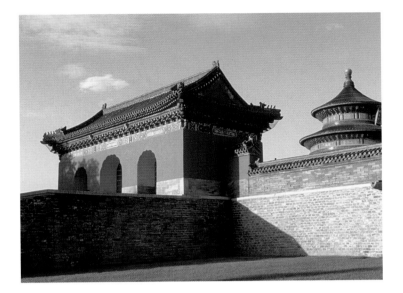

The compound, containing the Temple of Heaven and the Altar of Heaven, was set aside for major sacrifices in 1420. Qianlong enlarged it and standardized the colors of the roof tiles. Here, the temple can be seen rising above the wall.

Earth, as an accompanying spirit. Hence Yongzheng's tablet was enshrined at the Earth Altar. Qianlong may have done this in order to show his gratitude for having been chosen by Yongzheng to perform the Earth Sacrifice while he, then Hongli, was still a prince.

Since 1739 Qianlong had observed the ancient rule requiring three days of abstinence for participants in major sacrifices. That meant spending a night in the Abstinence Hall (or at first, in an imperial tent) at the Altar of Earth, during which the emperor would fast and get himself ready. He was supposed to reach the place of sacrifice one hundred minutes before sunrise. He came on foot rather than in a ceremonial sedan chair and without his ceremonial guards, changing into his sacrificial garments just before the ceremony.[45] Qianlong's regulations on rituals specified that the Earth Sacrifice required wine vessels made of undecorated gourds placed on sandalwood stands. Other vessels were to be of yellow-glazed ceramic. The altar was equipped with a well, a pavilion, a lamppost, and a meat-butchering pavilion. Because the ritual ranked as a first-grade sacrifice, cooking the meat and other food involved no fewer than 290 kitchen staff. The ceremony included music and dancing. The emperor was guided by an "official" in welcoming the deity, in offering the deity incense, cloth, meat, and wine, and in bidding him farewell.

In 1748 Qianlong was annoyed to find that not only did many officials absent themselves from the ritual, but that those who did come had failed to observe abstinence. He threatened to penalize them for this,

although he himself could not attend that year because of mourning for the recently deceased empress.[46] In 1762 it rained while the sacrifice was under way. Some of the participants sought shelter but Qianlong himself did not. Afterward, he presented bolts of silk to the accompanying princes, officials, and Palace staff whose clothes were wet. Those with dry clothes did not get anything.[47] In 1794 the eighty-four-year-old emperor announced with regret that he could no longer kneel and rise as required by the ceremony. But he still would continue to take part, with his sons to handle the kneeling and rising.[48]

The sacrifices to the gods of agriculture and sericulture, both of immense antiquity, followed a somewhat different course. The high point of the former was the actual plowing of a few furrows by the emperor, with the help of high officials and a hundred elderly peasants, chosen from farming communities near the capital. No other imperial sacrifice was attended by commoners. The plowing ceremony was a truly public event, a conspicuous demonstration of the emperor's concern for the welfare of his people. To drive the point home, similar plowing ceremonies were performed on the same day at the provincial and even district level all over China.

The sericulture or silkworm sacrifice was the female mirror image of the plowing ceremony. It was conducted by the empress or a substitute rather than the emperor, and with court women doing much of the work; one historian estimates that in 1744 there were 117 people taking part in the initial stages of the

195 (right)
Rubbing: Image of Confucius
Ink on paper; height 56 in.
(142 cm)
1734
The Field Museum 244842

The portrait was designed by
Prince Guo, an uncle of
Qianlong, for a stone slab
that was to be placed in the
Confucius temple at Xian.
Prince Guo's seal appears in
Chinese and Manchu.

194 (above)
Spirit tablet of Qianlong
Wood, lacquer; height
27½ in. (70 cm)
c. 1799

Originally kept in the Tai
Miao, the Imperial
Ancestors' Temple, this spirit
tablet bears the posthumous
name Gaozong, bestowed on
Qianlong by his successor,
Jiaqing. As an admirer of
the Song dynasty emperor
Gaozong (1127–1162),
Qianlong would undoubtedly
have been pleased.

silkworm rites, of whom thirty-four were eunuchs and
fifty-six were women.[49] Like the emperor, the empress
did manual work on this occasion, being required
symbolically to pluck a few mulberry leaves herself,
using a special small sickle, inspect the growing silk-
worms, and eventually make sacrifice to the wife of
the legendary Yellow Emperor, who was honored as
the Deity of Sericulture. As in shamanic rituals, the
role of court ladies in the sericulture ceremony dimin-
ished toward the later years of Qianlong's reign. The
court hired professional silkworm breeders, and main-
tained several mulberry yards away from the Altar of
Sericulture for that purpose. A major difference from
the agriculture ceremony was that the sericulture cer-
emony under the Qing was very private, as it was held
within imperial precincts (although outside the
Imperial Palace) where no commoners could, in
theory, intrude (sidebar pp. 72–73).

Ancestor Worship and Confucianism

Though commonly considered a Confucian concept
among the Han Chinese, ancestor worship was a tra-
dition of the Manchus as well. As a legacy of the Ming

dynasty, the Imperial Ancestors' Temple [Tai Miao] out-
side the southeast corner of the Forbidden City housed
spirit tablets and paintings of deceased emperors (side-
bar p. 157). The ancestors' spirits were represented by
a tablet (fig. 194) and a painting with the deceased
emperor's name or image on them. The Board of Rites
supervised regular sacrifices there in which the emperor
himself was often a participant (fig. 200).

The Qing emperors also maintained immediate
ancestor shrines within their households. Yongzheng
chose the Fengxian Dian [Hall for Worship of
Ancestors] in the Forbidden City for enshrining his
father's spirit. The idea worked well with Yongzheng,
as he spent hardly any time outside the Beijing area.
For a traveler such as Qianlong, however, the solution
was to build more ancestor shrines at his other resi-
dences, first the Anyou Gong [Peace Mansion] in the
Yuanming Yuan Summer Palace and then the
Suicheng Dian [Hall of Complete Peace] in the
Chengde Resort Palace. The Anyou Gong was the
largest and tallest building in the Yuanming Yuan
complex. Lamas prayed at the Anyou Gong on each
new and full moon day. Charitable meals were given

The Year-End Ritual for the Imperial Ancestors
Li Zhonglu

The year-end memorial ceremony for the imperial ancestors was an annual ritual peculiar to the Qing imperial family, held at the Imperial Ancestors' Temple [Tai Miao] (figs. 197, 199). The day before New Year's Eve, all the memorial tablets of imperial ancestors stored in the rear and central halls of the temple were prepared. Those in the rear hall were spirit tablets of remote ancestors and those in the central hall were tablets of imperial couples since the time of Nurhaci's reign. The year-end ceremony was established early in the Shunzhi period. Normally the emperor was required to attend.

According to court rules, the emperor was obliged to abstain from entertainment, music, and sex for three days prior to the ceremony (see fig. 196). Before the ritual day he had to review the sacrificial text personally, and also send officials to inspect the preparations – for the offerings, music, and dance. It was also decreed that the emperor's officials should announce the coming event to the spirits by burning incense, offering wine, kowtowing, and praying to the tablets. In addition, the shrine in the front hall had to be prepared for the day.

On the memorial day itself, nearly two hours before sunrise, a group of imperial clan members and officials, led by a prince and a duke, would move the tablets from the rear and central halls to the shrines of the front hall. These tablets had to be arranged in their proper sequence.

An hour before sunrise, the emperor would leave the Tai Miao. He would be dressed in a ritual robe and would ride in a golden sedan chair, with officials and ceremonial *lubu* guards leading the way to the south entrance of the temple. In a temporary tent before the gate, the emperor would cleanse himself before taking up his position. A typical ceremony unfolded as follows. After the reading of the sacrificial text, the spirit-welcoming rite began: the emperor offered incense sticks and homage before each tablet, returned to his place, knelt down three times and kowtowed nine times together with escort officials.

Amid music and dancing, the emperor made offerings of animals, silk, and grain to the spirits. Sacred wine and meat were then shared by those who had taken part in the ceremony. After the food had been cleared away, officials of the Taichang Si [Court of Sacrificial Worship] knelt down before the memorial tablets to announce the end of the ceremony. The tablets were then returned to the central and back halls. During this time, the emperor led his officials in again kneeling three times and kowtowing nine times. Then the ritual officials burned offerings in a furnace. When half the offerings had been burned, the officials informed the emperor that the ceremony was complete. The emperor then returned to his palace in the golden sedan chair.

This ceremony was maintained throughout Qianlong's reign. The emperor took the ceremony seriously, attending no fewer than fifty-nine times during the sixty years of his reign. In his first year he upgraded the memorial ceremony to a first-grade state ceremony, placing it in the same rank as that held at the Altars of Heaven and Earth. He also ordered that the Imperial Ancestors' Temple be renovated. The roof of the front hall was altered, giving it double rather than single eaves, and the width of the temple was enlarged from nine to eleven bays, signifying a higher status for the building. Many of its eighteenth-century features survive to this day.

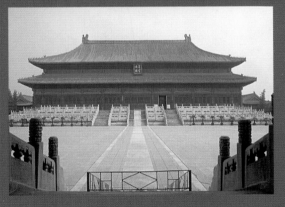

196 (left)
The Abstinence Hall, Forbidden City

The emperor would spend the night in the Abstinence Hall before attending major ceremonies at the temple.

197 (right)
The Imperial Ancestors' Temple [Tai Miao]

198 (left)
Ceiling of the portico and door lintel plaque, Abstinence Hall

199 (right)
Banners of the Imperial Ancestors' Temple

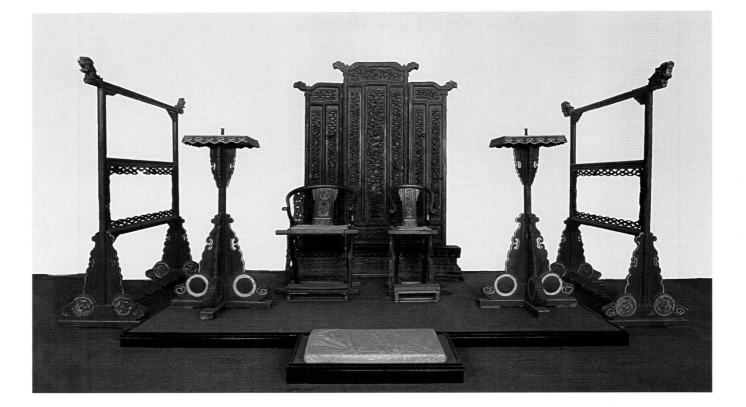

200

Reconstruction of Qianlong's Memorial Altar in the Imperial Ancestors' Temple

The shrines in the Imperial Ancestors' Temple have long been dismantled, but this setting has been reconstructed based on historical records. The spirit tablets were treated like living beings, seated on thrones and given offerings of food and drink.

to the poor just outside the north gate of the building, which is why the gate was nicknamed the Bobo Gate, after a common type of Manchu snack food.⁵⁰

Visits to the imperial tombs constituted another way of paying homage to ancestors. Qianlong visited both the Eastern and Western Tombs quite often. His interest in the Eastern Tombs may have been increased by the prospect of staying for a week or so at the imperial resort at Panshan Hill, not far from the main road back to Beijing. The tombs of Nurgaci and Hongtaiji near Shenyang were also of great ritual importance. Qianlong's four trips to Shenyang was all made under the excuse of visiting his ancestors' tombs. Indeed on each trip he went first to the tombs before entering the city.⁵¹

The leading exponent of ancestor worship in Chinese history was Confucius (fig. 195), and those visiting his temples must have been conscious of this. However, offerings to the great sage were less personal and were the business of the Board of Rites, not the emperor. All significant cities had central government-supported Confucian temples, generally well maintained and not overcrowded with fervent worshipers of the sort one still sees at Daoist and Buddhist temples,

burning candles and incense, having fortunes told, chanting, making money offerings, and so forth. Confucian temples everywhere were calm and dignified places, frequented more by officials, would-be officials, and students than by ordinary folk.

The main Confucius temple of Beijing was the one in the northeastern corner of the Inner City. Following the tradition required of emperors, Qianlong once a year gave a lecture there, as a gesture of respect for scholarship. There were also shrines that honored the sage inside the Forbidden City. Qianlong visited the sage's birthplace at Qufu in Shandong on a number of occasions and bestowed generous gifts and titles on the Kong family, Confucius's descendants. Qianlong had good reasons to demonstrate his respect to the sage. Like many earlier rulers, he approved wholeheartedly of Confucius's idea that one should put loyalty to the ruler even above loyalty to the family. But Qianlong also believed that Confucius had much to teach. Standing in front of the sage's shrine, he called himself a student: "For twenty years I have never stopped studying. In reality I am a scholar. ... For a person without scholarly inspiration is vulgar and materialistic, and should not be placed among scholar-officials"⁵²

Bixia and the Seven Stars

Chuimei Ho and Bennet Bronson

Qing shamanism included elements from other religions. A clear case of this is a group of three paintings in the Palace Museum that show a group of five or seven female deities. The paintings, two of which are shown here (figs. 143, 144, 201), formed the main focus of the evening ceremonies. Kept originally inside a red lacquer box on a black lacquered table in the Kunning Gong [Mansion of Earthly Tranquility], they depict ladies with most of the attributes of Bixia Yuanjun and her subordinate goddesses. Yet both are said by Palace Museum records to show the deity Kedun Nuoyan, an omnipotent goddess of the early Manchus.[15] The Manchu prayer for the evening ritual uses the term "Nadandaihuan" – "the Seven Stars,"

"the Seven Sisters," or "the Seven Female Immortals." Writing in the early nineteenth century, Prince Zhaolian, one of the very few eyewitnesses ever to describe a Kunning Gong ritual, confirms that the image brought out for worship was indeed that of the Seven Female Immortals.

As depicted, these deities could easily be confused with Bixia Yuanjun and her assistants. They sit in the same poses, wear the same Han Chinese court clothing, and are crowned with the same phoenix headdresses. Moreover, Bixia was a major deity in the eyes of many Qing ladies, who worshiped her in shrines within the Forbidden City and the Yuanming Yuan Summer Palace. Some ritual participants may well have thought that Kedun Nuoyan or Nadandaihuan was identical with Bixia. The historian Song Heping believes that this was indeed

the case. He points out that Omosi Mama, a popular female deity of the Manchus, was known as Zisun Niang Niang [the Lady for Sons and Grandsons] in Chinese, and that Zisun Niang Niang was also one of the many titles of Bixia Yuanjun. The primary roles of both Omosi Mama and Bixia Yuanjun were to protect children, and so it was natural for the two deities to merge (fig. 201).[16]

Incidentally, the paintings shown in figs. 143, 144, and here are not just images of Bixia that were moved into a shamanic shrine. The clue to their being real shamanic deities is the presence on one of them of a pair of magpies flying down from the upper right and left. Magpies and/or crows were sacred birds in Manchu shamanistic belief. Spirits in magpie form were the ones that fed off the sacrificial meat on top of the spirit pole in front of the shrine.

201
Painting of shamanic goddess or Lady of the Azure Clouds(?)
Color on paper; height 35½ in. (90 cm)
Possibly seventeenth century

The Palace Museum has at least three shamanic paintings similar to this one, which depicts an empress dressed in Han Chinese style with two immortal altar ladies and four female assistants, two of them in male costume. The empress's appearance, especially her phoenix-ornamented headdress, is confusingly similar to that of Bixia Yuanjun, the Daoist Lady of the Azure Clouds. (See also figs. 143, 144.)

Notes

1. Naquin 2000, pp. 407, 423.

2. *Ibid.*, p. 332.

3. *Ibid.*, p. 336.

4. DQSL(GZ), *juan* 134, p. 2007.

5. Elliott 2001, p. 240; Yan 1993.

6. The volume *Qinding Manzhou jishen jitian dianli* [Imperially commissioned Manchu rituals for sacrificing to deities and Heaven], completed in 1747 and reprinted in 1969 by Shen Yunlong, helped to standardize the ritual at court level but also cut off dynamic growth in a living tradition (Nowak and Durrant 1977, p. 33). See also QDDQHDSL 1976, *juan* 1181–1185, pp. 18,864–907.

7. Elliott (2001, p. 239) says three times, comprising the *zhao* [morning], *xi* [evening], and *beideng* [away from the light] sacrifices. Jiang (1995, p. 226) and Mo (1958, p. 197) refer to the

beideng (meaning only that the windows were curtained or shuttered) sacrifice as part of the *xi* sacrifice.

8. Fu 1990, pp. 139–41; Shenyang MEB 1991, pp. 248–58.

9. Elliott 2001, p. 239.

10. Tie 1991, pp. 152–53. The musicians for shamanic rituals in both Shenyang and the Forbidden City were men. See also QDDQHDSL 1976, p. 18,883.

11. The Kunning Gong, the emperor's personal shrine, was located within a compound that originally housed the empress. The Forbidden City had another shamanic shrine, the Ningshou Gong, within Qianlong's retirement compound. How often it was used is unclear.

12. Rawski 1998, p. 239.

13. In label notes sent to The Field Museum in 2002, Liu Sheng of the Palace Museum, Beijing, has offered a variant interpretation: "The deity is the Mulinhan god mentioned in Kunning

Gong palace's sacrifice. It was worshiped by the ancient Manchu people as a protection god. It was usually made of pigs' skins, branches, and grass. Shamanists thought that the dolls were bestowed by gods so that they didn't pay too much attention to physical similarity. The process of making these dolls was very strict: they had to be made by shamans, and had to be censed, worshiped, and solicited, etc. Only after this complicated process could the doll be efficacious. The dolls were forbidden to be sold or exchanged and were kept in storage most of the time. They were only used in sacrifices and were an important kind of deity in the Kunning Gong palace rituals during the Qing dynasty."

14. These particular figures may already have been in use in the eighteenth century. They are mentioned in court regulations for shamanic ceremonies. It is possible that the pair is not originally Manchu (Mo 1958, p. 196; Jiang 1995, pp. 54, 97).

15. Jiang 1995, p. 54; QDDQHDSL 1976, p. 18,887.

16. Elliott 2001, p. 238; QDDQHDSL 1976, p. 18,897.

17. Jiang 1995, pp. 150–51.

18. Zhaolian 1980, p. 377.

19. On one occasion Qianlong disparaged the use of new spirit poles, stating that the older the pole the better (Yan 1993, p. 58).

20. Qinggui *et al.* 1965, Yongzheng the 9th year, 5th day, p. 61.

21. Wan *et al.* 1990, p. 263.

22. Wang Jiapeng, "Qinggong zangchuan wenhua kaocha [A survey of Tibetan Buddhism in the Qing Palace]," in *Qingdai gongshi congtan* [Discussions on the palace history of the Qing Dynasty], ed. Qingdai gongshi yanjiuhui, Beijing 1996, pp. 135–52.

23. Tai Lu, *Tengyin zaji* [Miscellaneous records under the shade of wisteria] [1796], Shanghai (Shanghai guji chubanshe) 1985, *juan* 8, p. 88.

24. Zhang 1988, pp. 339–43.

25. Forêt 2000, p. 155.

26. Tchen and Starr 1981, p. 398.

27. Forêt 2000, p. 51.

28. Zhang 1988, p. 192.

29. For example, Kangxi was often referred to as Manjushri in Djungar documents (Chuang, Chi-fa, *Qingdai Djungar shiliu chubian* [Preliminary compilation of Djungar archival materials of the Qing dynasty], Taipei 1977, pp. 161–62. In the biography of Qianlong's own close friend and spiritual adviser, Rolpay Dorje, he is quoted as referring to Qianlong as Manjushri (Blo-bza'n-chos-kyi-ni-ma, Zhanjia guoshi Ruobi Duoji zhuan, Beijing [Minzu chubanshe] 1988).

30. Wang 2002.

31. Palace Museum 1992b, pp. 66, 98.

32. Wang 2002; Luo Wenhua, "Qinggong liupin foluo moshi de xingcheng [The building of the six-shrine Buddhist buildings in Forbidden City]," *Palace Museum Journal*, 2000, no. 4, pp. 64–79.

33. Wang Jiapeng, "Qianlong yu Manzu Lama Siyuan [Qianlong and Manchu-staffed Lama Temples]," *Palace Museum Journal*, 1995, no. 1, pp. 58–65.

34. Jin Qizong, "Shaman yu lama doufa de gushi [A story of a contest between shaman and lama]," in *Manzu de lishi yu shenghuo* [History and livelihood of the Manchus], Harbin 1981, p. 93.

35. Wang 1995, no. 1, p. 65; see also Zhaolian 1980, p. 385.

36. Naquin 2000, p. 502.

37. Naquin 2000, pp. 300–04.

38. DQGZCHDSX, *juan* 246, 52nd year, pp. 9–11.

39. Zhang 1998, pp. 122–23.

40. DQGZCHDSX, *juan* 261, 4th year, 5th month, pp. 9–10.

41. Marshall Broomhall, *Islam in China*, London 1910, pp. 94–95; Tchen and Starr 1981, pp. 377–78.

42. Danby 1950, p. 96.

43. Rawski 1998, p. 201.

44. Data on Qianlong's Earth Sacrifices from BJS Eastern Park District and BJS Archives 1998.

45. BJS Eastern Park District and BJS Archives 1998, pp. 50–51; Zhaolian 1980, pp. 371–72.

46. BJS Eastern Park District and BJS Archives 1998, p. 53.

47. *Ibid.*, p. 63.

48. *Ibid.*, pp. 70–71.

49. The empress usually sent substitutes. However, she did preside personally at one silkworm-raising ceremony in 1744 (Lu Yanzhen, "Qingdai huanghou ji xiancan [Qing empress offered sacrifice to Sericulture Altar], *Forbidden City* 1988, no. 5, pp. 14–15). The empress's normative role is well described in Susan Mann, *Precious Records: Women in China's Long Eighteenth Century*, Stanford CA 1997, p. 152; and in QDDDHDSL 1976, *juan* 1186, pp. 18,908–13.

50. Zhang 1998, p. 117.

51. Tie 1991, pp. 94–189.

52. Tang and Luo 1994, p. 443.

Sidebar notes

1. See, for instance, D.M. Farquhar, "An Emperor as Bodhisattva: The Governance of the Qing Empire," *Harvard Journal of Asiatic Studies* 38 (1978), p. 7; and Terese T. Bartholomew, "Thangkas of the Qianlong Period," in *Tibetan Art*, eds. Jane Casey and Philip Denwood, London 1997, pp. 107–17.

2. One from Puning Temple, Chengde; one from Pule Temple, Chengde; two from Yonghegong, Beijing, one from the Potala Palace, Lhasa; one from Xumifushou Temple, Chengde; and one at the Freer Gallery of Art in Washington, D.C. See Michael Henss, "The Bodhisattva-Emperor: Tibeto-Chinese Portraits of Sacred and Secular Rule in the Qing Dynasty," figs. I–II, in *Oriental Art*, XLVII, no. 3, 2001, pp. 2–16.

3. The wheel is usually associated with the Wheel of the Law, but in this instance, it represents the *cakravartin*, or wheel-turner, the symbol for a Universal Monarch, whose chariot wheels carry him upon his conquests.

4. Farquhar, *ibid.*, pp. 8–9.

5. See Robert Clark, "108 Icons from the Buddhist Pantheon, selected by Rolpai Dorje, illustrating the Buddhist lineage of the Qianlong Emperor," in Christopher Bruckner, *Chinese Imperial Patronage: Treasures from Temples and Palaces*, London 1988, p. 18.

6. Yang Boda, *Qingdai yuanhua* [Academic paintings of the Qing dynasty], Beijing (Forbidden City Press) 1993, pp. 74–75; Wang Jiapeng, "Zhongzheng dian yu Qing gong cangchuan fojiao [The Hall of Central Uprightness and Tibetan Buddhism of the Qing Palace]," in *Qingdai gongshi qiushi* [In search of truth: A history of the Qing Palace], ed. Qingdai gongshi yenjiuhui, Beijing (Forbidden City Press) 1992, p. 399.

7. *Ming shilu (Shizong shilu)* [The veritable records of the Ming dynasty (Shizong)].

8. *Qin'an Dian chenshe dang* [Furnishing documents of the Qin'an Dian].

9. *Qi sheng jia Qing tu xu* [Preface to the Painting of *Propitious Signs Betokening the Appearance of the Emperor*].

10. *Zaobanchu huoji dang* [Handiwork documents of the Imperial Workshops].

11. Yan Chongnian, *Beijing, The Treasures of an Ancient Capital*, Beijing 1987, p. 125; Liu Guilin, "Qianlong jinfata di zhuzao [The casting of the hair stupa for the Qianlong emperor]," *Gugong yishi* [Anecdotes from the Forbidden Palace], ed. Zijincheng, Shanghai 1984, pp. 55–57.

12. Terese T. Bartholomew, "Sino-Tibetan Art of the Qianlong Period from the Asian Art Museum of San Francisco," *Orientations*, vol. 22, June 1991, pp. 34–45.

13. Liu Guilin, *ibid.*, pp. 55–57.

14. Liu Guilin, *ibid.*, p. 56.

15. Liu Sheng, label notes sent to The Field Museum in March 2003.

16. Song 1998, p. 206.

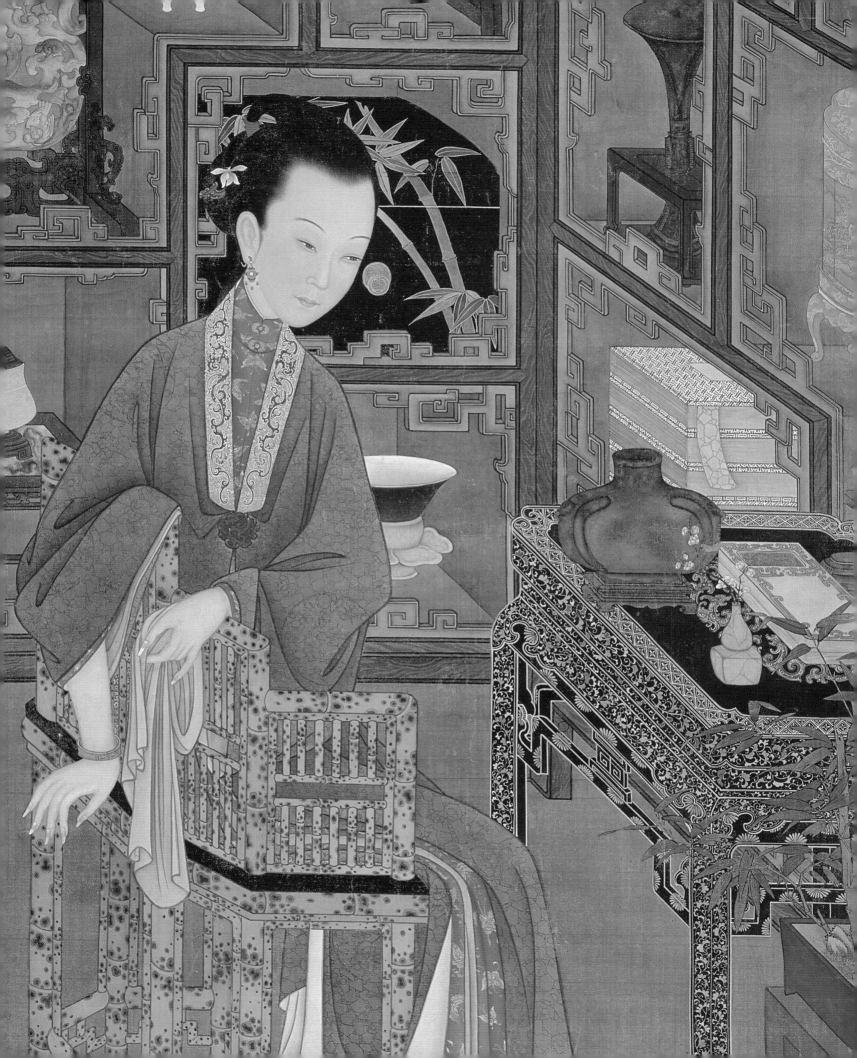

CHAPTER V
Family Life in the Palace

CHAPTER V

Family Life in the Palace

Theme: Borne on the wind, a suggestion of jade bridle-bells
Response: I suspect that the sound comes from the Forbidden Courtyards
Whose inhabitants are as far off as the Milky Way.
Imperial examination question from 1746, and the answer given by an examinee, the poet Yuan Mei[1]

202 (page 162)
A lady of the Yongzheng emperor in Han Chinese costume
(detail of fig. 223)

203 (opposite)
Inauguration Portrait of Qianlong, the Empress, and the Eleven Imperial Consorts
Artist: Giuseppe Castiglione (1688–1766)
Color on silk; height 20⅞ in. (53 cm)
1736, Qianlong seals
© The Cleveland Museum of Art, John L. Severance Fund 1969.31

Qianlong is depicted at the time of his first birthday as emperor. Unusually, he appears together with Empress Xiaoxian and all of his current consorts, of whom there were eight in 1736; the portraits of the last three were added much later. Castiglione seems to have painted only the first three: the emperor, empress, and first consort. The consorts' names – the small characters to the right of each portrait – were inscribed by the emperor himself at a later date. No other painting of an emperor with all his consorts is known from any period of Chinese history.

Introduction: The Hidden World of the Inner Court

The privacy of the Inner Court [Neiting] was well guarded. Palace records tell us about the regulations that governed the normative and ritual behavior of imperial women. But the human side of their daily lives was largely unknown to those outside the Inner Court. This secrecy has led to the general impression that imperial women were secluded during the Qing, as was the case in previous dynasties. However, their seclusion was far from absolute. Many traveled to the outside world. And in the palaces they had a great deal of company. This chapter discusses the relationship of imperial women with the outside world, the Inner Court, and the emperor.

On the day Qianlong came to the throne, he found himself already with a good-sized family: ten step-grandmothers, six stepmothers, his own mother, eight wives, three sons, and one daughter (fig. 203). In later years he acquired more wives and children, gradually lost his grandmothers and stepmothers, and married off his sons and daughters, most but not all of whom left the Palace. The total of resident imperial women was rarely fewer than forty or more than fifty. The day-to-day task of feeding, clothing, sheltering, and monitoring them was handled by the Imperial Household Department, or Neiwufu, which oversaw almost everything connected with the emperor's domestic life in the Inner Court. For such work, the Department employed two thousand eunuchs – castrated male servants – and between two hundred and three hundred ladies-in-waiting and maids. The eunuch supervisors were in turn overseen by trusted non-eunuch male officials who were either high-ranking bondservants or relatives of the emperor. Even though in theory the empress was in charge of household affairs, major domestic decisions were made by her husband.

Centuries of tradition held that normally sexed men, except for the emperor himself, should never be in contact with actual or potential imperial consorts, a category that included all ladies-in-waiting and maids. Thus male servants in the Inner Court had to be eunuchs. They entered the imperial service already castrated, mostly in their teens, were paid regular salaries, and because the majority did not live in the Palace, moved freely between the Inner Court and the outside world. Mindful of the great power attained by eunuchs in earlier dynasties, the Qing emperors from Shunzhi onward confined them to menial roles. Eighteenth-century court paintings usually show eunuchs as sedan-chair bearers, musicians, or servants, identifiable by their red coats decorated with small white circles. Some senior eunuchs, however, were given ranked titles and dressed like other officials (figs. 204, 205).

All Palace ladies resided in and were confined to the part of the Palace known as the Inner Court. The term applied in general to the northern part of the Forbidden City and more particularly to the several walled compounds where the ladies actually lived (fig. 206). Much of the northern part of the Forbidden City was sometimes accessible to males who were not the emperor: the theaters, the halls used for occasional

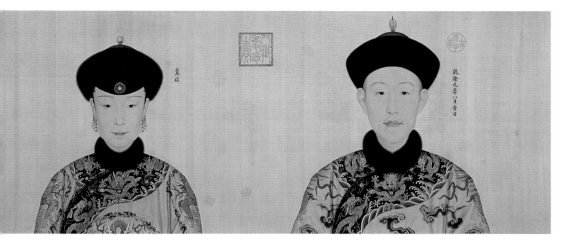

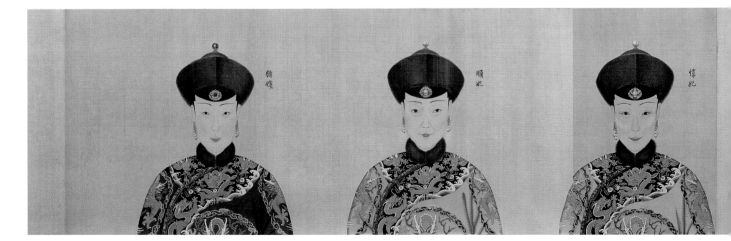

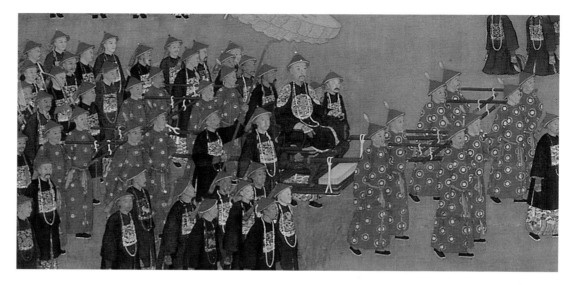

204

Imperial Banquet in Wanshu Garden
(detail of fig. 101)

Qianlong is carried into the banquet camp by eunuchs dressed in red. The more highly placed eunuchs wore the same robes and ornaments as other officials of equivalent rank.

205

The Qianlong Emperor on his First Inspection Tour to the South, **Scroll 12: Return to the Forbidden City**
(detail of fig. 112)

Here the red-coated eunuchs may be seen standing outside the Palace gate to greet the emperor on his return from the South. They are accompanied by the ceremonial *lubu* objects: symbols and weapons on poles, elephants, horses, and colored carriages.

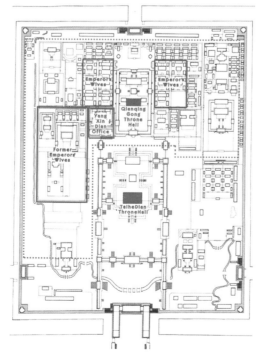

206

Plan of the Forbidden City

The imperial widows' and wives' quarters are outlined in blue, the main throne halls in red, and the Inner Court in violet.

receptions, the residences of unmarried and even married princes, and the buildings used by the Grand Council. Hence, the Inner City was not a seraglio, a large contiguous area used only by women, eunuchs, and the emperor. Yet the less sweeping gender segregation practiced by the Qing seems to have served its purpose. In the entire sixty years of Qianlong's reign, there were no reported cases of unauthorized romances between outside males and Palace women.

Of the two to three hundred ladies-in-waiting and maids, 80% were teenagers and young adults between thirteen and twenty-five years of age. Only 2% were over sixty. Except for wet nurses and a few others who came to the Palace as mature women, none of them was paid for her services. Almost all were recruited as young girls through having been drafted according to Qing custom, more or less like soldiers.

Imperial regulations required that all Banner families as well, as certain bondservant families, had to present all daughters who had reached puberty for possible selection as ladies-in-waiting (for Banner girls) or as maids (for bondservant girls). Drafts were held every three years for the former [*xiunu*] and every year for the latter. Rejected girls were sent home immediately. Ladies-in-waiting were sent home with a dowry after three to five years if they failed the second screening. Maids were usually released from service at the age of twenty-five, again assuming that they had not been promoted to consort. Like it or not, a consort had a lifetime job, with no chance of making arrangements to be away. She lived and died in the

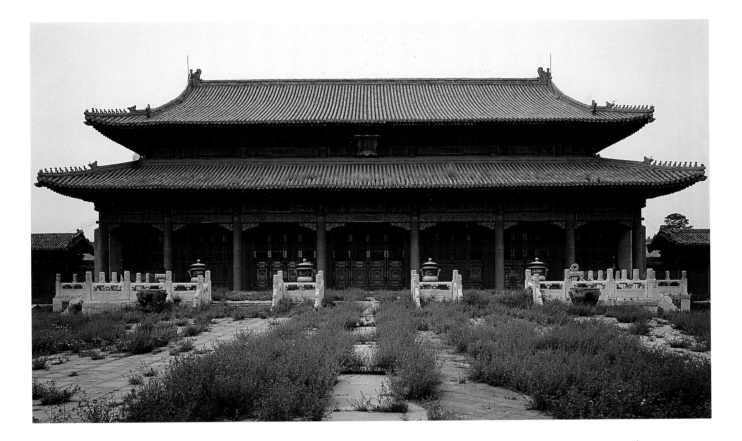

207
The Mansion of Motherly Tranquility

Qianlong's mother lived in the Mansion of Motherly Tranquility [Cinning Gong] and sometimes gave receptions there.

Palace, under the watchful eye of the Imperial Household Department.

In a world without newspapers, the Palace ladies relied on eunuchs for news of the outside world. Occasionally they had visitors, who must also have been their ears and eyes. Such visitors might include female imperial relatives with visiting privileges as well as the Palace ladies' own mothers and daughters-in-law. Married princesses and imperial step-grand-mothers could return to the Palace for short-term visits. And Palace regulations allowed a female rela-tive of each pregnant imperial wife to stay with the mother-to-be until delivery.[2]

Close male and female relatives of the emperor had certain privileges for visiting the Palace. In the year in which Qianlong came to the throne, these included ten uncles, two half-brothers, one step-grandmother, and two adopted sisters. In later years, married impe-rial sons and daughters would be added to the list of occasional visitors. Although they did not live in the Palace, the emperor supported them with allowances and took indirect responsibility for their welfare.

In addition, an unquantifiable number of female specialists of other kinds came and went from the Palace upon request and through special arrange-ments. These included female shamans, caterers, waiting persons, and wet nurses. Such women were often the wives of Imperial Household Department officials or of members of the upper three Banners. They too formed links to the world outside the Inner Court.[3]

The Mother and Grandmothers of the Emperor

In the morning of the 25th day of the 11th month in 1751, Qianlong, dressed in a colorful feathered cos-tume, picked up a cup of wine and executed a dance before offering the wine to his mother, who had turned sixty that day. Witnessed by much of the impe-rial family, the dance was part of the formal celebra-tions held at the empress dowager's mansion in the Forbidden City. Few Chinese emperors are known to have expressed their filial piety in such a style. While one assumes that this feathered dance was related to a Manchu custom of some kind, it also highlighted the importance of the person being honored.[4]

In theory the emperor's mother was the leader of the Palace women. She presided over and led the emperor's wives on formal domestic occasions. When

Lang Shining or Giuseppe Castiglione, an Italian Painter at the Qing Court
Nie Chongzheng

Originally named Giuseppe Castiglione, Lang Shining was born on July 19, 1688 in Milan, Italy. As a youth he trained as a painter before joining the Jesuits. In 1714 he left Europe to become a missionary, and the following year he arrived in Macao, where he adopted a Chinese name. He then moved to Beijing; this was at the end of the Kangxi period. He entered the Imperial Palace, where he began his career as a court painter, which was to last several decades. Lang Shining died in Beijing, following an illness, on July 16, 1766; he was aged seventy-eight. On his death the Qianlong emperor issued a special imperial order granting him the posthumous title of vice-minister and donating 300 *taels* of silver for funeral expenses. Lang Shining was buried in the foreign missionaries' graveyard outside the Fucheng Gate, Beijing. His art should be recognized as an integral part of Chinese painting history.

As a court painter he created numerous works to fulfill imperial orders, depicting figures, historical events, flowers, birds, and beasts, and so forth. He became one of the favorite court painters of both Yongzheng and Qianlong. Lang Shining not only created many paintings himself but also taught European techniques to Chinese court painters. Consequently, many Qing court paintings have a hybrid East–West character, which clearly distinguishes them from traditional Chinese court paintings, *literati* paintings, and folk paintings. He produced several

he abdicated in 1795, long after his mother's death, Qianlong explained to his officials that "the role of empress ... cannot be compared to that of empress dowager who as the mother of the emperor deserves the highest respect."[5]

The empress dowager played a major role in Inner Court life. It was she who hosted the bridal banquets for the groom's female relatives when marrying off imperial daughters, and she issued the order (but did not make the decision) to promote a junior wife to a higher rank. Sometimes she acted on her own. It was widely believed that in 1750 Qianlong had been pressured by his mother to appoint his senior consort Ula Nara as the new empress as soon as the mourning period for the deceased first empress was over. Although evidently a favorite of the empress dowager, Ula Nara proved a disastrous choice as empress (sidebar p. 172). The emperor's mother's judgment was not infallible.

Once or twice Qianlong was clear in showing displeasure at his mother's initiatives. One morning in 1756 the empress dowager sent him a full breakfast that included three dishes of duck, two of mutton, one of dumplings with pork stuffing, and five kinds of vegetables. For unknown reasons he was not happy. He rejected every dish, ordering his own kitchen to prepare noodles with duck and tofu-duck soup instead.[6] History does not record how the empress dowager felt about this.

This is not to say that Qianlong had serious problems in his relationship with her. On the contrary, mother and son shared a strong bond. Unlike most sons in China and elsewhere, Qianlong was willing to take his mother everywhere he went. She lived forty-two years after he became emperor, and for the first thirty of those she accompanied him on all his tours to Shenyang and the Yangtze delta. On such occasions the tours were organized under her name, so that the records usually say "the Emperor accompanied the Empress Dowager to" (see p. 96).

In the first year of his reign Qianlong built or renovated several residences and gardens for his mother, including the very large Changchun [Happy Spring] Garden and Xihua [West Flower] Garden, which together were almost as large as the Yuanming Yuan complex.[7] When she visited her son's summer palace north of her own, she stayed at the Long Spring Immortal Hall. She was given her own mansion in the Forbidden City (fig. 207). As long as she lived he visited her several times a week, sometimes waiting on her while she ate her meals.

The young emperor was willing to bend some rules to please his mother. In 1742 he decreed that a widowed princess, his cousin, would be allowed to remain in Beijing instead of being sent away to live, as was proper, with her in-laws out on the frontier. She would also be promoted to a second-rank princess. Qianlong agreed to this because his mother spoke to him on her behalf, after she in turn had pleaded tearfully at the empress dowager's feet.[8]

There were some rules he would not bend, however. One of the most important was the Aisin Gioro

portraits of emperors, empresses, and imperial consorts. While preserving European painting skills in terms of the accurate projection of anatomy, at the same time he absorbed traditional Chinese portraiture techniques. For example, he front-lit rather than side-lit his subjects so as to minimize the amount of shadow in his portraits; he also reduced light levels so that facial features could be clearly shown.

Working with other Chinese court painters, Lang Shining created many important paintings that recorded historically significant events and people. He often planned the overall layout and painted the main figures in a scene, thus endowing these works with a very real sense of history. Examples of this type of painting include *The Khalkha Horse Tribute*, *Emperor Qianlong Watching a Performance of Equestrian Skills*, *Imperial Banquet in Wanshu Garden* (fig. 101), and *Emperor Qianlong Hunting and Dining*. He painted both horizontal and vertical scrolls. Lang Shining also produced genre (bird-and-flower and animal) paintings by depicting the actual gifts brought by tribute bearers. These works have significant historical value.

Lang Shining was also renowned for his horse paintings. He used Chinese writing brushes to depict the texture of horsehair in short and thin lines. This painting style, differing from the traditional Chinese approach, was greatly admired by Chinese emperors. His surviving horse paintings include *The Ten Steeds*, *One Hundred Steeds*, *Herding in the Suburbs*, *Eight Steeds*, and *Two Steeds*. He also applied the European still-life approach to traditional Chinese genre painting, resulting in works such as *Auspicious Objects*, *Auspicious Objects for the Dragon Boat Festival*, and *Flowers in a Vase*. Most of these paintings are still in the collection of the Palace Museum, Beijing.

clan rule that forbade imperial women to maintain unauthorized contacts with their own families, to prevent them from becoming involved in politics. Two days after the former emperor Yongzheng's death, this rule led Qianlong to order his eunuchs not to pass to his mother any news of state business. A few months later he became upset because his mother's brother had visited her at the Palace without the emperor's prior knowledge. Her not having told Qianlong in advance seems to have been the issue; he did let her parents come to see her at her summer palace. A little later he became angry once again because he had not been informed of his mother's charitable contribution to a Buddhist temple. In both of these cases, he punished only his mother's eunuchs but she understood and never allowed such things to happen again.[9] Evidently there were limits even to filial piety. In the Inner Court, as in the rest of China, maintaining imperial authority mattered most.

The emperor was more patient than many sons when disagreements occurred. The empress dowager complained, apparently quite seriously, at his overspending for her sixtieth birthday celebration in 1751. In that same year Qianlong made a special effort in decorating the roads between the Forbidden City and the Yuanming Yuan Summer Palace, but his mother criticized the extravagance.[10] She died soon after the New Year celebration in 1777 and he went into the deep mourning required of a good Confucian son. Disregarding Confucian convention, however, he paid her spirit a Buddhist compliment by commissioning a large gold stupa with a design suitable for preserving a saintly relic, in this case her hair (sidebar pp. 152–53; fig. 190).

There were other senior imperial ladies who resided in the Forbidden City. The oldest generation would consist of the grand empress dowager [*tai huangtaihou*], and the paternal grandmother and step-grandmothers of the current emperor if still alive. Then came the surviving wives of the preceding emperor. Interestingly, it is not true that ladies of the senior generation were always more powerful than their juniors. Qianlong's several step-grandmothers and stepmothers played almost no role in domestic routines. They were not assigned a place in court regulations, were not included in any of the emperors' trips or other activities, and were not consulted in family affairs. They were left in seclusion in the northeastern quarter of the Palace (fig. 206), supported in reasonable comfort, but otherwise ignored.

The only time that most step-grandmothers and stepmothers were not ignored was at their deaths. When the last of his eleven surviving step-grandmothers, Wenhui Guifei, died in March 1768, Qianlong twice attended her funeral services, having also visited her twice in the Forbidden City just before she passed away. This required a special effort on his part as he was staying in the Yuanming Yuan Summer Palace at the time and had to make day trips to the Forbidden City in order to see her.

208
Lady in the Shade of a Tong *Tree*
Nephrite; length 9¾ in.
(24.7 cm)
1773, Qianlong poem and marks

This famous carving was made in a private workshop in Suzhou from a waste fragment left over after a cylindrical piece had been cut from the middle of a natural nephrite jade boulder. The woman next to the open door is said to be a Palace lady-in-waiting. Qianlong liked the carving and inscribed a poem on its bottom.

209 (opposite)
Portrait of Empress Xiaoxian in winter ceremonial robe
(detail of fig. 70)

Close-up of Empress Xiaoxian at the time of her inauguration. The new empress wears a headband, triple-paired earrings, a neckband, and a winter fur hat with golden phoenixes and pearls.

The Wives of the Emperor

In 1778 a fourth-ranked consort named Dun Fei (fig. 203, bottom right) was found guilty of beating a maid to death. Although homicide was a grave offense under Qing law, the penalty imposed on Dun Fei was light. Like all Palace personnel, she was exempt from the formal judiciary process and instead was judged by Qianlong himself. He demoted her to the fifth rank, made her give one hundred ounces of silver to the victim's parents, and had her pay half of the financial penalty levied on her eunuchs, whose salaries were suspended for one or two years.[11] Even this light sentence was modified, and within a short time she was re-promoted to her original rank. Qianlong's kindness to her stemmed partly from the fact that she was the mother of his favorite child, the Tenth Princess, Hexiao, who had just turned fifteen and was about to be married to Grand Councillor Heshen's son (see sidebar p. 86). Evidently a favored consort could even get away with breaking the law. The severity of her sentence depended entirely on her relationship with the supreme judge.

Emperors were entitled to have many wives. None was a concubine and all were consorts as those terms are usually defined – that is, they were legally married to him, unlike concubines, but of lower social rank than their spouse, like the husbands of reigning queens in England. Even the empress was technically a consort, as there was no way that she could enter the marriage as the social equal of the Son of Heaven.

Qianlong had more than forty consorts, making him the second most frequently married emperor of the dynasty, after his grandfather Kangxi. Even if one discounts the numerous legends about his strong interest in courtesans and other lower-class women, one still cannot doubt that he enjoyed female company. He first married at seventeen, became a father at eighteen, and went on to marry repeatedly in the course of a long and healthy life. He was sixty-five when his youngest daughter was born.

The consorts were mostly chosen from Banner families and of Manchu, Mongol, Han Chinese (from Chinese-martial Banner families only), or Korean ethnic origin. This East Asian wifely profile was set aside when a Turkish Muslim from far western Xinjiang, the famous Rong Fei, joined the imperial harem in 1760. Qianlong's first wife, Xiaoxian (fig. 209), became his first empress when he gained the throne in 1736. She

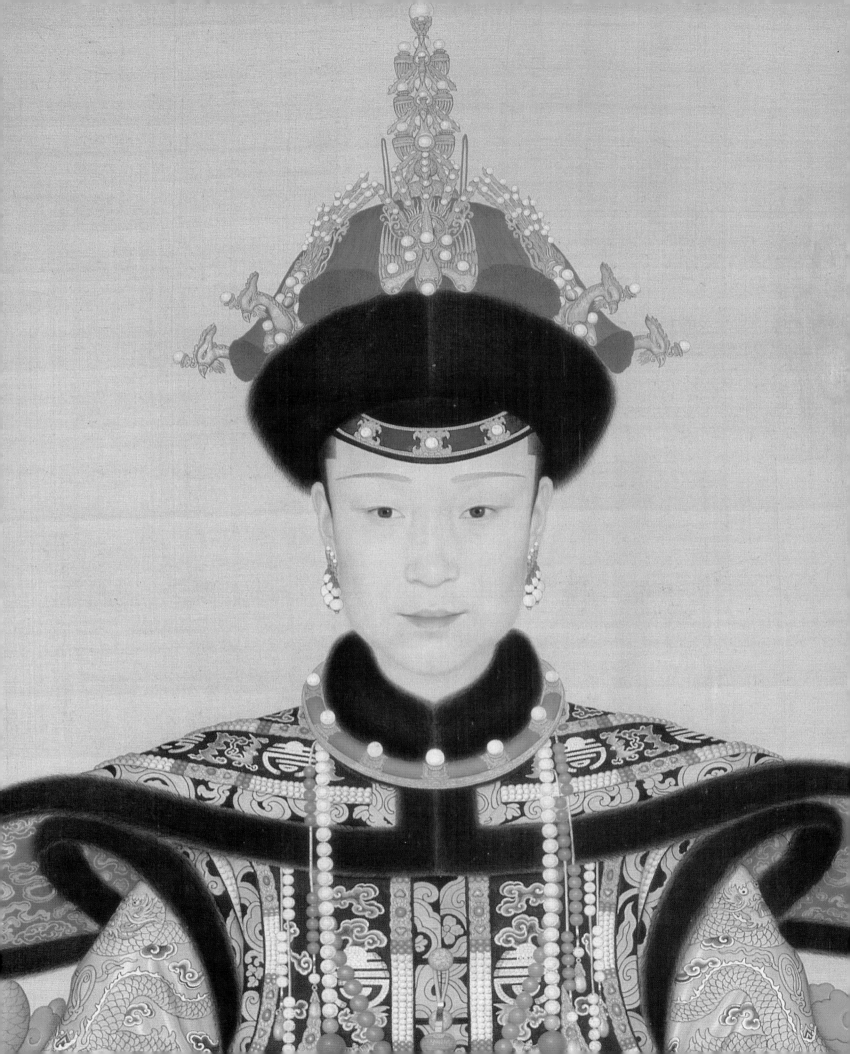

210

The courtyard of the Mansion of Eternal Spring

One of the twelve compounds for imperial wives, the Mansion of Eternal Spring [Changchun Gong] once housed Qianlong's empress Xiaoxian, and a century later the empress dowager Cixi. Each mansion was independent in having its own entrance, courtyard, and central reception room (see also fig. 22).

died in 1746 and a long-time senior consort, Ula Nara, was promoted to the rank of empress, Qianlong's second and last, two and half years later. The other consorts, although junior to the empress, held ranked positions that still carried immense prestige.

The empress, or *huanghou*, held a ritually powerful position and was entitled to more of the perquisites of wifehood than any other wife. However, a Qing empress was less secure and less powerful than her predecessors under the Ming.[12] Qing policymakers were so acutely aware of the problems caused in earlier dynasties by ambitious imperial in-laws – that

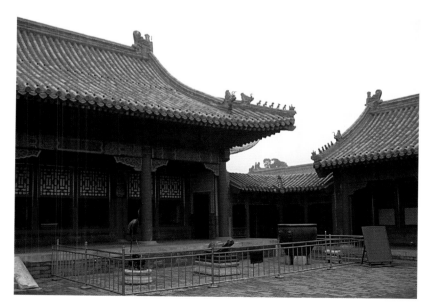

is, by brothers and other blood kin of empresses – that it was very difficult for an empress or other imperial consort to maintain an independent family power base or even to communicate directly with family members outside the walls of the Palace. Empresses could not even give or receive outside gifts without their husbands' permission. Moreover, an empress's status in the Qing imperial household was not so dominant that she could not be eclipsed by another, more favored consort. It could even happen that the household might not contain an empress. A widower emperor might refuse to choose a replacement, leaving that position vacant for personal or political reasons. Qianlong, for instance, did not take another empress after the disgrace and death of Ula Nara in 1766 (see sidebar above).

Below the empress came a series of other ranked consort positions, each with precisely defined ornaments and privileges:

Huang guifei [Imperial Honored Consort], 2nd Rank,
 1 position

Guifei [Honored Consort], 3rd Rank, 1 position

Fei [Consort], 4th Rank, 4 positions

Pin [Consort], 5th Rank, 6 positions

Guiren [Honored Person], 6th Rank, no fixed number
 of positions

Changzai [Ever Available], 7th Rank, no fixed number
 of positions

211
Jade album with posthumous title of Empress Xiaoxian
Nephrite; height 11⅝ in.
(29.5 cm)
1799

Even though Empress Xiaoxian was not the biological mother of the new emperor Jiajing, he added honorific terms to her posthumous title to show respect to the newly deceased Qianlong. The new title was recorded in this jade album stored at the Tai Miao, the Imperial Ancestors' Temple.

Daying [Agreeing/Answerable], 8th Rank, no fixed
 number of positions

The ranking system was expressed in a consort's possessions. The material, images, colors, and quantity of the ceremonial objects that went with each rank were prescribed and well understood by everyone. For instance, the certificates for appointment to the highest ranks and for titles were engraved in ten-page jade books, contained in two boxes each with dragon designs and wrapped in yellow cloth (figs. 211, 212). A fifth-rank *pin* consort's jade certificates were smaller with fewer pages, and were boxed in smaller containers with turtle or other designs. The sedan chair used by a second-rank *huang guifei* had a double-layered roof with gilt-bronze fixtures, covered with a shade of imperial yellow fabric, whereas a *pin* had to be content with a single-roofed sedan chair covered with green-yellow fabric. The headdress of an empress could have up to sixty-three second-grade pearls whereas a fifth-rank consort's headdress could have no more than twenty-five non-lustrous pearls.[13]

For young women whose lives did not go beyond the Palace, the ranking system was the only ladder of

212
Bound jade album
Nephrite, bound in yellow satin; height 10¼ in. (26 cm)
1661–1722, Kangxi period
The Field Museum 32903

The album was commissioned by the Kangxi emperor in honor of his grandmother. This is believed to be the way such books were originally bound. Like the album in fig. 211, it is in both Chinese and Manchu.

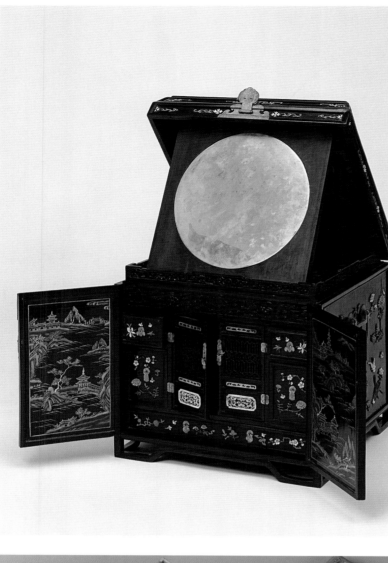

Dressing box with a mirror and box of combs
Painted black lacquer on wood, inlaid with ivory, coral, rubies; width 17¼ in. (44 cm) 1736–95, Qianlong period

Dressing boxes were not among imperial ladies' regular provisions, but "boxes of combs" are listed in the dowries for princesses. This dressing box still holds the original bronze mirrors. It is interesting that bronze mirrors were still in use during Qianlong times even though the glass variety was widely available by then.

social mobility. The system determined not only details of their costumes but also their standard of living. The top-ranked ladies got many more provisions than lower-ranked ladies. Always eager to set standards and keep records, in 1742 Qianlong ordered a team to compile an exceptionally detailed set of Palace policy guidelines, the *Guochao gongshi* [History of the Qing palaces]. These, which took effect long before their publication in 1769, meticulously laid out the provisions that each rank was to receive (sidebar p. 187). The quality of housing differed by rank as well. When in the Forbidden City, only *pin* and higher-ranked consorts had their own individual households.[14] Sixth-, seventh-, and eighth-ranked consorts had to live with the higher-ranked ladies and did not lead luxurious lives. When the emperor gave special gifts of food, upholstery, cash, or knick-knacks to a lowly *changzai* or *daying*, those items may have meant more to them than simply love.

Non-perishable provisions – furnishings, clothes, jewelry – were given to but not owned by Palace women (figs. 213–17, 219). Unlike ordinary Chinese and Manchu wives, imperial consorts received their dowries from the emperor rather than their own families and thus did not have those funds to fall back on.[15] In a 1741 statement Qianlong made it known that imperial wives of past and current emperors were not allowed to give away their personal belongings, stating that everything they had belonged to the Imperial Household Department (figs. 218, 220–22).[16] Qianlong later also commanded that none of the art objects on

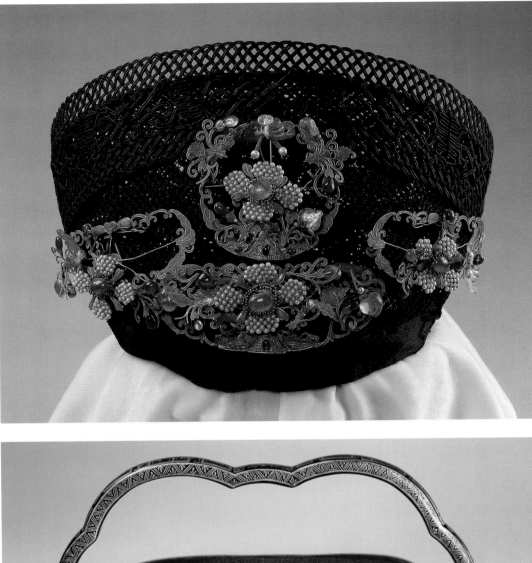

215
Manchu lady's hat [*dianzi*]
Black silk thread on wire, gilt silver, kingfisher feather, pearls, rubies, jadite; height 7½ in. (19 cm)
1736–95, Qianlong period

This semi-formal hat of the *dianzi* type was worn with a dragon robe. The decoration on these *dianzi* varied a good deal and appears not to have been closely regulated when worn, as was usually the case, by ethnic Manchus. Qianlong's tenth daughter received thirty such hats as part of her dowry.

216
Hand warmer with bail handle
Gold and black lacquer on wood; length 7¼ in. (18.4 cm)
1736–95, Qianlong period

As presents on her seventieth birthday, Qianlong gave his mother nine lacquer hand-warmers, along with nine of cloisonné and ninety-nine of bronze. This may be one of the nine in the birthday gift, for hand-warmers made of lacquered wood are otherwise very rare. It has an interior container of gilt bronze to hold the glowing charcoal, plus a bronze mesh cover. The painted design, of landscapes within panels, shows influence from the Japanese *makie* raised-lacquer technique.

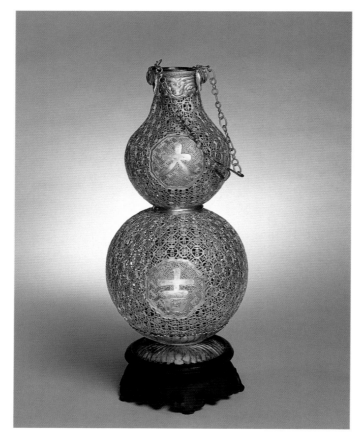

217

**Fumigator in the shape of
a gourd**
Gold exterior, silver interior;
height 16½ in. (42 cm)
1736–95, Qianlong period

Instead of the usual dragon
and phoenix designs, the
openwork is made up of
many connected characters
that read "happiness,"
"longevity," and "ten
thousand," with two solid
characters reading "great
fortune" in the middle.
The fumigator has a chain
for suspension.

a plainly visible sign of imperial favor, but it also imposed a devastating psychological burden on those who were unable to deal with the system. The life of the disgraced second empress, Ula Nara, shows what a terrible blow failure and demotion could be. In contrast, the life of Wei, the mother of Qianlong's successor, shows how a capable but not extraordinary woman could succeed splendidly within the system by living in peace and having sons. Wei was already eighteen years old when she came to the court as a sixth-rank wife, or *guiren*. Being a year or two older than the average imperial bride may have worked to her advantage. She must have pleased the emperor, for she was promoted to the fifth rank within months. Three years later she was promoted again to the fourth rank, or *fei*, after the births of her first daughter and son.

Wei continued to be close to the emperor. She was Qianlong's most productive wife in terms of children, bearing him four sons and two daughters in a seven-year period between 1756 and 1763. Even though the records are reticent about imperial personal relationships, they do offer glimpses of intimacy. In 1771, just two years before Qianlong wrote the secret decree making her son the crown prince, he took Wei with him to Shandong (to Qufu and Mount Tai) along with several other wives. Later that year he gave her a set of new bedding material. By then she had risen to the second rank, or *huang guifei*. She kept that title until her death in 1775 and was granted the posthumous title of empress after Jiaqing succeeded to the throne twenty years later.

display in the ladies' buildings (fig. 223) should be moved, changed, or stored away without permission. These entries sound highly restrictive. In reality, however, there were instances in which personal belongings of imperial wives were given away as they wished, so long as those plans had been approved by the emperor.

Not only did the hierarchy of consorts provide a pecking order, a reminder of the court power structure, and

218

**Pair of hairpins in the shape
of double knots**
Jadeite; length 8 in.
(20.4 cm)
1736–95, Qianlong period

In addition to holding the
hair, these traditionally
designed hairpins have blunt
ends that could be used for
cleaning the interior of the
ear. Double knots are one of
the Eight Buddhist Emblems
commonly used in Chinese
decorative arts.

Fumigating hat stand in veneer
Wood, bamboo, dyed ivory; height 11⅝ in. (29.7 cm)
1736–95, Qianlong period

The top of the stand is a bamboo box that could function as a herbal fumigator for the hat. Veneer using bamboo skin was a new decorative technique in the Qianlong period (see also figs. 343, 346, 348).

Although not on the fastest promotion track, Wei advanced more rapidly than most wives. Four to six years was the normal wait for promotion by a single rank. Some wives waited even longer than that – it took eighteen and forty-three years respectively for the consorts named Wan and Gong to achieve any promotion at all. A new wife started somewhere between the fourth and sixth rank if she was originally a lady-in-waiting from a Banner family, or at the seventh or eighth if she was originally a maid of bondservant origin. When a maid had been graced by the emperor and achieved consort status, she received exactly the same privileges as a similarly ranked consort from an élite background and could be promoted just as rapidly. The sole basis for promotion was imperial favor.

The above-mentioned Aisin Gioro clan rule that court ladies were excluded from external affairs was applied even more strictly to imperial wives than to the emperor's mother. The Ming and earlier dynasties had suffered greatly from the involvement of emperors' in-laws in court politics. Hence Qianlong not only forbade unauthorized contact between wives and their natal families, but went to some trouble to remind members of those families that they should not presume on their relationship with him.

Sanbao, the superintendent of the Changlu Salt Administration and the father of consort Jia Fei, was refused permission to leave his post in order to pay final homage to the newly deceased emperor, Yongzheng. His son-in-law Qianlong turned down his request, stating, "You should not expect special privileges from me just because your daughter is in the Palace. You must be cautious in everything. Be loyal to your office and remove any personal desires."[17]

Similarly, Qianlong returned the memo of the father of another consort, Gao Bin, who held a high position in the Navigation Department. Gao had written the memo to thank the Yongzheng emperor for sending him a bunch of fresh lychee fruit. But the thanks came a few days too late, as Yongzheng had passed away in the meantime. Thus the new emperor replied:

My imperial father recognized your skill and promoted you to a high position. You should do your utmost to return his grace. Do not harbor any special ideas just because your daughter is waiting on me. This will not be tolerated by national law. If you serve the country well with sincerity and integrity, I will not bend over backward to avoid being criticized for favoritism … .[18]

Occasionally, the records show Qianlong being less stern about his wives' relatives. A 1783 memo reported that an official named Zhu Yan was not doing that

220

Pair of hairpins in the shape of bats
Gold filigree, pearls, and rubies, with kingfisher feather inlay; width 2¼ in. (5.7 cm)
1765 or earlier

The imperial workshops made more than one hundred pairs of hairpins in the first year of Qianlong's reign, probably for him to give away to celebrate his enthronement. The original yellow Palace storage slip reads: "Stored on the 27th day of the 9th month, Qianlong the 30th year." The design conveys good wishes: fortune (bats) and longevity (character). Such hairpins were suitable birthday presents for ladies.

221

Headdress bar [*pianfang*] with squirrel motifs
Tortoiseshell, inlaid with pearls, coral, rubies, jade; length 12 in. (30.4 cm)
1736–95, Qianlong period

The *pianfang* is a Manchu style of ornament that helps fasten the hair and the hat in place. The craftsmanship on this example is exceptional. The tiny, finely carved coral animals are squirrels.

222

Headdress bar [*pianfang*] with inlaid bats
Jadeite with pearl shell inlay; length 11⅜ in. (29.6 cm)
1736–95, Qianlong period

This is probably one of the finest pieces of Burmese *feicui* [kingfisher green] jadeite to have entered the Palace in the Qianlong period. Although jadeite was a new material to Chinese carvers at that time, the techniques of working it evidently had already been mastered.

223

A lady of the Yongzheng emperor in Han Chinese costume
Artist: anonymous court painter
Color on silk; 76⅜ × 38⁹⁄₁₆ in. (194 × 98 cm)
1700–22

This pensive court lady in Han Chinese costume is shown surrounded by a tasteful selection of antique objects. The painting is one of twelve "fantasy" pictures made for Yongzheng before he took the throne in 1723, depicting his views of ideal pastimes for his consorts. Each painting shows a young lady engaged in such leisurely pursuits as reading, sewing, or enjoying flowers.

Interior of the Hall of Experiencing Completeness

In this room there once hung a painting that promoted the womanly virtue of not distracting one's husband, the emperor, by being too physically attractive. The room is in the Hall of Experiencing Completeness [Tiyuan Dian], situated within one of the twelve compounds for imperial ladies in the Forbidden City. It has since undergone some renovation, and the painting that hangs in it is not the original one.

well at his job. Qianlong's reply was lighthearted: "This is an in-law. Let it be … ."[19]

The main roles of the imperial wives were as providers of entertainment, sexual services, and heirs for the emperor. However, Palace women also had a significant share of ceremonial activities. According to the official *Qinding da Qing tongli* [Imperially commissioned rituals of the Qing dynasty], imperial wives and daughters were obliged to take part in sixteen of the fifty kinds of court ceremonies. These were mostly family rituals, such as offerings at imperial cemeteries, deaths, birthdays, promotions, acquired additional honorific titles, and weddings of key imperial family members, as well as the enthronement of a new emperor. State rituals included celebrations for New Year's Day, the Winter Solstice, the emperor's birthday, and most significantly for Palace women, the series of sericulture or silkworm-raising ceremonies (see sidebar pp. 72–73).

Entering the Palace at a young age, imperial women must have varied in terms of education. Those whose fathers hoped that their daughters would attract the attention of the emperor must sometimes have received a reasonably good education, but there must

have been other girls, including some from good families, who could barely read or write. For those who had been accepted into the Palace, there was no school as such but a good deal of informal training. Part of that training involved learning what was expected of an imperial consort.

Qianlong himself made his expectations clear. He cited twelve empresses and consorts of previous dynasties as models for behavior, praising them in poems and having paintings made of them. One painting hung in each of the twelve consort's buildings in the Forbidden City. Each embodied a particular virtue: skill in sericulture, being a good mother to sons, not using sex to distract the emperor from his duties (fig. 224), advising one's husband not to over-indulge in hunting, bearing and raising good sons, being a filial daughter-in-law, sacrificing oneself for the emperor's safety (fig. 225), putting the emperor's honor before one's own interest, being a role model in observing a simple lifestyle, being outspokenly truthful, being literate, and respecting horticulture.[20]

The emperor was by no means a feminist. Most of the above twelve virtues were traditional values

225

*Imperial Consort Jie Fei
Barring the Way of a Bear*
Artist: Jin Tingbiao (active
in court 1757–1767)
Color on paper; length
58¾ in. (149.4 cm)
1766, Qianlong seals and
poem

The painting depicts the
consort of a Han dynasty
emperor who became a
heroine by putting herself
between a bear and her
imperial husband when his
guards were caught
unprepared. Qianlong chose
this historical story to
promote the idea of self-
sacrifice by wives. The artist
Jin was a Zhejiang native
who had been recruited
as a court artist during
Qianlong's Southern
Tour of 1757.

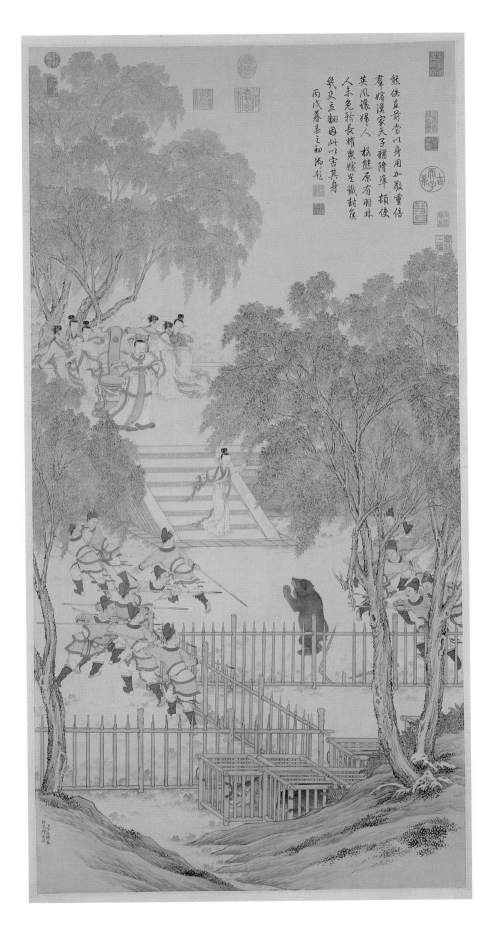

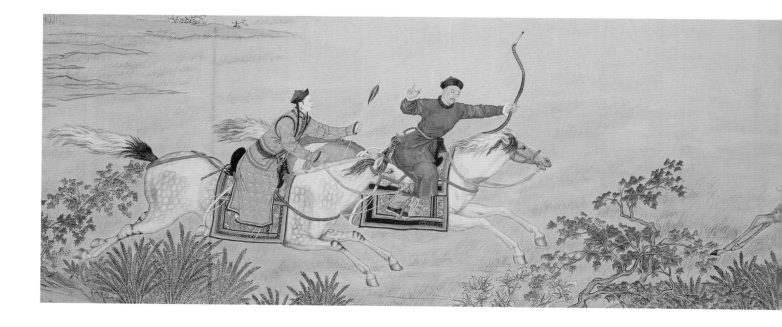

226

Taking a Stag with a Mighty Arrow

Artist: attributed to Giuseppe Castiglione (1688–1766)
Color on silk; height 12 in. (30.5 cm)
1760s, Qianlong seals and calligraphy

A fine example of the new Europeanized style of realistic documentary painting, this short handscroll depicts an unusual subject, a woman hunting alongside the emperor. Who she was has been the subject of much controversy (see sidebar p. 184).

widespread in Chinese society, which until recently demanded in peremptory terms that women be submissive to their husbands and in-laws, void of jealousy, thrifty, gentle, hardworking, and chaste. Qianlong agreed with his commoner subjects on the importance of those qualities. However, his ideal woman departed from tradition in two respects that were personally important to him: she should be intellectual and love gardens.

Yet another domestic virtue was relevant specifically to wives of the élite: they should be able to sew and embroider small ornamental pouches for their husbands of the sort that men wore hanging from their belts. Qianlong's first empress, Xiaoxian, on several occasions embroidered such pouches for him as holiday gifts. A surviving example in the National Palace Museum, Taipei, was an ideal gift for a dedicated hunter (see fig. 49). Made of deerhide in a northeastern style and meant to contain flint and steel for fire-making, it was not only useful in the field but also served to remind the emperor of his Manchu origins.

A last and somewhat unexpected virtue, which the emperor left off his lists but clearly appreciated, was the ability to be with him in the field and even to ride and hunt. Physical toughness must have helped. The wives who could survive and enjoy the undoubted hardships of the emperor's many field trips had an obvious advantage in gaining his affections. But he seems to have had a special regard for women who

could ride a horse and join in the hunt. He was very fond of the Muslim consort Rong Fei, who traveled with him frequently and usually was among the women who went with him to the imperial hunting park at Mulan north of Chengde. He also is known to have taken his beloved tenth daughter to Mulan and to have appreciated her riding and archery.

The painting shown here embodies this non-traditional ideal (fig. 226). It depicts a scene of deer-hunting on horseback, with a young woman standing in her stirrups to hand an arrow to Qianlong while he shoots at a deer, with both horses at full gallop. The question is, who is she? Rawski in her sidebar essay (p. 184) suggests that she is probably the Tenth Princess. Researchers in the Palace Museum maintain that she is Rong Fei.[21] The present writers cannot believe that such a portrait of either an imperial consort or a daughter would have been permitted. We think a third possibility is worth considering, that she is a fictional embodiment of non-traditional feminine qualities admired by the emperor: supportiveness and grace in extreme situations, plus athletic skill. In theme and composition the painting resembles several others that show men rather than women passing the arrow to Qianlong.[22] Thus the painting with the woman represents a conventional type of incident but with a different protagonist. It clearly was important to the emperor, which is why he asked his son to take the highly unusual step of painting a wrapper for it

226
Taking a Stag with a Mighty Arrow
Artist: Attributed to Giuseppe Castiglione (1688–1766)
Color on silk; height 12 in. (30.5 cm)
1760s, Qianlong seals and calligraphy

A fine example of the new Europeanized style of realistic documentary painting, this short handscroll depicts an unusual subject, a woman hunting alongside the emperor. Who she was has been the subject of much controversy (see sidebar p. 184).

(fig. 227). He may indeed have identified the fictional subject with a real woman or women. We see no reason why she could not have reminded him both of Rong Fei and the Tenth Princess, and perhaps of other unrecorded Mongol or Manchu women as well.

Only Birds in Gilded Cages?

A step-grandmother of Qianlong, Ding Fei, was allowed by the Yongzheng emperor to move in to the home of her son on a permanent basis. As soon as he ascended the throne, Qianlong received requests from two other uncles for permission to have their mothers, his step-grandmothers, do likewise. He was uneasy at the idea but finally decided:

> Henceforth during the summer and winter festivals and at birthdays the two princes and other princes may each welcome widowed consorts into their mansions. They can reside there for a total of several months a year; the rest of the time they will live in the Palace.[23]

These senior ladies were lucky to have the opportunity to leave the Palace and to stay with their sons instead of their fellow widows. Most imperial wives did not have that chance. At night when the doors of Palace mansions were closed, they did not even have the freedom to escape in case of fire. The situation changed only in 1760 when a fire occurred at Qianlong's mother's Shou'an Gong mansion and the

eunuchs inside refused to open the door to let her out or the firefighters in. Fortunately, no lives were lost. Recognizing the seriousness of the problem, the emperor ordered that henceforth the relevant rules could be overridden in case of emergencies.[24]

Although authorized male residents could come and go from the Inner Court more or less freely, it was a tightly closed system for its female residents. Palace regulations in general forbade imperial women to leave the Inner Court at any time, and did not allow them to be visited by their natal family members without the emperor's permission. But the regulations tell only part of the story, as shown by the above-mentioned cases of the three old ladies.

The Palace seems not to have always been remembered bitterly by the women who had left it. Former

227
Wrapping for painting shown in fig. 226
Artist: Prince Yongrong
Silk brocade, jade clip; length 14¼ in. (36 cm)
1760s, Qianlong seals

Decorated with a painting of an autumnal scene that echoes the weather of the hunting season, this wrapping was unusual in that Qianlong's sixth son, Yongrong, did the painting and signed it "Son, Official," thus conveying a sense of family intimacy. The word "son" was rarely included on works of art. Qianlong showed his approval of Yongrong's work by stamping it with the seal he used for art appreciation. This painted wrapping was not registered in Qianlong's own painting catalogs, perhaps because it was too personal.

Rong Fei and the Fragrant Concubine

Evelyn S. Rawski

Rong Fei was the only Uighur Muslim among the forty-one consorts of the Qianlong emperor.[3] Born in 1734, she belonged to a branch of the Khoja lineage that opposed Khoja Jihan and aided the Manchu conquest of present-day Xinjiang. At age twenty-seven, shortly after her family was rewarded with noble titles and settled in Beijing, she entered the harem as a sixth-ranked *guiren*. Promotions in 1762 and 1768 raised her to the fourth rank, *fei*. She was childless and lived in the Imperial Palace until her death on May 24, 1788.

The attention paid to Rong Fei stems from legends concerning the Fragrant Concubine [Xiang Fei] that circulated in the early decades of the twentieth century through novels, operas, and plays. The daughter of Khoja Jihan, Xiang Fei was said to have been brought to the capital after the Qing conquest and to have entered the harem, but to have steadfastly resisted the Qianlong emperor's advances. When she refused to submit, the empress dowager supposedly had Xiang Fei killed. Xiang Fei's importance as a symbol of Uighur ethnic nationalism was fed by stories about worshipers at her tomb in Xinjiang, while Han Chinese writers drew on her legend to reinforce popular anti-Manchu sentiments.

Scholarly identification of the legendary Xiang Fei with the historical Rong Fei took place shortly after Rong Fei's coffin was opened in 1979. Located in the Eastern Tombs outside Beijing, it had been looted by grave robbers and was also severely damaged by flooding, but the skeletal remains and remnants of the textiles covering the body were used to support the archival records concerning Rong Fei's life history. In keeping with the official multiethnic policy of the People's Republic of China, articles now emphasized the emperor's kind treatment of his Uighur consort.

Attempts to identify women portrayed in Qing court paintings as Xiang Fei (or Rong Fei) stand on shaky ground. An oil portrait of a young woman in European armor was first identified in 1914 as Xiang Fei,[4] but no one has explained why a Muslim woman would be so attired. Some have suggested that Xiang Fei is the young woman on horseback accompanying the emperor in the hunt in fig. 226,[5] but given the traditional confinement of Muslim women to the harem, this figure is more likely to have been the emperor's tenth daughter, Princess Hexiao, who dressed in men's clothing, practiced archery, and did hunt alongside the emperor, killing a deer on at least one occasion.[6]

The popularity of the Fragrant Concubine legends testifies to contemporary concerns linked with ethnicity and nation-building. Rong Fei, the historical figure, exemplified in her life the strategies of incorporation that were successfully pursued by the Qianlong emperor. She was honored not only for herself but also because of her male kinsmen's role in the Qing conquest of the far West. Archival records detail the imperial favors of silver, jewelry, and goods that were bestowed on her as well as on her brother Turdi. Her coffin bears an inscription in Arabic, suggesting that the court honored her faith.

maidservants quite often returned to the Palace to socialize, which caused concern within the Imperial Household Department.[25] Likewise, some married imperial daughters returned frequently for visits to their mothers and friends. A certain number of alumnae evidently found warmth and renewable relationships in the Palace. It cannot have been all that prison-like.

228
The Qianlong Emperor on his First Inspection Tour to the South, Scroll 12: Return to the Forbidden City
(detail of fig. 112)

Here the empress dowager brings up the rear of the imperial party as it makes a ceremonial re-entry into the Palace after the emperor's tour to the South. Although sedan chairs could be used for long-distance travel, it seems probable that she traveled most of the way by boat or in a larger wheeled carriage.

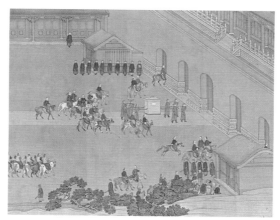

The only ones who never left the Palace were son-less wives of former emperors and out-of-favor wives of the current emperor. For imperial women such as these, life must have been intolerably dull. However, for the emperor's own mother and many of his wives, including some who were childless but loved by the emperor anyway, there were many events to break the tedium.

An imperial tour was one such event. Qianlong seems to have been fair-minded in distributing such favors. He almost always took five or six wives plus his mother along. Long-distance tours happened every two or three years, and trips to Chengde and nearer palaces happened annually. For his Southern Tour to the Yangtze delta region in 1765, for instance, he took his mother (fig. 228), the empress (Ula Nara), and six other consorts: Wei Huangguifei, Shu Fei, Yi Fei, Yu Keliyete Fei, Yu Boerjijin Fei, and Qing Fei.

Life in Beijing was not always tedious either. Numerous entertainments took place both in the

胭脂匀缀小桃枝別苑
春和二月時鏡戶團圞
清晝永揪枰斜倚共敲
棋竹籬石遅窗窓逗
漏春光日正眺怅底阿
香移步晚為拈紅綠誤
烹茶
御題

229

Ivory album: *Ladies Enjoying
Weiqi [Go] Game and Poem by
Qianlong*
Ivory work by Chen
Zuzhang, modeled after a
painting by Chen Mei
Ivory, gold, mother of pearl;
height 15⅜ in. (39.1 cm)
1741

One of twelve carved ivory
images in an album that
copies a series of paintings
by the court painter Chen
Mei. Each month depicts a
seasonal activity suitable for
court ladies. Here, in the
second month of the year, six
ladies are playing go while
two bring in tea and snacks.
Qianlong's poem, inlaid in
mother-of-pearl, praises the
idea of leisure in a pleasant
garden environment. Chen
Zuzhang was a renowned
ivory artist from Guangdong,
and this album was his
primary project during
his stay in Beijing.

women's winter quarters in the Forbidden City and in their summer residences in the Yuanming Yuan gardens. Many family members lived at the Summer Palace between December and July, with the emperor making short trips back to the Forbidden City for state rituals and celebrations. How many consorts went out to the Yuanming Yuan each year is not known. Perhaps only a favored few were on the list, or perhaps most of them packed up with their maidservants, eunuchs, and children just after New Year and moved with their possessions to the Yuanming Yuan. It is relatively certain, however, that the emperor's step-grandmothers and stepmothers stayed in the Forbidden City all year around. Their lives, and those of their personal servants, must have been the least enviable of any imperial women's.

Living in the summer palaces at the Yuanming Yuan and Chengde meant fewer physical restrictions and perhaps more relaxed regulations as well. This may have been part of the reason why the emperor's wives spent more time away from the Forbidden City than in it. Group activities in the Yuanming Yuan included excursions to Buddhist and Daoist shrines within the gardens, an annual Lantern Festival party hosted by the emperor in the women's quarters, dragon-boat races on Fuhai [Fortune Sea] Lake, going out in boats to view lotus flowers, and watching the floating lanterns released for the Hungry Ghost Festival. The year-round activities were conceptualized in court paintings and carvings, which typically illustrate one event for each month (fig. 229).

An important pleasure was shopping. In order to preserve proper seclusion for court ladies, Qianlong had a special market area built in the Yuanming Yuan gardens, in imitation of part of his favorite city, Suzhou. The market may have consisted of a row of shops on either side of a canal, like the modern reconstruction at the Yihe Yuan Summer Palace (fig. 230).[26] Goods for sale were brought in from outside, and eunuchs were trained to serve as shopkeepers and street vendors. To provide added excitement, staged bargaining sessions, commercial disagreements, and even thefts occurred from time to time. The shoppers

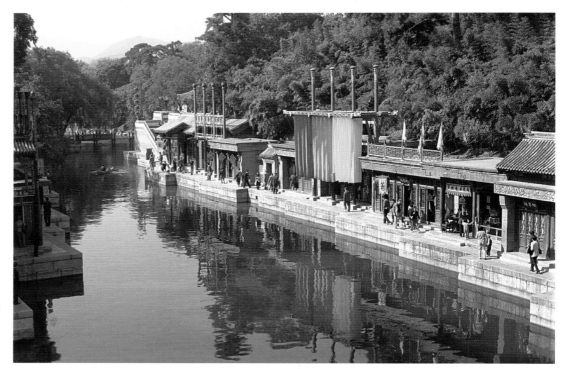

230

Market Street in the Yihe Yuan Summer Palace

All resort palaces, including those in the Yuanming Yuan and Chengde, seem to have included a shopping area to entertain the imperial family. The streets were usually modeled after shopping areas in the emperor's favorite city, Suzhou in central China (see fig. 110). This one is a recent reconstruction.

were exclusively court ladies, maidservants, and, one assumes, other eunuchs. They used real money from their allowances. Whether prices were high, fair, or low is not recorded.

As further evidence that Palace life was not all tedium and loneliness, we should consider a description left by the American artist Katherine Carl, who was commissioned to paint several oil portraits of Dowager Empress Cixi in the early 1900s. Carl lived for several months in the women's quarters of the Palace and was one of the few women of any nationality to produce a written eyewitness account of Inner Court life from a woman's point of view. Here she describes the Mid-Autumn Festival in the Yuanming Yuan gardens in 1903:

Their Majesties first made the bows and prostrations to the Moon, and placed floral offerings on the altar. Then the young Empress and the Ladies did likewise, while the eunuchs recited a poem in melodious and rhythmic cadence. ... When the recitation was finished, an "auto da fe" was made of the offerings, to which were added sticks of sweet incense and paper cut in curious designs. Over all was poured some of the inflammable wine from the flagons on the altar

and the flames leaped high above the huge incense burner that stood on a great bronze tripod in the center of the moonlit terrace. It was a wonderfully picturesque sight – the brilliant circle of splendidly gowned Ladies, with the Emperor and Empress Dowager in their midst, around the flaming censer, whose leaping flames glinted and glowed upon the jewels and gold embroidery of their costumes. The lantern-bearing eunuchs formed a faintly glowing circle around this shining center; and over the whole fantastic picture the brilliant Harvest Moon shone with unwonted splendor[27]

Raising an Emperor

When Qianlong's half-brother, Prince Guo, was seven years old, he was found watching fireworks instead of attending school. Worse still, the young prince ran from Qianlong when caught. Consequently the prince's chief eunuch was given sixty strokes of the cane, and the prince was severely scolded.[28] One day in 1766 a Palace memo revealed another source of imperial displeasure. Qianlong was upset because his eleventh son, who was fourteen years old, had given calligraphy and paintings to his younger half-brother

Provisions for Palace Ladies

Chuimei Ho

Official regulations specified living standards for Palace ladies of various ranks. This table lists some of the provisions supplied to the empress, two grades of consort, and maidservants. Empresses evidently lived much better than most consorts, not to mention maids.

Empress (1st rank)

Utensils: 36 gold, 105 silver, 46 bronze, 65 pewter, 16 iron, 1014 porcelain, and 68 lacquer items; 34 lamps

Cash: 1000 ounces silver

Textiles & fabrics: 150 rolls silk, 20 rolls gold thread, 50 catties other thread, 90 furs

Milk-cows: 100

Maids: 10

Food (daily): 16 catties red meat, 3 fowl, 15 catties vegetables, 10 eggs, 4.5 *sheng* rice, 2.4 catties seasoning

Fuel & Light (daily): 60–80 catties charcoal, 30 candles

Fei (4th rank)

Utensils: 6 silver, 12 bronze, 15 pewter, 2 iron, 83 porcelain, 4 lacquer items; 1 lamp

Cash: 300 ounces silver

Textiles & fabrics: 80 rolls silk, 10 rolls gold thread, 28 catties other thread, 28 furs

Milk-cows: 4

Maids: 6

Food (daily): 9 catties red meat, 20 fowl (monthly), 10 catties vegetables, 1.35 *sheng* rice, 0.9 catties seasoning

Fuel & Light (daily): 30–50 catties charcoal, 6 candles

Changzai (7th rank)

Utensils: 5 bronze, 5 pewter, 1 iron, 38 porcelain, 1 lacquer items; 1 lamp

Cash: 50 ounces silver

Textiles & fabrics: 9 rolls silk, 3 catties other thread

Maids: 3

Food (daily): 5 catties red meat, 10 fowl (monthly), 6 catties vegetables, 1.2 *sheng* rice, 0.6 catties seasoning

Fuel & Light (daily): 30 catties charcoal, 3 candles

Maid (no rank)

Cash: 6 ounces silver

Textiles & fabrics: 6 rolls silk, 2 catties other thread

Food (daily): 1 catty red meat, 0.8 catties vegetables, 0.75 *sheng* rice, 0.05 catties seasoning

1 catty = 605 grams (1 pound 3½ ounces), 1 sheng = approx 2 pints (1 liter)
Source: Qinggui *et al.* 1965

and signed them with his studio name. The emperor condemned the gift and the use of a studio name as part of a pretentious game practiced by scholars but unworthy of princes. He posted a notice to that effect for all of his sons and their teachers to see.[29]

As in previous dynasties, imperial sons during the Qing period had stressful childhoods. Although they lived with their mothers until the age of five or six, child-rearing decisions were made by a series of wet nurses, nannies, eunuchs, and teachers. Most very young princes rarely saw their fathers. The painting shown in fig. 232 is substantially fictional. The emperor and his wives may never have stood in a doorway on New Year's Day watching their sons set off firecrackers.

One historian has described the emotional burden this upbringing imposed: "None of the imperial princes had a normal boyhood, growing up under the care and close direction of parents, forming boyish friendships with sons of other families, learning how to be human beings in the patterns that prevailed among their subjects of whatever social level. Imperial children were psychologically deprived." He goes on to speculate that Qianlong in his youth may have experienced even more family stress due to his father, Yongzheng, having executed or imprisoned so many

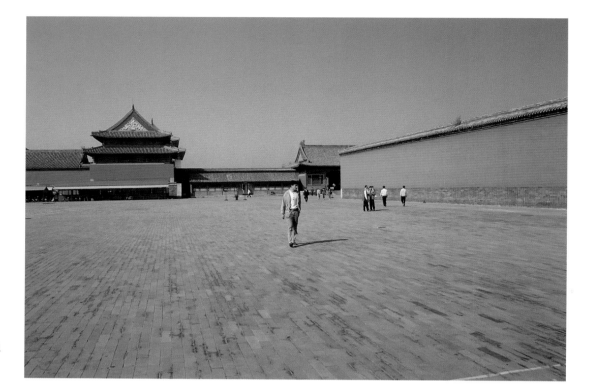

231
Space north of Archery Pavilion, Forbidden City

This empty space was used for archery training in Qianlong's day.

of his own brothers: "Jealousy and hatred filled his court and provided a grim atmosphere in which the young Prince Hongli, the future Qianlong emperor, was reared. That atmosphere must have deeply affected the young prince ... It cannot have been less than a defining element in the environment in which he spent his early years."[30]

The education of a prince was intensive. At the age of five or six he entered the Palace school to study with other princes and the sons of high-ranking Banner officials, under carefully selected tutors. The boys attended classes from 5 am through 2:30 pm, studying in sequence Manchu, Mongolian, and Chinese. After lunch, they practiced archery, on foot when in the Forbidden City (figs. 18, 231) but on horseback as well when at the Yuanming Yuan. Princes were given only five regular holidays per year: New Year's Day, the Dragon Boat Festival, the Mid-Autumn Festival, the emperor's birthday, and their own birthdays.[31]

Even though a prince was not supposed to bow to anyone except his mother, father, and father's mother, the Yongzheng emperor told his sons also to bow respectfully to teachers. When it turned out that the teachers were afraid to have a potential future emperor humble himself before them, Yongzheng said that the princes could bow to the teachers' empty chairs instead.[32]

Ordinarily, princes of school age did not have much time with their parents. Qianlong's sons left their mothers' residences when they first entered school. In the Forbidden City they moved into the Eastern Five Blocks, the princes' dormitories. Similar facilities existed in the Yuanming Yuan, which had a similar princes' school and dormitory.[33] Young teenaged princes might move quite often. Hongli, the future Qianlong, not only spent a summer with his grandfather Kangxi at Chengde when aged only eleven but also lived in the Yuanming Yuan and at least three buildings within the Forbidden City.

The youthful Hongli was something of a child prodigy. His exceptional memory enabled him to assimilate the basic classical Chinese literary texts at an early age, to become fluent in spoken and written Chinese and Manchu, to achieve an adequate command of Mongolian as well, and to gain a comprehensive grounding in the more practical aspects of government. Although never more than an industrious and well-trained painter, his youthful calligraphy – all-important in traditional Chinese eyes – became "pure and strong ... [with] a spirited, elegant feel."[34]

Emperor Qianlong's Pleasure during Snowy Weather
Artist: attributed to Giuseppe Castiglione (1688–1766)
Color on silk; 151 × 63 in. (384 × 160.3 cm)
c. 1738, Qianlong seals

Qianlong appears in the company of nine boys and two ladies in a courtyard where the trees known as the Three Friends of Winter bloom. It is a scene of a happy Han Chinese family at New Year time, with boys playing with lanterns and firecrackers while their parents look on contentedly. A similar painting was signed by six artists, including Castiglione, in 1738. This one must have been painted at the same time and by the same hands. Qianlong liked it. The three seals on the painting, added after he had turned seventy, are the same as those in fig. 60.

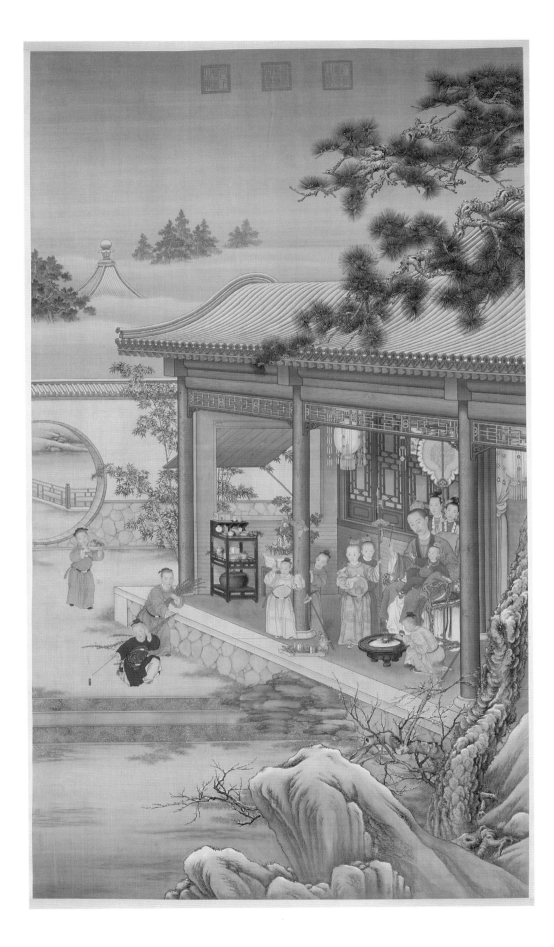

He evidently also learned to read and write with unusual speed. Few executives in any culture can have gotten through as much paperwork each year as did Qianlong, and few professional writers can have matched his prodigious literary output, which included thousands of prose essays and more than forty thousand printed or otherwise published poems, many of them quite long.

Of real relevance to the Manchu image of an ideal emperor, Hongli was more than a bright bookworm, being also tall, athletic, and brave. His grandfather, the Kangxi emperor, singled him out as a favorite among his ninety-seven grandsons, taking him on hunting trips from the age of eleven. Qianlong often referred in his writings to his warm, caring grandfather:

> I was 12 years old [11 by Western reckoning] and was allowed to accompany the holy grandfather to Rehe [Chengde] for the summer. He read or wrote whenever he could get away from his numerous office tasks. I admired his work but only observed quietly without asking for anything. The holy grandfather looked at me and said, "Do you like my calligraphy?" I was then given a long scroll, a horizontal scroll, and a fan. I took these to my father, and have treasured them since.[35]

The old emperor Kangxi, an ardent hunter and fine athlete in his youth, is said to have approved of his grandson's coolness when attacked by a bear (see sidebar p. 110). Proud of his own skill with horses, bows, and guns, Kangxi seems to have been favorably impressed by the fact that young Prince Hongli, the future Qianlong, could handle the first well and shoot the last accurately. But it is going too far to conclude, as a number of commentators and Qianlong himself suggested in later years, that Kangxi chose young Hongli's distinctly non-athletic father to succeed him solely because Kangxi foresaw that Hongli would become an ideal Manchu emperor in the next-but-one generation. In reality, Kangxi had other talented grandsons as well, and was far too experienced in dynastic politics to think that anyone could force the choice of a particular emperor two generations into the future.

Nonetheless, either Yongzheng read the mind of his father or the two emperors thought alike. Hongli was secretly appointed crown prince in the first year of Yongzheng's reign. Even though Hongli was not supposed to know about the appointment until his father passed away, he received strong hints. In his reminiscences, Qianlong recalled that when he was only thirteen he had a conversation with his father, the new emperor Yongzheng, to thank him for the gift of two of Kangxi's pearls as a keepsake.[36] Yongzheng used the opportunity to test his son's views on picking talented officials, and later did what the prince suggested. In later years Qianlong treasured a painting, supposedly commissioned by his father, that showed father and son engaged in a mysterious exchange in a rather surreal bamboo grove (fig. 233). Qianlong must have read this exchange retrospectively as an indication that Yongzheng had long intended to pass the torch to him.

When Hongli became a parent himself, he followed court regulations and disciplined his children quite strictly. In the second year of his reign as Qianlong he issued an order "to let the mothers and consorts know that clothing for young princes and princesses need not be lavishly embroidered or woven. Just give them regular clothing. This is a way of making merit for them."[37]

He was over-fond of offering himself as an example to his sons and nephews:

> Manchu, Mongol, and Han all have their own reasons for doing things. Just take studies of Han culture. Many know that what I have learned is a lot more than the average Han scholar knows. This is because I study very hard. You are all descendants of Nurgaci, but look where you are now. I feel sorry for you. You should heed my teaching today as though our ancestors were warning you from heaven. Keep away from bad habits. Follow tradition. Live up to the blessings of our ancestors. How could you not be mindful now?[38]

When it came to the political side of raising princes, Qianlong and his father both had learned from the painful experiences of Kangxi that officials were likely to try to form political cliques by allying themselves with princes. The rule of thumb was to forbid princes to socialize with officials for any personal reason. In 1763 Qianlong's younger half-brother, Prince Guo, who was brought up and frequently disciplined by Qianlong, was found to have contacted the officer in

233
Spring's Peaceful Message
Artist: Giuseppe Castiglione
(1688–1766)
Color on silk; length 27 in.
(68.8 cm)
1723–35, Yongzheng period,
Qianlong seals and text

This is the only painting of
an encounter between an
imperial father and adult son
known from any period of
Chinese history. Dressed in
Han Chinese costume,
Yongzheng and the youthful
Qianlong are the central
figures in a bleak, surreal
landscape. The inscription
is by Qianlong, added in
1782, stating that he had
re-examined this painting at
the age of seventy-two and
was pleased by Castiglione's
technique of portraiture. The
family resemblance between
the father and son is indeed
very strong. Was the painting
meant to indicate that the
young prince would inherit
the throne? Was it only
whimsy? Those who knew
did not say.

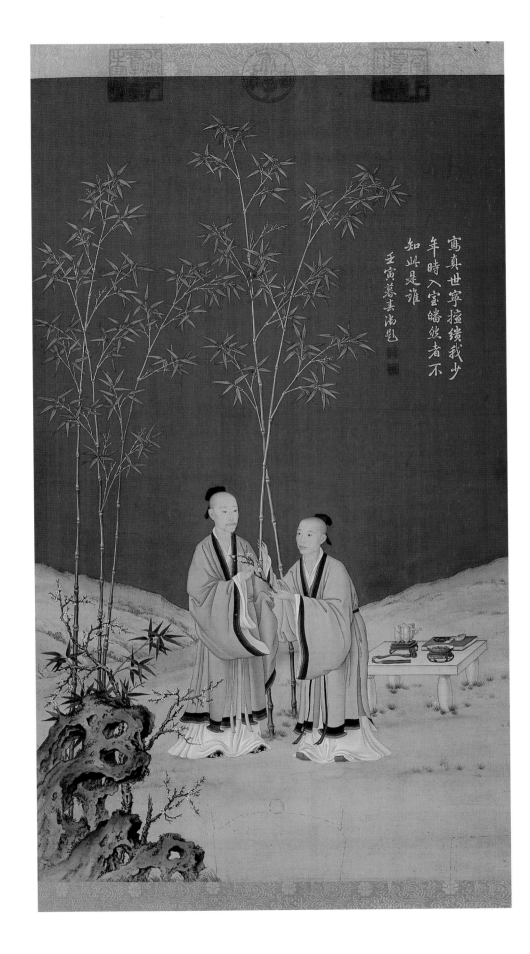

寫真世寧擅繢素
年時入室晤然者不
知此是誰
壬寅暮春御筆

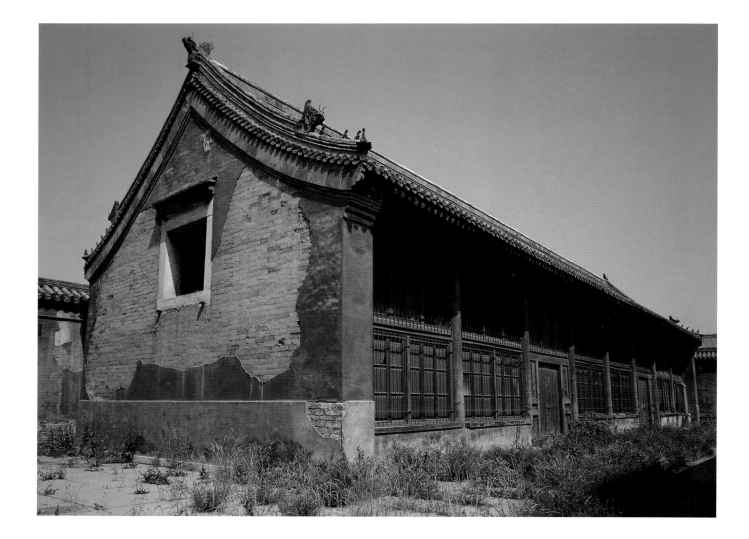

234

Imperial Kitchen in the Forbidden City

The Imperial Kitchen, Yucha shanfang, supplied daily meals to the emperor. Banquet food was prepared by another department. Keeping the food warm must have been a challenge, as the kitchen was some distance from the office-residence where the emperor usually dined.

charge of fabrics and garments at the Suzhou Imperial Textile Factory, to have maintained friendly correspondence with the son of that officer, and to have asked favors from officers of the Salt Administration who happened to be cousins of one of the emperor's consorts. All parties involved were penalized, including Prince Guo.[39]

To be fair to Qianlong, he was severe not only with his half-brother. His sons, too, were disciplined for their faults. In 1770 he caught two sons taking leave from the Palace school without notice. One of them, the Eighth Prince, even left the Palace compound without permission. It is easy to understand why Qianlong was upset about his sons being truants. What is surprising is that the princes in question were thirty-one and twenty-four years old, and that both were still attending school. In 1766 he scolded one of

his sons for bringing an outside barber into the Palace to shave his head.[40]

To show approval, Qianlong rewarded his children with projects. In spite of his disgust about sons indulging in foolish scholars' antics, he seems to have appreciated the landscape-painting skills of his sixth son, Yongrong. Qianlong asked Yongrong to decorate the cloth wrapping of the scroll that depicted the emperor hunting on horseback accompanied by a woman. On the top right-hand side of the painted wrapping the emperor stamped a seal to show his approval, "Treasure of Qianlong" (see fig. 227). If indeed the lady with Qianlong was Rong Fei, the scroll represents a surprising relationship between three people: the emperor, a favored consort, and an artistic son.

Like his father and grandfather, Qianlong often appointed his sons to stand in for him at state rituals,

brought them along on trips, and placed them in official positions. These activities were meant to prepare them for running the country. In 1770 the emperor's fourth son was in charge of the imperial publishing house, his sixth son was helping with the Imperial Household Department, and one of his grandsons was in the army.[41] In 1784 he took his eleventh, fifteenth, and seventeenth sons on his Southern Tour of that year, and in 1789 he took the same group to Shenyang. It is believed that by then Qianlong had secretly designated one of the three as his successor.

As early as 1773, the emperor at sixty-three was already being pressed to choose a crown prince. He had six living sons to consider, none of them of real star caliber. Only two of the six, the eleventh and the fifteenth, were serious possibilities. The others were out of the running by dint of their being too young or their having been too often tested and found wanting, or because they were no longer sons from a legal standpoint, having been given for adoption to another branch of the imperial family. The eleventh son was a twenty-one-year-old, while the fifteenth was only thirteen. After long thought, Qianlong placed his money on the thirteen-year-old. He himself had been thirteen when secretly made crown prince by Yongzheng, and he may have hoped that the younger son, the future Jiaqing emperor, would be a surprise and turn out to be another great Qing ruler. Sadly, that hope did not come to fruition. As China's disastrous nineteenth century showed, Qianlong himself was the last of the great ones.

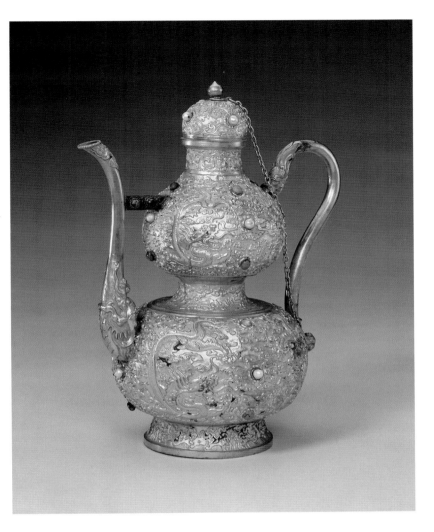

Dining in the Palace

In the early evening on the 8th day of the 2nd month of 1776, Qianlong ordered a plate of steamed crab and four other dishes for his evening snack. After finishing his own food, he gave the crab dish to Qing Guifei, a third-ranked consort.[42] This entry in the court records is revealing in several ways. It is almost certain that the lady in question was the selected bed partner of the evening. Qianlong was known to dislike seafood, especially shellfish, yet he was thoughtful enough to order a dish for his lover. He and she ate at different times, however. She did not eat until he was done.

An interesting feature of imperial meals was food sharing. As the emperor could not possibly eat the enormous quantity of food served to him each meal, he regularly shared it with others. Almost invariably, the direction of food sharing was from the emperor downward: to wives, princes, officials, and even his personal

235
Gourd-shaped ewer for wine
Gold, pearls, rubies, coral, other semi-precious stones; height 11¼ in. (28.8 cm)
1736–95, Qianlong period

The emperor used gold tableware at formal banquets. The gold signified political stability.

236

Portable stove for tea

Copper in clay-lined basketry; height 9 in. (23 cm)

c. 1751

In 1751, while visiting a monastery in Wuxi near Suzhou, the emperor drank tea brewed from water heated on a simple antique stove like this one. Giving the stove credit for the excellence of the tea, he had two copies made, of which this is one. The stove appears in several paintings that show Qianlong as a solitary scholar dwelling in the wilderness.

237

Ice box decorated with floral scrolls

Cloisonné enamel on wood, lined with lead sheet; width 28½ in. (72.5 cm)

1736–95, Qianlong mark and period

There is a hole at the bottom of the box for draining water and two holes in the lid for letting out cool air, thus making this splendid box into an air conditioner. As plain bronze ice boxes lined with pewter sheets were allotted to the empress and empress dowager, this cloisonné box was probably for Qianlong himself. It is one of a pair returned to the Palace Museum in 1985, having been removed from the Palace in the 1920s.

238
Teapot for serving milk tea
Silver body with repoussé
gilt-bronze fittings; height
7 in. (18 cm)
1736–95, Qianlong period

The Manchu, Mongolian,
and Tibetan style of tea
drinking involved mixing tea
with butter and milk. The
regular Han Chinese tea style
allowed no such additions.

servants. It was an honor on the recipient's side. The only ones who could reciprocate by offering food to him were his mother and, occasionally, his wives.

Like his imperial predecessors and successors but unlike heads of ordinary families, Qianlong usually dined alone. He had breakfast in the early morning at about 6 am and lunch at about 2 pm. These were his only fixed meals, but he usually ate one or more snacks in the early and late evening. Also unlike ordinary family homes, where food was eaten in a designated place, the emperor's home did not have a dining-room. He and his family ate where they liked, off tables that had been temporarily set up. Qianlong often ate in his office-study.

Qianlong was very fond of duck but he also liked chicken and pork. He did not like fish or any other seafood.[43] He received a great deal of dried and fresh seafood in the form of tribute goods, often when on tours to the Northeast and elsewhere, but promptly gave almost all of it away.[44] Like all good Manchus, he did not eat beef; surviving menus of the court show no beef dishes at all. He loved birds'-nest soup and

was an enthusiast for the traditional Manchu snacks and pastries called *bobo*. Otherwise, his tastes ran to the sophisticated Han Chinese cuisine of Suzhou in central China; he consistently ordered Suzhou food for himself even at formal banquets where one would think that Manchu food would have been a more appropriate choice (see fig. 234).[45]

He drank little alcohol although he used ornate wine vessels (fig. 235). On the other hand, he enjoyed tea. A custom particularly popular among scholar-officials in the Yangtze delta, tea of course was more than a drink. Tea connoisseurship was an art promoted by those who favored the elegantly simple lifestyle of the scholar-official classes of the Suzhou-Yangzhou-Nanjing-Hangzhou area. Qianlong's teaware collection shows that he, too, used the Yixing earthenware teapots favored by those scholar-officials (see fig. 296). Moreover, Qianlong also made copies of an antique stove that he saw being used by an intellectual monk in the Wuxi-Suzhou area (fig. 236). Han Chinese connoisseurs might doubt his commitment to fine green tea upon learning that he regularly drank tea with

239

**Flagon with dragon handle
and phoenix spout**
Porcelain; height 18½ in.
(47 cm)
1736–95, Qianlong period

The shape of this *duomu*
vessel derives from the
wooden flagons used by
Mongolians and Tibetans
to drink barley beer and
fermented mares' milk. That
this one is made of porcelain
imitating wood reflects
Qianlong's fondness for
material mimicry.

milk and used ostentatiously decorative tea kettles (fig. 342). The problem of keeping milk fresh was solved by using ice boxes (fig. 237). When he traveled, he took along a herd of milk-cows.

The Manchu custom of drinking tea with milk was shared by Mongolian and Tibetans. When those ethnic groups were entertained by Qianlong at formal occasions, the food was most likely in Manchu style with culturally sensitive tableware that included teapots for Manchu milk tea and beer pitchers in Tibetan style

(figs. 238, 239). Formal banquets in celebration of such late fall and winter events as the New Year, the Winter Solstice, and the emperor's birthday usually were held at the Hall of Supreme Harmony [Taihe Dian] in the Forbidden City.[46] At one medium-sized banquet in the Hall, no fewer than 300 sheep were cooked for 210 tables. The cooks of the Imperial Household, being well tuned to ethnicity issues, served set meals in both Chinese and Manchu styles, all carefully graded according to the eaters' ranks.[47]

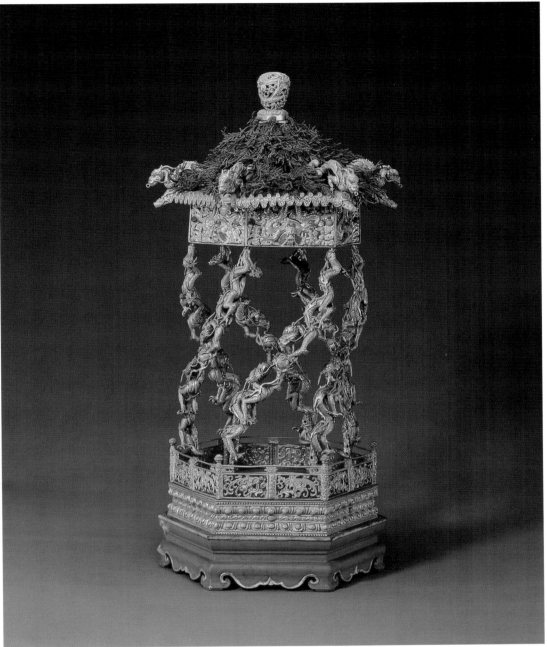

240
Fruit container
Gilt bronze and cloisonné enamel; height 23⅝ in. (60 cm)
1736–95, Qianlong period

Four containers such as this would have been standard furnishings for the emperor's table during banquets. They very probably held fresh fruit.

The Lantern Festival, the fifteenth day of the New Year, was one of the few occasions when Qianlong ate with his family. He dined separately with male and female family members. But not everyone was invited: only those who were currently in favor got to come. Westerners might find that the tableware prescribed for this kind of banquet was exceptionally well coordinated, and that the eating utensils are quite familiar. The emperor used cloisonné bowls and dishes (figs. 240–43), gold and jade chopsticks (fig. 245), a napkin (fig. 249), a spoon, a fork, and a knife (figs. 246–48). The knife and napkins were touches of Manchu ethnicity. Manchu men were supposed to cut their meat themselves so as not to fall into the decadent Han Chinese habit of eating their meat pre-cut. Even though the occasion was meant to be a party, Qianlong would have to sit by himself at a large table dominated by fruit containers and numerous dishes (fig. 250).

The ladies who dined with the emperor on this special occasion were provided with ceramic and lacquer

241
Large bowl with longevity characters
Cloisonné enamel; rim diameter 6 in. (15.2 cm)
1790

Four characters, which read "boundless longevity," are part of the cloisonné decorative patterns. Another four characters, "forever treasured by children and grandchildren," are engraved on the base of each vessel in this set of bowls and plates.

242
Small bowl
Cloisonné enamel; rim diameter 4½ in. (11.5 cm)
1790

243
Small plate
Cloisonné enamel; rim diameter 4¾ in. (12.3 cm)
1790

244
Pair of vases
Cloisonné enamel; height 10¾ in. (27.5 cm)
1736–95, Qianlong mark and period

The vases once held silk artificial flowers and were part of the cloisonné tableware sets used by Qianlong for formal banquets. The bowls and plates, and perhaps these vases as well, were made specially for Qianlong's eightieth birthday.

245
Pair of chopsticks joined by a chain
Workshop: Baoyuan
Gold; length 9¼ in. (23.4 cm)
1736–95, Qianlong period

246
Spoon with a spiral handle
Workshop: Baoyuan
Gold; length 7⅝ in. (19.4 cm)
1736–95, Qianlong period

The spoon, fork (fig. 247), and chopsticks (fig. 245) were made as a set by a commercial workshop, Baoyuan, probably in Beijing. The eighteenth-century Han Chinese rarely used forks and knives at the table. As a Manchu, however, Qianlong used both.

247
Fork with a spiral handle
Workshop: Baoyuan
Gold; length 7⅝ in. (19.4 cm)
1736–95, Qianlong period

248
Knife with a sheath
Gold, sheath with turquoise, coral, lazurite, nephrite jade handle; length 11⅝ in. (29.7 cm)
1736–95, Qianlong mark and period

The use of personal knives at meals was a mark of Manchu identity. When eating sacrificial pork, not only men but also women were expected to cut up their own meat. Knives with other eating utensils formed part of the dowries of princesses and even maidservants.

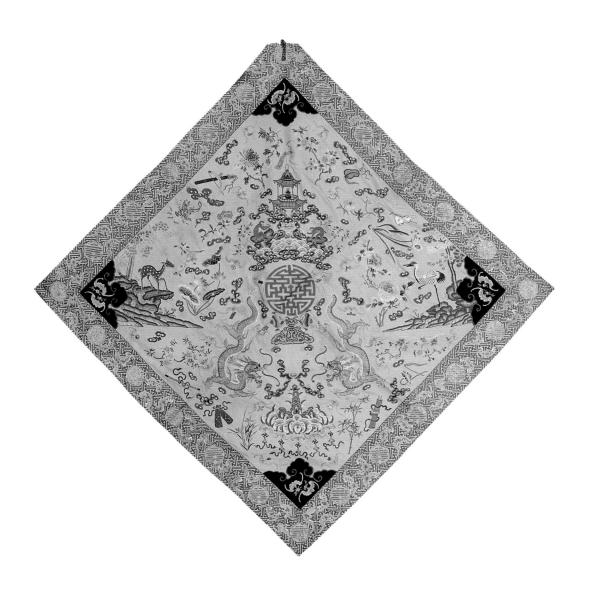

249
Square napkin [*huaitang*]
Yellow silk with embroidery; 28¾ × 27½ in. (73 × 70 cm)
Nineteenth century

This napkin is full of auspicious birthday symbols. A stylized character for longevity is in the center, with a crane and a deer on both sides and a pavilion rising above water, all meant to signify long life. Other auspicious designs include bats, the eight symbols of the Daoist immortals, and flower sprays of the four seasons. The pair of five-clawed dragons definitely places the owner in the top rank of imperial personnel.

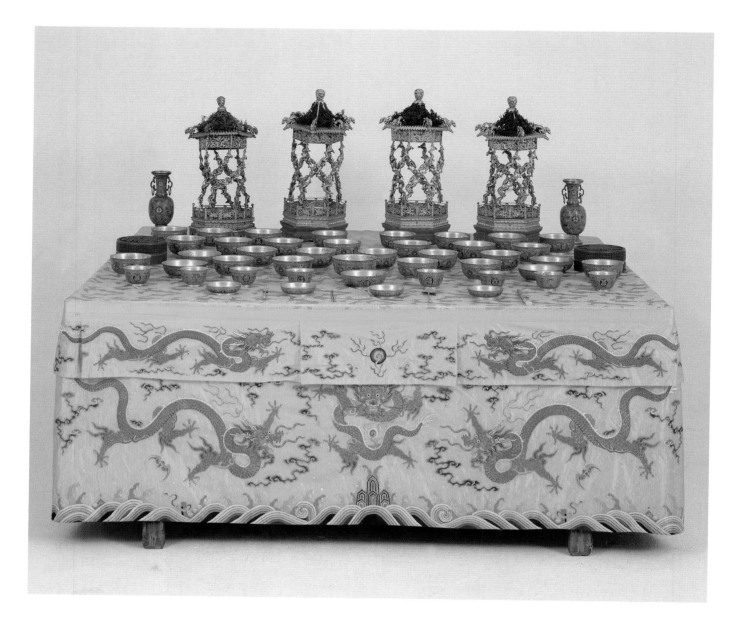

250

Reconstruction of the emperor's banquet table

The existence of detailed archival material has allowed the reconstruction of such details as imperial table settings. The four openwork containers were probably for fruit. The two cloisonné vases would have held silk or paper flowers.

wares that fitted their rank. According to Palace regulations, a fourth-rank *fei* consort used yellow-glazed ceramics with green dragons (fig. 251); a fifth-rank *pin* used blue-glazed ceramics with yellow dragons (fig. 252); a sixth-rank *guiren* used green-glazed ceramics with purple dragons; and a seventh-rank *changzai* used polychrome ceramics with red dragons (fig. 254).[48] All ladies were provided with gold and jade chopsticks, spoons, and forks but not with knives (figs. 255–60). Silver plates were for side dishes (figs. 261, 262), and lacquer boxes for food (fig. 263). Their bibs were more substantial than the emperor's (figs. 264, 265).

As a relief from the elaborate protocol required for formal banquets, Qianlong may have found picnick-

ing and barbecuing attractive alternatives. Perhaps that was why his birthday celebration was often spent in Chengde to coincide with hunting tours. Yet Qianlong was always a man for breaking records even in culinary matters. He is known in Chinese court history for having hosted the largest dinner party ever held in the Forbidden City. Kangxi was the first to hold a special banquet to honor seniors. A total of four such "Thousand Elderly Banquets" took place during the Qing, but the two hosted by Qianlong were extraordinarily lavish. The last and the largest one took place on New Year's Day in 1796, when Qianlong, himself eighty-five, hosted almost five thousand elderly officials and senior citizens aged seventy and above.[49]

Notes

1. Waley 1970, p. 25.

2. Data in this paragraph from QDGZXXZL 1979, *juan* 3, pp. 397, 592; Liu 1997, p. 260.

3. Data in this paragraph from ZGNWFXXZL 1937, Zhangyisi section, *juan* 2, pp. 8, 20, 25; Kuaijisi section, *juan* 3, p. 47; and from QDDQTL, *juan* 23, p. 9, *juan* 17, p. 29.

4. Wei 1982, pp. 24–25.

5. DQGZCHDSX, *juan* 236, 12th month, 60th year, p. 16.

6. Yao Wenjun, *Gongting yinshi* [Food for the court], Zhongguo huangshi congshu [Chinese imperial families series], vol. vii, Wuchang (Huazhong ligong daxue chubanshe) 1994, p. 165.

7. Zhang 1998, p. 15.

8. DQGZCHDSX, *juan* 262, 5th month, 7th year, p. 1.

9. Data in this paragraph from DQGZCHDSX, *juan* 236, Ql60; Qinggui *et al.* 1965, *juan* 4, pp. 65, 72. Yet Prince Zhaolian as an imperial clan member noted that Qianlong was often advised by the mother to spare lives by not starting so many wars (Zhaolian 1980, p. 21).

10. Ma Dongyu, "Historical Gossip about Qianlong's Mother," *Forbidden City*, 2000, no. 1, p. 22.

11. QDGZXXZL 1979, *juan* 1, pp. 62–63.

12. Larsen 1998, p. 30.

13. ZGNWFXXZL 1937, Guangchusi, *juan* 4, p. 79; Qinggui *et al.* 1965, *juan* 8, pp. 265–82.

14. QDGZXXZL 1979, *juan* 2, Minghao subsection, p. 229.

15. With the exception of Yongzheng's empress, who entered his household with dowries supplied by her father – a member of the Manchu élite. See Rawski 1998, p. 143.

16. QDGZXXZL 1979, *juan* 1, p. 26; see also Rawski 1998, pp. 132–33.

17. Tong 2001, II, p. 768.

18. *Ibid.*, p. 767.

19. Tong 2001, I, p. 258.

20. Qinggui *et al.* 1965, *juan* 55, pp. 1851–58.

21. Yang Boda, "A Qing Concubine's Portrait in her Dress of the Hui Nationality," *Forbidden City*, 1984, no. 1, pp. 6–8, 22.

22. Beiping gugong bowuyuan 1998, pp. 39, 67.

23. Rawski 1998, p. 139.

24. DQGZCHDSX *juan* 265, 25th year, 9th month, p. 17.

25. QDGZXXZL 1979, *juan* 1, p. 24.

26. Prince Zhaolian wrote in the early nineteenth century that in 1761 Qianlong built a Suzhou-style market for his mother's birthday (Zhaolian 1980, p. 357). This was burned by European soldiers in 1860. The "Mai-mai" [Market] Street that tourists see when visiting the Yihe Yuan Summer Palace nowadays is a reconstruction dating to the 1980s.

27. Carl 1986, p. 158.

28. DQGZCHDSX, *juan* 265, 1st month, 4th year, p. 5.

29. Qinggui *et al.* 1965, *juan* 1, p. 1166.

30. Mote 1998, p. 14.

31. Zhang 1998, p. 28.

32. Qinggui *et al.* 1965, *juan* 3, p. 42.

33. Zhang 1998, pp. 28–31.

34. Wang 2002, pp. 83–89.

35. Tong 2001, II, p. 930.

36. Qinggui *et al.* 1965, *juan* 69, p. 2142.

37. DQGZCHDSX, *juan* 265, 6th month, 2nd year, p. 4.

38. Tie 1991, p. 312.

39. Tong 2001, I, pp. 163–67, 170–71. Prince Guo supposedly died of depression after being demoted to second-rank prince. According to Zhaolian, Qianlong regretted having been too heavy-handed with Prince Guo. Zhaolian noted that Prince Guo was an excellent poet and good at managing his household (Zhaolian 1980, p. 181).

40. QDGZXXZL 1979, *juan* 1, p. 54.

41. Qinggui *et al.* 1965, *juan* 1, p. 1168.

42. Wu 1953, p. 83.

43. Ho 1998, pp. 78–79.

44. *Ibid.*, p. 79.

45. *Ibid.*, p. 78.

46. Zhang Min, "A Brief Discussion of the Banquets of the Qing Court," in Ho and Jones 1998, pp. 67–72.

47. Zheng and Qu 2000, pp. 32–36.

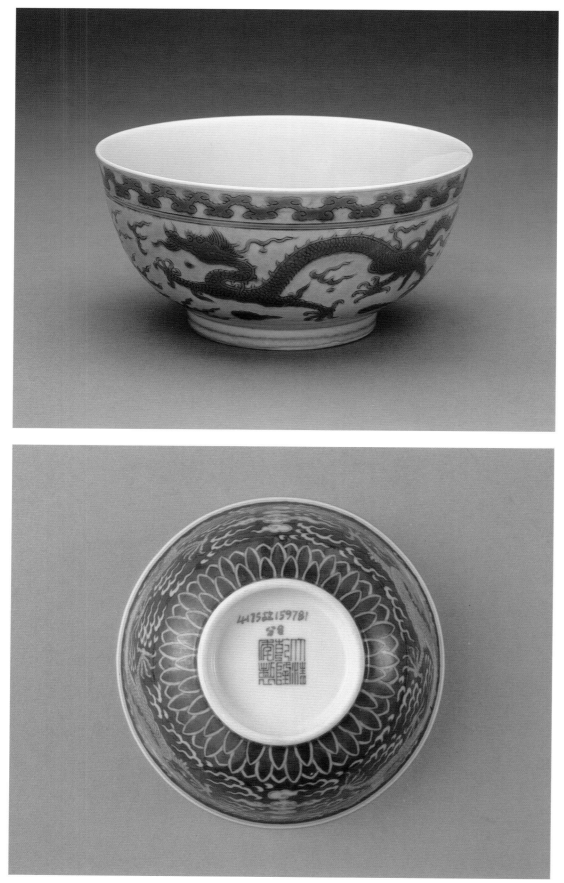

251
Bowl with green dragons on a yellow background
Porcelain; height 3⅛ in.
(8 cm)
1723–35, Yongzheng mark
and period

On the outside of the bowl,
two five-clawed dragons each
chase a pearl. On the inside
at the bottom is a dragon of
the same design. Bowls with
this combination of glaze
color and with five-clawed
dragons were used by a
fourth-rank consort, *fei*.

252
Bowl with yellow dragons on a blue background
Porcelain; height 2⅛ in.
(7 cm)
1736–95, Qianlong mark and
period

The bowl is similar in design
to that shown in fig. 251
except for the color
combination and border
details. These colors were
for fifth-rank consorts, *pin*.

253
Interior of bowl shown in
fig. 252

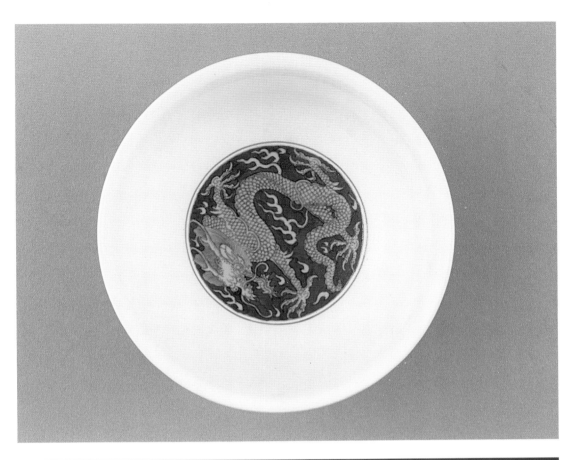

254
**Bowl with green dragon on
a blue background with
colored clouds**
Porcelain; height 2⅛ in.
(6.4 cm)
1736–95, Qianlong mark
and period

The bowl is of the same
design as that shown in
fig. 251 except for the color
combination and border
details. Bowls of this color
may have been used by a
seventh-rank consort,
changzai.

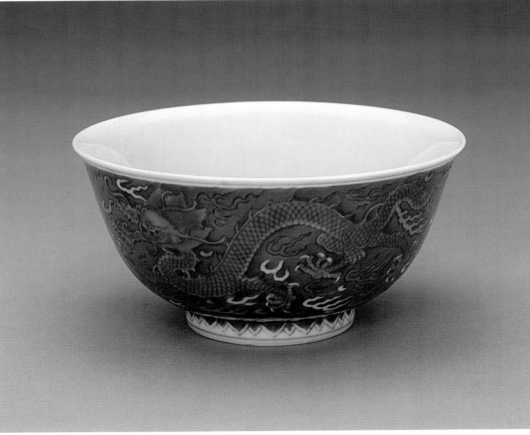

255
Pair of chopsticks
Gold, nephrite handle; length
11⅜ in. (28.9 cm)
1736–95, Qianlong period

The empress dowager,
empress, and princesses
could use chopsticks made
of gold and ivory. The Tenth
Princess's exceptionally rich
dowry included two pairs of
gold and nephrite chopsticks.

256
Pair of chopsticks
Gold, nephrite, wooden
handle with silver wire inlay;
length 10¾ in. (27.5 cm)
1736–95, Qianlong period

Most imperial ladies used
silver-covered ivory
chopsticks. It is likely that
higher-grade utensils were
used for special occasions.

257
Spoon
Gold, wooden handle with
gold and silver wire inlay,
nephrite jade finial; length
9½ in. (21.8 cm)
1736–95, Qianlong period

258
Spoon
Gold, nephrite jade handle, gold finial; length 7⅝ in. (19.5 cm)
1736–95, Qianlong period

At the end of the handle is engraved a "happiness" character.

259
Fork with handle finial in the shape of a bird
Gold, wooden handle with gold and silver wire inlay, nephrite jade finial; length 8½ in. (21.8 cm)
1736–95, Qianlong period

The wooden handle is decorated with forty-eight *shou* [longevity] characters.

260
Fork with bat and coin design
Gold, nephrite jade handle; length 7⅝ in. (19.5 cm)
1736–95, Qianlong period

The six items shown in figs. 255–60 form two sets of eating utensils for imperial ladies at banquets.

261
Dish for condiments
Silver; rim diameter 3⅝ in. (9.3 cm)
1736–95, Qianlong period

Silver plates were suitable for consorts of second rank or below.

262
Dish
Silver; rim diameter 3⅝ in. (9.3 cm)
1736–95, Qianlong period

263
Round box
Lacquer, engraved and inlaid with colored lacquer; rim diameter 10½ in. (26.6 cm)
1736–95, Qianlong period

Such boxes held bowls of soup as part of the table service.

264
Bib in yellow fabric
Silk; 32¼ × 20½ in.
(82 × 52 cm)
1736–95, Qianlong period

Both this piece and the one
shown in fig. 265 are made
of "Muslim" cloth decorated
with geometric medallions
and supplementary silver
thread. Foreign textiles were
given to the court as tribute
gifts and were sometimes
redistributed to imperial
ladies. Qianlong gave his
mother fabrics made in
Hindustan, Nepal, Bukhara,
Turfan, Korea, and Siam as
presents for her seventieth
birthday.

48. QDGZXXZL 1979, *juan* 3, pp. 543–56.

49. Zhaolian 1980, pp. 385–86; Wang Pengnian and Li Shuqing, *Qinggong shishi* [Qing palace history], Beijing 1991, pp. 241–42.

Sidebar notes

1. Tang and Luo 1994, p. 457.

2. DQGZCHDSL, *juan* 1766.

3. Major studies of Rong Fei include James Millward, "A Uyghur Muslim in Qianlong's Court: The Meanings of the Fragrant Concubine," *Journal of Asian Studies*, 1994, LIII, no. 2, pp. 427–58, and Yu Shanpu, "'Xiang Fei' kao" [An investigation of the Fragrant Concubine], in *Xiang Fei* [The Fragrant Concubine], ed. Yu Shanpu and Dong Naiqiang, Beijing 1985, pp. 103–14. The ages in the essay are by Chinese reckoning.

4. "Xiang Fei in European Armor," in *Lang Shining zuopin quanji* [Collected works of Lang Shining], ed. Guoli gugong bowuyuan, Taipei (National Palace Museum) 1983.

5. Palace Museum 1992a, pl. 129.

6. Rawski 1998, p. 29.

265
Bib in yellow fabric
Silk; 37 × 30 in. (94 × 76 cm)
1736–95, Qianlong period

Like the bib in fig. 264, this
is made of "Muslim" cloth.

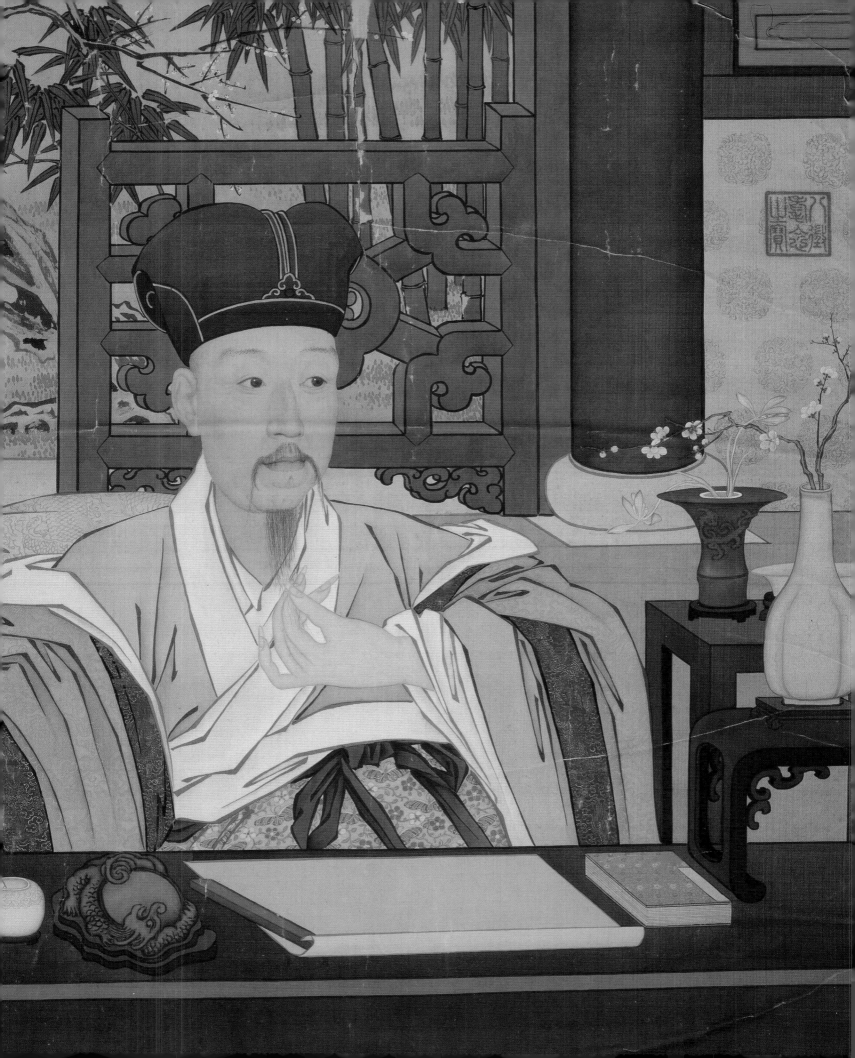

The Emperor as a Private Person

CHAPTER VI

The Emperor as a Private Person

266 (page 210)
Qianlong in his Study
(detail of fig. 278)

Introduction: Image and Reality

Any modern view of Qianlong is bound to be complex. One image of him, written by a twentieth-century American but expressive of a long-standing Chinese tradition, is as a *bon vivant* in the mold of Henry VIII:

> To his mother he was a devoted son; to his three [*sic*] empresses an affectionate husband. From his sons he won a wholesome and obedient respect – an achievement not always obtained by the heads of any imperial family. He was an excellent judge of horses, and he appreciated a good dinner, augmented by frequent cups of wine, almost as much as a compliant female. Incognito adventures to the teahouses, theaters, and bookshops in the Outer Chinese City held a special zest for him. His sayings and doings, usually exaggerated by gossip, were a delight to the common people and gave them an easy heart.[1]

Another image, often presented by eighteenth-century court painters and European commentators, is of Qianlong as a philosopher-king, a refined scholar who would have preferred to live the life of a cultured recluse if not for his sense of duty toward his people. Yet another is of an intelligent but harsh self-aggrandizer, constantly concerned with appearances, intolerant of criticism, and given to paranoid witch-hunts against imaginary political enemies.

And a last image is that evoked by the new emperor Jiaqing, who after Qianlong's death wrote the following to be engraved in a jade book:

> He set an example of cultivating a truthful heart. ... He was careful in his judgement and made upright decisions. ... He strove for sixty years as if they were one day, giving the people peace and quiet. ... He erected the ridge-pole of knowledge and spread civilization and learning. He extended his majestic influence. He was the pious, compassionate, divine, saintly, and perfect emperor[2]

It may be that none of these views is wholly true or false. Qianlong was deeply conscious of his own image. As much as the most poll-driven of modern politicians, he was always playing to an audience – Manchu soldiers, Han intellectuals, simple farmers, cultured businessmen, artists, poets, priests, Palace women, foreigners, and just about every other interest group in the Chinese empire. Consider, for instance, the New Year painting that shows him as a relaxed family man watching his sons set off firecrackers while his wives stand behind him in the doorway (fig. 267). This cannot have been shown to many people besides intimate family members, and yet, as will be clear to anyone familiar with media coverage of American presidents and their families around the White House Christmas tree, the paintings are political propaganda as well as, perhaps, wishful fantasy. Likewise, it is hard to believe that many outsiders were allowed to see the numerous portraits of Qianlong dressed as a Chinese scholar while writing poetry, playing the lute, or drinking tea in gardens. Yet those portraits, too, look very much like efforts at public

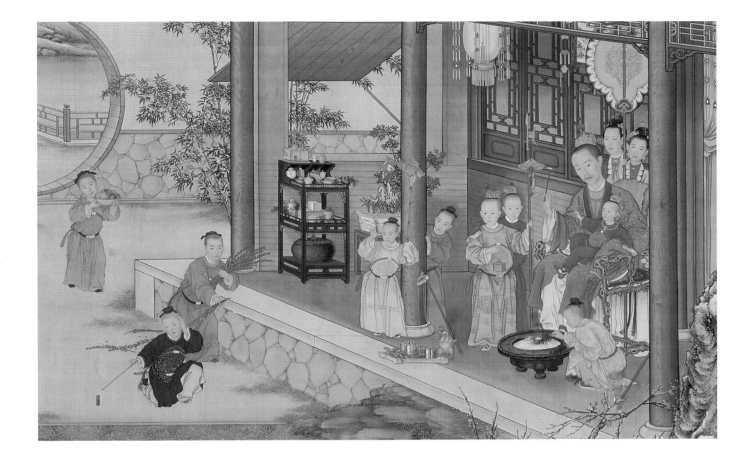

relations, aimed at the large and influential group of Han scholar-officials in whose eyes a love for lutes and poetry, not to mention tea, was an essential attribute of a good ruler.

Is it possible that Qianlong would have gone to such trouble to have himself depicted in so many culturally approved roles without an audience to appreciate it? It must be that word of his activities somehow got out in spite of the wall of privacy that was supposed to surround his every action, and that he counted on those leaks. With the gaze of all China focused on him so intensely and so long, he must have been reasonably sure that what he said and did, as well as the lifestyle he chose, would be carried from one end of the empire to the other.

Central to the emperor's lifestyle was his intense interest in culture of many kinds. He was a learned collector and vigorous patron of the arts as well as an artist himself. Like previous emperors, he sponsored publishing projects that would have been impossible without imperial patronage. His greatest project of this kind was the production of the great *Siku quan-*

shu [Complete library in four divisions]. Perhaps the largest single publishing project ever realized in any nation, the project was designed to collect and preserve every important Chinese work ever written at any time in history except for an unknown (but quite large number) that were deemed too subversive to be worth reprinting. Three hundred scholars and 3800 scribes worked on the project for ten years. The finished product consisted of 36,000 hand-written volumes covering 3460 works for a total of 4.7 million pages, stored in 6750 boxes. The Chinese University of Hong Kong has recently reproduced the full set as scanned digital images; it fills 167 CD-ROMs.

The emperor evidently saw the project as a personal achievement, declining help from others – for instance, a group of rich salt merchants who offered to pay for copying. When the project was completed, in 1782, he gave a banquet to eighty-six eminent scholars on the editorial board, entertaining them with gifts and an opera performance, with princes to wait on their tables. The seven copies of the *Siku quanshu* were distributed and housed in such a way as to give

267

Emperor Qianlong's Pleasure during Snowy Weather
(detail of fig. 232)

Qianlong appears here with nine boys and two consorts, all depicted as individuals. He and the three closest boys wear crown-like headgear. In 1738, when the picture was officially accepted, Qianlong had three sons aged ten, eight, and three. These boys look about two years younger than that. The emperor is shown amusing his youngest son by hitting a butterfly-shaped chime hanging from a toy weapon held by an older son. The boys in plain caps, presumably cousins, carry fruit and branches as well as toys but are allowed to light the firecrackers. The family scene is completed by a flowering bonsai tree and a tea stand equipped with teacups, teapots, caddies, and a stove.

268, 269
Jun ware bowl and page from imperial ceramic catalog:
Flower vessel in the shape of a Chinese flowering apple
Ceramic and color on paper; height of bowl 3⅛ in. (8 cm)
Jin–Yuan periods
(1126–1368)
National Palace Museum, Taipei, ROC

Like many connoisseurs before and after him, Qianlong collected the classic ceramics of the eleventh to fourteenth centuries. The hand-painted page from the imperial collection catalog, *Jingtao yungu*, describes this particular Jun ware piece. The seals are Qianlong's.

maximum assurance of their survival. The copy kept in the Forbidden City, for instance, was housed in a specially built structure, the Wenyuan Ge, which had black roof tiles symbolizing protection against fire. As evidence that these conservation measures worked, no fewer than four complete or substantially complete sets have survived to the present day.

Qianlong also produced a number of other major publications that originated in his literary and collecting interests, including an extensive set of calligraphy reproductions (discussed below); a monumental, well-reasoned catalog of his magnificent collection of ancient bronzes, still considered a major reference on the history of Chinese bronze art; and two major publications on his painting collection, one on his Buddhist and Daoist works and the other on his secular paintings. Both had to be republished in 1791 near the end of his reign, as the collections had expanded greatly. With more than ten thousand items, the publications on paintings remain the most comprehensive of all catalogs of ancient Chinese graphic art. Anticipating modern museum accession systems, each recorded work was entered with its size, inscriptions, seals, associated colophons, and display or storage location within the Palace. Qianlong also produced a catalog, somewhat less comprehensive but with color illustrations, of his ceramic collection (figs. 268, 269). His systematic approach to preserving infor-

mation extended even to his own writings, a staggering number of poems plus thousands of essays, all arranged in chronological order, which were published at intervals during his lifetime (fig. 270).

Such grandiose cultural projects were in line with the traditional interests of the Chinese scholar-official élite, and by engaging in them Qianlong showed his respect and approval for Han Chinese opinion. They illustrate his commitment to satisfying that opinion as well as his capacity for rational organization. However, by themselves they are not good indicators of his personal taste. Emperors were expected to sponsor grand projects, and Qianlong more than most emperors was deeply aware of the expectations of contemporaries and of future historians. And yet beneath the projects and the attendant publicity lay a stratum of deep personal involvement with connoisseurship and artistic creativity. The emperor found satisfaction, pleasure, and even escape in these. They lay close to the core of his identity.

Qianlong was an enthusiastic and intelligent collector. Given the resources available to him he was able to collect virtually anything he fancied, which is more or less what he did. Some of his collectibles were idiosyncratic, such as his thousands of European and Chinese clocks (fig. 271). Others of his collectibles were antiquities and hence more in line with the traditional interests of Chinese intellectuals – old

270
Slipcase and two volumes from *The First Collection of the Poetry of Qianlong*
Textile and paper;
11.6 × 7⅛ in. (29.5 × 18.1 cm)
1747

Qianglong published five collections of poetry, released at twelve-year intervals, totaling more than forty thousand poems. As many of these included prose comments by the emperor, they constitute a detailed diary of his entire reign. *The First Collection* contains 4150 poems written between 1736 and 1747. A similar slipcase, somewhat less worn, can be seen on the desk in fig. 278 and in fig. 157.

calligraphy, paintings, scholarly desk accessories, ceramics, jades, and bronzes (see figs 273–75). Conscious of the possibility of being criticized for spending too much time on ancient art, he explained his collecting in philosophical terms: "One may conclusively say that collecting can lead to the loss of one's life's priorities. There is the other side of the argument. Antiquities are rustic and modern objects are decorative. But who can criticize when one prefers rusticity to decorativeness?"[3]

His connoisseurship did not stop at the mere gathering of art. He studied his pieces, published the results, and rejoiced at his findings. His holdings of Chinese fine art – paintings and calligraphy in particular – were (and are) the best in existence. Much of his leisure was spent working on them.

Like most collectors, Qianlong wanted his holdings and his opinions about them to be known. His seal and comments appear on the great majority of the important paintings that have survived from earlier dynasties. The same is true of important examples of early calligraphy. In the case of classic Song dynasty ceramics, he had his identifications and comments cut into the glaze, presumably to make sure they would be preserved. Modern art historians are given to vitriolic denunciations of Qianlong as an arch-vandal for doing this. However, as Stuart points out in her sidebar essays (pp. 221 and 233), Qianlong's

271
Spring-operated clock in the shape of a pavilion
Manufacturer: Williamson, Great Britain
Gilt bronze; height 31½ in. (80 cm)
1775

Between thirty and forty Williamson clocks and watches came into the imperial collection through Guangdong, making them the most numerous of the many European timepieces owned by the Palace. The pavilion design and the dragons with bells in their mouths are not Chinese but an example of chinoiserie – European designs meant to convey the exoticism of China to other Europeans. Qianlong liked such designs, ordering local clockmakers to prepare copies for him.

272

A lady of the Yongzheng emperor in Han Chinese costume
(detail of fig. 223)

Among the antiques on the shelves are three bronzes: a bell, a *gu* wine vessel, and a flattened flask. They are similar to the bronzes shown on this page.

273 (below)

***Gu* wine vessel, "Mu," with *taotie* mask design**
Bronze; height 10½ in. (26.5 cm)
Western Zhou period, eleventh–eighth century BC

A fine example of bronze work for the ruling classes, this *gu* has molded dragon and banana-leaf designs. It bears the character "mu" [wood]. A vessel recorded in one of Qianlong's bronze catalogs, *Ningshou jiangu* (completed 1780s–90s), bears the same character and matches the design and size of this piece.

274 (right)

Hanging bell with mythical animal design
Bronze; height 13¼ in. (33.5 cm)
Early Eastern Zhou period, seventh–eighth century BC

Ancient bells like this were the models for the sets of bells played at ceremonies in the Qing period (see fig. 44). Accidental finds of such bells, as happened in 1761 in Jiangxi province, were considered an auspicious sign from Heaven. Several similar bells were already in the Palace collection when Qianlong came to the throne; they were recorded in Qianlong's catalogs of bronzes *Xiqing gujian* (1749) and *Xiqing xujian jia, yi bian* (1793).

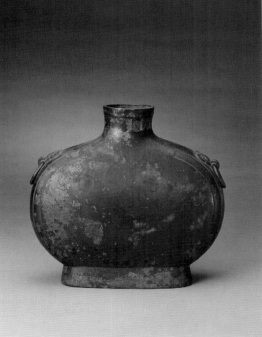

275

Flattened flask
Bronze; height 10¼ in. (26 cm)
Western Han period, second–first century BC

Intended for wine or water, most flasks of this type would originally have had a lid. Apart from the two *taotie* monster heads, which hold a ring for a chain or strap, the vessels tend to be plain. Qianlong's catalogs of the imperial bronze collection recorded more than twenty pieces like this one.

276
Rubbing: *Sudden Clearing after Snow*
Ink on paper; height 15⅜ in. (39 cm)
1780

From the recut edition of a famous collection of ancient calligraphy, a set of stones inscribed with facsimiles of texts by various masters and called *Kuaixue Tang fashu*. The name derives from the text shown here, *Sudden Clearing after Snow*, written by the greatest of calligraphers, Wang Xizhi. Qianlong took a strong personal interest in the project of recutting the stones. He owned what he believed was the original of *Sudden Clearing*. Perhaps the most admired of all examples of calligraphy, it is currently in the National Palace Museum, Taipei.

contemporaries did the same thing with objects in their own collections. Neither they nor he agreed with modern conservators that the first duty of the owner of a work of art is to preserve it in as pristine a condition as possible.

Artist and Collector

Qianlong's most important collections were in the areas of calligraphy and painting, both of which he practiced personally and thus saw from the viewpoint of an artist as well as a connoisseur. He was a highly accomplished but not a great calligrapher and an indifferent painter. While he seems to have known this, it did not diminish his intense pleasure in owning and viewing the work of past masters. He knew the history of calligraphy and painting intimately. Unlike most other great collectors, his judgment was not only sound but his own. He did not feel the need to hire private curators or ask acquisition committees, and yet he assembled the greatest of all collections of two-dimensional Chinese art.

Calligraphy

Qianlong's passion for collecting old and rare calligraphy was well known. His pattern for showing off an important acquisition was to create a special environment for it named after the newly acquired pieces, and then to make new copies for wider circulation.

His pleasure at being the owner of a tenth-century set of rubbings tells us about his thoroughness in handling his collections. After having acquired an

original set of the tenth-century *Chunhua getie* [Model letters from the Chunhua reign], a famous compilation of ink-on-paper rubbings of writing samples by masters of previous dynasties, Qianlong constructed a "museum" building for it in the future retirement compound at the Yuanming Yuan Summer Palace. The new Chunhua Xuan building, finished in 1770, included a bedroom and study for the emperor himself. At imperial command, new stone blocks were cut for a facsimile edition and a total of 400 sets of new rubbings were made from these blocks.

Qianlong published other sets of calligraphic rubbings as well. He managed to obtain another famous collection of ancient calligraphy, a set of stones inscribed with facsimiles of texts by various masters and called *Kuaixue Tang fashu* after one of the texts, *Sudden Clearing after Snow*, written by the immortal Wang Xizhi (AD 321–379) (fig. 276). That Qianlong owned the ink-on-paper original of the *Sudden Clearing* inscription did not lessen his enthusiasm for his latest acquisition. He had the entire collection recut on uniformly sized stone slabs. This was accomplished by 1780 and the slabs were used to produce a new edition of rubbings.[4]

In the emperor's own eyes, his most precious single possession was a group of three actual ink-and-paper examples of writing by a trio of fourth-century artists named Wang, collectively the greatest calligraphers in Chinese history. One of the three works was Wang Xizhi's *Sudden Clearing*, mentioned above. Believing all three manuscripts to have come from

277
Poem about "East Mountain" brush rest
Calligraphy: Qianlong
Ink on paper; width 87¾ in.
(223 cm)
1768, Qianlong seals

A good example of Qianlong's calligraphy, modeled after that of Wang Xizhi, this large-format text was the centerpiece of a room similar to that shown in fig. 283. The poem is about a brush rest bearing the name Dongshan [East Mountain] that the emperor had been delighted to acquire. The brush holder in fig. 347, which also is titled Dongshan, may be related to the brush rest in the poem.

the hands of the masters themselves, Qianlong called them his Three Rarities, *Sanxi*, and housed them in his favorite studio in the Forbidden City, the Sanxi Tang. On at least two occasions he commissioned copies to be cut in stone so that rubbings could be made and distributed. Wang Xizhi was Qianlong's favorite artist. He patterned his own handwriting on Wang's and devoted many hours to studying the perfections of his written characters, especially *Sudden Clearing*. The work still survives but has evidently paid the price of the emperor's devotion. Almost every time he viewed it he wrote another comment on it. In forty-nine years he managed to add seventy-three comments. These too survive, along with the comments of previous owners.

There is no doubt that Qianlong enjoyed practicing calligraphy. He was good at it. He wrote most of the present-day lintel inscriptions above Palace gates and doorways as well as many texts to decorate the walls of working and living spaces inside the Palace (see fig. 277). The subjects of those "public" writings were usually didactic. He was definitely proud when forty volumes of his own calligraphy were published in 1761. In a poem entitled "Learning Calligraphy," writ-ten in 1742, he portrayed himself as a leisured artist absorbed in a world of his own (see fig. 278):

In a long idling summer day, resting at the water
 pavilion,
The engaging breeze teases the flowered branches,
Moving the jade brush to capture the master's
 strokes,
The ink is pale and pale, the strokes flow and flow.
The Wangs are long gone, real works by Yan and Liu
 are rare,
Yet in copying their work to pass the time, they are
 companions who make me stay[5]

Not having enough leisure to enjoy calligraphy was a cause of sincere lament. As he wrote during the later years of his reign: "Time was when I could happily turn the pages of the *Sudden Clearing* album. But subject as I am at every moment to the duties of my office, what leisure is left me now to go back over the memorial tablets of the past?"[6]

278
Qianlong in his Study
Artist: attributed to Giuseppe
Castiglione (1688–1766) and
Jin Tingbiao (active at court
1757–1767)
Ink on paper; height 38⅜ in.
(100.2 cm)
Before 1767

One of a set of two, this
painting shows a close-up
of the emperor at his desk
dressed in Han Chinese
clothes. He is gazing not at
the poem he is about to write
but at a lady, presumably a
consort, who appears in the
other painting.

Painting

In 1783 Qianlong gave an official two of his own paint-
ings on a favorite subject: pine trees (see fig. 350). The
official thanked him profoundly and praised the paint-
ings in such an exaggerated manner that even the
emperor was embarrassed, replying "Those were just
casual exercises. Don't waste so much of your energy
on them."[7]

Most painting specialists would agree with
Qianlong's own assessment of his painterly skills. He
had much less hands-on talent in painting than in cal-
ligraphy. The several dozens of works by him that sur-
vive in the Palace Museum in Beijing bear witness to
the fact that he was no more than competent with

Chinese ink and watercolors. But he did try. Although
he enjoyed it enough to have continued to paint
throughout his life, he never published his paintings
and seldom wrote about them.

He gained real pleasure from viewing the art of
other painters. One of his favorite paintings in his
vast collection was a landscape scroll by the fourteenth-
century artist Huang Gongwang, *Fuchunshan jutu*
[Painting of dwellings at Fuchun Mountain], a work
based on a scenic river landscape in Zhejiang
province. Qianlong carried the painting with him on
numerous trips and even checked out the details on
the ground during one of his Southern Tours to north-
ern Zhejiang. His own memoirs of gazing at that

Qianlong and Paintings: Astute Connoisseur, Serial Defacer, or Both?

Jan Stuart

Qianlong's passion for art is incontestable, but assessment of him as an art critic is open to interpretation. To an unprecedented degree, he filled the Palace with contemporary and antique objects, many of which – regardless of age or rarity – he freely inscribed with his poems and critical assessments. This aggressive marking of art allowed him to assert his ego and pride in ownership of a collection finer than any previous emperor's, while at the same time his inscriptions allowed him to manipulate important cultural properties as part of his political strategy. The emperor was astute and even ruthless in using the Palace collection. However, his profound level of connoisseurship and genuine delight in art must be recognized.

In the modern world, irreversible changes to a work of art, including those made by a conservator as repair, are considered to be unacceptable, even reprehensible. By this standard, Qianlong's indelible alterations are criminal – all the more so for something as seemingly capricious as recording personal opinion. Yet we should judge his behavior in its historical context. By the eighteenth century, it had long been felt that objects, especially paintings, were enhanced by collectors' seal impressions and calligraphy, which imbued them with ongoing life as documents of ideas generated in response to a work of art. Qianlong's inscriptions belong to this well-established tradition, but because of his supreme self-confidence and the expectation that an emperor's comments and seals should overshadow those of previous collectors, he made his inscriptions prominent and large. His approach was immodest but not ignorant. Sadly he seems not to have realized that his touch often compromised the very art he celebrated.

A case in point is the short masterpiece by Zhao Mengfu (1254–1322), *Sheep and Goat,* in the Freer Gallery of Art (fig. 279). Qianlong obliterated the artist's well-calculated breathing space around the animals by inserting a poem and more than ten bright-red seal impressions that detract from the subtle ink brushwork. But the poem, as well as a handsome frontispiece that Qianlong wrote for the painting, reveals that his engagement with *Sheep and Goat* showed thoughtfulness and respect for a treasured painting. Like most of the emperor's art commentary, the poem demonstrates an impressive command of classical allusions and illustrates his ability to make clever associations between visual images and literature. Although his writing can be ponderous and sometimes vacuous, it is still a wonder that in more than forty thousand poems he did not succumb to boilerplate.

Sheep and Goat does not visually refer to suckling sheep, but Qianlong worked this image into his poem, calling upon a reference in ancient literature that takes the motif as a symbol of filial piety. Zhao Mengfu's original meaning for the painting is a matter for speculation, but it seems likely to have been an altogether different message of loyalty to the dynasty under which one is born, a theme implied by association between sheep and the Han dynasty loyalist Su Wu.[1] Qianlong's choice of words may reflect the first apt image he thought of when confronted by the uncommon theme of sheep, but it is noticeable that his art judgments often have a moralistic or didactic approach. How clever, too, if the sharp-witted emperor purposely touched upon the positive image of filial piety to deflect Zhao's original meaning, obviously unsuitable for a conquest dynasty like the Qing.

Two other Yuan dynasty handscrolls in the Freer Gallery, *Rice Culture* and *Sericulture*, further attest to Qianlong's habit of effusively marking artwork, and in this case using it outright to serve a political agenda. The emperor wrote more than twenty poems on each painting, presumably as an opportunity to show his erudition about activities said to prosper under an ideal ruler. Embellishing the painting with his brushwork was also a way to burnish his image as a sovereign. In 1769 he had the paintings with his inscriptions carved in stone, and rubbings made for dissemination. He also demonstrated impressive critical discernment in judging these paintings. He identified the signature of Liu Songnian (active c. 1190–1224) as spurious and assigned both paintings to Cheng Qi (active thirteenth century), who was mentioned in one of the late thirteenth-century colophons. Qianlong's opinion holds strong today.

279
Sheep and Goat
Artist: Zhao Mengfu
(1254–1322)
Ink on paper; image only:
9¹⁵⁄₁₆ × 19³⁄₁₆ in.
(25.2 × 48.7 cm)
c. 1300
Freer Gallery of Art,
Smithsonian Institution,
Washington, D.C., F1931.4.

280 (opposite)
Qianlong with Lute
Artist: Zhang Zongcang
(at court 1751–1756) and
others
Ink on paper; height 76⅜ in.
(194 cm)
1753, Qianlong seals and
poem

"Sitting among pines and
rocks, and alongside a
running stream, it is cool
even though this is summer
time." Qianlong's poem at
the top of the painting
conveys a desire to escape
and lead a simple, solitary
life in the wilderness. This
wish, conventional among
Chinese artists and writers,
was clearly impossible for
an emperor, yet it was a
fantasy that Qianlong often
entertained. He and his
successor Jiaqing both liked
the painting enough to put
several of their seals on it.

painting describe how he fantasized that he was traveling through the natural world it depicted. On days when the rain would not go away, he relied on the painting to lift up his spirits.[8]

The present authors cannot believe that a man as down-to-earth as Qianlong was given to daydreaming about other possible lives while looking at his paintings. And yet undeniably he was fond not only of the great landscape paintings of previous dynasties but also of contemporary landscapes depicting a man who is recognizably himself in wild, mountainous settings, with only a handful of companions or completely alone except for a servant or two. Perhaps emperors, too, sometimes feel the need for solitude (fig. 280).

The landscapes with Qianlong in them were done by the Ruyi Guan, the office responsible for all imperial painting and graphic design, located in the southern part of the Yuanming Yuan Summer Palace. The teams of court painters included a number of well-trained European artists who, as members of the Jesuit order, had been sent to Beijing to serve at Qianlong's court and, it was hoped, to act as missionaries. With their Chinese colleagues, these Jesuit artists produced not only landscapes but also, as shown in this book, documentary images of imperial events – hunting scenes, ice-skating exhibitions, holiday celebrations, official banquets for visitors. Until recently, critics have disapproved of those documentary paintings, maintaining that despite their flawless technique they lack scholarly aspiration and are functional rather than creative. But now there are signs that modern critics may be changing their minds, and historians have always admired them anyway. Their detailed, naturalistic style makes them as useful as photographs, long before photography was invented.

The court paintings of the Qianlong period represent a fusion of European and Chinese techniques. Western methods of graphic representation had been known in China for more than a century, and both foreign and Chinese artists had begun to experiment with vanishing-point perspective and three-dimensional rendering of solids through chiaroscuro. However, Qianlong was the one who ensured that those techniques would be adopted on a large scale. The impetus was his decision to direct the hands of Western- and Eastern-trained artists to work jointly

on single works, presumably because the near-photographic accuracy of the Western style made it more valuable as a record, while the traditional Chinese conventions for depicting buildings, landscapes, birds, and plants were more pleasing to his eyes.

The best known of these Western court painters was the Italian Jesuit Giuseppe Castiglione, or Lang Shining in Chinese (see sidebar pp. 168–69). As the paintings by him in this book show, he was a superb technician as well as a capable organizer and teacher of other artists.[9] Other foreign painters were French Jesuits, including Jean Attiret (said to have been as talented as Castiglione but too modest to sign his work), Michel Benoist, and Louis de Poirot, as well as Ignatius Sichelbart, a Bohemian.

Qianlong recognized the contributions of these artists, and in 1754 wanted to have their portraits painted on a screen in one of the Western-style structures that were to be built in the Yuanming Yuan gardens. Qianlong first asked Castiglione to identify seventeen Westerners who had served the Chinese court well. Castiglione could name only fourteen. Qianlong rejected three and added Castiglione's name to the list.[10] Sadly, the screen does not survive.

The emperor took a strong personal interest in the work of his court painters. In 1756 he paid eight visits to Castiglione in the Ruyi Guan to oversee the draft plans for the new Western-style buildings in the Yuanming Yuan. Qianlong seems to have been even more involved during the early years of his reign. In letters published in 1743, Attiret noted that the emperor came nearly every day to watch his Western artists, complaining that this meant he and his fellows could not absent themselves from the studio even for a moment. Moreover, Qianlong was not just a passive patron: "We prepare the drawings; he looks them over, and has them changed and corrected as seems best to him. Whether the correction is good or bad we have to submit to it, without daring to say a word."[11] Attiret could at least dare to complain, writing as he was in French to his superiors in far-off Paris. His Chinese colleagues, some of whom were undoubtedly as temperamental as Attiret, had to suffer in complete silence.

Qianlong's archivist instincts were at work when he ordered the artists of the bureau to come up with a full painting of Yuanming Yuan Summer Palace.

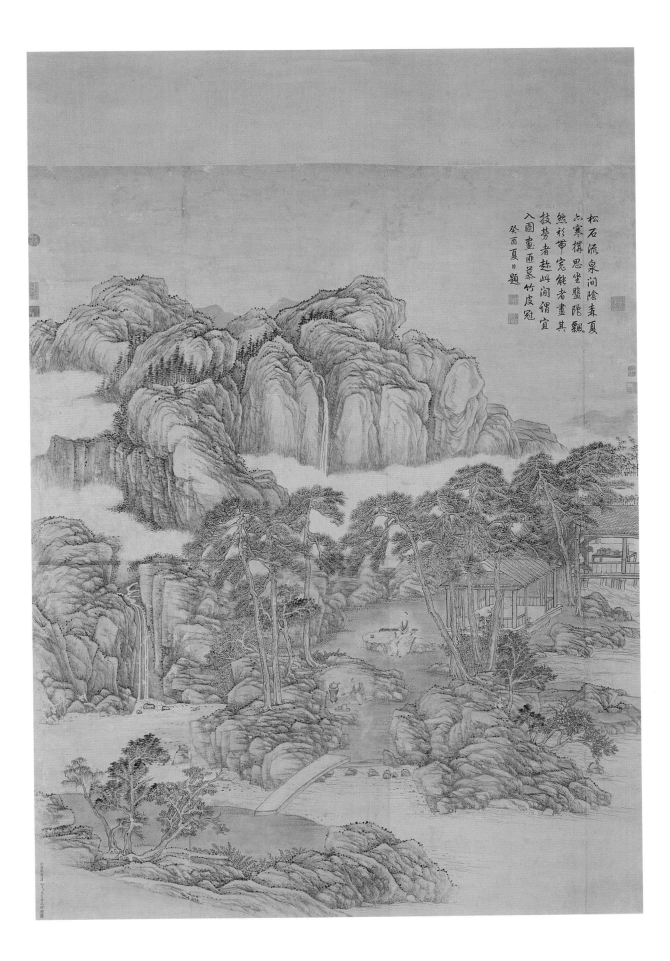

松石流泉間陰未夏
亭寒撐思坐盤陂飄
然衫筆寬能者盡其
技芳者熱此間謂宜
入圖畫匝慕竹皮冠
癸酉夏日題

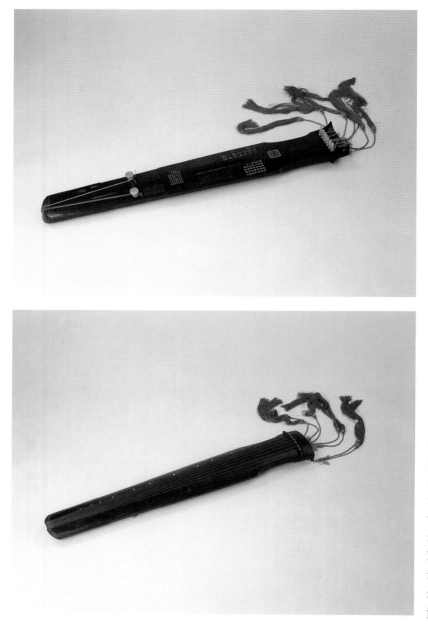

281

Lute called "Qinglai" [Clear Sound]

Maker: Yan Gongyuan
Black lacquered wood, jade;
length 49½ in. (125 cm)
Eighteenth century,
"Qianlong yushang" mark

Qianlong's personal *qin* [lute], this old string instrument bears several inscriptions of earlier periods as well as one of Qianlong's marks, *Qianlong yushang* [Qianlong imperial appreciation].

His memos conveyed his sense of partnership as well as ownership in the project. His role as an art patron went beyond commissioning the work. He was involved at the designer's level, from the format of the painting to the choice of artists and of details. The Yuanming Yuan Summer Palace painting was initiated by Qianlong in the first year of his reign. He designated three artists – the Italian Jesuit Castiglone, Shen Yuan, and Tang Dai – to do the job and asked for a grand expansive format. The first draft was completed in fifteen months but did not quite meet Qianlong's expectations. He suggestions were to

Enlarge it to 8 [Chinese] feet high and 32 feet wide. The part outside the main entrance should show an imperial procession with full ceremonial guards. Everyone in the court retinue should be shown in court costume. Add more potted plants, trees, and people doing cleaning jobs within the compounds[12]

Several years later he asked the artists to highlight the forty most favored views of the Summer Palace in a separate album. This time Shen Yuan was asked to do the architecture and Tang Dai the landscape (fig. 282), with Castiglione's participation. Most of the garden is now gone, and the rest survives as ruins. We would know little of the great beauty of the Yuanming Yuan if those paintings did not exist and if the emperor had not promoted a highly realistic style of depicting not just rulers and courtiers but landscapes as well.

Collector and Patron

At first glance, Qianlong's involvement with the decorative arts seems to be that of a large-scale conventional collector. He was a connoisseur of antiques, especially of bronzes, ceramics, and jade. He assembled vast numbers of contemporary objects as well. He was concerned about how to store and display his objects. He outfitted them with specially made boxes, shelves, and even rooms. Several examples are shown here: snuff bottles kept in a specially designed box (fig. 284), jades in lacquer boxes made to their exact shape (fig. 285), and objects of all kinds displayed on special stands in elaborate curio shelves like those in

fig. 223. He stored his collections everywhere – the paintings alone occupied eighteen locations within the Forbidden City and the Yuanming Yuan Summer Palace. More importantly, he displayed them everywhere. The sitting-room attached to his Yangxin Dian study-office, shown in fig. 283, illustrates his use of interesting pieces of art for interior decoration. His pride as owner and decorator was so strong that he forbade his staff and wives to move antique decorative pieces without his consent.

Further acquaintance with Qianlong's approach to the decorative arts reveals that with regard to contemporary objects he was much more than a collector. As in the case of court painting, he evidently enjoyed observing and participating in the creative process. The basic design concepts seem often to have been his, and he exercised close supervision of design and finish on a wide variety of products. He was in reality the producer, if not the director, of the production process, enjoying the fun of juggling different ideas, materials, and skills in turning out new and interesting art objects.

Not everyone admires the ornate, richly encrusted appearance of the more extreme Qianlong style. Even the gaudy splendors of eighteenth-century European Rococo pale by comparison with certain Qianlong-influenced designs. Some, despite their technical virtuosity, are laughable or even ugly. Others, like the vistas and ornaments of the great imperial gardens, rank with the most beautiful of human creations. The point is that Qianlong by pushing the limits of the genres of his time became an integral part of the creative process in a variety of arts. In general, Chinese decorative art in the eighteenth century was characterized by four trends: an increasing use of archaic motifs, a strong interest in European designs and techniques, an aesthetic that valued the imitating and combining of materials, and an emphasis on symbolism. Qianlong strongly influenced the development of the first three trends. He did so by staying closely in touch with designers and artists (see sidebar pp. 228–29).

The Imperial Household Department included a number of excellent workshops for making various types of decorative art, publishing books, designing interiors and exteriors of buildings, and producing graphic art.[13] Most such workshops were in or near the Forbidden City or the Yuanming Yuan. Others had to be located farther from the imperial residences. The main imperial ceramic and textile factories, for instance, were six hundred miles (one thousand kilometers) away in

282
Quarante vues du Yuan Ming Yuan: The Double Mirror and the Sound of the Lute
Artists: Tang Dai
(c. 1673–1752), Shen Yuan (eighteenth century), and Giuseppe Castiglione
(1688–1766)
Album page, ink and color on silk; 31⅜ × 28⅜ in.
(79.25 × 71.6 cm)
c. 1745, Qianlong seals and text
Bibliothèque Nationale, Paris

This is the thirty-fifth of forty scenes in the album *Pictures and Poems of the Yuanming Yuan by the Emperor*. Chosen as one of the garden's forty most beautiful scenes, the hill, lake, and tiny waterfall are the work of imperial garden designers, not of nature.

283
Sitting-room in the Hall of Mental Cultivation

The Hall, the Yangxin Dian, was the residence and executive office of Qianlong while in the Forbidden City. This view is of the very private sitting-room in the bedroom suite behind the rooms used as offices and a study. There are two small bedrooms, one on either side of the sitting-room. (See also figs. 31, 85.)

the Yangtze delta, the former in Jingdezhen and the latter in Suzhou, Hangzhou, and Nanjing. All such workshops were administered by specialists, often closely supervised by the emperor in person.

Ceramics

The Qianlong court had an unsurpassed collection of classic Song-Yuan (tenth- to fourteenth-century) porcelain and stoneware. A large percentage of the finest existing Ru, Guan, and Ge wares, representing the very pinnacle of historic Chinese ceramic design, are incised with comments composed by Qianlong during the period when he owned and studied them.[14]

Whether the comments forever ruined the ceramics is a matter of taste; in modern times at least, the market value of the ceramics has been greatly increased. Moreover, Qianlong has recently begun to be seen as a well-informed connoisseur who made mistakes sometimes but whose judgment was, by and large, excellent (see sidebar p. 233). He was aware of controversial issues and often took up debate voluntarily. Like all collectors, Qianlong had anxious moments about authenticity and dating. He researched the pieces and wrote academic arguments to express his views. He consulted specialists and kept track of their comments. When proved correct he was happy and

284
Box with snuff bottles
Lacquered wood, painted
enamel, glass, and porcelain;
box height 3 in. (7.5 cm)
1736–95, Qianlong period

The emperor was very fond
of fitted boxes for ancient and
contemporary art objects.
The fact that snuff bottles
were kept in such boxes is
evidence that, although
tobacco snuff was fairly new
to China, bottles for keeping
and taking snuff were already
regarded not only as
accessories but also as
collectibles.

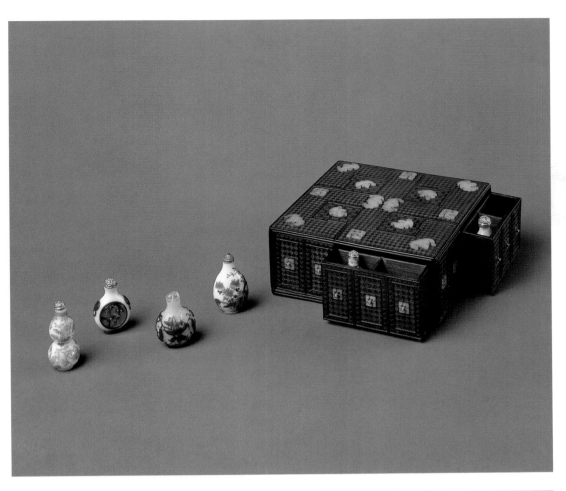

285
**Lacquer box with antique
jade disks**
Lacquer and jade; box height
2¾ in. (7 cm)
1736–95, Qianlong period

Two jade disks of the Han
dynasty (206 BC–AD 220),
were fitted in this lacquer
box. The central character on
the lid means "spring."
Together with the
surrounding dragon, the
design is typical of the court
style of the Qianlong period.
The part that projects
through the holes bears three
horizontal bars. These, one of
the Daoist trigrams, may be
pronounced "qian" and are a
playful reference to the
emperor's name.

A Memorial to the Emperor on Porcelain

Excerpts selected and translated by Peter Y.K. Lam

In late 1742, the imperial bondservant Tang Ying, supervisor of the Imperial Kilns at Jingdezhen, had an exchange of letters with Qianlong on the subject of ceramics. His letter (written in black), and the emperor's response (in cinnabar red) are shown in fig. 286. The subject of the letter, a new type of hanging vase suitable for a sedan chair, appears in fig. 287.

17th day, 11th month, 7th year of the Qianlong reign[2]

Your servant Tang Ying humbly presents this memorial.[3]

Through Your Majesty's bounty your servant took charge of the Jiujiang Customs Office and concurrently supervised the production of porcelain at the Imperial Kilns [in Jingdezhen]. On the 20th day of the 9th month your servant temporarily handed over the customs duties to Shi Tinghan, Prefect of Jiujiang, so that he could carry out the annual inspection of the works at the Imperial Kilns, and that the routine vacation [for the potters] could begin on the 1st day of the 10th month. After staying at the Kilns for over one month, and having finished with the inspection, your servant started his return trip [to Jiujiang] on the 25th day of

the 10th month.[4] On the 27th day while he was on his way back, he met his household messenger who respectfully handed an imperial poem together with a letter to him.[5] In the letter there was an edict saying, "Give this poem to Tang Ying. Ask him to copy the poem word-for-word, together with the imperial seal impressions, onto a porcelain hanging vase for a sedan-chair.[6] He can make his own judgment to reduce it in proportion so as to fit the poem and match the decorative scheme. He can decide on the quantity as well. Respect this."

[In translation, the poem reads:[7]

Guan wares and those of Ruzhou are famous classes [of ceramics],
Yet the shapes of the new vases are even more admirable.
This hanging vase inspires the traveler both to chant poems,
And to gather fragrant flowers by the wayside.
A sedan chair is indeed a suitable place for it to be hung,
As over its side wild flowers droop so appropriately.
The mortal world [red dust] is barred from entrance,
But fragrance can penetrate the gauze of the window blind.

– An imperial inscription by the Qianlong emperor]

286
Tang Ying's letter with the emperor's reply
1772
First Chinese Historical Archives, Beijing

Tang Ying's message is in black and the emperor's in red.

wrote a few more poems about his success. When proved wrong in the area of antique ceramics, he was a good sport. He reacted with good humor even when he found he had been cheated.

He was very interested in contemporary ceramics as well, and supervised their production closely. Unlike the Ruyi Guan, the Imperial Painting and Design Office, which was within walking distance of Qianlong's office in the Summer Palace, the Imperial Ceramic Factory was down in central China. All imperial ceram-

ics were made there, although a few porcelains were further decorated with paintings added in Beijing. Qianlong exercised his control remotely through frequent communication with the factory's administrator, the Superintendent of Ceramics (see sidebar above). There must have been millions of ceramics made at Qianlong's order. The majority served as furnishings and tableware for the imperial family and banquet guests. Some were given as state gifts to officials and visiting foreign envoys. A few were meant for the

Upon receiving Your Majesty's instruction, your servant immediately returned to the Imperial Factory where only a score of artisans [having stayed behind] were working and tidying up unfinished biscuit wares. Skillful artisans were recalled so as to attend to Your Majesty's order under the supervision of your servant and Laoge, the foreman.[8] Relying on Your Majesty's blessing, the weather was fine and warm, the artisans were excited. The work processed: the making of the body, the firing, the enamel decoration and the painting, all went smoothly. Varied forms of the sedan-chair vases were made with Your Majesty's imperial poem respectfully fitted into place. The characters were done in four different scripts so as to match with the vase forms and to avoid repetition.[9] Six pairs were produced and presented herein for Your Majesty's inspection, hoping that Your Majesty would grace comments and corrections. Your servant humbly begs to have the manuscript of the imperial poem kept temporarily in the

Imperial Factory so that in the next spring, when the Factory begins its new sessions of production, your servant can change the design, make some more of these vases and copy according to the manuscript the calligraphy of the imperial poem. When everything is finished your servant shall respectfully return the manuscript together with the finished products.

As to the order for festival celebratory porcelains of dinner bowls with four medallions of landscape scenes, hexagonal vases with blue dragons, and cups and dishes after paper and wooden prototypes, they are now being produced.[10] Once they are ready your servant shall immediately ask his household servant to deliver them to the Capital without delay, to make sure that they will meet the deadline of the New Year.

For the above your servant respectfully submits this memorial for Your Majesty's attention.

[Imperial rescript in vermilion:]

This is noted. You have done a very good job.

287
Hanging vase for a sedan chair
Porcelain with polychrome glaze; height 7³⁄₁₆ in. (18.6 cm)
c. 1742, Qianlong seals and text

This is either one piece from the six pairs sent by Tang Ying to Beijing in 1742, or a slightly later copy.

emperor's own enjoyment. Designs were astonishingly variable, ranging from elegant versions of traditional shapes and glazes (figs. 289, 290) to radical experiments (figs. 287, 288), some of which must qualify as the most technically accomplished but outrageous porcelains in the history of ceramic manufacture.

Only recently have art historians recognized Qianlong's skill as a researcher in ceramics. He wrote a number of essays and poems to dispute conventional wisdom, based on first-hand observation and library work. Unlike his father, who relied on the expertise of others in acquiring antique ceramics, Qianlong accepted the challenge of authentication with ease and confidence.[15] As a patron, Qianlong probably inspected sample pieces from every batch he received from Jingdezhen. In 1738 he wrote Kiln Superintendant Tang Ying that "the color of the dragons on the underglaze red *meiping*-vases did not come out nicely. Bake better ones. *Cha-dou* pots are not used often so make fewer in the future. ... Why is it that

This Guan ware piece originated in the Song;

But it was called a cat feeder of the [earlier] Tang [dynasty]

Though Yue ware [also Tang] enjoys much fame, its sparks have long been extinct. ...

These spurmarks can still be seen through the glaze and its captured fire shines

It is good for washing hands but was not really for feeding cats.

288

Hat stand in three pieces
Porcelain with polychrome glaze; height 12⅜ in. (31.5 cm)
1736–95, Qianlong period

Certainly not conservative, the design of this piece poses a challenge to conventional aesthetics. There are many colors, and the form, featuring three sets of worm-like dragons with octopus suckers on their backs biting a lotus stand, defies description. It is a technical masterpiece. It is also, to some modern eyes, exceptionally ugly.

this year so few ceramics have arrived?" Even though Tang Ying was one of the best superintendents the Qing court had ever had, Qianlong often found fault with him. In 1741 he commented "Tang Ying's porcelain is coarse and the glaze is no good. There were even broken pieces."[16]

His ceramics illustrate two of Qianlong's favorite approaches to the decorative arts. First, he loved making copies, not just overt replicas but exact imitations that if commissioned by a lesser collector would be called fakes. It is unclear why he did this. He owned the originals, did not intend to sell them, and had no economic incentive to commit the fraud. Was it simply another level of interaction with officials and family members? In his poetry and essays he enjoyed using obscure references to puzzle his subordinates. His own inscription on the base of a copied Guan ware dish in Song dynasty style hints that he may have wanted to test people with his ceramics (figs. 291, 292). The inscription reads:

Qianlong, of course, knew that the dish was a copy because it was probably made to his order. So who mistook the piece for Yue ware from the eighth to ninth century? And who in his entourage could have dared to tease the emperor by claiming he had collected an antique cat dish? An official who was also a good friend? A male relative? One of his wives?[17]

Another of his favorite approaches was to make objects in one material that looked like other materials. He frequently asked his kiln officials to make copies in porcelain that would pass as wood, bronze, or lacquer (figs. 239, 295). He may have seen this as a way of breaking through technical boundaries, and he evidently enjoyed playing with visual and tactile deception.

Both the faking and the eye-tricking themes are illustrated by a porcelain teabowl and saucer (figs. 298, 299). The shapes are very close to that of lacquerware from the twelfth and thirteenth centuries, and the color and surface look exactly like cinnabar lacquer. A seal at the bottom of the saucer (fig. 301)

289

Vase in gourd form with gourd vine decoration
Porcelain with blue-and-white glaze; height 22 in. (56 cm)
Eighteenth century

The shape, color, and painting are conservative by Qianlong's standards yet beautifully executed. The bats and gourd vines form a pleasing composition.

290

Vase with floral scrolls and phoenixes
Porcelain with light-turquoise glaze; height 11¾ in. (30 cm)
1736–95, Qianlong mark and period

Yongzheng's experiments with this unusual glaze color were continued by Qianlong. The very high relief of the surface decoration suggests that it may have been carved rather than molded. The overall effect, though conventional, invites comparison with glass rather than traditional ceramics.

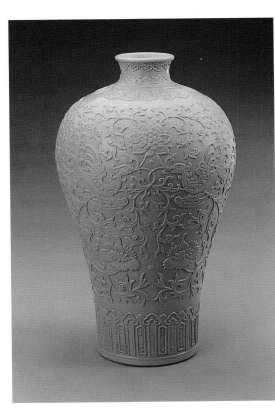

291 (above)
Flower basin or bulb bowl
Porcelain, Ru ware glaze;
length 8½ in. (21.6 cm)
1772

The basin is fully covered by
a thick translucent glaze in
light bluish green with a
yellow-brown stained crackle.
The simple form and quiet
glaze color are hallmarks of
imperial Ru, Guan [official],
and Ge wares of the twelfth
and thirteenth centuries.
Qianlong and his father were
passionately fond of such
wares, ordering copies to be
made each year. That this is a
copy rather than an antique
original is not admitted in
the emperor's inscription
on the base, shown in
fig. 292. He incorrectly
calls it Guan ware.

292 (left)
**Base of flower basin or bulb
bowl in fig. 291**

The poem inscribed on the
bottom, added after the basin
was made, was also recorded
in the fourth of the published
collections of Qianlong's
poetry. As noted in the main
text (see p. 230), the poem
ends with a humorous denial
that it is a cat-feeding dish.
But it also includes an
expert's comments on spur
marks, the small brown spots
where narrow spurs
supported the basin during
firing so that the base could
be fully glazed without
sticking to whatever was
underneath. Such marks are
typical of the thick-glazed
bluish green "official" wares
and Ru wares of the eleventh
to thirteenth centuries.

Qianlong as a Collector of Ceramics

Jan Stuart

Qianlong not only brushed his words upon some outstanding paintings but also frequently had his calligraphy engraved into the finest jades, lacquers, and ceramics – his writing filled with vermilion paste to give it added prominence. He showed substantive knowledge of those other arts and was often able to turn his art comments to political advantage. Some modern scholars propose that his most stringent connoisseurship was applied to jade, which James Watt theorizes may be because of this material's extreme cultural importance and association with gentlemanly virtues.[11] Yet Qianlong also linked connoisseurship of ceramics with moral virtue.[12]

Two inscribed pieces in the Freer Gallery of Art in Washington, D.C. reveal a great deal about his interest in ceramics. As with other surviving pieces from his collection, on both he begins with an identification of the ware. One of the two is a Jun ware bowl of the Yuan dynasty. Qianlong comments on its dating and quality, noting that it is "second-rate and later than the Song dynasty" – fair comments. Then he goes on to explain that while the piece is not of the caliber he usually collects, it is important because it was discovered by Qing soldiers in the territory of Xinjiang, which Qianlong was trying to annex at that time. His inscription ends by justifying his military exploits: "Soldiers' encampments can safeguard the frontier peoples so that dwellers in small villages can endeavor to live happily for a hundred generations."[13]

A twelfth- to thirteenth-century Cizhou-type pillow in the Freer Gallery of Art inscribed by Qianlong helps to summarize his complexity as an art critic (fig. 293). The emperor's clerical-script commentary is deeply incised into the glaze and still bears traces of vermilion. He

begins as usual with an art-historical judgment, which in this case is erroneous. Because robust Cizhou wares were seldom collected in the Palace, he understandably misidentifies the originally pristine white, antique pillow as Ding ware, one of his favorite ceramics.[14] In the inscription he intelligently references two classical allusions to dreaming on pillows, but the heart of his text is an allusion that takes the plainness of the ceramic as its greatest virtue and connects simplicity with human integrity. Qianlong's art critiques often use flawlessness and purity in an art object as an analog for moral virtue, so that his patronage of art becomes tied with imperial propriety.

Could he have been unaware that his vermilion-filled calligraphy negated the very quality – the lack of adornment of the pillow – that he extolled as a metaphor for his own integrity? Apparently he did not see any irony in this. Time and again, he

permanently altered great masterpieces by embellishing them with his writing, but he never acted with maliciousness or out of stupidity. Rather, he studied art and treasured it, and with the self-confidence of a Universal King turned his art patronage into an expression of his role as China's moral exemplar. How regrettable for us that Qianlong was so energetic about the task!

293
Cizhou-type ceramic pillow
Stoneware with white slip under colorless glaze and traces of cinnabar
Song–Yuan dynasty, twelfth–thirteenth century, with Qianlong's inscription dated 1768
Freer Gallery of Art, Smithsonian Institution, Washington, D.C., 42.21.

shows Qianlong's confidence in appropriating styles. It reads "Great Qing Qianlong Imitation Antique."

Qianlong's casual treatment of certain cultural icons may seem insensitive. For instance, the earthenware teapots of Yixing near Suzhou were highly valued by scholars for their unique ability to brew good tea and for their rustic, quiet designs that connected users with the simplicity of nature. Qianlong knew and endorsed that philosophy. Yet he commissioned Yixing teapots covered with showy gilt decoration, anathema to the refined intellectuals of the Suzhou area but in keeping with the glitzy atmosphere of the Beijing court (figs. 296, 297).

Porcelain was an important material for snuff bottles in the Qianlong period and attained a very high level of quality, due partly to the emperor's strong interest in such containers and partly to the superlative technical capabilities of the Jingdezhen kilns. The snuff bottle shown here (fig. 300) is typical of Jingdezhen enamel-on-porcelain work. As with the crane-decorated brush pot shown in fig. 295, it is clear that the enamel workers at the imperial kilns were every bit the equal of their counterparts in the enamel-on-metal and enamel-on-glass workshops in Beijing.

294
Vase with alternating panels of poems and flower paintings
Porcelain with polychrome glaze; height 25½ in. (64.7 cm)
1736–95, Qianlong seals and poems

The main body of the vase is treated like an illustrated album, with a panel of poetry followed by a panel of illustration. Gold and dark-blue glazes cover the neck and footring. As this piece shows, the imperial ceramic factory at Jingdezhen had fine calligraphers on its staff.

295
Brush holder with cranes under pine tree
Porcelain with overglaze enamel, partly imitating wood grain; height 5½ in. (14.2 cm)
1736–95, Qianlong period

The illusion of wood texture is interrupted by an excellently painted design that conveys good wishes for longevity. This brush holder is yet another example of Qianlong's penchant for material mimicry and visual tricks.

296, 297 (reverse)
Teapot with landscape painting and calligraphy
Purple-clay earthenware, gold and silver lacquer painting, calligraphy; height 4 in. (10.2 cm)
Made at Yixing, near Suzhou, 1736–95, Qianlong mark

One of the emperor's poems on fish-watching covers three sides of the teapot, and a gilded landscape is on the fourth. The luxurious decoration was in keeping with court taste but not that of contemporary tea experts, who loved Yixing teapots for their plainness and simplicity as well as their claimed ability to brew better tea than any other kind of teapot.

298
Saucer in chrysanthemum form inscribed with Qianlong poem
Porcelain with glaze imitating cinnabar lacquer; diameter 6¼ in. (16 cm)
1774 or earlier, Qianlong poem and mark

The shape and color of this piece could easily fool casual observers into calling it lacquerware of the twelfth- to thirteenth-century Song period. Qianlong's interest in imitations of this kind may well have been inspired by his father, Yongzheng, who ordered forty similar plates in 1734. Although it appears to be a saucer for the matching cup/teabowl shown in fig. 299, it was in fact inscribed by the emperor two years before the teabowl was made.

299
Teabowl with lid in chrysanthemum form, inscribed with Qianlong poem
Porcelain with glaze imitating cinnabar lacquer; diameter 4¼ in. (11 cm)
1776, Qianlong poem and mark

Made at least two years after the plate in fig. 298, the teabowl matches the plate's design perfectly.

300 (below)
Snuff bottle with quails and chrysanthemums
Porcelain with gilt-bronze lid and spoon; height 2½ in. (6.2 cm)
1750–95, Qianlong mark

The bottle was made in the imperial kilns at Jingdezhen but the lid and inside spoon must have been fitted by the Palace workshop in Beijing. The brilliant red color against a white background became a style in itself. Together, the images of quail and chrysanthemum signify a peaceful household.

301
Inscriptions from figs. 298 and 299

Clockwise from top left: in the center of the saucer, a poem by Qianlong expresses pleasure that the piece not only has the look of lacquerware but also is light in weight; in the center of the teabowl lid top is a Qianlong reign mark; on the underside of the lid, a poem by Qianlong praises the teabowl's chrysanthemum design; on the base of the saucer is an unusual reign mark: "Great Qing Qianlong Imitation Antique."

Jade

Jade was an economic commodity as well as a material that appealed to Qianlong's personal taste. The Qing period is seen by modern scholars as the single most eventful era in the history of jade carving, when the art saw more and faster changes than at any time since the Han dynasty (206 BC–AD 220). New designs appeared in profusion and new materials began to be carved by private workshops in such places as Zhuanzhu Alley, the lapidary center of Suzhou (see fig. 208). Surprisingly, Qianlong knew about the private jade industry:

> Lately Hetian has supplied plenty of jade.
> Official tribute, private transactions; the traffic is
> busy.
> Craftsmen are plentiful in Zhuanzhu Alley
> Competing with endless new designs.[18]

The poem was written in 1787, years after the 1750s military campaign that resulted in the incorporation of Xinjiang, in the far West, into the directly administered part of China. This opened the great nephrite mines south of Hetian [Khotan] to intensified exploitation. Indeed, Qianlong in his poems frequently associated jade with the victories of his armies in Xinjiang. For example, part of the poem on the large jade dish found in Xinjiang (fig. 306) reads:

> Strange indeed that this beautiful jade dish
> Is neither food nor clothing
> Yet is so rare that it has cost a city

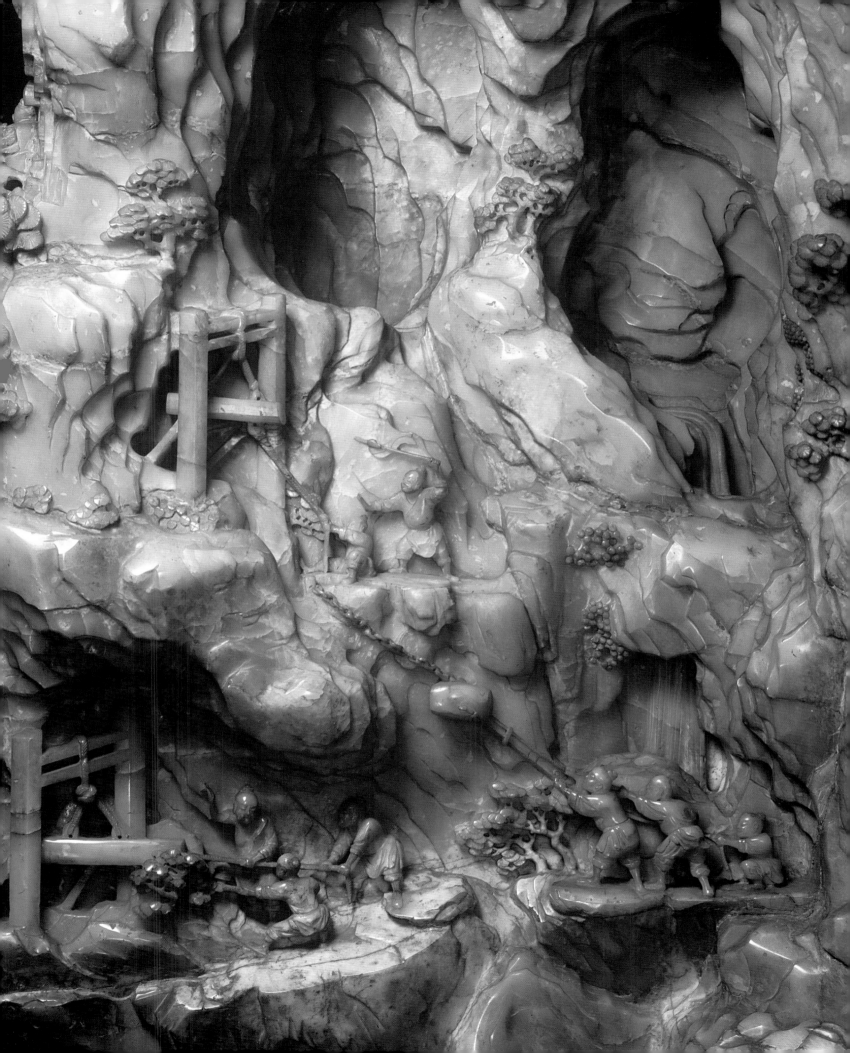

Monuments in the Jade-Carving Industry of the Qianlong Period: Two Jade Boulders

Yang Boda

Jade in China has a long and brilliant history. The Chinese love of jade is well known, and it is widely appreciated and collected. Imperial pieces hold a special place in the history of Chinese jade. Their highest peak of artistry and craftsmanship was reached during the Qianlong period.

The Qianlong emperor was not only a very capable monarch but also an advocate of jade art. Under his guidance, the Chinese jade-carving industry merged closely with the art of painting and sculpture, thus beginning a new era in the history of jade. It was only natural that such

masterpieces as *Da Yu Controlling the Floods* (figs. 302, 303), a finely carved jade boulder, emerged during the prosperous Qianlong period.

At 78¾ in. (200 cm) high and 37¾ in. (96 cm) wide, and weighing more than 11,000 pounds (5000 kilograms), *Da Yu Controlling the Floods* is the largest and heaviest work of monumental jade art. It was also the most time-consuming to produce, taking nine years to complete (from 1778 to 1787). Under the directorship of Qianlong, the Salt Administration of the Two Huais oversaw the completion of the task in Yangzhou. The carving

depicts a scene from Chinese ancient history, in which the semi-legendary tribal chief Da Yu led his people in a major flood-control project. It is a spectacular piece that inspires both admiration and awe.

The Nine Elders of Huichang (figs. 304, 305), weighing 1814 pounds (823 kilograms), was carved from a smaller jade boulder that originally came from Hetian [Khotan] in Xinjiang. The carving depicts a scene from the life of Bai Juyi, the Tang poet. In 845 Bai invited nine equally learned and elderly friends to celebrate his seventieth birthday at Fragrant Hill in Xian. The

jade carving shows an elegant party, with the nine gentlemen enjoying the beauty of the mountain by hiking, playing music, and sharing drinks. The carving is reminiscent of scenes in many literati paintings. Like the *Da Yu* jade boulder, the *Nine Elders* boulder has been on display in the Imperial Palace for many years, and has not been easy to move!

302

Carved boulder: *Da Yu Controlling the Floods*
Nephrite; height 93 in. (224 cm)
1788, Qianlong seals and poem

The boulder was mined at Mount Mileta, south of Hetian [Khotan] in Xinjiang, carved in Yangzhou, and displayed by Qianlong at the Leshou Tang Study (see fig. 335) in the Forbidden City. The subject of the carving is a semi-legendary leader named Yu who carried out the first great flood-control plan in Chinese history. As Yang notes in the accompanying sidebar, above, it is not only the largest single piece of carved jade from the Qing period but also one of the most beautiful. This detail shows hydraulic specialists digging a tunnel.

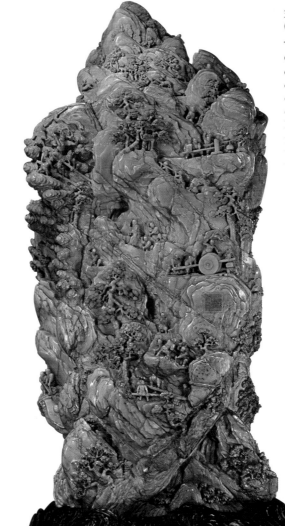

303
(reverse of fig. 302)

The inscription is a poem of Qianlong's in which he defends his expenditures on curios and treasures instead of traditional fine arts. Jade carvings such as this one, he says, last longer than paintings. He implies that they can have equal aesthetic value. If this seems a strange opinion, it should be remembered that Qianlong loved classical paintings, owned a great many, and was a distinguished critic of them.

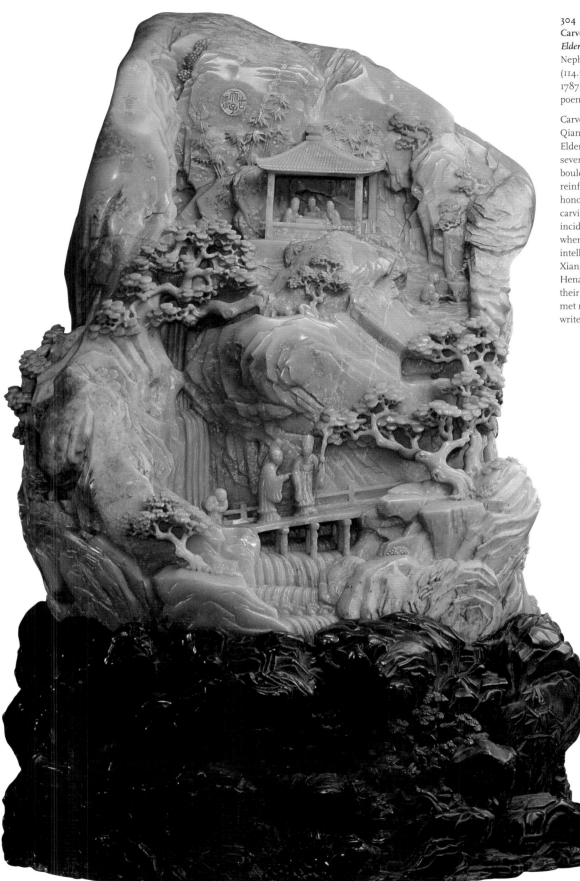

304
Carved boulder: *The Nine Elders of Huichang*
Nephrite; height 45 in. (114.5 cm)
1787, Qianlong seals and poem

Carved a year after Qianlong's lavish "Thousand Elders Banquet" for his seventy-fifth birthday, the boulder was meant to reinforce the importance of honoring older people. The carving depicts a historical incident of the ninth century, when nine famous elderly intellectuals visited Xiangshan [Fragrant Hill] in Henan province to celebrate their birthdays. The group met regularly to socialize and write poetry.

305
(reverse of fig. 304)

The carving of this side depicts two elders playing a lute, and two more carrying another lute on the way to join them. Qianlong's poem is engraved on top of the boulder. As with his poem on the *Da Yu* boulder (fig. 303), the emperor notes that crystallizing the event in jade means that the memory of it will last longer than if it were painted in ink on paper. He ends the poem with an implied tribute to the jade carvers, referring to the challenge they faced in completing the commission.

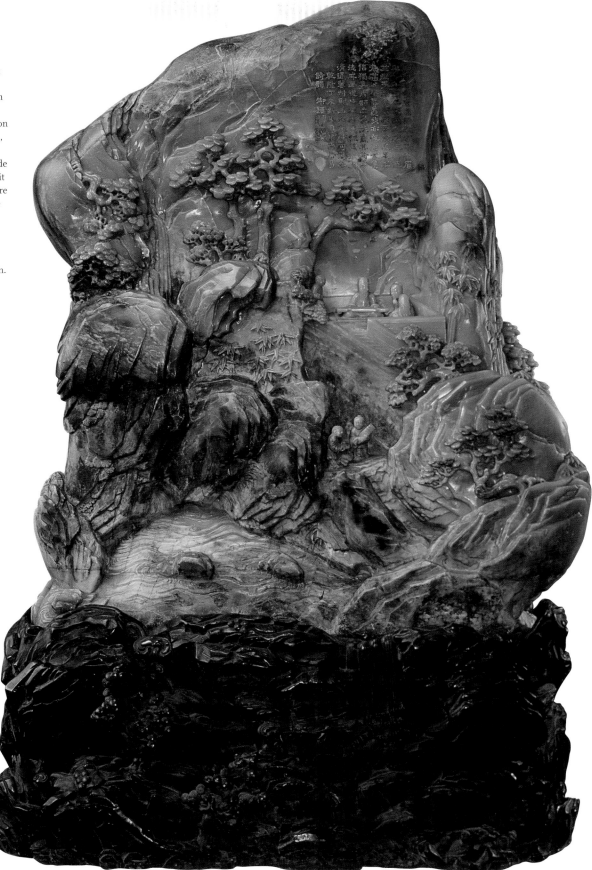

Large plate inscribed with Qianlong poem

Nephrite; diameter 25⅝ in.
(65.3 cm)
Fifteenth–sixteenth century,
Qianlong seals and poem
dated 1757

Weighing almost sixty-eight
pounds (thirty-one
kilograms), this plate came to
Qianlong as a war trophy
from the newly pacified
western province of Xinjiang
in 1757. An almost identical
one arrived in 1762 from the
same source. As noted in the
main text, the emperor's
poem says that the plate "is
so rare that it has cost a city."

The pacification of the region and the improvement of roads made it possible to bring large boulders of jade from Hetian to eastern China. Hence jade carving in the later part of Qianlong's reign was characterized by unusually large items, the size of which allowed them to be treated as entire landscapes rather than as the traditional containers, animal figures, and so forth. Such landscape pieces were a radically new idea in the history of Chinese jade. Usually formed from natural boulders, they were more like three-dimensional paintings than the jade carvings of previous centuries. Some were monumental in size. It took more than three years to bring one famous boulder from Hetian to Beijing, and then several more years for it to be sent to Yangzhou for carving in a private workshop. It was returned to the capital for display as a finished work, *Da Yu Controlling the Floods* (figs. 302, 303) (see sidebar p. 239).[19] The almost equally famous carved boulder *The Nine Elders of Huichang* displays a similar landscape-painting-like treatment (figs. 304, 305).

Skirmishes with the Russians in Central Asia and the pacification of the northern Mongolian tribes opened up the black-flecked green "spinach" nephrite sources south and west of Lake Baikal (fig. 308). Of even more importance for the future, jadeite from the great Mogaung mines in northern Burma began for the first time to filter into China, partly because Chinese gem merchants had become familiar with the mineral resources of that country through the Qing military campaigns of 1662 and 1767 in northern Burma. In the Qianlong period, most Chinese probably had never heard of either Mogaung or Burmese jade.[20] Qianlong not only failed to recognize jadeite as a separate kind of mineral but thought that a jadeite piece in his collection had come not from Burma but from Khotan.[21]

Only small amounts of jadeite entered China during the Qianlong period, and those seem to have been limited in color to a snowy translucent white and the brilliant green later called *feicui* or "kingfisher" jade.[22] The pink and lavender kinds were still unknown to

Chinese lapidaries. That Qianlong, as indicated above, did not know about Burmese jade at all is somewhat surprising, considering that his court jewelers were already making effective use of the green variety (see fig. 218). He actually referred to tribute jade coming from Yunnan – through which the trade route to northern Burma ran – as "useless," and asked that province to send peacocks instead.[23]

Qianlong's court workshop made a great variety of jade objects. He used them as display articles, often in imitation of ancient bronzes (figs. 307, 309), and as household vessels, personal ornaments, tablets, and other items meant to carry inscriptions. Jade was also fashioned into scholars' writing implements (see figs. 88, 89, 96–100), images of deities, tableware (see figs. 248, 255–60), jewelry (see figs. 218, 222), and parts of weapons (see figs. 127, 129, 130).[24] One of the more extreme examples of jade design in the imperial collections was a forked spinach jade candlestick in a hybrid European–Indian style (fig. 308); a truly ugly artifact, it illustrates not only the occasional tastelessness of Qianlong-period jade carving but also the craftsmen's boldness and willingness to experiment.

Qianlong had a fondness for the Mughal Indian jade style, believing that it was thinner and more finely carved than any Chinese jades: "Hindustan jade is so good that Chinese cannot copy it."[25] He collected gen-

uine Mughal pieces and had Chinese jade workers make replicas. Some replicas are so good that they would fool most jade experts if it were not for their Chinese inscriptions. Many vessels and jade-handled weapons in the Mughal style were in the emperor's collections (see "Martial arts and hunting," pp. 105–18), plus several gem-inlaid pieces like the one that appears here (fig. 310).

310

Teacup with beechnut-shaped handles

Nephrite with inlay of rubies and gold; height 1⅞ in. (4.8 cm)

1785, Qianlong seals, poem, and mark

Used by the emperor personally, this milk teacup is studded with rubies and gold foil in an Indian style. The poem inscribed on the interior makes it clear that the cup was meant for Qianlong's personal use on formal occasions. The mark at bottom reads "Imperial Use, Qianlong."

311

Sword hilt

Nephrite inlaid with rubies, coral, turquoise; height 5⅛ in. (13 cm)

1736–95, Qianlong period

While the jade work and decoration are unmistakably Indian in style, the hilt was made for a straight sword of Chinese type. (See fig. 132 for a complete view.)

This particular piece was made in 1785 and used by Qianlong himself to drink Mongolian-type milk tea at the formal New Year banquet for 1786. It is unclear whether the jade worker who made it was Chinese or Indian. If he was Chinese, he did a fine job in copying the unique Indian *kundan* inlay technique, whereby piled-up and burnished gold leaf, perhaps touched with flame from a blowpipe, is used to hold inlaid gems on a hard surface. Another example of *kundan* work is the sword hilt shown in fig. 311. The fact that it is attached to a sword of typically Chinese design indicates either that Chinese jade workers had mastered the Indian technique or that such sword hilts were specially ordered from India – the latter is perfectly possible in view of the intensity of intra-Asian trade in the eighteenth century,

As with ceramics, Qianlong was interested in forgeries in jade and the technical details of jade manufacture. In 1743, before he had an almost unlimited supply of jade from Hetian (Khotan), he asked jade workers in Suzhou to make him several early-style pieces as illustrated in a twelfth-century drawing. About a year later, he asked the Palace workshops to burn two of the newly made pieces to give them a Han

dynasty color and to distress another, after which he had them mounted on stands that matched the original illustration. As a final touch, he ordered that the stands be inscribed with the twelfth-century reign mark Xuanhe, thus furnishing the faked pieces with faked documentation.

In one instance, Qianlong was in doubt about the age of a certain jade cup (fig. 312). His researches are described in the note shown here, which he wrote and kept with the cup. He says that he showed the cup to a Palace jade worker named Yao Zongren. Yao giggled at seeing it. He then informed a puzzled emperor that the cup had been made by his, Yao's, grandfather and went on to describe the secret formulas for forging antique jades. After a very satisfying conversation with Yao, Qianlong concluded: "Even though workers are low people they can do good things and they can say

inspiring things. It does no harm to record this" Qianlong's note bears witness to one of his more appealing traits, his willingness to converse at length with artists and craftsmen, no matter what their status. While it may be going too far to say that he respected artists – except where senior kin and gods were involved, respect was not a common emotion on the part of Qing emperors – he seems not to have minded when they giggled at him.

We should note in passing that Qianlong himself may have tried his hand at cutting jade. There was formerly a jade book in the Museum für Völkerkunde in Berlin that is said to have borne a few lines carved by the emperor himself while at Chengde.[26]

312
Cup, saucer, and booklet in lacquer box
Nephrite, sandalwood, gilded lacquer, paper; height of cup 1¾ in. (4.4 cm)
1736–95, Qianlong seals and mark

The booklet, written by the emperor but penned by an official, Dong Hao, relates how the emperor was deceived by a clever fake that had been distressed by being pickled and boiled for almost a year.

313 (left)
Box with mother-of-pearl inlay
Wood, lacquer, shell; length 9 in. (22.8 cm)
1736–95, Qianlong period

Finely inlaid lacquer of this kind, called by Westerners *laque burgauté*, was popular in eighteenth-century China. This piece is very light, made of thin wood.

314 (right)
Dinner box with ten cups
Carved red lacquer box, cloisonné bowls; length of box 10 in. (25.3 cm)
c. 1746, Qianlong mark

The design of this box was determined by Qianlong himself. Its most unusual feature is the use of gilt-bronze wire mesh in its sides. Boxes with openwork like this were called "see-through" boxes. The emperor named this one "The Flying Dragon Banquet Box."

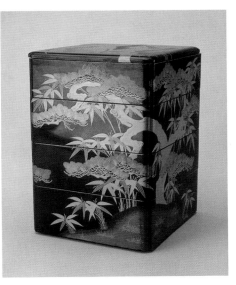

Lacquerware

Lacquerware did not see an outburst of innovation under Qianlong. Most of the major types of lacquer – layered and cut lacquer (fig. 316), carved cinnabar-pigmented lacquer (figs. 318, 319), shell-inlaid *laque burgauté* (fig. 313), lacquer-in-lacquer inlay (fig. 317), raised gold on black or red lacquer in Japanese *makie* style (fig. 315; see also fig. 216), and so forth – already had a long history of manufacture in China, most going back many centuries before the Qing period. Even though there was little technical innovation, many of the designs were new and the quality of workmanship was very high.

An example of such workmanship is a set of cloisonné bowls in a cinnabar lacquer box finely carved with symbols of dragons and phoenixes (fig. 314). Both the box and the bowls were made to Qianlong's detailed specifications. In 1743 he showed models of the box and silver-base cloisonné enamel bowls to his workshop supervisors and ordered two sets of copies to be made, with brass-base instead of silver-base cloisonné. The bowls were to carry four gilded characters, "longevity without limits," but he wanted the box to have a longer inscription: "'Made in the great Qing dynasty Qianlong reign' in one long line, and 'Flying Dragon Banquet Box' in a square format. Both to be drafted and approved before sending the order to the South. Respect this."[27] As can be seen, these instructions were carried out punctiliously.

Qianlong ordered a great deal of cinnabar lacquer furniture, which was a major innovation for a material that in previous reigns had been used almost exclusively for containers. Cinnabar lacquer, like large jade and cloisonné work, was labor-intensive and costly to make. The Imperial Workshop was well known at the time for its skill in handling this material. The red and black informal throne screen shown in fig. 320 is an example of the lacquerers' design skills, showing the same fondness for boldly asymmetrical layouts that appears in carved boulders and garden designs of the Qianlong period. It sets off admirably the matching informal throne, rigidly symmetrical but equally well carved (fig. 321). Even closer to the irregular designs of gardens and boulders is the magnificent table screen shown in fig. 322, which combines superlative precision with an island landscape that could have been taken from a detail of one of the imperial gardens.

In 1772 the emperor held a design contest for boxes to store the newly published *Chunhua* rubbings (see p. 218). Contestants from six different provincial offices sent boxes decorated by various kinds of lacquer techniques: with gold or silver wire inlay, with mother-of-pearl inlay, and with layered and cut designs, as well as with bamboo veneer and polished plain wood. Qianlong chose lacquer boxes decorated in the Suzhou shell-inlaid style, as recorded in the Yuanming Yuan archives. It may be that Qianlong was prejudiced in favor of Suzhou from the start – after all, he is known to have loved the gardens and cuisine of Suzhou and to have admired that city's jade carving, lacquerwork, and even drama.

316

Square box with *ruyi* design
Carved layered lacquer box;
height 4¾ in. (12 cm)
1736–95, Qianlong mark and
period

Named "*ruyi*-cloud box" by
characters on its base, the
box has layers of alternate
black and yellow lacquer that
have been revealed by cutting
down through them. The
technique, called *guri-bori* in
Japanese, is old in China.
This particular color
combination dates back to
the twelfth century.

317

Box for album
Polychrome painted lacquer
on wood, carved sandalwood
support for album; length
8⅝ in. (22 cm)
1736–95, Qianlong period

The design is formed by
inlaying different colors of
lacquer, giving a densely
patterned effect like that of a
fine textile. The technique
and the design are unusual.
The carving of the
sandalwood support is
conventional by comparison.

318, 319
Pair of boxes
Red carved lacquer; diameter
7⅝ in. (19.6 cm)
1736–95, Qianlong period

The characters for "fortune"
and "longevity" are carved on
the lids. These eighteenth-
century boxes were originally
used for serving food at
imperial family banquets
(see "Dining in the Palace,"
pp. 193–209). They later
functioned as containers
for books.

320

Large three-section throne screen

Carved cinnabar lacquer; height 76¾ in. (195 cm) 1780–95, Qianlong seals and poem

The three sections depict a continuous landscape, although each section has its own title and poem. The format reminds one of the pictorial records of the gardens at the Yuanming Yuan and Chengde Resort Palaces. The red portions have been cut away to reveal a layer of black lacquer underneath, representing water. The sky is shown as a polished, lacquer-free surface.

321
Throne and footrest
Carved cinnabar lacquer;
height 41⅜ in. (105 cm)
1780–95, Qianlong period

Like the top of the matching
screen, the throne is fully
covered with deeply carved
dragons among clouds. The
set displays a mixture of
decorative concepts. The
rich density of the dragon motifs
was a novelty in Qianlong's
day, whereas the screen
shows a traditional landscape
painter's fondness for spare
design and empty space.

**Table screen showing an
island in the sea**
Carved cinnabar lacquer;
height 26¾ in. (67.9 cm)
1770–95, Qianlong period

The superlatively intricate
carving depicts an island
landscape that could have
been taken from a scene in
one of the imperial gardens.
It illustrates the traditional
birthday motto, "Longevity
Island in Fortune Sea."

Glass

Both glass and painted enamel were relatively new art
forms in the Qianlong period. Both materials took a
great leap in technology and artistry in the eighteenth
century, and much credit should go to court patron-
age. Without the emperor's personal interest, Chinese
glass in particular would never have caught the eyes
of the world's curators and collectors.

Compared to ceramics, imperial glass had a short
and unglamorous history before the Qianlong period.
Kangxi established a glass factory in the Forbidden
City in 1696 under the supervision of a German Jesuit
named Kilian Stumpf.[28] Yongzheng subsequently
moved the factory to the Yuanming Yuan because of
the danger of fire. Through his and Kangxi's interest,
imperial glass developed from the status of exotic nov-
elty to that of familiar luxury. However, it was not until
Qianlong took a strong interest in glass that take-off
occurred. By the later part of his reign, Chinese glass
had reached levels of aesthetic and technical quality
that in China would not be reached again.

Chinese glassmakers had already succeeded in
developing a distinctive group of products that were
quite different from those made in Europe. Chinese
glass was thick, usually opaque, as likely to be cut
from a solid block as it was to be blown, and often
decorated by the cameo technique, whereby a glass
core was dipped into molten glass of a contrasting
color that, after hardening, was partially cut away to
form often complex designs. The technique of cameo
glass had been known to the Romans but subse-

**323
Snuff bottle with bean and
cricket design**
Glass, green overlaid on
yellow, with amethyst lid and
ivory spoon; height 2 in.
(5.1 cm)
1736–95, Qianlong period

There are several reasons for
thinking that this piece was
made outside the court
workshops. The subject-
matter is different from those
favored by the court, and the
composition is lively. It does
not have the gilt-bronze lid
that is usual on Palace
products, and it has no reign
mark. Officials in Suzhou,
Yangzhou, and Guangdong
often sent locally made snuff
bottles as presents to the
court. This may well be one
of them.

**324
Snuff bottle with European
figure**
Glass, painted enamel, gilt-
bronze lid, ivory spoon;
height 1½ in. (4 cm)
1736–95, Qianlong mark and
period

The snuff bottle depicts a
young European woman
carrying a basket of flowers.
Perhaps to emphasize their
exotic appeal, European
women in Qing court art
were often shown with bare
necks and low-cut dresses.
The difficult art of enameling
on glass was also exotic,
having only recently been
introduced in China. (See
fig. 333 for a detail view.)

325
Snuff bottle with magpie and bamboo design
Glass, blue overlaid on white, with ivory inlay, gilt-bronze lid, and ivory spoon; height 2⅛ in. (5.4 cm)
1736–95, Qianlong mark and period

The court workshops under Qianlong excelled in the cameo technique, whereby two or more colors of glass were overlaid and then partially cut away. It was unusual, however, to combine cameo decoration with inlay, in this case of carved and dyed ivory protected by clear glass. Together, a bamboo and a magpie signify the arrival of good and peaceful news.

326 (opposite)
Altar set of five pieces in cameo glass
Blown and cut overlay glass; height of candlestick 9⅝ in. (24.4 cm)
1736–95, Qianlong mark and period

The five-piece altar set copies the appearance of similar sets made of blue-and-white porcelain. The interior of the censer is gilded. While the floral pattern and the shape of each piece is traditional, the material – overlay or cameo glass – was new in the eighteenth century.

quently lost. The secret of making it – which involved close cooperation between lapidaries and glassmakers – was rediscovered in China in or just before the Qianlong period. Within a few decades the art had been taken to extraordinary heights.

The keys to this rapid, successful development were continuing imperial involvement and the close relationship that grew up between the Palace glass workshop and the traditional glass industry of Boshan in Yanshen district, Shandong province. Boshan provided skilled workmen while the Yuanming Yuan glass workshop provided technological leadership through its continued hiring of European experts. In 1740 Qianlong appointed two highly qualified Jesuit specialists, Gabriel Leonard de Broussard and Pierre d'Incarville, to direct the workshop.

He urged the new directors to experiment with new shapes and effects. Snuff bottles became a favorite vehicle for experimentation. The emperor, who gave the bottles as official gifts and used them himself, ordered quantities of them. He evidently preferred innovative designs and techniques. Most glass snuff bottles made under his patronage were of enamel-painted, cameo (fig. 323), or plain glass, sometimes made to imitate such natural minerals as jade, aventurine, or amethyst. Some displayed an inlay technique known only from the Qianlong period (fig. 325). They were often decorated with unconventional subjects, including European landscapes and ladies (fig. 324).

The imperial glassworks produced many objects other than snuff bottles: glass vases, bowls, altar pieces, and

327
(detail of fig. 326)

Reign mark of Qianlong on rim of censer. Most of the wheel-cut reign marks on glass fail to match the high standard of reign marks on other materials made by the imperial workshops, probably due to technical difficulties.

328
(detail of fig. 342)

Qianlong's two glass-technician-missionaries, Gabriel Leonard de Brossard and Pierre d'Incarville, are credited with introducing imitation aventurine to China in 1741. The glass imitation, with more sparkle than the natural mineral, created a sensation in court circles. As used in this kettle handle grip, eighteenth-century Chinese called it "golden star glass."

329, 330
Pair of vases in imperial yellow
Blown and cut glass; height
10¼ in. (26 cm)
1750–95, Qianlong seals,
poem, and mark
The Field Museum 259808
and 259808, gift in memory
of Abba Lipman

The vases are covered with a
floral scroll network in high
relief. Each bears two fan-
shaped and two circular
panels with inscribed poems.
The poems in the fans – and
perhaps the others as well –
are by Qianlong. The poems
on each vase are different,
making eight poems in all.
The bodies are more than
one-third of an inch (one
centimeter) thick, formed by
repeated dipping and rolling
prior to cutting the
decoration.

containers of other kinds. The Chinese altar set shown
here (figs. 326, 327) is an example of the way in which
Qianlong's glass workers combined traditional shapes
with new decorative methods – in this case, cameo glass.
This grip of the handle of a European-style teakettle
(fig. 328) is made of glass too, a sparkling imitation of
the mineral aventurine that Qianlong seems to have
liked but that probably had never been used for such a
purpose before. A pair of vases in imperial yellow is
finely carved with floral motifs and a number of the
emperor's poems (figs. 329, 330).

The emperor was enthusiastic about another novel
use for glass: to make windows, lamps, and mirrors
for Palace buildings. Glass as an architectural mate-
rial was new to China at the time, and the best sheet
glass was produced not in the Imperial Workshops
but in Guangzhou (Canton), in the far south of China.
He chose glass to replace many of the paper-covered
windows in the Yuanming Yuan Summer Palace and
was eager to explore the possibilities of the new mate-

rial in interior design. For instance, in 1739 he ordered
glass windows to be partially painted in an apparent
effort to create a *trompe-l'œil* effect:

The glass windows behind the bookcases ... are to be
painted with potted plants in gilt black or colored
lacquer, or with Western gilding. On top use ivory
to match the flowers, below match the stand with
zitan wood. ... and add railings to look real. On both
the east and west side [of the windows] paint some
bookcases[29]

Qianlong collected Western glass years before he
started his European buildings project in the
Yuanming Yuan Summer Palace. In the fourth year of
his reign, he ordered the glass lamps in the Yuanming
Yuan to be collected in one place so that he could view
them all. They included lamps in the form of a flower
vase, a miniature plant, grapes in a glass basin, a
European man, and a European dog.[30]

331
Snuff bottle in peacock-tail shape
Painted enamel on copper, ivory spoon; height 1¾ in. (4.5 cm)
1736–95, Qianlong mark and period

Decorated with thick enamel colors separated only by other enamels of differing melting points, this piece represents an experiment with a wholly new technique. Peacock feathers had meaning in Qing social organization. The owner of this one may have been of very high rank (see "Imperial adornment: Accessories," pp. 54–59).

332
Snuff bottle in gourd shape decorated with squash and butterfly designs
Painted enamel on glass, ivory spoon; height 2⅛ in. (6.1 cm)
1736–95, Qianlong mark and period

A squash on a vine together with butterflies signifies a wish for perpetuating the family line.

Enamel

Technically speaking, enamel can mean any low-melting-point colored glass that is used to decorate the surface of another material. Low-firing glazes applied to high-fired ceramic bodies may be called enamels. The term enamelware, however, usually refers to colored glass decoration on metal (usually copper alloy) bodies. Four types of enamel art existed during the Qianlong reign: champlevé, cloisonné, painted enamel, and transparent *basse-taille* enamel.

The first two types had been known in China from the early Ming period onward but never had been produced in such quantities as under Qianlong's patronage. As shown by a number of the illustrations in this book, Palace regulations specified cloisonné on copper alloy as the material of choice for many of the ritual furnishings of formal throne rooms and for the bowls and dishes from which the emperor ate semiformal meals. Forever searching for new ways of using materials, Qianlong ordered exceptionally large objects such as cloisonné stupas (see fig. 158), cloisonné-champlevé elephant censers (fig. 334), and cloisonné guardian lions.[31] He also explored the potential of cloisonné as an architectural material. He outfitted his studies with cloisonné details such as balusters, railings, cabinets, and panels (fig. 335). In addition, he often ate from cloisonné tablewares (see figs. 241–44) and made use of cloisonné furnishings: censers (see figs. 33, 34, 37), braziers (see fig. 38), and coolers (see fig. 237).

In spite of the emperor's interest in cloisonné, the enamel itself showed no sign of technical improvement. Its surface was invariably covered with unsightly pinholes, apparently caused by gases emitted when the objects were fired in the enamel workshop. Cloisonné objects from earlier reigns show the same defects – it would seem that either the enamel formulas or the application methods were defective and that no solution had been attempted except, as rumor has it, to fill the pinholes with colored wax. By the end of the Qianlong reign, cloisonné and champlevé makers may have added a new color or two and had become skilled in making very large pieces. But otherwise, their techniques had not changed since the Ming dynasty.

333
Snuff bottle with European figure
(detail of fig. 324)

Enamel painting depicting European scenes or figures was mainly applied to glass and copper alloy rather than porcelain during the Qianlong period. The former materials seem to have had a more strongly Western connotation, even though porcelain, because of its chemical stability and very high melting point, was an eminently suitable base for painted enamel work.

334
Large elephant censer
Cloisonné and champlevé
enamel on copper alloy;
height 60¾ in. (154.5 cm)
1746

Elephants carrying large
vases on their backs
conveyed the meaning of
universal peace and hence
were included in the ritual
lubu objects, as shown in
fig. 205. One of a pair, this
was a gift to Qianlong from
Li Shiyao, the viceroy in
Guangdong, known for its
skillful enamel workers.
Apparently elephants,
whether models or alive,
were a regular tribute item
from Guangdong. In 1774
Prince Cheng, Qianlong's
eleventh son, was delighted
with a baby elephant sent as
tribute by that province to
his father. (See also fig. 82.)

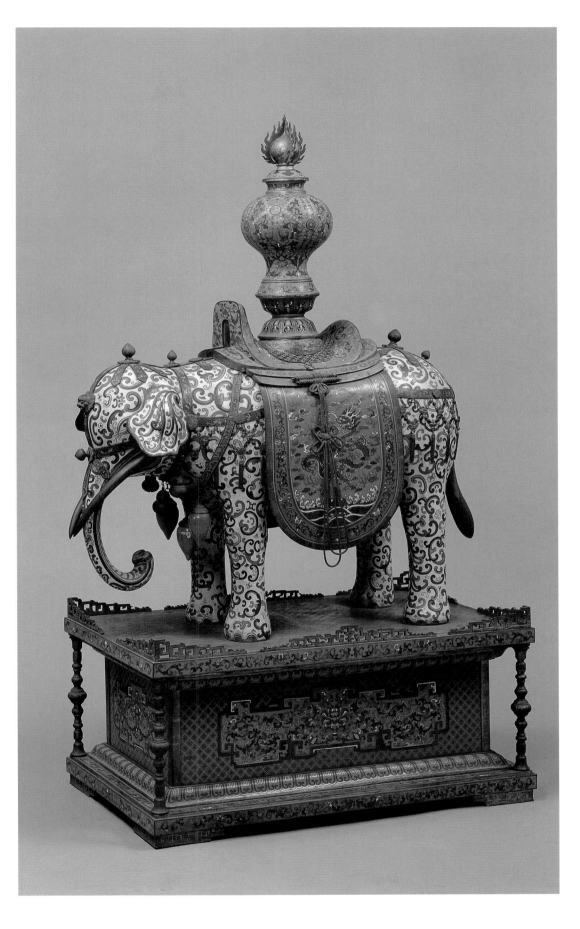

335
Leshou Tang Study

The study in Qianlong's retirement compound, the Ningshou Gong, in the Forbidden City. Its interior was ornamented with *zitan* wood and cloisonné enamel, inlaid with bronze and jade. The architectural use of cloisonné on such a scale was unprecedented. The jade boulder in fig. 303 originally stood in this building.

336
Lidded jar with wrapped-cloth design
Painted enamel on copper alloy; height 12 in. (30.5 cm)
1735–95, Qianlong mark and period

An interesting piece that acknowledges inspirations from several cultures: the Chinese interpretation of floral design has an Indian tone that anticipates the later Victorian style, yet the painted cloth wrap is unmistakably a Japanese concept, borrowed from decorations on lacquerware.

337
Lidded spittoon with butterfly and flower painting
Painted enamel on copper; height 3⅜ in. (8.6 cm)
Eighteenth century

Shallow spittoons of this shape hardly survive outside the Palace. Commoners may have felt that such a shallow, open shape was less practical than conventional spittoons with a flaring rim, restricted mouth, and deep body. Hygiene issues aside, this spittoon is a beautiful one. Butterflies among flowers, signifying happy encounters, were a popular theme in the Qing period.

338
Lidded box in five-lobed shape
Painted enamel on copper alloy with gilding; height 5⅝ in. (14.5 cm)
1736–95, Qianlong mark and period

The overall shape is Western, as is the subject-matter of the middle horizontal band, upon which European ladies and children are depicted. The other bands, depicting flowers and scenery, are definitely Chinese in sentiment. A piece like this would have needed the kind of close cooperation between painters and other skilled craftsmen that was only possible in the Palace workshops.

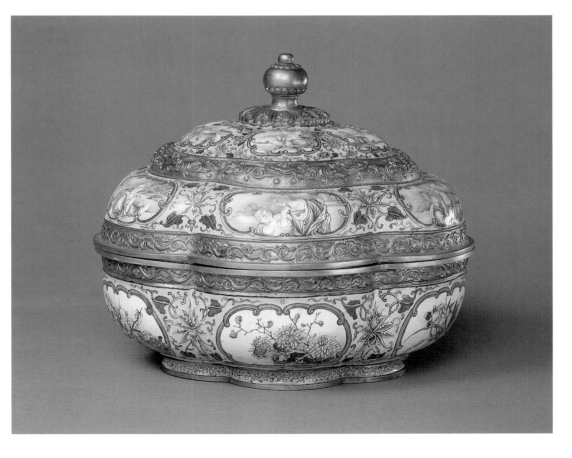

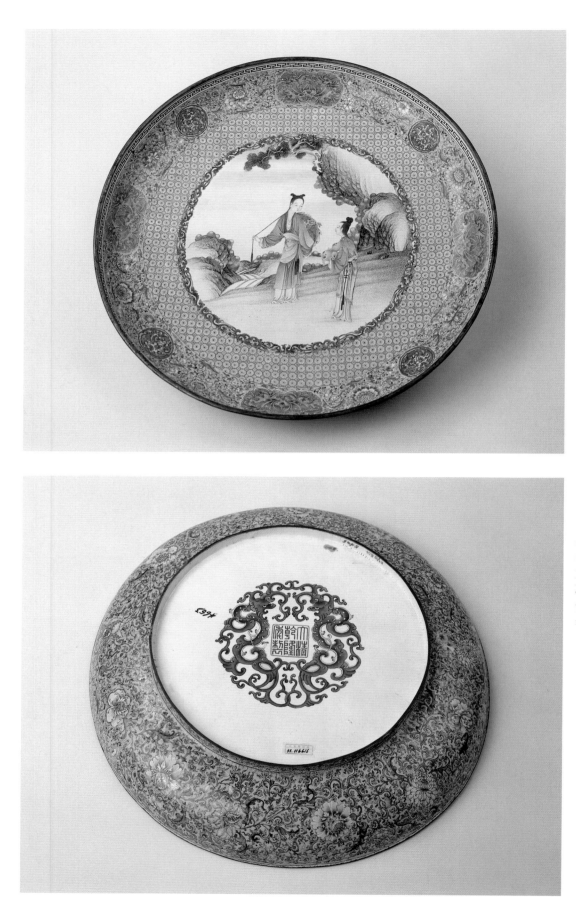

339
Large plate painted with women collecting herbs
Painted enamel on copper alloy; diameter 22 in. (56 cm)
1736–95, Qianlong mark and period

Meticulously painted, the central panel shows two women, one carrying herbs in a net on her back and the other displaying the herbs she has collected in a gourd.

340
(reverse of fig. 339)

In an attempt to integrate European with Chinese motifs, the borders on both sides have been painted with dense floral patterns that have a strongly Western look. The reign mark is encircled by a carefully painted interwined dragon.

**Basin with Daoist and
Buddhist emblems**
Basse-taille enamel on copper
alloy and on gold and silver
foils; height 4¾ in. (12.3 cm)
1740

One of a pair, this basin was
a gift to the emperor from
the wealthy Guangdong
Customs Office. *Basse-taille*
work, using transparent
enamel, produces a
smoother and more brilliant
effect than cloisonné.
Although the technique had
only recently been
introduced to Guangdong
enamel workers, they were
already adapting *basse-taille*
methods to make pieces with
typical Chinese designs and
motifs. The eight emblems
on the flat rim represent the
eight Daoist immortals,
while those on the cavetto are
the Eight Treasures of
Buddhism.

In contrast, the workers who made painted and
transparent enamels were strikingly progressive. Their
products rarely show any pinholes at all, indicating that
different enamel formulas were used. Painted enamel,
in fact, became a defining art form of the Qianlong
style, in terms both of quality and innovativeness
(figs. 336, 337). Much of the actual painting was done
either by European artists at court or by Cantonese
artists employed by private workshops in Guangzhou.
Both groups were capable of turning out virtually flaw-
less, intricately designed pieces that often combined
Chinese and European elements (figs. 338, 342). In a
few cases, the cultural mixture was more intricate: the
large plate in fig. 339, although made in the Palace
workshops for Palace use, is decorated with a European
"chinoiserie" design. The painted enamel method, once
adopted, was not confined to copper- and brass-based
objects. Glass (figs. 332, 333) as well as porcelain
(fig. 300) objects were often decorated with enamels
formulated to be applied in much the same way as
painters' pigments.

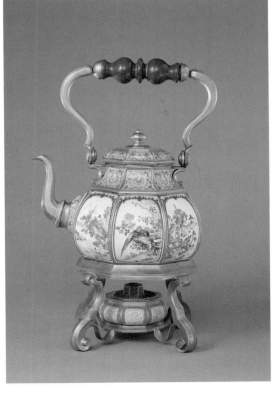

342
Kettle on stand with warmer
Painted enamel on copper
alloy with gilding and glass
grip on handle; diameter
35¾ in. (9.1 cm)
1736–95, Qianlong mark and
period

Apart from the very fine
Chinese landscape and
flower paintings on the side
panels, the decoration and
design of the kettle are
entirely European. The
warmer was fueled with
alcohol. Kettles with built-in
heaters had long been known
in China, but kettles like this
must have seemed an exotic
novelty.

343
Brush holder
Wood, bamboo veneer;
height 5⅞ in. (15 cm)
1736–95, Qianlong period

The piece represents yet
another variation on
Qianlong's ideas of what is
beautiful – it is devoid of any
decoration except for the
texture of the bamboo.
Interestingly, that texture is
not natural. The joints
between bamboo sections
have been carved on strips
originally without joints, so
that bamboo is made to
imitate bamboo.

344, 345
Table top and table
Red and gold lacquer painted
on wood; height 31½ in.
(80 cm)
1736–95, Qianlong period

An unusually decorated
piece of court furniture.
The painting on the table
top (right) is so fine and
dense that it resembles a
piece of textile.

It also happened that Palace enamel workers tried
completely new techniques. One example is the snuff
bottle with a peacock-feather design shown here
(fig. 331). The individual feathers are formed by either
the champlevé or the cloisonné technique – it is dif-
ficult to tell. The enamel itself is as thick as in any tra-
ditional cloisonné work. The colored patterns are not
produced by that technique, however. Instead, they
are built up using enamels of different melting points,
perhaps applied in solid rather than in powdered form,
without metal dividers in between. Very few other
enamels in Chinese history were decorated in this way.

The basin shown in fig. 341 is covered with a thick,
highly polished layer of enamel that has no visible
pinholes or other flaws. It is the only piece in this
book – and one of the very few from the entire
Qianlong period – to explore the possibilities of the
basse-taille technique, using transparent enamel over
a reflective base of silver and gold foil. It was definitely
made in China, although transparent enameling on
silver had long been known in Europe.[32] The basin
came to Beijing from Guangzhou, a center for
Western-style "painted" enamel and evidently a cen-
ter for experimentation with other foreign enamel
techniques as well. In is interesting to consider that
no thickly enameled piece from the cloisonné work-
shop in the Palace can begin to compare with this one
in terms of technical quality. Contrary to what many
believe, the Imperial Workshops were not invariably
the best in China.

Brush holder with carving, "Dongshan Victory"
Carver: Wu Zhifan (active seventeenth century)
Bamboo, wood; height 7 in. (17.8 cm)
Early seventeenth century, with Qianlong's poem dated 1776

Carved by a native of Shanghai, this noted brush holder illustrates an ancient battle won by a psychological trick. Qianlong removed part of the carving to make room for his own poem and seals.

Bamboo and Wood

A minor specialty of Qianlong's reign was the use of bamboo as a veneer material to cover objects made of other kinds of wood. The effect is exceptionally soft and pleasing. As was often the case when new decorative arts techniques were introduced in Qing China, new designs evolved in parallel with the techniques. Shown here are a square bamboo brush pot, a masterpiece of imaginative simplicity, which hardly looks traditionally Chinese at all (fig. 343), and two other objects – an interlocking box (fig. 348) and a container shaped like a lotus bud (fig. 346) – that have moved quite far from the lacquer and ceramic objects that may be their prototypes. The emperor clearly liked and supported the new art form. Almost all of the best surviving examples are in Palace collections.

Classical wood and bamboo carvings of the Ming and early Qing periods continued in use at court during the eighteenth century (see fig. 347). However, under Qianlong, wooden furniture and furnishings for the court took new directions, moving toward highly ornate, rococo effects. The desk shown in fig. 95 and the openwork room dividers in fig. 224 presage the dark, sterile intricacy of imperial Chinese interiors of the nineteenth century and form a sad contrast with the clean-lined purity of Ming furniture design. However, as the above-mentioned desk shows, the court designers in the eighteenth century were much more innovative than their peers a century later. Experimentation was still in vogue, even if the results were sometimes unfortunate. An interesting example is the

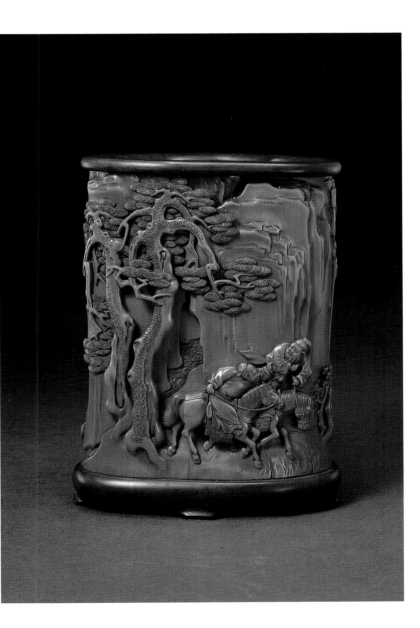

346
Box in lotus-pod shape

Wood, bamboo veneer;
height 4 in. (10.2 cm)
1736–95, Qianlong period

Eighteenth-century China
saw a movement toward
making realistic but
miniature copies of natural
objects; such copies were
favored by scholars for
decorating their studios. This
box would have fitted well
into an elegant studio in the
minimalist Yangtse delta
style, if its owner had been
prepared to overlook the fact
that it has a gaudy gold-
lacquer interior.

348
Double box

Wood, bamboo veneer,
lacquer, inlaid with shell,
jade, dyed ivory; height
2½ in. (6.5 cm)
1736–95, Qianlong period

The eight Daoist emblems
on the lid were popular
decorative designs and may
not have had a specifically
religious meaning for those
who used the box.

349
Map of Yuanming Yuan garden

The main offices and residences were on the south side of the west section.

table shown in figs. 344 and 345, with complex gold-painted decoration that has a strongly European look.

Gardens

In the area of landscape architecture, the designs created under Qianlong's direction were brilliantly innovative and unprecedentedly sweeping in scope. One of the best contemporary descriptions is that of the French Jesuit artist Jean Denis Attiret, who emphasized the carefully planned irregularity of the Yuanming Yuan gardens (see fig. 349):

> In Europe, uniformity and symmetry are desired everywhere. We wish that there should be nothing off, nothing misplaced, that one portion should correspond exactly with the part facing it. In China they also love this symmetry ... But in the [Yuanming Yuan] pleasances there reigns everywhere a graceful disorder, an anti-symmetry is desired almost everywhere. Everything is based on this principle. It is a natural, rustic countryside they wish represented, a solitude, not a well-ordered place conforming to all the rules of symmetry and harmony.

Attiret adds that he is tempted to believe that the pleasances of Europe were "poor and sterile by comparison."[33]

This book is not about buildings or landscapes. Thus we will confine ourselves to agreeing with Attiret's opinions about the gardens and to noting that Cary Liu in his sidebar essay (p. 35) is quite right to remind us that the "curious" European-style buildings in the Yuanming Yuan, still its most famous feature in the eyes of Westerners, occupied only a small and not very important sector within the grounds.

We should also note that Qianlong played the same role in landscape architecture as he did in the decorative arts – as a closely involved patron with patience, strong opinions, and deep pockets. There is no evidence that Qianlong's Jesuit advisers ever told him about the European habit of using kings' names for styles in art and architecture, as in Georgian, Queen Anne, Louis XV, and so on, but he would undoubtedly have found it an excellent idea. He deserves much more credit, or some would say blame, for the development of the "Qianlong style" than did any of the Louis in France or the Georges in Britain.

350
An Old Pine
Artist: Qianlong
Color on silk; height
10⅞ × 51⅛ in.
(27.5 × 130 cm)
1754, Qianlong seals and text
The Iris & B. Gerald Cantor
Center for the Visual Arts,
Stanford University, gift of
Mrs. Charles Ure, 1967.76

The painting, though only
competent by most art critics'
standards, shows admirable
focus and enthusiasm.
Qianlong had a genuine
love for trees.

At Leisure

Among the things that Qianlong liked best were traveling and hunting. As pointed out in Chapter III, he argued that those activities had serious purposes. However, the two to three months each year spent on the road and in the hunting parks were more than he needed simply to inspect the dikes, inspire the troops, and give feasts to Mongol princes. He clearly found pleasure in being outdoors and constantly on the move.

When in residence at one of his three regular palaces, the Forbidden City, the Yuanming Yuan, or Chengde, Qianlong indulged in more sedentary entertainments. He enjoyed drama and quite often sponsored operas in one of the several palace theaters, performed by specially trained eunuch actors and on occasion by professional troupes brought in from commercial theaters in Beijing and other cities. While he usually avoided certain official celebrations, notably his birthday, he seems to have enjoyed the popular holidays that involved lights and fireworks. He rarely missed the Lantern and Dragon Boat Festivals in company with his womenfolk and is recorded to have attended Ghost Festival celebrations, when clouds of small floating lanterns were launched on the lakes and canals of the Yuanming Yuan, even when alone. He seems to have liked the special eunuch-staffed markets that were organized for court officials and, separately, court ladies. And he was a great feeder of goldfish. In 1756, over a period of 157 days, he stopped at Tantan Dangdang in the Yuanming Yuan and fed the fish there on no fewer than seventy-two occasions.[34] As one of his poems shows, there was an emotional resonance:

I dig a pool to see the happiness of fishes
Smooth and wide is the pool and suitable to swim in
Why should the fishes dream of rivers and lakes?
We laugh at Zhuangzi, who argued that fishes swim
 because they are happy.
If you asked me how to answer the question,
I would say that fishes know the secret of happiness.[35]

Waiting on his mother for meals and taking her and other ladies on excursions in the gardens was more than a duty. He often went with her to such beauty spots as the Tongle Yuan and Wanfang Anhe.

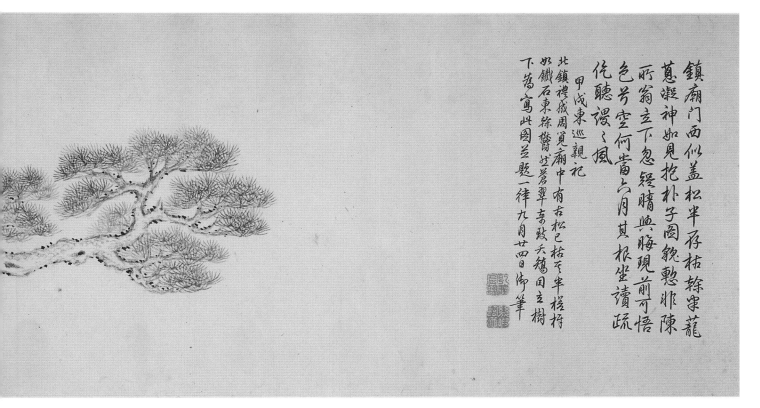

Less sedentary was his habit of going riding within the Yuanming Yuan at Shangao Shuichang and shooting targets outside the gateway of Churen Xiangliang with his sons, Princess Hexiao, and his guards. To make sure he would have fresh mounts for this, he kept many horses in the Yuanming Yuan.[36]

Qianlong was interested in his horses and in exotic, often European, dogs. He kept the latter for hunting rather than as household pets. Like his favorite horses, his dogs had names: Snow Claw, Lacquer Spot, Yellow Leopard, Snowflake Owl, Water Dragon, Golden Wing, Black Jade Dragon, and Air Diving Sparrow. His interest in tame deer, which he received as tribute from Malan Zhen northeast of Beijing, was primarily for use in sacrifice. Kept near the Eastern Tombs, at Fragrant Hill, and in the Yuanming Yuan, they were sacrificed, perhaps together with pigs, at most of the major altars of the State Religion.

He was also fond of trees – more fond of them, perhaps, than he was of most other plants and of animals. He painted pictures of trees, as in fig. 350. He wrote poems about trees in general and also about individual trees: three poems on separate occasions about a single miraculous pine in the Western Hills, two on a famous group of gingkos, also in the Western Hills, and one on a *Shorea* tree to accompany the drawing of the same tree that he gave to the Sixth Panchen Lama (see fig. 152). He thought that all these poems were important enough to have them engraved in stone so that rubbings could be made from them. He also wrote appreciative poems about groups of pines within the Forbidden City and the Yuanming Yuan. He was especially attached to a group of nine pines at the latter location because he had played under them as a boy. When they were destroyed by a fire in 1763, he dreamed about them and remembered them in poems. An official of the Ministry of Rites was given a promotion for helping to fight the fire, and Qianlong's half-brother, who was seen looking cheerful at the disaster scene, was promptly demoted.[37]

There was a botanical nursery, the South Garden, in a corner of the Forbidden City. Its purpose was to grow unusual plants from central and southern China. In 1751 Qianlong brought back miniature bonsai trees from a famous spot in Zhejiang. Later he specified that garden stones from Lake Taihu, pine trees from

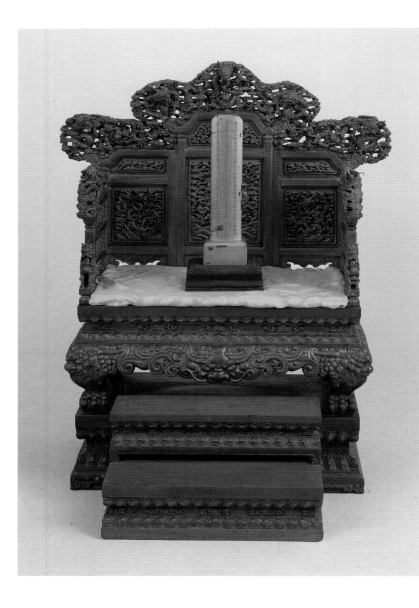

351
Qianlong's spirit throne and footrest
Gold-lacquered wood with carving; height 57½ in. (146 cm)
c. 1800

Customarily, three tablets were made for the spirit of a deceased emperor. This is one of the three made for Qianlong after his death, in 1799. The throne for a spirit tablet is somewhat smaller than that of a living emperor; it also has a footrest with two steps rather than one, as was usual for imperial footrests (see fig. 39).

of the leading poets of his day, including the prolific and gregarious Yuan Mei, who, as an erstwhile Hanlin scholar, had been presented to him and who was good friends with several of his top officials, including Heshen. Publicly, at least, the emperor was not fond of lightweight literature. As he wrote in response to a request for a preface to a poetry anthology, "What is poetry? It is an expression of the writer's loyalty to the Throne and piety toward his parents. Poetry that does not fulfill these functions, I do not count as poetry at all."[38] Considering that most of his own poems were not about political loyalty and filial piety (at least one, after all, was about the happiness of fish), we may assume that the emperor did not always take such a bleak view of the books he read.

Growing Old

Qianlong was an extraordinarily self-confident man. He rarely had moments of doubt and, like many successful executives, had the knack of deciding complex issues quickly. On the other hand, he was conscious of advancing age and, from his sixties onward, of less than perfect health. He seems to have suspected that his capabilities were declining:

When I was young I formed a resolve to hand over government to a deputy as soon as I reached the age of eighty-five, that is, the sixtieth year of my reign. Now I am eighty years old and still six years remain before I can delegate my duties. Not a day's rest do I ever have from the burden of my vast people. Their welfare is

Tiantai, and southern plums should be planted in the Changchun Garden at the Yuanming Yuan. He even took an interest in fragments of petrified wood stored in the Forbidden City and in a building on nearby Zhongnanhai Lake; he wrote a poem about them.

Qianlong was fond of music and, like other intellectuals of his time, valued the Chinese lute, or *jin*, a classical instrument that one often played while alone, as shown above in figs. 280 and 281. He was also a constant reader, but which books he really liked, besides the orthodox classics he said he liked, is unclear. He read and commented favorably on Cao Xueqin's *Dream of the Red Chamber* at the time of its publication; it would later be judged the greatest of all Chinese novels. He must also have known the work

352

Lidded stem-bowl for sacrificial food
Porcelain with polychrome glaze; height 11½ in. (29.2 cm)
1796–1820, Jiaqing mark (effaced)

This is modeled after a type of ancient bronze vessel, the *dou*, that was almost as ancient as the *jue* (fig. 353). In Qing times, the *dou* form was commonly used as a ritual food container on altars for both deities and ancestors. This example must have been made shortly after Qianlong's death, in 1799. However, the reign mark of the Jiaqing emperor has been largely effaced and replaced with the reign mark of the Daoguang emperor (reign 1820–50), indicating reuse at a time when the court was poorer and the imperial kilns less capable.

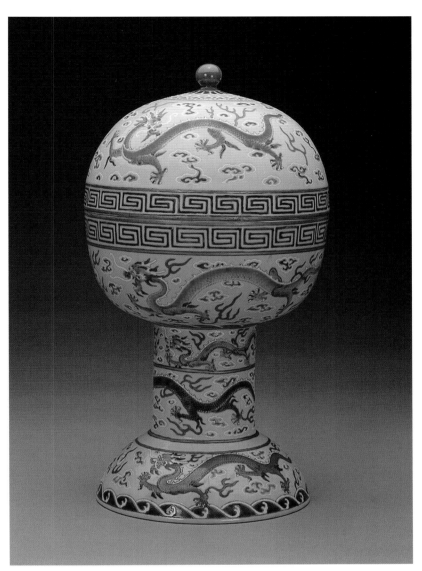

constantly in my heart. ... In strict etiquette the age of eighty is called *mao*. It is a time when one learns what it is to be reputed senile. And now I am eighty I may be beholden to others for taking over my responsibilities.[39]

Also like many successful executives, he may not have meant exactly what he said on the subject of retirement. He did not enjoy sharing power and, as it turned out, would have great difficulty in letting go. And yet he needed help, both practical and emotional. The question was, where could he turn?

Reminiscence helped. The images of Kangxi and Yongzheng gave him strength when he was young. He dedicated the compound in which he had been raised as a museum to house personal gifts from his grandfather and father, complete with labels that he had written himself.[40] His mother, too, who lived until Qianlong was sixty-six, must have provided emotional support, and his first empress meant much more to him than one would expect in a man with so many wives. Visiting her tomb a half century after her death, he wrote:

I wanted to drive past without stopping
But pretending is no good either
The three cups did not stop short of offering
The four seasons announce the coldness
The planted pine trees are now tall and scaly
The green sky opens wide above the buildings
Holding hands we returned home together
What joy is longevity for me [alone]?

Qianlong also kept up with his former teacher, Cai Xin, even after Cai's retirement. His letters to Cai were warm and caring, showing a need for approval that is surprising in such a self-reliant man. In a letter written late in his own seventies, when Cai was in his eighties, he wrote:

I read your sincere response and felt your presence. There was much snow ... fortunately January was only normal. The second half of February was short of rain. ... small showers came but not the feet-wetting type. ... I am very anxious these days because of the still unsettled rebellions in Taiwan. Here is a short essay from which you can tell what my situation is. It is accompanied by several seasonal [gift] items.[41]

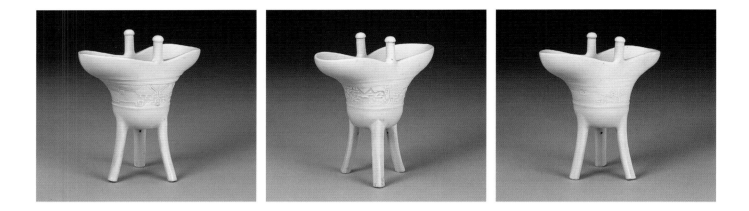

A few years later the emperor decided to invite the old teacher to come to Beijing for his, Qianlong's, eightieth birthday celebration. Cai agreed, but Qianlong fretted:

> I am excited that we will meet soon. But I am worried about the long journey you will face. You know my feelings so do not push yourself too hard. ... I am sending you a few essays of mine to read.[42]

He had a few other friends. Not counting his consorts, with whom he spent much of his time and who seem to have been his closest companions, he was on friendly terms with several of his officials, notably Shen Deqian, Yu Minzhong, and Heshen, as well as his Buddhist mentor, Rolpay Dorje. He was very fond of certain daughters and seems to have had a reasonably cordial but not intimate relationship with his sons, of whom only four lived longer than he.

He still was lonely and, perhaps almost as serious from his point of view, desperately overworked. He seems to have felt that none of his sons was capable of lifting the burden from his shoulders. He may have had hopes for his fifteenth son, whom he made his successor, the Jiaqing emperor. However, Jiaqing too proved a disappointment and Qianlong himself continued to rule, in fact but not in name, until the day of his death. Qianlong's chief helper and confidant was not Jiaqing but the brilliant, handsome, corrupt, and much hated by Jiaqing, Heshen.

If Heshen had been one of his sons, Qianlong must sometimes have thought, things would have been dif-ferent. Heshen had more talent and drive than any of the sons, and he was not only an effective administrator but a highly cultured individual with whom Qianlong could share his multifarious interests. Unfortunately, however, Heshen was not the emperor's son and took merciless advantage of the old man's seemingly blind affection. He may have been the chief comfort of Qianlong's old age. However, in the eyes of contemporaries and later commentators, he was also a cancer, so arrogant and corrupt that single-handedly he precipitated a decline that would nearly destroy the empire within a few decades of Qianlong's death.

If Qianlong realized what was going on he did not show it, continuing to support Heshen while attending to other priorities. He fell into a stream at the Chengde palace and wrote a poem about it revealing his embarrassment while denying that he was becoming clumsy or weak.[43] He spent much time in reminiscence. When about to retire at the age of eighty-five, he wrote a humorous poem admitting that "his left ear had hearing problems for forty years and his left eye had vision problems for almost twenty," adding a mock-philosophical conclusion:

> Half-seen means half unseen, half-heard means half
> unheard
> It is a common saying that is most logical
> One avoids the extremes and walks the middle way. ...

The emperor died on the 3rd day of the 1st month of 1799. He was buried in the imperial Eastern Tombs

354
Reconstructed spirit altar set for Qianlong
Lacquer throne, spirit tablet, and table; jade wine cups and lidded stem-bowls

The Imperial Ancestors' Temple [Tai Miao] was the home of the spirits of deceased emperors. Each was given a throne, a spirit tablet bearing his posthumous and temple titles, and sets of ritual utensils for food and and beverage offerings.

and his spirit tablet (fig. 194) was placed on a spirit throne in the Temple of Imperial Ancestors, with appropriate offerings (figs. 351–54).

His successor Jiaqing prepared the eulogy. With more than a little truth he praised his father for

Being a most filial son waiting on his mother for forty-two years [while emperor];

Working hard, handling thousands of items of business day after day, going over paperwork, meeting officials;

Caring for the people, benefiting everyone – cutting all taxes five times and spending millions on emergency relief;

Demonstrating leadership in sustaining the court, in improving and managing the administration, in setting and sharing standards with officials and clans, and in promoting capable people;

Pacifying the unsettled boundaries, expanding the empire's territory to more than 20,000 *li*, and succeeding in ten military campaigns;

Being very intelligent and well-informed, having read all the classics;

Starting a new trend with his poetry and writing great essays that surpassed those of many great writers before him;

Traveling without forgetting his work, his principles, and his people; and

Assembling and publishing great literature of the past.[44]

Notes

1. Frank Dorn, *The Forbidden City*, New York 1970, p. 39.
2. Watson 1963, pp. 46–47.
3. Qinggui *et al.* 1965, *juan* 59, p. 1920.
4. The Field Museum's set, FM 244473, 1–22, is described in Tchen and Starr 1981, pp. 393–97.
5. Wan *et al.* 1990, p. 311.
6. Watson 1963, p. 43.
7. Tong 2001, II, p. 846.
8. Wan *et al.* 1990, p. 313; for Qianlong's refusal to believe that another version could be the original and his the copy, see Chang 1996, p. 21.
9. Nie Chongzheng, "A study of G. Castiglione's Paintings Without the Mark '*chen*' in his Name," *Palace Museum Journal,* 2002, no. 2, pp. 85–92.
10. Zhongguo diyi lishi danganguan 1991, II, p. 1352.
11. Danby 1950, p. 78; Evelyn S. Rawski, "Re-imagining the

Qianlong Emperor, a Survey of Recent Scholarship," in *Symposium on "China and the World in the 18th Century,"* Taipei (National Palace Museum) 2002, pp. 1–12.

12. Zhongguo diyi lishi danganguan 1991, II, p. 1248.

13. Yang Boda, "The History of the Imperial Art Academy in the Emperor Qianlong's reign of the Qing Dynasty," *Palace Museum Journal,* 1992, no. 2, pp. 3–11.

14. See, for example, Stacey Pierson with Amy Barnes, *A Collector's Vision: Ceramics for the Qianlong Emperor,* London 2000, pp. 10–33.

15. Hsieh 2002, p. 203.

16. Zhenlun Fu and Li Yan, "Tang Ying's Ceramic Business Records," *Jingdezhen Taoci,* 1982, no. 2, pp. 19–66.

17. The Palace did use fine-quality ceramics for feeding cats, however. In 1745 Qianlong ordered a nice wooden stand to match a newly made Ru-style "cat feeder," and he ordered another feeder to be made by Tang Ying a few months later. (See note 16 above, Fu and Yan 1982, p. 45.)

18. Yang Boda, "Qing Qianlong di yuqi guan chutan [Discussion on Qianlong's views on jades]," *Palace Museum Journal,* 1993, no. 4, p. 65.

19. Yan Jing, "Hetian caiyu yu gudai jingji wenhua jiaoliu [Jade mining in Hetian as ancient economic and cultural exchanges]," *Palace Museum Journal,* 1995, no. 1, p. 20.

20. Yang Boda, "A Study of the Jadeite Distribution in China in the Light of Historical Documents," *Palace Museum Journal,* 2002, no. 2, p. 16.

21. Yang 1991, p. 171.

22. Yang Boda, "A Brief Account of the Qing Court Collection of Jadeites," *Palace Museum Journal,* 2000, no. 6, pp. 40–44.

23. Liu Guilin, "Animals found favor in the Qing court," *Forbidden City,* 1980, no. 4, pp. 37–38.

24. Yang 1993, p. 4.

25. Yang 1991, p. 179.

26. Watson 1963, p. 15.

27. Zhang Rong, "Carved Red Lacquer 'Flying Dragon' Banquet Box," *Forbidden City,* 1989, no. 4, p. 16.

28. Donald Rabinber, "Chinese Glass and the West," in *A Chorus of Colors,* ed. Asian Art Museum of San Francisco, San Francisco 1995, pp. 17–19.

29. Zhongguo diyi lishi danganguan 1991, II, p. 1270.

30. *Ibid.,* II, p. 1262.

31. The largest known pair is in the University of Pennsylvania Museum, Philadelphia.

32. Sir Harry Garner, *Chinese and Japanese Cloisonné Enamels,* Rutland vt 1962, p. 94.

33. Attiret's entire letter is translated in Danby 1950, pp. 69–78.

34. Zhang 1998, p. 109.

35. Danby 1950, p. 52.

36. Zhang 1998, p. 42.

37. *Ibid.,* p. 138.

38. Waley 1970, p. 169.

39. Watson 1963, p. 45.

40. Qinggui *et al.* 1965, *juan* 69, pp. 2142–44.

41. Tong 2001, I, p. 855.

42. *Ibid.,* p. 388.

43. Lao Yin, "Emperor Qianlong Fell into the River," *Forbidden City,* 2000, no. 3, p. 46.

44. DQSL(RZ) 1964, *juan* 37, pp. 369–71.

Sidebar notes

1. See Chu-tsing Li, *The Freer "Sheep and Goat" and Chao Meng-fu's Horse Paintings,* Ascona, Switzerland (Artibus Asiae) 1968, for a full treatment of the subject-matter.

2. This is equivalent to December 13, 1742. The original of this "palace memorial with imperial rescript in vermilion [*Gongzhong zhupi zhoujie*]" is in the First Chinese Historical Archives in Beijing and has been published in First Chinese Historical

in "Kieng-Tsin" (*i.e.*, Jiangxi province), where the Imperial Kilns of Jingdezhen were located.

We will not comment on Voltaire's evaluation of the two rulers' poetry. A great writer himself, he was certainly qualified to judge what Frederick wrote, and he had read quite carefully (and admiringly) the Jesuit Amiot's translation of Qianlong's *Ode to Mukden* (see sidebar p. 32). Even though he was prejudiced by

his hopes for financial support from Frederick, his evaluation was thoughtful and perhaps correct.

On the other hand, Voltaire was wrong or disingenuous about the relative merits of the two rulers' porcelain. Frederick's was made at a new official kiln near Berlin, staffed by workmen brought from Meissen, where Böttger a few decades previously had rediscovered the Chinese secret of true "hard-paste"

porcelain. This Berlin porcelain was nice enough, but Frederick himself (who had much genuine Chinese porcelain in his collection) must have known that his small factory could hardly compete with the vast and technically advanced imperial kilns of Jingdezhen. Voltaire must have known it too.

355
Image of Qianlong
From Jean Amiot, *Mémoires*, vol. I
1771

356
Frederick the Great of Prussia
Contemporary engraving
c. 1780

Archives, *Qingdai dang'an shiliao congbian* [Serials of historical archives of the Qing dynasty], XII, Beijing (Zhonghua shuju) 1987, p. 8.

3. For a general introduction to Tang Ying, see Peter Y.K. Lam, "Tang Ying (1682–1756), The Imperial Factory Superintendent at Jingdezhen," *Transactions of the Oriental Ceramic Society*, LXIII, 1998–99, pp. 66–82.

4. Every year Tang Ying, whose base was at Jiujiang, would make two such inspection visits to Jingdezhen in spring (3rd month) and autumn (10th month), each of which would last slightly more than a month. See Tang Ying, *Tang Ying ji* [A collection of works by Tang Ying], collated and annotated by Zhang Fayin and Diao Yunzhan, Shenyang 1991, II, pp. 873–74. In Tang Ying's time the trip from Jiujiang to Jingdezhen took four to five days.

5. Tang Ying regarded himself as very honored and privileged to receive such a command. Hence, he ordered the imperial poem to be inscribed permanently on a stele on Zhushan in Jingdezhen. He also composed a preface and poem to celebrate the event. See Tang 1991, I, pp. 148–49.

6. Wall-vases, *guaping* (hanging vases) or *qiaoping* (hanging vases for a sedan chair), are vases with rectangular or oval sections, and a flat, undecorated back for hanging on the walls or interiors of sedan chairs. The best known are those hanging on the left wall of the Sanxi Tang [Study of the Three Rarities] in the Yangxin Dian in the Forbidden City; see Zhu Chengru *et al.*, *The Life of Emperor Qian Long*, Macao (The Macao Museum of Art) 2002, pp. 194–204, 231.

7. The translation is modified from that of Sheila David. The poem is a well-known one describing wall-vases. It was published in Hongli (Qianlong), *Qing Gaozong yuzhi shiwen quanzhi* [Complete collection of imperial poems and essays by Qing Gaozong], II, *Yuzhishi chuji* [Imperial poems, first part], Taipei 1976, Ch. 11, p. 8.

8. For a discussion of Laoge, see Ts'ai Ho-pi, *Taoci tanyin* [Studies

on ceramics]; Taipei (Yishujia chubanshe) 1992, pp. 192–99; and Zhu Shan, "Laoge – taocishi shang bei yiwang de ren [Laoge – a forgotten figure in the history of ceramics]," *Jingdezhen taoci*, V, no. 1, 1995, pp. 36–37, 42.

9. At least four varieties of wall-vases inscribed with this poem are known. See, for instance, Peter Y.K. Lam (ed.), *Qing Imperial Porcelain of the Kangxi, Yongzheng and Qianlong Reigns*, Hong Kong 1995.

10. Such annual orders for porcelain from the Imperial Household Department were placed to coincide with the major feasts of the year, which would include the Chinese New Year, the Duanyang Festival (5th day of the 5th month), the emperor's birthday, and the empress dowager's birthday.

11. James Watt, "Jade," in Wen C. Fong and James C.Y. Watt, *Possessing the Past: Treasures from the National Palace Museum, Taipei*, New York (The Metropolitan Museum of Art) 1996, p. 71.

12. See Hsieh 2002.

13. For a color illustration, see Jan Stuart, "Beyond Paper: Chinese Calligraphy on Objects," *Antiques Magazine*, October 1995, pp. 502–14, illustrated p. 513.

14. As early as 1387, in the connoisseurs' book *Gegu yaolun*, Cizhou ware was compared to Ding ware, so the mistake is not egregious. There are other examples of Qianlong's mixing up similar ceramics, such as a Ru ware bowl now in the Percival David Foundation in London that he called Jun ware.

Glossary

Agui	阿桂	chaofu	朝服
Ah Musun	阿木孫	Chen Mei	陳枚
Aisin Gioro clan	愛新覺羅	Chen Zuzhang	陳組章
Amiot, Jean Joseph Marie	錢德明	Cheng Qi	程棨
Amitayus Buddha	無量壽佛	Cheng, Prince	誠親王
Amoghasiddhi Buddha	成就佛	Chengde	承德
An Tai	安泰	chuandi	船底
Analects	論語	Chunhua getie	淳化閣帖
Anuttarayoga-tantra	密教無上瑜伽部	Chunhua Xuan	淳化軒
Anyou Gong	安祐宮	Cining Gong	慈寧宮
Attiret, Jean Denis	王致誠	Cixi	慈禧太后
		Cizhou	磁州
Bai Juyi	白居易	Confucius	孔子
baling	芭苓		
Bao, Prince	寶親王	d'Incarville, Pierre	王致中
Baoenta	報恩塔	Da Qing shilu (Shengzu)	大清實錄(聖祖)
Baohe Dian	保和殿	Da Qing shilu (Shizong)	大清實錄(世宗)
Baoxiang Lou	寶相樓	Da Qing Gaozong Chun	大清高宗純皇帝聖訓
Baoyuan, zuchi	寶源，足赤	huangdi shengxun	
beideng	背燈祭	Da Qing huidian	大清會典
Beihai	北海	Da Qing Qianlong fanggu	大清乾隆仿古
Beijing/Peking/Beiping	北京	Da Qing Qianlong nian zhi	大清乾隆年製
Bishu shanzhuang	避暑山莊	Da Qing Yongzheng	大清雍正年製
Bixia Yuanjun	碧霞元君	nianzhi	
bo-bell	鎛鐘	Da Yu	大禹
bobo	餑餑	Dai Miao	岱廟
Bohai	渤海	Dalachi	大拉翅
Bordered Yellow Banner	鑲黃旗	Dalai Lama	達賴喇嘛
Boshan	博山	Danyuan Lou	淡遠樓
Bukhara	布魯克巴	Daoguang	道光帝
		Derling Yukeng	德齡
carya-tantra	密教行部	Dexing sword	德興刀
Cai Xin	蔡新	Dharmadhaturagisvara	法界妙音自在佛
caishui	彩帨	Buddha	
Cao Xueqin	曹雪芹	Di Tan	地壇
cha-dou	喳斗	dianzi	鈿子
Changbai Shan	長白山	Ding ware	定窯
Changchun Gong	長春宮	Djungar	准葛爾
Changchun Garden	長春園	Dong Hao	董浩
Changchun Yuan	暢春園	Donghai	東海
Changlu Yanzheng	長盧鹽政	Dongyue	東嶽
changzai	常在	dongzhu	東珠
chao xie	朝鞋	Dorgon	多爾袞

dou vessel	豆	Guanyin	觀音
Duanyang	端陽	guaping	掛瓶
Dun Fei	惇妃	Gugong	故宮
duomu jug	多穆壺	Guhya-Manjushri Buddha	秘密文殊室利佛
		Guhyasamaja-Aksobhyavajra	不動金剛祕密佛
Eastern Tombs	東陵	guifei	貴妃
Evenks (Solons)	素倫族	guiren	貴人
		Guo, Prince	果親王
Fang Guancheng	方觀承	Guochao gongshi, xubian	國朝宮史續編
Fanhua Lou	梵華樓	guxi tianzi	古稀天子
Fanjinna	方吉納		
Fanxiang Lou	梵香樓	Hada	哈達
Fanzong Lou	梵宗樓	Han dynasty (206 BC–AD 220)	漢朝
Fayuan Si	法源寺	Han, Western	東漢
fei	妃	Han, Eastern	西漢
feicui	翡翠	Hangzhou	杭州
Fengxian Dian	奉先殿	hanjun (Chinese-martial)	漢軍
fu (bat)	蝠	Hanlin Academy	翰林
fu (poetry)	賦	Hebei	河北
Fucheng Gate	阜成門	Heilongjiang (river)	黑龍江
Fuchunshan jutu	富春山居圖	Henan	河南省
Fuhai	福海	Heshen (an official)	何珅
Fujian	福建	Hetian (Khotan, Hotan)	和闐，和田
Fushan	撫順	Hevajra	喜金剛
		Hexiao, Princess	和孝公主
Ganguli	綱古里	Hongli	弘曆
Gao Guifei	高貴妃	Hongtaiji	皇太極
Gao Bin	高斌	Huai	淮
Gaozong	高宗	huaitang	懷鐺
Ge ware	哥窯	hualama	畫喇嘛
Gegu yaolun	格古要論	Huang Gongwang	黃公望
Gelugpa	格魯派	huang guifei	皇貴妃
Genghis Khan	成吉斯汗	huangdi	皇帝
Gengzhi tu	耕織圖	huanghou	皇后
Gongzhong jindan	宮中進單	Huangji Dian	皇極殿
Gou (thunder deity)	苟元帥	huangtaihou	皇太后
gu vessel	觚	Huangzhong	黃鐘
Guan ware	官窯	huapandi	花盤底
Guandi	關帝	huidian	會典
guang/gong	觥	Huiyao Lou	慧曜樓
Guangchusi	廣儲司		
Guangxu	光緒	Jangjya Hutuktu	章嘉・胡圖克圖
Guangzhou	廣州		

Jebtsundanba Hutuktu	哲布尊丹巴・胡圖可圖	mao (old age)	耄
Jiangnan	江南	Marquis Yi	曾候乙
Jianting	箭亭	meiping	梅瓶
Jianzhou	建州	Miao tribe	苗族
Jiaotai Dian	交泰殿	Miaoying Si	妙應寺
Jiaqing	嘉慶帝	Ming dynasty (1368–1644)	明朝
jiazi tou	夾子頭	ming huang	明黃
Jibao	吉保	Mount Mileta	密爾岱山
jifu	吉服	Mount Tai	泰山
Jilin (Kirin) province	吉林省	Mount Wutai	五台山
Jin kingdom	大金國	Mukden (Shengjing)	盛京
Jin Kun	金昆	Mukden (Shenyang)	瀋陽
Jin Tingbiao	金廷標	Mulan	木蘭
Jingdezhen	景德鎮		
Jingshan	景山	Nadandaihuan	納丹岱琿
jinni	金猊	Nanhai	南海
Jiujiang	九江	Nanjing	南京
juan	卷	Nantang	南堂
jue	爵	Nanyuan	南苑
Jun ware	鈞窰	Nava-sikhin Buddha	九頂佛
Junjichu	軍機處	Neiting	內廷
Jurchen	女真	Neiwufu	內務府
Juyong Pass	居庸關	Niang-niang	娘娘
		Ningshou Gong	寧壽宮
Kalachakra	時輪王佛	Ningshou jiangu	寧壽鑒古
Kangxi	康熙帝	niru	牛錄
Kangyur	甘珠爾經	Nurgaci (Nurhachi)	努爾哈赤
Kedun Nuoyan	喀敦諾延		
kesi	緙絲	Omosi Mama	鄂謨錫瑪瑪
Khitan (Qidan)	契丹	Orochons	鄂倫春族
Kriya-tantra	密教事部		
Kuaixue Tang fa shu	快雪堂法書	Palden Lhamo	吉祥天母
Kubilai Khan	忽必烈	Panchen Lama	班禪喇嘛
Kunning Gong	坤寧宮	Panshan	盤山
		pianfang	扁方
Lang Shining (Giuseppe Castiglioni)	郎世寧	pin	嬪
		pipa	琵琶
Latter Jin kingdom	後金國	Plain White Banner	正白旗
Leshou Tang	樂壽堂	Potala Monastery	布達拉宮
Lhasa	拉薩	pulao	蒲牢
li (distance measure)	里	Pule Si	普樂寺
Li Shiyao	李侍堯	Puning Si	普寧寺
liang (weight)	兩	Putuozongsheng	普陀宗乘，小布達拉宮
liangba tou	兩把頭	Puyi	溥儀
Liao	遼國		
Liaoning	遼寧省	qian	錢
Liaoyang	遼陽	Qianlong	乾隆帝
ligong xing huangjia yuanlin	離宮型皇家園林	Qianlong yuyong	乾隆御用
		Qianlong yuzhi	乾隆御製
Lin Guiren	林貴人	Qianqing Gong	乾清宮
Lingguan	靈官	qiaoping	橋瓶
Liuheta	六和塔	Qin dynasty (221–207 BC)	秦朝
longpao	龍袍	qin (string instrument)	琴
Longyu	隆裕皇太后	Qin Shihuangdi (emperor)	秦始皇帝
lubu	鹵簿	Qin'an Dian	欽安殿
luduan	甪端	Qin'an Dian chenshe dang	欽安殿陳設檔
		Qinding da Qing Gaozong Chun huangdi shilu	欽定大清高宗純皇帝實錄
Macao	馬交（澳門）		
Macartney	馬嘎爾尼	Qinding da Qing tongli	欽定大清通禮
Mahayana Buddhism	大乘佛教	Qing dynasty (1644–1911)	清朝
Malan Zhen	馬蘭鎮	Qing Gaozong yuzhishi chuji	清高宗御制詩初集
Malanyu	馬蘭峪		
Manjushri	文殊菩薩	Qing Guifei	慶貴妃
Manzhou (Manchu)	滿州	Qing shilu	清實錄
Manzu	滿族	Qingdai gongshi congtan	清代宮史叢談
mao	畝	Qinghai	青海

Qingning Gong	清寧宮	thangka	唐卡畫像
Qingyi Yuan	清漪園	Tian tai	天台
qipao	旗袍	Tian Tan	天壇
qiren	旗人	Tiananmen Gate	天安門
qitou	旗頭	Tianhou	天后
Qufu	曲阜	Tianqiong Baodian	天穹寶殿
		Tib-hgro-ba-hdul-ba Buddha	度生佛
Rehe, Jehol	熱河	Tiyuan Dian	體元殿
Ritian Linyu	日天琳宇	Tokugawa	德川
Rolpay Dorje	若必多吉國師	Tongwo yuanshu	統握元樞
Rong Fei	容妃	Tongle Yuan	同樂園
Ru ware	汝窰	Tongzhi (1862–74)	同治帝
ruyi	如意	Torgut (Durbet) Mongols	杜爾扈特
Ruyi Guan	如意館	Trailokyavijayavajra Buddha	能胜三界佛
		Tsongkhapa	宗喀巴
Samvara	上樂王佛	Tungusic	通古斯
Sanbao	三保	Turfan	吐蕃
Sancai tuhui	三才圖會		
Sanxi Tang	三希堂		
Sarvavid-Vairocana Buddha	普慧宏光佛	Uighur Turkish	維吾爾族
Shakyamuni, Buddha	釋迦牟尼佛	Ula Nara	烏拉納喇氏
Shaman	薩滿	Uttamasri Buddha	最上功德佛
Shandong	山東省		
Shang dynasty (1750–1040 BC)	商朝	Vairocana	毗卢佛
Shangao Shuichang	山高水長	Vajracchedika-Prajnaparamitra-Sutra	金剛般若波羅蜜經
Shanxi	山西省		
Shen Deqian	沈德潛	Vajradhatu Buddha	金剛界佛
Shen Yuan	沈源		
sheng (unit of measurement)	升	Wan Guifei	婉貴妃
Shengjing fu	盛京賦	Wanfang Anhe	万方安和
Shenyang	瀋陽	Wang Xizhi	王羲之
shilu	實錄	Wanli (1573–1620)	萬曆帝
shou	壽	wanshou wujiang	萬壽無疆
Shou'an Gong	壽安宮	Wanshuyuan Garden	萬樹園
Shoukang Gong	壽康宮	Wei Huangguifei	魏皇貴妃
Shu Fei	舒妃	Wenhui Guifei	溫慧貴妃
Shuangming sword	霜明	Wenyuan Ge	文淵閣
Shun Fei	順妃	Western Tombs	西陵
Shunzhi (1644–63)	順治帝	Wu Zhifan	吳之璠
Siam	暹羅	Wufuwudai guxi tianzi zhibao (seal)	五福五代古稀天子之寶
Sichelbart, Ignatius	艾啟蒙		
Sichuan	四川	Wumen (Meridian) Gate	午門
Siku quanshu	四庫全書	Wuxi	無錫
Song dynasty (960–1279)	宋朝		
Songhua	松花	xi	夕
Suicheng Dian	綏成殿	Xian (city)	西安
Suizhao tu	歲朝圖	Xiancan Tan	先蠶壇
Sulu	蘇錄	Xianfeng (1851–61)	咸豐帝
Sun Dianying	孫殿英	Xiang Fei	香妃
Suzhou	蘇州	Xiangshan	香山
		Xiannong Tan	先農壇
Tai Miao	太廟	Xiaoxian, Empress	孝賢皇后
tai huang taihou	太皇太后	Xinjiang	新疆省
Taichang Si	太常寺	Xiqing gujian	西清古鑑
Taihe Dian	太和殿	Xiqing xujian, jiayi bian	西清續鑑，甲乙編
Taihu	太湖	Xu Yang	徐揚
Taiji Dian	太極殿	Xuantong/Puyi (1909–11)	宣統帝（溥儀）
Taizong	太宗	Xuanwu	玄武
Tang Dai	唐岱	Xumifushou Temple	須彌福壽廟
Tang dynasty (618–907)	唐朝	Xun Pin	循嬪
Tang Ying	唐英		
Tangse	堂子	Yalu river	鴨綠江
Tantan Dangdang	坦坦蕩蕩	Yamantaka-Vajrabhairava	大威德（閻羅敵）
taotie	**饕餮**	Yan Gongyuan	嚴恭遠
Tashilhunpo Monastery	札什倫布宮	Yang Xifu	楊錫紱
Tengyin zaji	藤陰雜記		

Yangtze river	揚子江	Zaoban chu	造辦處
Yangxin Dian	養心殿	Zaobanchu huoji dang	造辦處活計檔
Yangzhou	揚州	Zhang Jie	張節
Yao Wenhan	姚文瀚	Zhang Weibang	張為邦
Yao Zongren	姚宗仁	Zhang Zongcang	張宗蒼
Yehe	葉赫	Zhangjing	章京
Yi, Prince	怡親王	Zhao Mengfu	趙孟頫
Yihe Yuan	頤和園	Zhaolian, Prince	昭槤
Yilaqi	伊拉齊	Zhejiang province	浙江省
yin	陰	Zheng Chenggong	鄭成功
Ying Fei	穎妃	Zhengda guangming	正大光明
Yingyue sword	映月	Zhengjue Si	正覺寺
Yinzhen	胤禎	Zhenwu	真武
Yixian	易縣	Zhongguo diyi lishi dangan guan	中國第一歷史檔案館
Yixing	宜興		
yoga-tantra	密教瑜伽部	Zhonghe Dian	中和殿
Yonghe Gong	雍和宮	Zhonghua Gong	重華宮
Yongrong	永容	Zhongnaihai	中南海
Yongzheng (1723–35)	雍正帝	Zhongzheng Dian	中正殿
Yu Minzhong	于敏中	Zhou dynasty (1100–256 BC)	周朝
Yuan dynasty (1271–1368)	元朝	Zhu Yan	朱琰
Yuan Mei	袁枚	Zhu Youlang	朱由榔
Yuanming Yuan Summer Palace	圓明園	Zhuangzi	莊子
		Zhuanzhu Alley	專諸巷
Yue ware	越窰	Zhushan	珠山
Yuhua Ge	雨花閣	Ziguang Ge	紫光閣
Yuling	裕陵	Zijincheng	紫禁城
Yunnan	雲南省	Zisun Niang Niang	子孫娘娘
yuntou lu	雲頭路	zitan (wood)	紫檀
		Zunhua	遵化

Bibliography

Amiot, Jean, *Mémoires concernant l'histoire, les sciences, les arts, les mœurs, les usages, &c. des Chinois: par les missionnaires de Pékin ...*, 15 vols., Paris 1776–91

Bagley, Robert, "Percussion," in *Music in the Age of Confucius*, ed. Jenny So, Seattle and London 2000, pp. 35–64

Bartlett, Beatrice S., *Monarchs and Ministers: The Grand Council in Mid-Ch'ing China, 1723–1820*, Berkeley CA 1991

Beiping gugong bowuyuan (ed.), *Qingdai dihou xiang* [Portraits of Qing emperors and empresses] [1931], Beijing (Zhongguo shudian) 1998

BJS (Beijing shi) Eastern Park District and BJS Archives, *Beijing Ditan shiliao* [Archival materials on Earth Altar, Beijing], Beijing (Beijing Yanshan chubanshe) 1998

Bredon, Juliet, *Peking* [1920], 2nd edn, Shanghai 1922

Bredon, Juliet, and Igor Mitrophanow, *The Moon Year*, Shanghai 1927

Cammann, Schuyler V.R., *China's Dragon Robes*, New York 1952

Carl, Katherine, *With the Dowager Empress of China* [1906], London and New York 1986

Chang, Lin-sheng, "The National Palace Museum: A History of the Collection," in *Possessing the Past*, ed. Wen C. Fong and James C.Y. Watt, New York 1996, pp. 3–36

Chen, Hsia-Sheng, "Materials used in Ch'ing Dynasty Jewelled Costume Accessories," in *Catalogue of the Exhibition of Ch'ing Dynasty Costume Accessories* (exhib. cat.), ed. National Palace Museum, Taipei 1986, pp. 29–50

Crossley, Pamela Kyle, *The Manchus*, Oxford 1997

DQGZCHDSX: *Da Qing Gaozong Chunhuangdi shengxun*, in *Da Qing shichao shengxun*, Gaozong section, *juan* 57–63, Beijing(?), n.d. (1900–1930?), no page numbers

DQSL(GZ): *Da Qing shilu (Gaozong Chunhuangdi)* [The veritable records of the Qing dynasty (Gaozong Qianlong)], Taipei (Taiwan Huawen shuju) 1964

DQSL(RZ): *Da Qing shilu (Renzong)* [The veritable records of the Qing dynasty (Renzong Jiajing)], Taipei (Taiwan Huawen shuju) 1964

Danby, Hope, *The Garden of Perfect Brightness*, Chicago 1950

DerLing, Princess Yukeng, *Two Years in the Forbidden City* [1911], Project Gutenberg E-text #889, 1997

Du Halde, J.B., *A Description of the Empire of China and Chinese-Tartary*, 2 vols., London 1738

Elliott, Mark C., *The Manchu Way: The Eight Banners and Ethnic Identity in Late Imperial China*, Stanford CA 2001

Forêt, Philippe, *Mapping Chengde*, Honolulu 2000

Fu, Yuguang, *Shaman jiao yu shenhua* [Shamanism and legends], Shenyang (Liaoning daxue chubanshe) 1990

Ho, Chuimei, "Food for an 18th-Century Emperor: Qianlong and His Entourage," in *Life in the Imperial Court of Qing Dynasty China*, ed. Chuimei Ho and Cheri A. Jones, Denver 1998, pp. 73–94

Ho, Chuimei, and Cheri A. Jones (eds.), *Life in the Imperial Court of Qing Dynasty China*, Denver Museum of Natural History, Series 3(15), Denver 1998

Hsieh, Ming-liang, "Qianlong's Connoisseurship of Ceramics," in *Symposium, China and the World in the 18th Century*, Taipei (National Palace Museum) 2002

Huang, Nengfu, and Juanjuan Chen, *Zhongguo fuzhuang shi* [A history of Chinese costumes], Beijing 1995

James, H.E.M., *The Long White Mountain or a Journey in Manchuria*, London 1888

Jiang, Xiangshun, *Shenmide Qinggong shaman jiji* [Mystical sacrifice of the Qing Palace Manchu shamanism], Shenyang (Liaoning renmin chubanshe) 1995

——, *Manzu shi lunji* [A collection of papers on the history of Manchu ethnicity], Shenyang (Liaoning chubanshe) 1999

Ko, Dorothy, "The Emperor and His Women: Three Views of Footbinding, Ethnicity, and Empire," in *Life in the Imperial Court of Qing Dynasty China*, ed. Chuimei Ho and Cheri A. Jones, Denver 1998, pp. 37–48

Larsen, Jeanne, "Women of the Imperial Household: Views of the Emperor's Consorts and Their Female Attendants," in *Life in the Imperial Court of Qing Dynasty China*, ed. Chuimei Ho and Cheri A. Jones, Denver 1998, pp. 23–37

Lattimore, Owen, "The Gold Tribe, 'Fishskin Tatars' of the Lower Sungari," *Memoirs, American Anthropological Association*, XL, 1933, pp. 1–77

Laufer, Berthold, "The Decorative Art of the Amur Tribes," *Memoirs, American Museum of Natural History*, VII, 1902, pp. 1–86

Levin, M.G., and L.P. Potapov, *The Peoples of Siberia*, Chicago 1964

Liu, Yi, *Ming Qing huangshi* [Imperial houses of the Ming and Qing dynasties], Beijing 1997

Lu, Tong, "Qingdai buzi [Mandarin squares of the Qing dynasty]," *Forbidden City*, 1987, no. 2, pp. 38–39

Mayers, William Frederick, *The Chinese Government: A Manual of Chinese Titles, Categorically Arranged and Explained* [1886], 3rd edn, revised and ed. G.M.H. Playfair, Shanghai 1896

Millward, James A., "A Uyghur Muslim in Qianlong's Court: The Meanings of the Fragrant Concubine," *Journal of Asian Studies*, LIII, no. 2, May 1994, pp. 427–58

Mo, Dongren, *Manzushi luncong* [A collection of papers on Manchu history], Beijing (Renmin chubanshe) 1958

Mote, Frederick, "Becoming an Emperor," in *Life in the Imperial Court of Qing Dynasty China*, ed. Chuimei Ho and Cheri A. Jones, Denver 1998, pp. 11–22

Naquin, Susan, *Peking: Temples and City Life, 1400–1900*, Berkeley CA 2000

Naquin, Susan, and Evelyn S. Rawski, *Chinese Society in the Eighteenth Century*, New Haven CT 1987

Nei, Chongzheng (ed.), *Qingdai gongting huiha* [Paintings by court artists of the Qing court], Hong Kong (Shangwu yinshuguan) 1999

Nowak, Margaret, and Stephen Durrant, *The Tale of the Nisan Shamaness: A Manchu Folk Epic*, Seattle and London 1977

Palace Museum (ed.), *Court Painting of the Qing Dynasty*, Beijing (Cultural Relics Publishing House) 1992a

——, *Cultural Relics of Tibetan Buddhism Collected in the Qing Palace*, Beijing (Xinhua Shudian) 1992b

Parker, Geoffrey, *The Military Revolution: Military Innovation and the Rise of the West, 1500–1800*, Cambridge 1988

QDDQTL: *Qinding da Qing tongli* [Imperially commissioned rituals of the Qing dynasty], ed. Mukedengge [1824], in *Siku quanshu zhenben baji*, ed. Wang Yunwu, vols. 125–30, Taipei n.d.

QDDQHDSL: *Qinding da Qing huidian shili* [Imperially commissioned collected regulations and precedents of the Qing dynasty] [1899], 19 vols., Taipei 1976

QDGZXXZL: *Qinding gongzong xianxing zeli* [Imperially commissioned current palace regulations] [1742], in *Jindai Zhonguo shiliao congkan*, ed. Shen Yunlong, vols. 621–24, Taipei 1979

QDZGNWF: *Qinding zongguan neiwufu xianxing zeli* [Imperially commissioned current regulations of the ministers of the imperial household department], ed. Guoli Beiping Gugong Bowuyuan Wenxianguan, Beijing 1937

Qinggui *et al.* (eds.), *Guochao gongshi zhengxubian* [History and sequel to history of the Qing palaces], Taipei (Taiwan xuesheng shuju) 1965

Rawski, Evelyn S., "Re-envisioning the Qing: The Significance of the Qing Period in Chinese History," *Journal of Asian Studies* LV, no. 4, 1996, pp. 829–50

——, *The Last Emperors: A Social History of Qing Imperial Institutions*, Berkeley CA 1998

Shenyang Municipal Editorial Board (ed.), *Shenyang Manzu zhi* [A gazetteer of Manchu in Shenyang], Shenyang (Shenyang minzu chubanshe) 1991

Shirokogoroff, S.M., "General Theory of Shamanism among the Tungus," *Journal of the North China Branch, Royal Asiatic Society*, LIV, 1923, pp. 246–49

——, *Social Organization of the Manchus*, Extra Volume 3, Shanghai (North China Branch, Royal Asiatic Society) 1924

Song, Heping, *Nisan shaman yanjiu* [A study on Nisan shamanism], Beijing 1998

Stuart, Jan, and Evelyn S. Rawski, *Worshiping the Ancestors: Chinese Commemorative Portraits*, Washington, D.C. (Freer Gallery of Art and the Arthur M. Sackler Gallery, Smithsonian Institution) 2001

Tang, Wenji, and Qingsi Luo, *Qianlong zhuan* [A bibliography of Qianlong], Beijing 1994

Tchen, Hoshien, and M. Kenneth Starr, *Catalogue of Chinese Rubbings from the Field Museum*, Fieldiana Anthropology, n.s., III, Chicago 1981

Tie, Yuqin (ed.), *Qingdi Dongxun* [The Eastern Tours of the Qing emperors], Shenyang 1991

Tong, Jianzhong, *Qianlong Yupi* [Penned by Qianlong], 2 vols., Beijing (Zhongguo huaqiao chubanshe) 2001

Torbert, Preston M., *The Ching Imperial Household Department*, Cambridge MA 1997

Wakeman, Frederick, *The Great Enterprise*, 2 vols., Berkeley CA 1985

Waley, Arthur, *Yuan Mei, Eighteenth Century Chinese Poet*, Palo Alto CA 1970

Wan, Yi, S. Wang, and L. Liu, *Qingdai gongtingshi* [Court history of the Qing dynasty], Shenyang 1990

Wang, Yao-t'ing, "Ch'ien-lung's Painting and Calligraphy: The Possibility of Ghostwriters," in *Symposium on "China and the World in the 18th Century,"* Taipei (National Palace Museum) 2002, pp. 83–89

Wang, Zilin, "Yangxin dian Xianlou fotang ji tangkha xi, [Analysis on the shrine and *thangkha* paintings at Buddhist Xianlou in Yangxin Dian]," *Palace Museum Journal*, 2002, no. 3, pp. 28–40

Watson, Burton (trans. and ed.), *Records of the Grand Historian, Translated from the Shih Chi of Ssu-ma Ch'ien*, 2nd edn, New York 1962

Watson, William, *Chinese Jade Books in the Chester Beatty Library*, Dublin 1963

Wechsler, Howard J., *Offerings of Jade and Silk*, New Haven CT 1985

Wei, Ji, "Cining Gong – the home of widows of the Forbidden City," *Palace Museum Journal*, 1982, no. 4, pp. 24–25

Wheatley Paul, *The Pivot of the Four Quarters*, Chicago 1971

Wu, Kong, "Archery, Combats and Dismounting Tablet," *Forbidden City*, 1987a, no. 3, pp. 9, 13

———, "Ziguangge History," *Forbidden City*, 1987b, no. 4, p. 11

Wu, Xiangxiang, *Zijincheng mitan* [Secret chats about the Forbidden City], Taipei (Yuandong tushu gongsi) 1953

Wu, Zhenyu, *Yangjizhai conglu* [Collected notes from the Yangji Studio] [1896], Hangzhou 1985

Yan, Chongnian, "Qingdai gongting yu Shaman wenhua [Qing Palace and shamanism]," *Palace Museum Journal*, 1993, no. 2, pp. 55–64

Yang, Boda, "The Glorious Age of Chinese Jades," in *Jade*, ed. Roger Keverne, New York 1991, pp. 127–94

Yu, Tao, *Ancient Bells in China*, Beijing (Zhongguo luyou chubanshe) 1999

Yuan, Jieying, *Zhongguo lidai fushi shi* [Costumes from successive dynasties in China], Beijing 1994

ZGNWFXXZL: Zongguan neiwufu xianxing zeli [Current regulations of the ministers of the Imperial Household Department], ed. Guoli Beijing Gugong Bowuyuan Wenxianguan, Beijing 1937

Zhang, Enyin, *Yuanming daguan hua shengshuai* [The rise and fall of the grand Yuanming Yuan], Beijing 1998

Zhang, Qin, *Qingdai falu zhidu yanjiu* [Studies on the system of Qing laws], Beijing 2000

Zhang, Yuxin, *Qing zhengfu yu lama jiao* [Qing government and lamaism], Henan (Tibet renmin chubanshe) 1988

Zhaolian, *Xiaoting zalu, Xiaoting zulu*, [Random notes from the Whistling Pavilion, More random notes from the Whistling Pavilion], Beijing (Zhonghua shuju) 1980

Zheng, Zhihai, and Zhijing Qu, *Beijing Zijincheng* [The Forbidden City in Beijing], Beijing (China Reconstructs Press) 1988

———, *Qinggong dihou shanyin* [Imperial food for Qing emperors and empresses], Beijing (Jiuzhou chubanshe) 2000

Zhongguo diyi lishi danganguan (ed.), *Yuanmingyuan: Qingdai dangan shiliao* [Yuanming Yuan: Historical materials from the Qing archives], 2 vols., Shanghai (Guji chubanshe) 1991

Zhou, Xibao, *Zhongguo gudai fushi shi* [A history of costumes and ornaments in traditional China], Taipei 1989

Picture Credits

All photographs and other images, unless otherwise credited below, are the property of the Palace Museum, Beijing, and depict museum structures or items in its collections. The photographers are Hu Chui, Feng Hui, Liu Zhigang, and Zhao Shan.

Figs. 1, 2, back jacket (bottom): © 2003 Macduff Everton

Figs. 3, 23, 31, 75, 76, 103, 135: Osvald Sirén, *The Imperial Palaces Of Peking*, 3 vols., Paris and Brussels (G. Van Oest) 1926, in the collection of The Field Museum Library

Figs. 5, 6, 8, 25, 104: Bennet Bronson and Jill Seagard, The Field Museum

Fig. 7: J.B. Du Halde, *A Description of the Empire of China and Chinese-Tartary*, 2 vols., London 1738, in the collection of The Field Museum Library

Figs. 12, 26, 140, 149: The Library of Congress, Washington, D.C.

Figs. 13, 27, 62, 69, 152, 185, 191, 212, 276, 329, 330: © 2003 The Field Museum, A114241_02d, A114247_02d, A114246_02d, A114245_01d, A100689_A, A114248_01d, A114249_01d, A114242_04d, A114249_01d, A114240_01d, photographer: John Weinstein

Fig. 14: H.E.M. James, *The Long White Mountain or a Journey in Manchuria*, London 1888, in the collection of The Field Museum Library

Fig. 15: Greg Mueller, The Field Museum

Fig. 17: Levin, M.G. and L.P. Potapov (eds.), *The People of Siberia*, translated from the Russian by Scripta Technica, Inc.; English translation edited by Stephen Dunn. Published by The University of Chicago Press. © 1964 by The University of Chicago. All rights reserved.

Fig. 21: © P.K. Mok/Greater China Photo

Figs. 22, 193: Robert Weiglein, The Field Museum

Fig. 24: © Liu Liqun/CORBIS

Figs. 28, 139, 148, 206: Bennet Bronson, The Field Museum

Figs. 30, 176: Matt Matcuk, The Field Museum

Figs. 40, 84, 136, 195: © 1933 The Field Museum, CSA76951; © 1965 The Field Museum, A100678; © 1959 The Field Museum, A97838; © 1914 The Field Museum, CSA35932

Figs. 49, 122, 268, 269: National Palace Museum, Taipei, Taiwan, Republic of China

Figs. 50, 123: Arthur M. Sackler Gallery, Smithsonian Institution, Washington, D.C.

Fig. 65: Freer Gallery of Art and Arthur M. Sackler Gallery Archives, Smithsonian Institution, Washington, D.C.

Fig. 66: Thomas Allom, *China, in a series of views, displaying the scenery, architecture, and social habits of that ancient empire*, 4 vols., London (Fisher) 1843, in the collection of The Field Museum Library

Fig. 72: Courtesy of The Bata Shoe Museum, photographer: Hal Roth

Fig. 79: Nordiska Museets Bildbyrå

Fig. 110: The Metropolitan Museum of Art, Purchase, The Dillon Fund Gift, 1988 (1988.350). Photograph © 1995 The Metropolitan Museum of Art

Fig. 113: © The British Museum

Figs. 147, 349: Bennet Bronson and Chuimei Ho, The Field Museum

Fig. 151: © 1967 The Field Museum, A101440c, photographer: Ron Testa

Fig. 159: Bennet Bronson, The Field Museum, and Technical Arts Services

Fig. 179: © Liu Liqun/ChinaStock Photo Library

Fig. 180: © Chinapix Ltd.

Fig. 203: © The Cleveland Museum of Art, John L. Severance Fund, 1969.31

Fig. 210: Robin Groesbeck, The Field Museum

Fig. 230: Photo courtesy http://philip.greenspun.com

Fig. 231: Chuimei Ho, The Field Museum

Figs. 279, 293: Freer Gallery of Art, Smithsonian Institution, Washington, D.C.

Fig. 282: © Bibliothèque nationale de France

Fig. 350: Iris & B. Gerald Cantor Center for the Visual Arts, Stanford University; 1967.76, gift of Mrs. Charles Ure

Fig. 355: Jean Amiot, *Memoires concernant l'histoire, les sciences, les arts, les mœurs, les usages, &c. des Chinois: par les missionnaires de Pekin ...*, 15 vols., Paris 1776–91, in the collection of The Field Museum

Index